MAPPING INDIA

This book presents an alternate history of colonial India in the 18th and the 19th centuries. It traces the transitions and transformations during this period through art, literature, music, theatre, satire, textiles, regime changes, personal histories and migration. The essays in the volume examine historical events and movements which questioned the traditional parameters of identity and forged a new direction for the people and the nation. Viewing the age through diverse disciplinary angles, the book also reflects on the various reimaginings of India at the time.

This volume will be of interest to academics and researchers of modern Indian history, cultural studies and literature. It will also appeal to scholars interested in the anthropological, sociological and psychological contexts of imperialism.

Sutapa Dutta is in the Department of English at Gargi College, University of Delhi, India.

Nilanjana Mukherjee teaches English literature in Shaheed Bhagat Singh College, University of Delhi, India.

MAPPING INDIA

Transitions and Transformations,
18th–19th Century

*Edited by Sutapa Dutta
and Nilanjana Mukherjee*

LONDON AND NEW YORK

First published 2020
by Routledge
2 Park Square, Milton Park, Abingdon, Oxon OX14 4RN

and by Routledge
52 Vanderbilt Avenue, New York, NY 10017

Routledge is an imprint of the Taylor & Francis Group, an informa business.

© 2020 selection and editorial matter, Sutapa Dutta and Nilanjana Mukherjee; individual chapters, the contributors

The right of Sutapa Dutta and Nilanjana Mukherjee to be identified as the authors of the editorial material, and of the authors for their individual chapters, has been asserted in accordance with sections 77 and 78 of the Copyright, Designs and Patents Act 1988.

All rights reserved. No part of this book may be reprinted or reproduced or utilised in any form or by any electronic, mechanical, or other means, now known or hereafter invented, including photocopying and recording, or in any information storage or retrieval system, without permission in writing from the publishers.

Trademark notice: Product or corporate names may be trademarks or registered trademarks and are used only for identification and explanation without intent to infringe.

British Library Cataloguing-in-Publication Data
A catalogue record for this book is available from the British Library.

Library of Congress Cataloging-in-Publication Data
A catalog record for this book has been requested

ISBN: 978-1-138-50642-8 (hbk)
ISBN: 978-0-429-31846-7 (ebk)

Typeset in Sabon
by Apex CoVantage, LLC

CONTENTS

List of illustrations viii
Acknowledgements ix
Notes on contributors x

Introduction 1
SUTAPA DUTTA AND NILANJANA MUKHERJEE

PART I
Space, place and displacement 15

1 Imperial guidebooks for charting India 17
 SUTAPA DUTTA

2 Scottish resonances in James Baillie Fraser's travel accounts 37
 NILANJANA MUKHERJEE

3 The correct view: ethnographic representation of Darjeeling hill tribes, from drawings to photography 56
 AGASTAYA THAPA

4 Patterns of migration and formation of the Indian diaspora in colonial India 77
 AMBA PANDE

CONTENTS

PART II
Regional formations and movements 93

5 Struggle over a Mughal office: English response
to Maratha expansion along coastal Western India in 1733 95
VIJAYANT KUMAR SINGH

6 Pre-modern cosmopolitanism: a challenge to Ladakh's
'Tibetanness' 114
RIYA GUPTA

7 The 'Cow Protection' discourse in India: the making
of a 'movement' 133
RIDHIMA SHARMA

PART III
Generic alterities of representation 153

8 Aristocratic households during the transition to early
modernity: representation of domesticity in an
Indo-Muslim 18th-century biographical compendium 155
SHIVANGINI TANDON

9 Delhi through Ghalib's eyes: politico-cultural transitions
in the aftermath of the revolt of 1857 173
MOHIT ABROL

10 Mapping transformations in the Indian public sphere: an
analysis of the *Punch* and *Oudh Punch* cartoons 192
NEHA KHURANA

PART IV
Transigent cultures 217

11 Music before the 'Moderns': a study of the changing
economy of pleasure 219
VIBHUTI SHARMA

CONTENTS

12 Urban theatre in North India during the 19th century: a study 241
 MADHU TRIVEDI

13 Indian trade textiles: transition in patronage,
 transformation in style 255
 GAURI PARIMOO KRISHNAN

 Index 276

ILLUSTRATIONS

Figures

3.1	Phuchung, Brian H. Hodgson	61
3.2	Lepcha Girl and Buddhist Lama, Joseph D. Hooker	65
3.3	*Baksheesh!* L. A. Waddell	66
3.4	Meech and Meech Group	71
10.1	The Red Tape Serpent: Sir Colin's Greatest Difficulty in India	196
10.2	The British Lion's Vengeance on the Bengal Tiger	198
10.3	Justice	200
10.4	The Clemency of Canning	201
10.5	Mr. Punch	204
10.6	Punch Dinner	207
10.7	Opium Den in Lucknow	208
13.1	Ramayana battle scene, ceremonial hanging *maa'* depicting a Ramayana battle scene	258
13.2	*Seluar cinde* (trouser)	263
13.3	Large caparisoned elephant pattern hanging	264
13.4	Block-printed flower basket pattern patola	266
13.5	Piece good of three identical parts depicting *daun bolu* motif	268
13.6	Hanging with grape leaf pattern	270
13.7	Hanging depicting women with veenas and parrots	272

Table

4.1	Major Indian indentured labour importing colonies	80

ACKNOWLEDGEMENTS

The idea of a collection of essays on 'Mapping India' emerged after a conference of the India International Society for Eighteenth-Century Studies (IISECS) which took place in Delhi in March 2017. The multidisciplinary papers presented at the conference were as fascinating in their range as were the participants who represented diverse geographical areas and interests. This is not a collection entirely of papers presented at the conference, although the presentations and interactions at the conference were surely the reason that made us aim for a collection of essays that could showcase the multiple dimensions and layered complexities of this period of transition in Indian history.

The list of friends, colleagues and students who have contributed their inputs and ideas is so long that it is quite unfair to put down just our names as the editors of this volume. In that sense, we owe this book to the author-contributors who believed in us, patiently revising and re-revising their work numerous times, and to our colleagues who, despite their multiple commitments, found time to respond to the chapters providing invaluable feedback. We owe special thanks to Farhat Hasan, Anisur Rahman, Christel Devadawson, Mallarika Sinha Roy, Anshu Malhotra, Rohit Wanchoo, Denys Leighton, Amit Rahul Baishya, Radica Mahase, Nandini Chaterjee and Agniva Ghosh for their expert critical comments on individual pieces. We are also grateful to Deeksha Bhardwaj, Ruchika Sharma, Meenakshi Jain, Katherine Schofield and Sayantani Choudhary for their advice, assistance and support.

We wish to express our gratitude to the anonymous reviewers for their constructive comments and for giving direction to this work; to Aakash, who right from the onset expressed keenness, hope, and interest in our collection; and to Shloka for her constant assistance. Lastly, special thanks to the copy-editors for their patience, meticulous editing and for always being available.

CONTRIBUTORS

Mohit Abrol is an assistant professor in the Department of English, Gargi College, University of Delhi. His research interests include the postmodern condition, the rise of Fascism and the Cold War era, continental philosophy, Marxist studies, political violence and the idea of justice. He has published articles on the Fascist propaganda, Auschwitz and language games in various journals. His recent publications include extensive commentaries on Gramsci, Althusser and Aijaz Ahmad in *A Critical Reader to Literary Theory* (2017).

Sutapa Dutta is in the Department of English at Gargi College, University of Delhi. She is currently a fellow at the Indian Institute of Advanced Study (IIAS), Shimla. She received her PhD from Jawaharlal Nehru University, New Delhi. Her research interests and publications are focused on 18th-century writings and issues related to culture, identity and representation. She has received several grants, including an Early Career Fellowship by the International Society for 18th-Century Studies (ISECS) and Manchester University, UK, a grant for research work at Oxford University, and a Research Project grant from the University Grants Commission (UGC). She has presented many papers in national and international conferences and has published book chapters and papers in reputed journals. Her recently published book is titled *British Women Missionaries in Bengal, 1793–1861*, Anthem Press, UK (2017).

Riya Gupta works as a research scholar at the Centre for Historical Studies, Jawaharlal Nehru University. Her research topic is 'Being a *Mansabdar*: Norms of Civility and Issues of Identity in Mughal Lower Bureaucracy', which is on the political and socio-cultural lives of low-ranking Mughal *mansabdars*. Her other areas of interest are maritime and trade history, history as reconstructed through the writings of foreign travellers, regional histories, and history as received in the public discourse in the form of historical fiction or mythology-based fiction.

CONTRIBUTORS

Neha Khurana teaches in the Department of English, Gargi College, University of Delhi. With a keen interest in the broad area of culture studies, she is particularly invested in researching the various facets of surveillance and censorship imposed upon the citizens of a state and the counter activity of resistance offered by the 'citizens' in their own ways. Her interests range from looking at the use of satire in political cartoons as a tool of resistance to analysing visual representations of virtual and spatial manifestations of surveillance and censorship that characterise 'modernities' in urban spaces. Two of her papers on the themes of visual culture, modernity and surveillance have recently been published by the *Lincoln Humanities Journal* (2016).

Gauri Parimoo Krishnan is an art historian, independent curator, museum consultant and professional dancer who has dedicated three decades to the development of museums in Singapore. She has a PhD in art history from the M.S. University of Baroda, India, where she taught art history and aesthetics before moving to Singapore. She is the director of DMBG Consultants based out of Singapore and India, was the inaugural centre director and lead curator of the Indian Heritage Centre (2009–2015) and senior curator for Indian art at the Asian Civilisations Museum (1993–2011) in Singapore. Gauri served as the director for Research and Fellowship at the Culture Academy on the National Heritage Board and adjunct associate professor for Indian art history at the South Asian Studies Programme of the National University of Singapore. Some of her publications are 'The Power of the Female: Devangana Sculptures on Indian Temple Architecture', 'Ramayana in Focus: Visual and Performing Arts in Asia' and 'Nalanda, Srivijaya and Beyond: Re-exploring Buddhist Art in Asia', among others. Gauri is a recipient of the Singapore government's Commendation Medal (2008) and Public Administration Medal (Bronze, 2015) for her contribution to the arts and heritage sectors.

Nilanjana Mukherjee teaches English literature in Shaheed Bhagat Singh College, University of Delhi. She received her PhD from Jawaharlal Nehru University for her thesis titled 'Articulating Colonial Space: British Representations of India' in the year 2011. In 2009, she received a visiting scholarship from King's College, London, to conduct archival research work towards writing her PhD dissertation. She is the recipient of the Meenakshi Mukherjee Memorial Prize for the year 2014 by the Indian Association of Commonwealth Languages and Literature for her article titled 'Drawing Roads/Building Empire: Space and Circulation in Charles D'Oyly's Indian Landscapes' published in *South Asia: Journal of South Asian Studies*, Vol. 37. She was a Charles Wallace Visiting Fellow at the University of Edinburgh from September to November 2017.

CONTRIBUTORS

Amba Pande is associated with the School of International Studies, Jawaharlal Nehru University. She received her PhD from Centre for Southeast Asia and South West Pacific Studies, School of International Studies, JNU, New Delhi. Her research interests are the Indian diaspora, international migration and the Indo-Pacific. She has also been a visiting faculty/scholar at University of Amsterdam (the Netherlands), the University of South Pacific (Fiji) and Otego University (New Zealand). Dr Pande is a prolific writer and has many publications to her credit in national and international journals. She has been invited to give independent lectures, present papers and be a discussant and chair in a number of national and international seminars and conferences.

Ridhima Sharma has done her MPhil on 'Revisiting the Cow Protection "Movement": Gender and Caste in the Space of a "Gaushala" in Faridabad, Haryana' from Jawaharlal Nehru University, New Delhi. Prior to this, she worked as a researcher at the Advanced Centre for Women's Studies, Tata Institute of Social Sciences, Mumbai, and was a visiting faculty at Sree Narayan Guru College, Mumbai University. She has done her master's in Media and Cultural Studies at the Tata Institute of Social Sciences, where she received the Smitu Kothari Memorial Award for her dissertation. Her research interests include Feminist theory and methodology, ethnography, caste, queer and sexuality studies, the politics of nation-making and violence. Her recent publications include her work with men's rights groups in India and the intersections of caste and gender in 'episodes' of caste-based violence in contemporary northern India. She has also made two documentary films, 'Her Stories' and 'Kaaye Sexual', which have been screened and won awards at several national and international film festivals.

Vibhuti Sharma did her PhD in Theatre and Performance Studies from the School of Arts and Aesthetics, Jawaharlal Nehru University. Her thesis, titled 'Bhatkhande and the Notion of Abstraction: Critique of a Scientific Consciousness', explored the complex development and limits of artistic consciousness informed by a certain scientific impulse in the context of Indian modernity. Since then, she has been working on the philosophical and historical ramifications of the relationship between science and aesthetics, particularly music.

Vijayant Kumar Singh teaches in the Department of History, at Lady Shri Ram College, University of Delhi. He received his doctorate in Medieval Indian History from the Centre for Historical Studies, Jawaharlal Nehru University, New Delhi. His research interests lie in early modern South Asian studies, environmental histories of South Asia and Indian Ocean networks in the early modern period.

Shivangini Tandon is an assistant professor at the Centre for Women's Studies, Aligarh Muslim University, Aligarh (India). She is also a visiting

fellow at the Max Planck Institute for Human Development, Berlin (Germany), where she is working on the representation of emotions in the literary cultures of early modern South Asia. Her research interests include feminist theory, gender history, biographical literature and questions of culture and language. She has been the recipient of many national and international fellowships, like the Jawaharlal Nehru Scholarship for Doctoral Studies, the Max Planck India Mobility Grant, the Foreign Travel Grant from ICHR and the Sanwa Bank Scholarship (funded by the Bank of Tokyo, Mitsubishi, Japan) among others. Her research papers and book reviews have been published in many national and international journals like the *Indian History Review*, the Occasional Paper Series of Nehru Memorial Museum and Library, *Studies in People's History* (SAGE), *Biblio, The Book Review Literary Journal* and most recently an article in a special issue (on emotions) of *South Asia History and Culture* (under publication).

Agastaya Thapa is an independent researcher. She did her PhD at the School of Arts and Aesthetics at Jawaharlal Nehru University, New Delhi, on *Circuits of Representation: Visual Art Practices and the Formation of the Subject in Darjeeling from the Colonial Period to the Present*. Her thesis was on the representation through the lens of tourist art and colonial ethnology. Her research interests include colonial visual culture, photography, popular paintings and prints, Eastern Himalayan history and socio-political movements.

Madhu Trivedi retired as an associate professor from the Department of History, School of Open Learning, University of Delhi. She obtained her PhD from Aligarh Muslim University. She has written extensively on medieval Indian art and culture, including performing art. She has participated in national and international seminars and has written over 50 research papers, out of which 30 articles have been published in reputed national and international journals, the *Encyclopedia of Islam* and edited volumes. Both of her books, *The Making of the Awadh Culture* (2010) and *The Emergence of Hindustani Tradition: Music, Dance and Drama in North India, 13th to 19th centuries* (2012), have received excellent reviews in academic circles. Her research work is based on use of contemporary Awadhi, Braj-bhasha, Sanskrit, Persian and Urdu sources.

INTRODUCTION

Sutapa Dutta and Nilanjana Mukherjee

The intention of this volume is to present a stimulating and meaningful collection of essays which conveys the incredible diversity and range of issues that shaped the transformation of India from the 18th to the 19th century. Each major historical era has been marked by a significant transition, sparked by events or ideas that have generated new ways of thinking and profoundly impacted society and have brought enduring influences in transforming the world. The 18th and 19th century in India was a time of manifold transitions and transformations in all spheres of life – political, social, economic and cultural. On the political front, the death of Emperor Aurangzeb in 1707 presaged the beginning of a 'decentralisation' of the mighty Mughal Empire that had ruled the subcontinent for the last two centuries. The vacuum that was created led to the struggle for power among the local rulers, the Rajputs, the Sikhs, the Marathas, the Nawabs of Bengal, Hyderabad and Awadh. This was in many ways the vulnerability that invaders like Nadir Shah and Ahmad Shah Abdali took advantage of. As has been sometimes suggested, British conquest of India was possible mostly by taking advantage of this internal political chaos and the general disturbed conditions in this period, rather than a 'conquest' (Seeley 2005). Similarly, other European powers – the French, Portuguese, Dutch and Danish – too strategised to gain control over large tracts of the subcontinent for trade and political power. Commerce preceded colonialism, and almost all major European powers maintained their outposts in strategic coastal cities in India.

These efforts of control and consolidation were evident through acts of aggression both on the political and economic fronts. On the economic front, the land-based economy and trade gave way to sea-based trade as the British activity in India transformed from a primarily commercial company to one with substantial territorial interests. By the end of the 18th century, the political fragmentation of the Mughal Empire, coupled with the distinct military strength of the British East India Company (EIC), tilted the balance of power in the company's favour, making them the de facto rulers of Bengal. Within the next hundred years, the aggressive expansionist policies

INTRODUCTION

of the EIC under Cornwallis and Wellesley had successfully dethroned the last vestiges of Mughal power in India and had firmly established the sovereignty of the British Crown in India.

The coming of the British when the Mughals ruled India has been a period marked by two civilisations in contact, institutional changes and unique patterns of interaction. Both their rules remain crucial in the historical study of South Asia, and yet the Mughals have largely been prototyped as eclipsed by the greater glory of the British Raj. When colonial power was beginning to make its power felt, Indian society was structured on an intransient and intricate form. Much of northern and central India had been under an Islamic empire for nearly six centuries and had largely co-existed along with indigenous social practices and power structures. British colonial domination in India, even though its immediate instrument was a commercial company, introduced a political 'imaginary institution' of an entity called the state (Kaviraj 2005, 2010). By the first half of the 19th century, they had successfully controlled much of the military power, commercial activity and administrative apparatuses and had a substantial influence on the cultural life in most parts of India.

This period, which saw a shift in power, has been the subject of a rather continuous and contentious debate with scholars arguing on how to define this time in history.[1] The interpretation of the Mughal rule in the 18th century as a 'dark', 'medieval' period of history which predated the 'modern' state of 19th-century British India was subscribed to by early historians, both English and Indians alike. Both William Irvine and Jadunath Sarkar propounded the 18th century to be a 'dark age' marked by poverty and moral degradation (Irvine 1922; Sarkar 2003). Sarkar blamed Aurangzeb in whose reign 'the purity of domestic life was threatened by the debauchery fashionable in the [Mughal] Court' and conclusively stated that 'On 23rd June 1757, the middle ages of India ended and her modern age began' (Sarkar 2003: 497). Even though it may not have been as dramatic as Sarkar makes it out to be, the Battle of Plassey on that fateful day did decide the destiny of the British, who continued to dominate India for the next two hundred years. Athar Ali and Irfan Habib too look at the period within the framework of Mughal 'decline' (Ali 1978, 1997; Habib 1999). They see the Mughal political collapse as a result of endemic structural flaws in its political and economic systems. Again, while British Orientalists like William Jones and H. T. Colebrooke were exploring the 'golden age' of the Vedic period, Anglicists like Thomas B. Macaulay and J. S. Mill proposed that westernisation was a valid passport to modernity. Even when the British took a scholarly interest in India's glorious past, it was based on the irrefutable premise that the English were the agents of rescuing the people from the anarchic reign and cultural degeneration of their immediate predecessors. David Kopf continues to view British influence and westernisation as the reasons for the 'renaissance' of the country and relates it to 'tradition versus

INTRODUCTION

modernity' (Kopf 1969: vii). Sudipta Kaviraj too distinguishes between a traditionally limited pre-modern conception of state in the Hindu-Islamic context as distinct from the European modern state and goes on to clarify that these two are very different, although we tend to 'house them inside a capacious general category' (Kaviraj 2005).

Recent scholars like C. A. Bayly have pointed out the positive aspects of the decentralisation of the Mughal rule, as it allowed the regional enterprises to collaborate with the English East India Company, so that the early British rule was generally seen as a continuation of the preceding regime (Bayly 1983). Muzaffar Alam too throws a new light on the nature of the Mughal period and suggests a coordinating agency between various sociopolitical systems and communities at various levels. Alam argues that it was the remarkable growth of commercialisation and economic prosperity in this period that led to the regional assertion of political autonomy (Alam 1986). These polarised inferences lead us to rethink what exactly the Mughals represented. While some scholars have condemned them for their despotic and oppressive reign, others have nostalgically lauded their contributions in terms of culture and material life.

The British presence too has been perceived in various shades of light. John Stuart Mill proclaimed that the British rule in India was 'not only the purest in intention but one of the most beneficent in act ever known to mankind' (cited in Curtis 2009: 213). And imperialist historians like Bruce McCully suggested that the 'benevolent Raj' was more altruistic than previous local rulers (McCully 1942: 40). Though the empire is dead and gone, the debates continue to this century, with the historian Niall Ferguson making a fervent case for the British Empire as a force for progress and modernisation (Ferguson 2003). While acknowledging the 'sins of empire', Ferguson is also quick to point out that 'no organisation in history has done more to promote the free movement of goods, capital and labour' or to impose 'Western norms of law, order' and 'modernity' than the British Empire (ibid: xxii).

The arguments against colonisation are too obvious and too numerous to recapitulate here. J. R. Seeley, the English historian whose discussions have greatly given a new perspective about the empire, spelt out the weakness and danger that a nation like Britain had to contend with when it extended into other territories whose subjects could not be perfectly assimilated (Seeley 2005: 46). The Marxist assumption is, of course, that imperialism was economically exploitative (Habib 1995)[2]. Much earlier, Adam Smith in his *Wealth of Nations* (1776) too had expressed his doubts regarding the profitability of such a commercial venture (Smith 1937: Bk IV, 466–71). Even a hardcore Anglophile like Nirad C. Chaudhuri was critical of the repressive methods of the British government (Chaudhuri 1968).[3] And more recently, Shashi Tharoor, calling it 'an Era of Darkness', feels that Britain ought to as a symbolic reparation return one pound per year to India for the next 200 years to 'atone' for the rapacity and cruelty of British rule (Tharoor 2016: Preface).

3

INTRODUCTION

The historiographical framing has been obviously mediated by a wide spectrum of source materials, documentations, individual perceptions and interests. Needless to say, the ideational representation of the period has largely been, and continues to be, the result of how India required to be imagined and framed. The interpretive possibilities of the idea of transformation are not just confined to corporeal alterations but extend across genres and cultural discourses. Such transformations blurring generic types and traversing across disciplines and geographical boundaries have caught the attention of scholars in recent times for interrogating and understanding this period in Indian history. Sunil Khilnani points out two dominating models evident in the burgeoning literature on transition – (a) the 'shock therapy' model, which is based on a sudden rise of institutions, and (b) a 'gradualist' model, which emphasises the unintended results of action (Khilnani 2001). Both these models, as Khilnani points out, were used in Adam Smith's *Wealth of Nations* to analyse the process of transition from a pre-commercial to a commercial society. 'Transition' and 'transformation' in time and space presuppose strategic causes and influences. A 'transition' from pre-colonial to colonial or from pre-modern to modern or pre-commercial to commercial therefore assumes a rectilinear direction. But to see this period as a straight movement from one state to another will be to assume the most basic kinds of dichotomies, which will be inadequate to explain the range of socio-political, economic and cultural practices that marked the complex realities of this period. The contour of the transition was marked by numerous configurations and juxtapositions. The insights drawn through the historiographical studies have only proved that there was no single identifiable pattern of change. The transitory phase in Indian history was a state of flux, an indeterminate condition that was prone to change, marked by new interdependencies, necessities and sentiments, as the emerging society witnessed a different set of dynamics reinforced by the wider colonial web of cohesive government, commercial activities and social interactions.

II

We generally understand the term *empire* as an expanse of land often connected and controlled through successive conquests and military domination. In this sense, the concept of empire is spatial. However, space, as we know from the expositions of Lefebvre, Harvey, Gregory and others, is not a pre-given entity but socially constructed. Therefore, when we talk about the Mughal Empire gradually falling apart, to be replaced ultimately with the British Empire, the change-over seems rather smooth: merely an occupation of a pre-existing configuration with another successive set of administrative order. In the 18th century and through the 19th century, the spatial narrative in historiography is caught up in the assumptive and teleological

INTRODUCTION

trajectory of release from and resumption of power until its liberation in the 20th century. However, when we invoke this frame of territoriality in simplistic terms, we often fail to address the complex political, social and cultural ways to organise vast regions. Even the interregnum can be read as a moment of crisis forming a torsion and a breakaway from the past, making way for myriad possibilities. The concept of 'empire', too, is heavily Western in its formulation (Hardt and Negri 2001; Meyer, Rau and Waldner 2016). It is only after Edward Said, and the later voices in subaltern studies, that we recognised and learned to engage with alternative local, indigenous and regional models. It is not to suggest that the two, the Orient and the Occident, are exclusive binaries, existing in isolation as neatly partitioned, disconnected units. Following Subrahmanyam, we can today talk of 'connected histories' of pre-colonial pasts, the thematic of which can lead us to open up not only spatial boundaries but disciplinary borders as well (Subrahmanyam 1997). Likewise, we thought it fit not to adhere to any form of regional, disciplinary or generic rigidity in this volume.

Similarly, we can no longer view empires as homogenous, cultural monoliths devoid of diversities and disconsonance. It should not be entirely without benefit to track the faultlines that exist within and evade the larger power structures of the hegemons in hunting out disparate and local investments locatable in the interstices of the imperial formations. In so doing, we can shift from the script of occupation to that of inhabitation, and look for lived realities and space. For example, areas talked about in chapters in this book dealing with Gujarat and Ladakh can be seen in terms of the concept of the 'shatter zone' (Ethridge and Shuck-Hall 2009; Dzüvichü and Baruah 2017). Placed outside dominant paradigms because of their geographical location, these were sites of instability which were not without possibilities of reorientation and rebuilding or simply became the crucible of new formations. Post contact with British colonisation, some groups embraced the new power structure, prompting fresh orientations, such as the indentured labour. This led to the forging of new societies from the resulting displacement caused by the introduction of colonial capital which transformed the empire into a new circulatory regime.

The most fruitful way to chalk out the history and arrangement of a land could be by employing a spatiotemporal approach. A well-known productive model in this regard is Mikhail Bakhtin's 'Chronotope' (Bakhtin 2010a, 2010b). Though formulated to identify ruling tropes in literary genres, it should be equally rewarding to employ this model to study and examine binding worldviews and trace developments in formulating a space and time for a particular epoch. On adding the dimension of time to space, we could fruitfully unearth 'intrinsic connections in spatial and temporal relationships' specific to the period (Bakhtin 2010b). This is to say that we can see the unfolding of space in time and the materialising of what came to be known as a self-referential single geographical unit known as India in

INTRODUCTION

the Subcontinent. The chronotope for this volume is, then, the map, which would be instrumental in tracking the transformation and transition in the period. The map projects the layout of a spatiotemporal arrangement and a superimposition of a certain order onto a two-dimensional planar surface. This relentless physical conversion of what goes on on-site as survey is a curious mix of seeing, observing, noting, making and unmaking until the point of geographical objectivity is attained. The process is overtly textual following a narrative formula of a story or a plot. In addition, in newer ways of thinking of interlinkages, especially in terms of continuities, the emplotted place does not emerge at a single moment in time in the book but as a continuing legacy. In other words, maps are histories of all the journeys they summarise and the earlier maps they supplant (Sharrad 2004). The expansive vision that British colonialism had in the subcontinent affects its conceptualisation of space as territory: with ever-shifting boundaries in the North-West and North-East just as a gradually unfolding narrative in an anecdotal form. The map is figurative too, as it is epistemological. It emblematises a range of practices marking a culmination of discourses which aspire to stabilise an imaginary construct.

Therefore, the 18th century beckoned in an age of European-styled geographical consciousness manifesting through myriad modes of knowledge practices, which affected both adherence and resistance. The idea of one's location and transitions therein played an important role in forging regional identities and hardening characters. The agents of European companies, whose interactions with the Indian subcontinent intensified over the few centuries prior to the 18th century, were no longer content with the capital which steadily seeped into their home countries. Soon, these corporations were dreaming of dominions in India and not before long, establishing presidencies in various parts in India. Having fortified their quarters, the gaze became expansive, steadily encompassing the suburbs, villages and wastelands, its outward gaze looking for a secure frontier. While mature epistemological forms materialised later in the 19th century, the 18th century is characterised by a great deal of travel and survey literature by Europeans, doing the primary task of data mining. These practices soon evolved as crucial technologies of knowledge, power and future domination. The colonially inherited Enlightenment worldview began to devise new ways of perceiving the conquered land, nature and its people. Indigenous understandings, however, differed from those of the European officials, travellers, surveyors, missionaries and officials. While the script of acquisition unravelled, the bipartite process of both claiming and defending space gathered impetus, marking out affinities to the land and to the natural habitat through ever more distinct ways. The place sense generated a range of cultural values which shaped definitions and identities. The process of both wresting and retaining or claiming it triggered numerous interactions with the given space in order to create a place. In this regard, tracking layered

relations among knowledge practices and cultural expressions which either emanate from the schematic formalisation, resist it or pre-empt it is but a worthwhile way to think about the age.

III

The 18th to 19th century in Indian history has seen a strange grafting, a mingling and overlapping, and often a confusing mosaic of cultures, identities and ideas. This has inevitably created a unique repository of literature, philosophy, art, architecture and history. It was a period of transition and transformation, of facing new challenges, of questioning traditional parameters of identity and, above all, of forging a new direction for the people and the nation. This period provides an insight into the seeds of change that were planted that then are crucial in decoding contemporary Indian society and culture. This book aims to uncover some of the wider trends of the period and the transitions that characterise the era by drawing in connections between a spatial and an imaginary construction of the country. It is also about understanding the processes of 'transculturation' rooted in the 18th to 19th century (Ortiz 1947; Pratt 1992) and tries to identify areas, practices and cultures left out of the scope of colonially begotten larger discursive processes of progress and advancement simply because these were not perceived to be imperative for the mercantile pursuits of the Company Raj.

The essays engage in thought-provoking debates on the changes and transitions that reflect on issues like society, economy, polity, religion, art and literature that had wide and enduring influence. What these essays share is an emphasis on the agency of change in this period, the ways in which various political, linguistic, religious, artistic and socio-economic denominators have been negotiated by creating, reflecting, appropriating, denying or reimagining 18th- to 19th-century India. The book has been divided into four sections: the first dealing with colonially induced spatial practices of travel and migration which necessitate a discussion on mechanisms of surveys and surveillance; the second dealing with the precolonial existence of fluid cosmopolitan regional patterns; and the third and the fourth sections dealing with convergences in literary, cultural and material productions during the time.

The first section, **'Space, place and displacement'** introduces the theme of exploration discourse and colonial fixing of spatial boundaries and identities. It explores the ocularities ranging from geophysical mapping to physiological stereotyping concretising a fictive landscape with its native inhabitants. This imaginary construct soon overshadowed indigenous lived spaces and created a homogeneous overarching metanarrative which shaped global and specifically European scholarship and epistemological understanding about the region. In 18th-century studies, thinking geographically is critical not merely in a metaphorical sense but also as a form of textual

INTRODUCTION

practice. Today, scholarship has moved beyond merely asking the 'why' and 'how' of things to 'where', as space has become one of the master metaphors of epistemological enquiries. Thus, it is only apt in this book that we look into how the autonomous geographical space of India comes into being, takes shape and defines borders and how those notional boundaries are punctured through mobility and circulation of capital, people and products. The opening section in this book, 'Space, place and displacement' addresses the processes of spatial production through acts of perambulation. The standardisation and codification of the idea of India as a geographical entity is an outcome of such spatial practices during the colonial period. The chapter by Sutapa Dutta titled 'Imperial guidebooks for charting India', traces the lineage and the making of the genre of guidebooks on India from the 18th century Vade Mecums to the present-day Lonely Planet travel guides. Overlapping with studies in book history, she shows how compact modules of knowledge and focused information were systematically packaged in the form of apodemic literature, popular throughout the colonial period in India. These ensure a processual formalisation of the contours of what came to be known as India. The process of taxonomic illustrations augments the visualisation of the spatial category 'India', portending its later objectification. The next chapter, 'Scottish resonances in James Baillie Fraser's travel accounts' by Nilanjana Mukherjee, examines the complex nature of travel accounts which can be placed on the cusp of literary geography, history and scientific expeditions in the Himalayan region. The paper compares it with the aesthetic and cartographic framing of the Scottish Highlands in Great Britain, arguing that the spatial layout and tropes which unfolded in the British home territory were readily adopted as a model by colonial administrators in the South Asian region. A continuous territorial expansion pushed the frontiers to the Himalayas, establishing it as a formidable natural barrier devised for the security and defence of the mainland. The chapter also highlights the influence of Scottish Enlightenment thinking, which played out in the laboratories of the colonial fringes through agents of the colonial regime like the travellers, collectors and explorers. Travel to the hinterlands not only opened up prospects for spatial aggrandisement but simultaneously characterised the travel writer as a veritable man of science. Taking epistemological enquiries in the Himalayas to another level, ethnology and statistics are taken up as a major project. Agastaya Thapa's 'The correct view: ethnographic representation of Darjeeling Hill tribes, from drawings to photography' elaborates the scientific and systematic amassment of data on racial types, flora and fauna varieties found in these mountains in Eastern India. This chapter, too, like the preceding one, emphasises the aesthetic framing of the exotic and the unfamiliar as they recur in sketches, paintings, photographs and postcards. While the first three chapters talk about the processes of stabilisation and fixity of a geographical unit within a global grid through initiatives of traversing the region, the fourth chapter in this

section 'Patterns of migration and formation of Indian diaspora in Colonial India' by Amba Pande broaches another important colonial pattern of travel: that of migration, displacement and destabilisation of native and indigenous populations under the aegis of a plantation economy. The chapter specifically talks of the mobility and circulation of populations from the Indian subcontinent as a result of imperial policies of plantation slavery and indentured labour and following this, the creation of localised diasporas away from their homeland. In this case, oral literature is replete with nostalgia for the lost homeland in India. However, the long isolation, complete breakdown of networks and institutions like caste and encounters with new cultures and local conditions led to the evolution of sub-cultures and distinct hyphenated identities in these newly formed communities giving rise to attempts to nurture a continuity with home culture. Methods of imperial travel that provided impetus to the grammar and language of associative ligature in the first two cases are reversed in the latter case of overseas travel.

While the overall regimes of the two major empires have assumed primacy, it is significant that scholars are recognising and acknowledging the regional experiences and vicissitudes that defined this period. The section on **'Regional formations and movements'** marks the nature of interpretation pertaining to such changes in this period. As the Mughal Empire gradually fragmented and its military and financial resources evidently depleted, a number of regional powers seized the opportunity and sought an independent space for themselves within the emerging political scenario in different parts of India. The fifth chapter by Vijayant K. Singh, 'Struggle over a Mughal office: English response to Maratha expansion along Coastal Western India in 1733', highlights the emergence of the indigenous capitalist and mercantile classes in Gujarat, who found an opportune moment to alleviate their position. Gujarat constituted the most important commercial zone for the Mughal Empire, with its important commercial ports for overseas trade. The role of the financiers and bankers as fiscal agents to the provincial Mughal authorities is quite significant in order to understand their interdependency as well as their confrontation in the early phase of transition. Singh's paper looks at the EIC's official documents to understand the emerging interactive regional politics between the company officials, Mughal administrators, Maratha factions and the local marine merchants and the resultant decline in relations between Gujarat and the Mughal centre. The sixth chapter by Riya Gupta, 'Pre-modern cosmopolitanism: a challenge to Ladakh's "Tibetanness"' looks at another major entrepot of important trade routes and the changes and continuities in this region shaped by colonialism and modernisation. She contests the rigid classification of categories like 'modern' and 'cosmopolitan' associated with the northern peripheries of the country, and like James Scott's Zomia, provides a counter narrative of modern concepts of state, borders and identity. Gupta studies early 19th-century accounts of western travellers to substantiate the existence of what she calls

INTRODUCTION

'pre-modern' cosmopolitanism during this period and discusses how it acted as a challenge to Ladakh's supposed 'Tibetanness' or Tibetan identity. She goes on to argue that the long intertwined influences of trade, religious and cultural association that Ladakh experienced over the ages made it 'cosmopolitan' even before such 'modern' categories were established. The next chapter in this section, 'The "Cow Protection" discourse in India: the making of a "movement"' by Ridhima Sharma traces moments in history and various debates on how the cow has become a principal symbol for the mobilisation of society based on religion and community. Sharma takes a look at the myths associated with the cow as a potent ideological motif to generate nationalistic and often communitarian politics in the colonial times and the negotiation of the 'public space' by religious communities and colonial administration. This chapter reinforces how the cultural landscape and territorial identity of the greater part of India north of the Vindhyas were deeply influenced and shaped by the notions of a 'sacred' symbol.

The third section **'Generic alterities of representation'** examines the ways in which representational alterities between the textual and the visual and also the audial (as in the case of poetry that is recited or plays that are enacted) is predicated within the hermeneutics of signifier/signified. The section indicates the resistance to homogenised representational modes and seeks to differentiate the dualistic status of visible and lisible practices of representation. The paradigmatic relationship between art and literature, words and images, the verbal and the pictorial exists to fill in the gaps in the significance so as to render the representation more meaningful. The three chapters in this section, on biographical literature, poetry and graphic satire, span the alterities of representation of the beliefs, culture and ideas of the time and society and the changes happening in 18th- to 19th-century India. Shivangini Tandon's 'Aristocratic households during the transition to early modernity: representation of domesticity in an Indo-Muslim 18th-century biographical compendium' seeks to throw light on the importance of *tazkirahs* in shaping social perceptions of ethical thinking. These collections of biographical details were a valuable record of impressions and evaluations of the court culture, power politics and lives and writings of the socially and politically dominant elites of the times. Tandon's paper examines the organisation of domestic spaces in these documentations and asserts the necessity to place human experiences, emotions and subjectivities in the greater historical narrative to fully understand the larger forces of historical changes. Mohit Abrol's 'Delhi through Ghalib's eyes: politico-cultural transitions in the aftermath of the revolt of 1857' tries to understand the cultural and political decay of Delhi in the aftermath of the 1857 uprising as seen through the eyes of Ghalib, arguably one of the greatest Persian-Urdu poets of the age and perhaps of all time. The closing years of the Mughal rule and the advent of the English in Delhi brought with them a narrow, insular society fraught with insecurities and uncertainties. Ghalib's compositions

INTRODUCTION

lament the passing away of an epoch and manifest a certain degree of irritability and opposition towards authority, with a distinct air of vanity to stand apart from the common and the vulgar. Neha Khurana's 'Mapping transformations in the Indian public sphere: an analysis of the *Punch* and *Oudh Punch* cartoons' studies graphic satire as a distinct literary genre that reflected the changing scenario of the 19th-century public sphere in India. The chapter emphasises that the *Oudh Punch*, an Urdu weekly which came into publication in 1877 in Lucknow and was seen as the very first Indian version of the British *Punch*, went much beyond a simple adaptation of its British counterpart. Such visual representations, she asserts, have continued to inform our understanding of the role of satire, cartooning and censorship even post-independence.

The last section, **'Transigent Cultures'** rearticulates late Mughal political and cultural traditions in 18th- to 19th-century India from sources left out of the ambit of colonial historiography. Scholars like Ranajit Guha and Partha Chatterjee have explored the appropriation of colonialist historiography in the 19th-century making of modern India within a nationalist agenda by a dominant elite (Guha 1987; Chatterjee 1993). However, Kumkum Chatterjee is of the opinion that Indian nationalist historiography was preceded by a trend in the 18th century when a precolonial bureaucracy engaged in a similar contest for self-representation before a newly formed colonial state. While Indians became willing collaborators in transmitting local knowledge to the new masters, their project also became an act of self-representation (Chatterjee 1998). As the EIC's interest expanded into the central and northern provinces of India, it was generally believed that a journey inward would reveal authentic Indian culture. The Kingdom of Awadh, with its historic cities of Benaras and Lucknow, where the company quickly founded residences, became the centre of interest and enquiry. This area was soon to be recognised as the hub of cultural activities, and what was called the 'Hindoostannie Air' was accepted as the dominant indigenous musical culture giving the elite in Calcutta a ready resource to nurture (Woodfield 1994). Vibhuti Sharma's 'Music before the 'Moderns': a study of the changing economy of pleasure' tries to uncover the prehistory of the colonial project of ethnomusicology which sought to standardise a national air. This chapter begins with the ban on musical practices during the rule of Aurangzeb and their ebullient resurgence in the late Mughal period. It deals with the little-known aspects of complex patronage structures and often overlooked rich diversity of styles, gayakis and gharanas, having existed in this belt prior to the state takeover by a colonial regime with the annexation of Awadh in 1856. Madhu Trivedi's 'Urban theatre in North India during the 19th century: a study' excavates continuities within a tradition of theatrical practices in North India. The chapter speaks of numerous folk performances which were assimilated into a more formal repertoire of courtly drama. She takes up the classic case of the drama *Inder-sabha* in order to

highlight it as a quintessential representation of the 18th-century courtly performance. Various forms of regional and folk dance and music converge in this performance to spawn a genre of musicals which was adopted by the later Parsi theatre and retained even in the Bombay films as late as in the 20th century. As we investigate further into the material and visual cultures of the 18th to 19th century, Gauri Parimoo Krishnan's 'Indian trade textiles: transition in patronage, transformation in style' speaks of cultural transigence of another kind in another region in India. This chapter, in tracing precolonial connected histories, explores the continuities in travel and export of handmade textiles, such as the Ikat, across the desert from Central Asia and thereafter the Indian Ocean, in this case, from ports in Gujarat to islands in South East Asia. This chapter assays the vibrant transoceanic trade routes that decayed and dried with the establishment of European trade posts in crucial parts of coastal India.

This collection of essays hopes to set the stone rolling, to stimulate further pursuit of academic enquiries into this very exciting period of Indian history. A caveat for the too demanding reader – space limits geographical and thematic comprehensiveness. Though we have consciously tried to include diversity of region and subjects, we are also aware that not all areas or possible themes can be satisfactorily accommodated. It is hoped that the book will be useful for general historians and students of colonial history, sociology, anthropology, art and aesthetics, cultural studies and area studies.

Notes

1 For a comprehensive understanding of the 'debates' among historians, see Alvi 2002.
2 Also see Dipesh Chakrabarty's (1996) review of Habib's work.
3 In his dedication to *The Autobiography of an Unknown Indian* (1968), Nirad Chaudhuri wrote. 'Because all that was good and living within us/Was made, shaped and quickened/By the same British rule.' At the same time horrified with the brutal massacre of unarmed Indians by the British troops at the Jallianwala Bagh in Punjab on 13 April 1919, he wrote, 'I like the rest of my countrymen, was horrified and infuriated by the . . . gratuitous display of vindictiveness and racial arrogance that accompanied the restoration of order in the Punjab' (375).

References

Alam, Muzaffar. 1986. *The Crisis of Empire in Mughal North India: Awadh and the Punjab, 1707–48*. New Delhi: Oxford University Press.
Ali, M. Athar. 1978. 'The Eighteenth Century: An Interpretation'. *Indian Historical Review*, 5 (1–2): 175–86.
———. 1997. *The Mughal Nobility Under Aurangzeb* (Revised Edition). New Delhi: Oxford University Press.
Alvi, Seema (ed.). 2002. *The Eighteenth Century in India*. New Delhi: Oxford University Press.

Bakhtin, M. M. 2010a. 'Forms of Time and of Chronotope in the Novel: Notes Towards a Historical Poetics'. In *The Dialogic Imagination: Four Essays* (Vol. 1). Austin: University of Texas Press.

———. 2010b. *Speech Genres and Other Late Essays*. Austin: University of Texas Press.

Bayly, C. A. 1983. *Rulers, Townsmen and Bazaars: North Indian Society in the Age of British Expansion, 1770–1870*. Cambridge: Cambridge University Press.

Chakrabarty, Dipesh. 1996. 'Marxist Perception of Indian History'. *Economic and Political Weekly*, 31 (28): 1838–40.

Chatterjee, Kumkum. 1998. 'History as Self-Representation: The Recasting of a Political Tradition in Late Eighteenth Century Eastern India'. *Modern Asian Studies*, 32 (4): 913–48.

Chatterjee, Partha. 1993. 'Histories and Nations'. In *The Nation and Its Fragments: Colonial and Postcolonial Histories*. Princeton, NJ: Princeton University Press, 76–94.

Chaudhuri, Nirad C. 1968. *The Autobiography of an Unknown Indian*. Berkeley and Los Angeles: University of California Press.

Curtis, Michael. 2009. *Orientalism and Islam: European Thinkers on Oriental Despotism in the Middle East and India*. Cambridge: Cambridge University Press.

Dzüvichü, L. and M. Baruah (eds.). 2017. *Modern Practices in North East India: History, Culture, Representation*. London and New York: Routledge.

Ethridge, R. F. and S. M. Shuck-Hall. (eds.). 2009. *Mapping the Mississippian Shatter Zone: The Colonial Indian Slave Trade and Regional Instability in the American South*. London: University of Nebraska Press.

Ferguson, Niall. 2003. *Empire: How Britain Made the Modern World*. London: Penguin Books.

Guha, Ranajit. 1987. *An Indian Historiography of India: A Nineteenth Century Agenda and Its Implications*. Kolkata: S.G. Deuskar Lectures on Indian History.

Habib, Irfan. 1995. *Essays in Indian History: Towards a Marxist Perception*. New Delhi: Tulika.

———. 1999. *The Agrarian System of Mughal India, 1556–1707*. Oxford: Oxford University Press.

Hardt, M. and A. Negri. 2001. *Empire*. Cambridge, MA: Harvard University Press.

Irvine, William. 1922. *Later Mughals*. Edited by Jadunath Sarkar (2 Volumes). Kolkata: M. C. Sarkar & Sons.

Kaviraj, Sudipta. 2005. 'On the Enchantment of the State: Indian Thought on the Role of the State in the Narrative of Modernity'. *European Journal of Sociology*, 46 (2): 263–96, August.

———. 2010. *The Imaginary Institution of India: Politics and Ideas*. New York: Columbia University Press.

Khilnani, Sunil. 2001. 'The Development of Civil Society'. In Sudipta Kaviraj and Sunil Khilnani (eds.), *Civil Society: History and Possibilities*. Cambridge: Cambridge University Press, 11–32.

Kopf, David. 1969. *British Orientalism and the Bengal Renaissance: The Dynamics of Indian Modernization 1773–1835*. Kolkata: Firma K.L. Mukhopadhyay, Preface.

McCully, Bruce Tiebout. 1942. *English Education and the Origins of Indian Nationalism*. New York: Columbia University Press.

Meyer, H., S. Rau and K. Waldner (eds.). 2016. *SpaceTime of the Imperial* (Vol. 1). Berlin: Walter de Gruyter GmbH & Co KG.

Ortiz, Fernando. 1947. *Cuban Counterpoint: Tobacco and Sugar*. Translated by Harriet De Onis. New York: Alfred A. Knopf.

Pratt, Mary Louise. 1992. *Imperial Eyes: Travel Writing and Transculturation*. London and New York: Routledge.

Sarkar, Jadunath (ed.). 2003 [1943]. *History of Bengal* (Vol. II). New Delhi: B.R. Publishing Corporation.

Seeley, John Robert. 2005 [1880]. *The Expansion of England: Two Courses of Lectures*. New York: Cosimo Classics.

Sharrad, P. 2004. 'Following the Map: A Postcolonial Unpacking of a Kashmir Shawl'. *Textile*, 2 (1): 64–78.

Smith, Adam. 1937 [1776]. *An Inquiry into the Nature and Causes of the Wealth of Nations*. Edited by Edwin Cannan. New York: The Modern Library.

Subrahmanyam, S. 1997. 'Connected Histories: Notes Towards a Reconfiguration of Early Modern Eurasia'. *Modern Asian Studies*, 31 (3): 735–62.

Tharoor, Shashi. 2016. *An Era of Darkness: The British Empire in India*. New Delhi: Aleph Book Company.

Woodfield, Ian. 1994. 'The "Hindostannie Air": English Attempts to Understand Indian Music in the Late Eighteenth Century'. *Journal of the Royal Musical Association*, 119 (2): 189–211.

Part I

SPACE, PLACE AND DISPLACEMENT

1

IMPERIAL GUIDEBOOKS FOR CHARTING INDIA

Sutapa Dutta

A guidebook, as the *Oxford English Dictionary* (1977) defines it, 'is a book of information for tourists'. It is essentially a book of direction and advice for prospective travellers, written to facilitate potential journeys. Unlike a travelogue, which is an individual's personal experiences of travels already made, a travel guidebook sets about 'guiding' would-be travellers.[1] Tony Wheeler, the co-founder of *Lonely Planet*, is of the opinion that 'a great guidebook should do three things: inform, educate and amuse'.[2] He should know, considering that he and his wife, Maureen, co-founded one of the best-selling and most-popular guidebook series on practically every place worth its name in this world. When in 1979 the Wheelers wrote a voluminous 700-page guide on India, which was four times as long as the previous books in the series, it went on to sell 100,000 copies and won the prestigious Thomas Cook literary award for the best guidebook of the year (Epelde 2004: 146). Interest in India is not just a postcolonial fad or a rehash of imperial nostalgia. A spurt in the writing of guidebooks on India in the 19th century can be seen as a systematic mapping of Orientalist discourse and the shifting ideational and ideological apparatuses that determined the West's conception of itself in relation to what was perceived as the Other. This chapter looks at a broad array of guidebooks for travellers, written in the true spirit of apodemic literature to facilitate travelling and settling in India.[3] These guidebooks, I argue, express a sub-text of dominion and control of the geological, economic and ethnographic, as the British imperial power sought to chart its way in the colony.

Showcasing the empire

The middle of the 18th century saw the transformation of the English East India Company (EIC) in India from a mercantile company to an administering body. Along with territorial expansion, the British existence in India depended largely on shaping its imperial image. As the British defined their

own identity vis-à-vis the rest of the world and sought to establish their cultural hegemony, a more organised, structured and scientific inventory of information was required of the Other. It was important to 'know' the country to sustain colonial authority. The almost obsessive effort to 'standardise' and 'codify' what was seen as essentially anarchic both in terms of space and culture was most apparent in the detailed cartographic and cadastral surveys undertaken by the British in India. This was also evident in the systematic surveying, mapping, cataloguing and indexing of each and every aspect of India, of land, languages, tribes, castes, coins, flora, fauna, religious texts, images and antiquities. The establishment of the Survey of India in 1767, the foundation of the 'Great Trigonometrical Survey of India' a few years later and the cartographic surveys made by James Rennell soon had the entire country covered in a network of geographical surveys and mapping. As the surveyor general of Bengal, Rennell had made an extensive collection of topographic data which provided a definitive image of 'India' to the rest of the world. Francis Buchanan was also commissioned by the EIC to survey, map and report on the territories in Bengal. He provided a detailed account of the natural history, genealogy, popular culture and religion of eastern India.[4] All these exercises were a massive campaign to transform the incomprehensible to a known entity. It can be endlessly argued whether such physical maps depicted the 'real' India or not, but such cartographic representations of a 'British India', often coloured in red, left no doubt that its mark and domain was graphically manifested. Mapping the landscape, studying the geological and the ethnographic, recording the economy and the society were not just a defining of the spatial and territorial expanse of the Empire, they were a visual representation of the greatness of the British Empire.

If James Rennell's framing of India as a geographical unity was a 'creation' of the British Empire, a far more potent image-building was the epistemological mapping of the country. This sinuous relationship between colonial knowledge and power has been amply demonstrated by Michel Foucault and Bernard Cohn (Foucault 1991, 1998; Cohn 1996). With the establishment of institutions like the Asiatic Society and the Fort William College, early British administrators and officials began an epistemological and cultural mapping of India. After the first flush of Orientalism in the 1780s, undertaken by William Jones, N. B. Halhed, H. T. Colebrooke and protégés of Warren Hastings to study India's past, it was time to explain the differences. As the British undertook a more detailed study of the empire, it was no longer enough to depend on intellectual exercises like James Mill's *History of British India* (1817)[5] to point out the differences. Such perceived differences had to be scientifically enumerated to secure a better understanding of the uncharted civilisation they had to administer. Col. Colin Mackenzie, the surveyor general of India from 1815–21, during his extensive tour of southern India, collected vast hordes of materials in order to gather more

knowledge of the country.[6] And an eight-volume compilation, *The People of India* (1868), containing 468 annotated photographs recorded the 'ethnic types' of India, their precise characteristics, physiognomy, occupation, dress and manners.

Such compendiums of information were often essentialist, coloured by subjective perceptions and prejudices. These interpretations soon became part of the larger colonial discourse and contributed further to the colonial imagination of India. The Other became a commodified spectacle to be visually consumed and interpreted, while the imperialist observer, from his vantage point, became the unchallenged disseminator of 'knowledge'. As Said's seminal text *Orientalism* has amply demonstrated, such discourses were closely based on preserving differences between the Self and the Other (Said 1978). Mary Louise Pratt in *Imperial Eyes* also highlights the politics of power behind such seemingly benign 'scientific' projects (Pratt 1992). The great imperial project of forming an archive of Eurocentric knowledge of 'the rest of the world' was not just to consolidate binaries of differences between the West and the East; it was simultaneously a part of the European Enlightenment.

Along with the physical exploration and mapping of other regions of the world, a major part of the expansionist strategy of Europe was focused on gathering and exhibiting information. The publication of *Systema Naturae (The System of Nature)* by the Swedish naturalist Carolus Linnaeus in 1735 ushered in a systematic classification of all plants, differentiating and distinguishing species and providing standard botanical nomenclature. Linnaeus's taxonomy had a huge impact on placing all species in a ranked hierarchy. Naming, classifying, categorising and differentiating became a common 18th-century project, as museums and large-scale public spectacles became popular. In India, William Carey, a linguist and missionary, systematically 'organised' vernacular languages and provided extensive grammars of some of the major Indian languages like Bengali, Marathi, Urdu and Tamil. Apart from his enormous contributions to languages and Bible translation, Carey went on to provide meticulous notes and substantive comments on the plants growing in the EIC's Botanic Garden at Calcutta (Carey 1814). The celebrated Orientalist Sir William Jones made a detailed study of the genealogy of languages and delved into every conceivable aspect of India (Jones 1799). India featured prominently in the first Great Exhibition, also referred to as the Crystal Palace Exhibition, which was held in London in 1851. Industrial artefacts and trophies from colonies, including the Kohinoor diamond from India, were exhibited to the public. It was a platform to showcase Britain's achievements, akin to a collector's cabinet of curiosities, a 'spectacle' exhibiting the might of imperialism to the general public at home (Breckenridge 1989; Burton 1996).

It can be argued that colonial guidebooks on India were likewise a systematic production of knowledge that constituted a panopticon of a single

and coherent India. If physical maps had to be authenticated by technological solutions like 'triangulation' and 'trigonometrical' surveys, then the veracity of such 'knowledge' of the country had to be supplemented by actual observations. If the field surveyor was dependent on his instruments and mathematical calculations, then the other empire builders had to authenticate it by their 'official' observations and information. The imperial power was thus emphasised in a totalising and all comprehensive creation, which involved not just physical mapping but all forms of knowledge.

Early vade mecums

An early work which presented India through the eyes of an Englishman was *The East India Vade Mecum* of Captain Thomas Williamson written in 1810 (Williamson 1810).[7] Meant as a 'Complete Guide to Gentlemen intended for the Civil, Military, or Naval Service of the Hon. East India Company', this colonial documentation is a patient and meticulous noting down of minute aspects of life and the people in India. It spread over two volumes of more than a thousand pages; the author's professed aim in undertaking this stupendous labour was for 'public utility' (Letter to the Hon. Court of Directors of the EIC in Williamson 1810). Captain Thomas Williamson who first arrived in Bengal in 1778 attributes his considerable insight and knowledge of the country to his profession as a captain in the Bengal army and his long stay of 'twenty years' in Bengal. As a first travel guide to India intended for Europeans, Williamson's *Vade Mecum* was intended to fill up the gaps in information required by prospective travellers to India. 'The want of some previous instruction', 'absence of any experienced friend, or the impossibility of obtaining some publication suited to guide' had induced him to write, he says (Williamson 1810: I, 1). His guide, he claims, has been written with the purpose to provide a 'just' conception of the 'characters of the natives' in India and would remove all doubts, prejudices and 'false' notions (Williamson 1810: I, Preface, vii). A *vade mecum*, which means a portable book for handy consultation, was thereby a formal, sacrosanct 'guide'. Like the Bible, which was meant to be a spiritual companion, the *vade mecum* was always to be carried around by people who would otherwise be 'lost' without it.

John Borthwick Gilchrist, who went on to bring out a revised version of Williamson's *Vade Mecum*, was equally insistent on the accuracy of his account. His guidebook titled *The General East India Guide and Vade Mecum* (1825) was deemed an essential reading for every cadet of the EIC. The purported design was to 'communicate the information' that the author had so meticulously gathered during his 'residence of 22 years in Bombay and Bengal', so as to provide 'correct knowledge' to all those who come to serve in British India (Gilchrist 1825: Preface, v). Gilchrist had joined the

medical service of the EIC, but his scholarship in Indian languages soon led to his appointment as the first principal of Fort William College when it was established in Calcutta in 1800. As a professor of Urdu and Hindi at Fort William College, Gilchrist went on to produce several works of grammar, vocabulary and dialogues, and established a standardised language, what he called 'Hindoostanee', and what he thought was the common language spoken by the 'Moors'. Gilchrist's *Guide*, which otherwise closely adheres to the earlier *Vade Mecum* by Williamson, appends an elaborate reading list 'suited for students intent on applying to the most valuable source of oriental learning' (Gilchrist 1825: Preface, v).

Both Williamson and Gilchrist provide extensive and detailed instructions on travelling to India. Every piece of information which is reckoned essential or otherwise is located, categorised and reported. The excessive detailing and the 'unsuitableness of many of its details', as one unknown reviewer mildly put it,[8] may at best seem amusing and at worst quite exasperating. Such meticulous assemblage of knowledge on India was to give the impression of a 'true' representation. Over the next hundred years, the focus and purpose of guidebooks on India was to see a huge transformation. From representation of territorial supremacy to the complex ideological imagining of imperial power, these guidebooks achieved what no cartographic mapping could have merely accomplished.

A ready market

Ars apodemica, or the genre of travel advice literature, gained popularity in Europe in the 18th century. The Industrial Revolution in Britain and improvement in transportation technology meant a more empowered middle class with faster access to traveling. While for the working class, travelling was still an economic necessity and a part of their occupational duty, for the upper class elites, travelling came to be associated with 'class' and 'taste'. Matthew Arnold's *Culture and Anarchy*, published some years later, was to successfully indoctrinate the concept of a 'cultured' class, and going on a grand tour of the continent was soon to be considered not just fashionable among the rich but also mandatory (Arnold 1869). Lord Byron's representation of the Orient in *Childe Harold's Pilgrimage* (1812), *Don Juan* (1824) and *Oriental Tales* (1813–16) based on his 'experience', in combination with his Philhellenism, contributed largely to growing interest in the exotic East. While one cannot deny the authenticity of Byron's travel experiences, his knowledge of the Orient was clearly derived from travel books written by earlier travellers which presented the Orient in clichéd details. Byron's attempt to authenticate his travels by donning oriental clothing was again a way of convincing gullible readers. All this certainly helped to create a market for pseudo-oriental works in this period, as can be seen by the popularity of Robert Southey, William Beckford, S. T. Coleridge and P. B. Shelley.

Travel across the Indian subcontinent and beyond had existed much before the coming of the colonisers. Sophisticated trading networks meant that people, animals and goods had circulated across the country for thousands of years. With the British occupation of India, as more travellers, sailors, merchants, missionaries and officers sought economic and professional advancement in new geographical contexts, a whole range of travel guidebooks came up that reflected the very essence of a burgeoning bourgeois market. These guidebooks depict the frequent ambivalent positioning of whether to sell the place as exotic and therefore 'complex' and 'different', or to assure the potential traveller of uniformity and familiarity. Edmund C. P. Hull echoes the bewilderment of the Europeans at the 'grotesque jumble of ancient and modern' that meets the sight upon their first landing in India (Hull 1871: 43). The paintings of the nephew-uncle duo Thomas and William Daniell portrayed the aesthetic of the picturesque India, which as Inderpal Grewal puts it was concerned with 'framing and controlling alterity and heterogeneity' (Grewal 1996: 97). The attempt was to divest the place of its strangeness and to fit it into a familiar framework that would be more comprehensible for the Western onlooker. As Roland Barthes had famously asserted in his essay 'Blue Guide' published in *Mythologies*, guidebooks by focusing on the 'picturesque' and the illusory 'types' could directly influence consumer understanding. His contention was that such texts, by ignoring that 'which is real and which exists in time' merely express a 'mythology' (Barthes 1972: 74–7). Like the topographical maps, guidebooks were a representation of territorial acquisitions, an exemplification of power and an institutionalising of a mythic reality.

Dangerous and desirable

Almost all colonial guidebooks on India conveyed the fascination with the unfamiliar and the exotic, warning of the dangers of forests and wild animals, not to mention the most dangerous of them all, the Indian femme fatale. The early guidebooks show this inevitable contrast between a seductive desirous India and a land which is at the same time threatening and fearsome.[9] The central representational modes of such writings showed the powerful attractions of a sensual India which had to be held in check by an imposing policing. Williamson's *Vade Mecum* reveals the underlying subtext of fascination especially for the 'private lives and customs of those native women that are secluded from the public eye' (Williamson 1810: I, 346). At the same time, it warns European men that alliances with Indian women are not so 'respectable' and concedes that 'matrimony is not so practicable in India as in Europe' (Williamson 1810: 1, 456). 'Plurality' (polygamy) he says, 'is common among natives of opulence, and is not unprecedented among Europeans', and one such elderly gentleman 'solaced himself with no less than SIXTEEN, of all sorts and sizes!' (Williamson 1810: I, 412,

original emphasis). Williamson presents remarkable minute observations of the dressing, toilette, and ornamentation of native women, which then can be a practical guide for the newly arrived Englishmen to negotiate native customs to 'retain' and 'domesticate' native mistresses.

Williamson points out that in India the women who are euphemistically 'under the protection' (Williamson 1810: I, 451) of European gentlemen consider such relations to be as sacred as marital ties. Such connubial attachments with native women which are liable to be deemed in terms of 'Christian religion' as 'libidinous or licentious' are justified because of the sheer shortage of mates for these men.

> The number of European women to be found in Bengal, and its dependencies, cannot amount to two hundred and fifty, while the European male inhabitants of respectability, including military officers, may be taken at about four thousand. The case speaks for itself; for even if disposed to marry, the latter have not the means.
> (Williamson 1810: I, 453)

The impediments that stand in the way of a 'consummation devoutly to be wished' are frequently monetary, but at the same time, lack of friends and an incompatible climate can be oppressive enough to prevent the arrival of European women to India (Williamson 1810: I, 453–4). Williamson's advice to those importing worthy dames from Europe is to have the requisite 'well-lined purse', which has to take care of the expenses to be borne for clothing, accommodation, number of domestics, in keeping a carriage, in sending the children to Europe and the mother herself being frequently compelled to return so as to restore her health. Because 'matrimony is not so practicable in India as in Europe' (Williamson 1810: I, 456), admirable doctrines like 'fornication is a deadly sin' must be kept aside, and it is advisable for the European to keep a concubine rather than marry a native of India (Williamson 1810: I, 457).

Worth noticing is the way Williamson parleys about what is morally right according to the Christian theology and what would generally have been considered 'pagan' or 'heretic'. Rules, doctrines and scriptures are squeezed and modified and conventions negotiated to often justify the ways that will work out in India. Moreover, such alliances and attachments were to be allowed in the private sphere but to be kept strictly separate from the more formal public existence of the officers. European men who had Indian mistresses and children did not enjoy the same social position and respect as those whose alliances were more 'pure'. The text manifests the anxiousness of potential complications arising out of such alliances and legal and state responsibilities towards children born of such biracial relationships and mixed marriages. In 1792, Lord Cornwallis had banned the biracial children from being sent to England (Spear 1998: 63). Recent scholarships

have traced the colonial association of the 'Orient' with 'lascivious sexuality' and 'inherent violence' and the attempts of the colonial state to regulate 'deviant' sexual practices (Chatterjee 2016; McClintock 1995). The central representational modes of such writings highlight the powerful attractions of a sensual, seductive India, which had to be held in check by an imposing policing.[10] Williamson mentions the orphanages and the institutions where children born of such illicit alliances were removed, to the considerable 'distress of mothers' (Williamson 1810: I, 463). These institutions then were attempts to hide and efface some unwanted, undesired aspects of life in colonies. Such writings make it evident that the enduring vision of India was of a temptress and seductress. India embodied the overwhelming of the rational by the sensual, but such aberrations of the senses were considered inevitable, transitory and unregulated.

Imperial identity

A noticeable characteristic is the contrary and often oscillating stand that the guidebooks take in projecting the white man's identity. There is obviously a fascination for the native way of life, and at the same time the urge to maintain the 'purity' of their race. Europeans' imitation of the natives is regarded as disgraceful, undignified and even scandalous. The natives copying the Europeans' dress, table manners and titles are considered to be vain, boastful and pretentious.[11] It is simultaneously the contrary feelings of attraction and repulsion and an overwhelming feeling of being threatened in those very aspects that mark their greatness as Englishmen.

Williamson's advice to those who arrive in India is to divest themselves of their English possessions and 'alienate their English opinion' (Williamson 1810: I, 7). At the same time, he writes, 'a certain idea, not very comfortable to feminine propriety creeps into our minds', when a European lady is seen smoking, which is common among the 'ladies of Hindostan'. Such a habit is seen as an 'intrusion upon masculine characteristics' and the senses 'revolt' when the European ladies adopt the costumes of the natives, and this in no ways 'raised them in the estimation of those they imitated' (Williamson 1810: I, 501). He gives an elaborate list of clothing ranging from silk stockings and ties to 'essentials' like napkins, soaps and guns required both by the military and the civilians upon their arrival in India, which will conform to the image of a superior Englishman, very much *in control* of himself.

Again, *The East India Voyager: Or 10 minutes advice to the Outward Bound* (1839) by Emma Roberts, which seeks to instruct travellers to British India, is equally particular of the clothes and furniture that 'ladies who study their comfort' ought to take with them (Roberts 1839: 4). Roberts, who had accompanied her sister and brother-in-law to India, presents a detailed list that includes couches, cots, chairs, looking glasses, pianos,

fancy shoes, dresses, fashionable bonnets and scarves. She even advises on current fashion trends, saying,

> Formerly, there was a strong prejudice in India against dresses trimmed or embroidered in gold or silver, as such ornaments were considered too much in the native taste to be proper for European ladies... [but now] whatever be the fashion in Paris or London is eligible in Calcutta.
>
> (Roberts 1839: 16)

In an age when it was customary for the male voice to give 'advice' and be the guide and instructor, Emma Roberts's previously mentioned book of advice and her delightfully insightful, if slightly elaborate, *Scenes and Characteristics of Sketches of Anglo-Indian Society* (1835), in three volumes, provide a fresh perspective from a woman's point of view. The series, which first appeared in the *Asiatic Journal*, was praised by the *Calcutta Literary Gazette* for its 'light, animated, and graphic' description of manners and people that did 'justice to the magnificence of the Eastern World' (Roberts 1835: no pagination). This was perhaps the first detailed compendium that furnished information particularly to 'ladies proceeding to India' and provided exhaustive advice on ladies' outfits, feminine employments and amusements, domestic economy, handling servants, bringing up children and the gossips, scandals, flattery, balls and parties that surrounded the life of the '*Bibby-Saib*' (Anglo-Indian society woman) in general.

In 1844, the still relative paucity of handbooks on India led J. H. Stocqueler to indignantly observe in *The Hand-Book of India: A Guide to the Stranger and the Traveller, and a Companion to the Resident* that 'there is not one single volume extant which presents, at one view, an outline of *every thing* relating to the country' (Stocqueler 1844: Preface, v, [sic, original emphasis]). Stocqueler, based on his experiences as a journalist and traveller, proceeds to 'supply the desideratum' by providing a comprehensive outline of British India (Stocqueler 1844: Preface, vi). He acknowledges that much of the information was derived from Miss Emma Roberts's accounts and the *Bengal and Agra Guide and Gazetteer*. Stocqueler's astute observation of the character and manners of the British in India is worth quoting in length as it appropriately reflects the period of colonial history when it was transiting from a mercantile company to an imperialist power. The native of Great Britain, he writes,

> may not change his soul with the skies, but his manners assuredly undergo, in India, a remarkable metamorphosis. . . . Invested at once with authority, or treated by his personal domestics, and the traders with whom he may traffic, with abject humility, he naturally conceives a much higher opinion of his own merits than he ever

entertained before, and hence is begotten an overweening *amour propre*, which henceforth more or less influences his character through life.

(Stocqueler 1844: 50)

Stocqueler maintains that though the British are endowed with a loftiness of character that characterises them as energetic, active, upright, brave and enterprising, the Englishmen have not done enough for the betterment of the people under their dominion. He acknowledges, 'We have drained the country of its wealth, and offered no compensation for the heavy appropriation'. But a better spirit has arisen of late years, he says, and he hopes that 'every man whose fortune may carry him to India will consider it personally incumbent upon him to return, in some degree, the blessings . . . an endeavour to improve the condition of its interesting population' (Stocqueler 1844: 51).

The Englishmen thus maintained a quintessential identity that occupied a nebulous space, often overlapping binaries of sovereign and server, a space that they at once wanted to dominate and domesticate. There is a definite undertone of anxiety in such handbooks on India, the anxiousness to do justice to a country that is so indefinable, a grappling in the dark to comprehend the unknown and hence the fearful. There is the anxiety to maintain the 'separateness', not to blend in with native ways and looks, and to 'master' all that is unfamiliar and therefore a threat to one's identity. Interaction with domestic servants and dealings with them is an area of advice frequently reiterated in the interest of the colonial master. Employing and retaining a multiplicity of menials was a common practice among the Europeans, domestic help being an inevitable support system that no European could afford to disregard during his or her stay in India. At the same time, exercising a strong control, it was felt, was imperative for keeping them 'in their place'. Gilchrist, in his *Dialogues*, instructs young officers to always address their servants derogatively, to give cryptic orders and to liberally douse their orders with abuses (Gilchrist 1826: 569–70). But it was generally felt, as a letter from a well-meaning general officer to a young subaltern advised, that 'the John Bull system of inculcating respect' would not work out in their favour for too long, and it would be a mistake to treat native servants with disrespect or derision. It was conceived that 'judged by the English standards', most native servants were insolent, lazy and petty thieves; 'they may have looser ideas, but it is your duty to keep him straight and guide him' (Curtiss & Sons [Publ date not mentioned]: 132).

Survival guides

Probably the one threat that they failed to master was the climate, and there are recurrent worries regarding this in most of the guides on India. Medical guidebooks for Anglo-Indians were a must-read if one was to survive the

harsh and unwelcoming climate of India. James Johnson noted his observations in *The Influence of Tropical Climates on European Constitution* in 1813 (Johnson 1813) under the supervision of James Ranald Martin, a surgeon in the Bengal army, who with further additions to it published it under the same title in 1856 (Martin 1856). Martin provided a comparative analysis of the physical and temperamental difference between the Europeans and the natives of India and gave a scientific-medico reason for the inability of the former to cope in a hot climate, its consequences, and the prescription/cure to mitigate the 'violence' of the environment. Other than advice on diet, clothing, exercise and cure, some like John M'Cosh's *Medical Advice to the Indian Stranger* warn against 'native practitioners' and 'their combination of quackery and superstition, without the knowledge of anatomy or chemistry' (M'Cosh 1841: 12). R. S. Mair, a fellow of the Royal College of Surgeons, Edinburgh, and the deputy coroner of Madras, in his *Medical Guide for Anglo Indians* strongly advocated temperance and discipline. Blaming the 'habits and mode of life of the European not conducive in any country, far less in India, to good health', the cause, he asserts, is 'their own impudence and want of self-restraint, rather than any direct influence of the climate' (Hull 1871: 231).

The general feeling that repeatedly emerges from these guidebooks is the short limitation of stay in such climate. Johnson was skeptical of the duration of stay that young officers to India could endure and felt that protracting the station beyond two years was too much to ask from those in the military service. And in spite of the encouragement to muster a determined resolution and to bear with fortitude 'the assault . . . like a tiger', hoping that the 'enemy . . . will sneak off and leave us victorious for the time' (Johnson 1813: 28), there is the stoical acceptance of the inevitable:

> Of those Europeans who arrive on the banks of the Ganges, many fall early victims to the climate . . . others droop and are forced, in a very few years, to seek their native air. And, that the successors of all would *gradually degenerate*, if they remained permanently in the country, cannot easily be disaproved [sic].
> (Johnson 1813: 3, original emphasis)

Johnson was writing this as early as 1813. The fear of 'degeneration', physical and moral, remained a constant and niggling worry. And in 1856, just a year before the Revolt of 1857, James Ranald Martin, in his revised edition of *The Influence of Tropical Climate*, writes:

> the term of thirty years of actual residence in the East, is the very utmost during which persons under ordinary health, and an average constitution, may be expected to retain their British vigour of thought and action.
> (Martin 1856: 434–5)

He claims that 'after much and careful inquiry' he has not found a sample of the third generation of unmixed European stock, which according to him, speaks

> so much for the question of European colonization, respecting which much has been said and written – regardless of the fact that Nature has set her ban – a blighting interdict – upon it.
> (Martin 1856: 444)

And as late as 1871, Mair still holds the same view:

> It is rare to find a third generation of pure Europeans in India, that is, of those of pure, unmixed blood, who have, since the first generation landed in India, never quitted the plains for a temperate climate. It is for this reason and for this reason alone, that it is idle to talk or think of colonising the plains of India with Europeans.
> (Hull 1871: 215)

Commodified places

With the end of the Napoleonic wars, the roads in Europe had become safer to travel. The Industrial Revolution had brought in improved transportation, and with steamships crossing the Channel and the introduction of steam locomotives, travelling became easier and faster. John Urry has brought out the complex ways in which places in the post-industrialised capitalist world have been commodified for 'consumption' and how places have been increasingly restructured as centres for consumption (Urry 1995). This then was the time of booming trade links and devouring of new lands. Organised travel caught on, as tour operators saw it as an appropriate moment to seize the commercial opportunity to begin marketing exotic destinations and excursions. Thomas Cook was the first one to conduct planned tours, beginning with his first escorted trip in 1841 from Leicester to Loughborough in Britain, for more than 500 workers to attend a rally. Very soon, Cook was organising for 150,000 people, mainly workers, to travel to the 1851 Great Exhibition in London to view the fruits of the Industrial Revolution. Thomas Cook's son, who joined the organisation in 1865, believed in commercial profits and catered to an upper-class clientele, and soon the organisation had established its reputation as tour organisers in the Continent, in the United States and also the 'Eastern lands'.[12]

As travel organisations became more structured, tours became more regulated. This was then the era of mass travel and the beginning of corporate tourism. A degree of comfort and basic amenities were increasingly being sought for by discerning tourists. Most of the travel operators provided comprehensive service to travellers, from collection of baggage, ticketing,

warehousing, and insurance to arranging hotels and so on. Messrs. Curtiss & Sons were reputed as a general forwarding agent through the army and navy; the Bradshaw Railway Guides were indispensable for quite a long time; and handbooks by John Murray and Karl Baedeker became a must-read for those venturing to unknown destinations. As travelling became more of an independent activity, for self-awareness and pleasure, Baedeker was to observe in the preface to his guide to South Germany and Austria, written in the early 1850s, that the principal object of the guidebooks was

> to render the traveller as independent as possible of hotel-keepers, commissionaires, and guides, and thus enable him the more thoroughly to enjoy and appreciate the objects of interest he meets with on his tour.
>
> (Baedeker 1873: v)

The popularity of 'independent' travel resulted in a volley of guidebooks being written – Ebel for Switzerland, Boyce for Belgium, Mrs. Starke for Italy and the publishers John Murray in Britain and Karl Baedeker in Germany. John Murray III claimed that their motto for the average tourist, 'Travelling made Easy' was possible because of the Murray 'Handbook for Travellers', which came out in 1829 when his father sent him on a trip to Europe to collect information (Murray 1920: 41). Over the next century, 165 handbooks published by them on different countries provided extensive descriptive and practical information along numbered 'routes'. By the time, John Murray's *Handbook for India* was published in 1859, the Murray 'Handbooks' were an established name, easily identifiable by their red cloth binding with golden lettering. The *Handbook for India* was originally published in three separate volumes for the Bombay, Madras and Bengal Presidencies. The first two appeared in 1859, with the volume on Bengal being added in 1882 and another on the Punjab and North-West India in 1883. These volumes were consolidated in a single volume in 1891. Such was its popularity that it went through 22 editions up to 1975. The early volumes were prepared by Captain Edward B. Eastwick, who had joined the Bombay infantry as a cadet. His long and arduous journeys through India to collect materials were made at a time when the railways were in their nascent form and many areas in India remained off the map. Moreover, the District gazetteers were few in number, and Sir W.W. Hunter's *Imperial Gazetteer* had not yet been compiled.

Murray's *Handbook* thus did what no cartographic mapping could have done – it provided a fascinating perspective to Britain's largest and most important colony. India had always held a special place in the British imagination, and with its transition from a company holding to a Crown colony in 1858, it emerged as a new destination for middle-class European tourists. The complete title of Murray's guidebook *A Handbook for India; Being an*

Account of the Three Presidencies, and of the Overland Route; Intended as a Guide for Travellers, Officers, and Civilians; with Vocabularies and Dialogues of the Spoken Language of India was sufficiently indicative of the wide range of potential travellers to British colonial India for whom this handbook was to act as a guide. Moreover, though the Sepoy Mutiny of 1857 had jolted the British in India, its successful quelling meant that India was no longer to be seen merely as a commercial outpost. India was now a part of the British Empire, where British settlements were to be of a more permanent nature rather than a transient visit.

Exhibitionary possessions

The *Handbook for India* was most comprehensive, meant for those intending to stay in India for a longer duration. As the author mentions in the Dedication, the attempt was 'to make India better known to Englishmen' (Murray 1859). Dialogues from English to Indian languages on various topics appended at the end of the handbook were meant to teach long-term British residents in India to successfully converse with Indians in the vernacular languages. Every conceivable topic was dealt with: seasons, dress, food, exercise, bathing, sleep, moral conduct, medicines, administration of the Indian government, the hiring of servants, consulting doctors, famine and plague, the working of the railway and postal departments, irrigation, Christian religion in India and other sundry things. In the early edition, India continued to be seen through the same Orientalist frame and described as a land of 'ruins', 'antiquities', 'curiosities', 'eminently beautiful' and 'picturesque' and at the same time of 'formidable difficulty' posed by heat, diseases, jungles, and wild beasts (Murray 1859: Preface, i). In the later editions with additional extensive maps of 'British India', there is the unmistakable sense of possession, a consciousness of a vast 'field' that now *belonged* to them, to be used as they deemed fit. In the Preface to the fifth edition, H. C. Fanshawe, the late chief secretary of the Punjab Government and commissioner of Delhi, noted,

> The public, moreover, are yearly becoming better aware of the glorious field which in India is opened up for the enjoyment of travel and sport, and of the inexhaustible opportunities afforded them for the study of an engrossing history, an interesting nationality, and an unrivalled art, as displayed not only in architectural monuments, but also in native industries and handicrafts.
> (Murray 1904: Preface, vi)

It was an invitation for imperial consumers to see a grand show. India was akin to a museum, a spectacle displayed for commodification and

consumption. And India was being marketed to cater to all types of travellers – the casual traveller for whom it was a 'glorious field' of sport and adventure and for the discerning tourists to 'study' its 'engrossing' history, art, architecture and culture.

If Murray showed the world *where* to go, then the series of railway timetables and travel guides started by the British cartographer and publisher George Bradshaw showed people *how* to go. Soon after the introduction of railways in Britain in 1825, his company published the first compilation of railway timetables, which over the years grew in volume, geographic coverage and demand. Such was the popularity of these publications that 'a Bradshaw' soon became synonymous with railway timetables. In India, with the introduction of the railways in the early 1850s, a transport revolution took place, and by 1883, an Indian statesman was echoing what was unmistakably the British sentiment[13]:

> What a glorious change the railway has made in old and neglected India! The young generation cannot fully realise it. . . . population which had been isolated for unmeasured ages, now easily mingle in civilized confusion. In my various long journeys it has repeatedly struck me that if India is to become a homogeneous nation, and is ever to achieve solidarity, it must be by the means of the Railways as a means of transport, and by means of the *English language* as a medium of communication.
>
> (Kerr 2007: 4; original emphasis)

Bradshaw's guidebook on India, *Handbook to the Bengal Presidency and the Western Provinces of India* (1864), claimed to be an 'indispensable' guide for those in Her Majesty's service in India by including every piece of information, 'detailing *every* inch of ground'. Further, Bradshaw's *Hand-Books to the Presidencies* (Bombay and Madras) and *The Overland Bradshaw*, which also purports to compile an '*accurate* description of every kind of practical information' within 'a *portable* form' (Bradshaw 1864: Preface, iii–v, original emphasis), truly became 'indispensable' for generations of Indians. Imitating the all-too-familiar red cloth binding with golden lettering and the numbered routes that were associated with Murray's publications, such guidebooks soon became what Nitin Sinha calls 'a standardised way of seeing' India (Sinha 2012: xxv). Apart from a detailed chronicling of Indian history, festivals and sports, the Bradshaw guides provided a thorough listing of places on the Indian map, their historical and geographical relevance, the local attractions, rail routes and distances and suggested hotels and excursions.

It is interesting to note that the Bradshaw guidebooks aimed to be simultaneously a moral guide, as they frequently interspersed practical

information with advice on etiquette and manners for those who came to work in India.

> The moral behaviour of all classes of Europeans should be extremely discreet, not only to preserve that inestimable blessing, health, but to command the respect of the native community.
> (Bradshaw 1864: 5)

The magnitude of the Bradshaw handbook, with more than 339 routes listed in the Bengal Presidency alone was indeed, as the publishers maintained, an 'intensely laborious' undertaking. The publishers were firmly of the faith that such guidebooks would prove to be crucial for the strategic management and administration of the country, because had this

> been placed before the public *prior* to the Sepoy Rebellion of 1857–58–59, it is but natural to presume that many Europeans would have been spared from those misguided and cruel men; as then they would have been able with this *pocket* volume to have traced their way to some place of refuge; whereas it was utterly impossible for them, in the hurry of the moment, and the *disadvantages* under which they then labored as regards travelling conveyances . . . and consequently being without Guide or Route-Book, were either lost in the interminable jungle or fell into the hands of the blood-thirsty enemies.
> (Bradshaw 1864: Preface, iv, original emphasis)

A transformation

Early vade mecums often seemed like strict regimental laws, military in their precision and unpardonable if ignored. These were not for tourists seeking pleasure; these were manuals for survival in an unknown country. These did more for their readers than merely guide them on routes and places. These guidebooks were truly the guardians of the company recruits to India, some of whom were very young and inexperienced. These books combined moral righteousness with practical wisdom as they advised them on practically everything worth knowing in India. It cautioned them of dangers, instilled prudence and discipline, taught manners and ways of life and, most important, exemplified the 'correct' image of the English in a foreign country. With travel becoming easier and faster, colonial guidebooks on India too underwent a definite change. The earlier purpose of guidebooks to enable British travellers to survive in India was replaced by a more pacifist attitude that aimed at the political steadfastness and settling in a country that still remained an 'enemy'. There was perhaps a tacit recognition that winning the respect and confidence of the people whom they ruled was a more viable way to last longer in this country.

Mass travel meant mass production of such guidebooks which aimed to provide practical and useful information not only to the romantic bourgeoisie eager to explore the world but also for those armchair travellers who were eager to *know* about these places. The romantic enthusiasm for the 'picturesque' India gave way to the scientific exactitude of routes, maps and locations. Since 'seeing' remained the principal intention of the producers and consumers of guidebooks, the visuality of earlier guidebooks with their sketches and art plates were now replaced by empirical facts, figures, maps and itineraries in order to make the strange land visible. Moreover, the local, subjective perception was replaced by a more transnational, corporate personality. Publishers like Murray, Baedekar and Bradshaw endowed the guidebooks with an authority that was seldom to be seen in the vade mecums written in the beginning of the century. The tone of these later publications was more assured and informed. The information disseminated appeared not to be a traveller's observations but those of a settler who owned the territory and therefore knew it well. What were actually personal observations became authoritative wisdom, a new intellectual construct through which to exhibit the might and power of a collective entity. Such knowledge construction was a space for self-promotion. These 'guides' served the purpose of conceptualising and representing an imaginary space. Such guidebooks were then quintessentially a colonial activity – of a production of knowledge that reemphasised the territorial sovereignty and superiority of the British. But such 'knowledge' has always been and still continues to be predominantly manufactured and consumed by the members of an international, elite, educated, and well-to-do people. As the *Lonely Planet* guide on India exhibits, it continues to take its colonial legacy seriously and remains structured on the picturesque and the exhibitionary, based on features of essentialism, objectification and otherness.[14]

Notes

1 For a comprehensive definition and terminological conceptualization of 'guidebook', see Peel 2016.
2 All Lonely Planet series relate the 'Story' of the initiation of the travel guide that began from the Wheelers' humble kitchen table.
3 Some of these rare books are available in the British Library, London.
4 Buchanan's impressive compendium was titled *Genealogies of the Hindus, Extracted from their Sacred Writings*. For a detailed analysis of Buchanan's contribution, see Marika Vicziany. 1986. 'Imperialism, Botany and Statistics in Early Nineteenth Century: The Surveys of Francis Buchanan (1762–1829)'. *Modern Asian Studies*, 20 (4): 630–2, October.
5 James Mill expressed his contempt for traditional Indian knowledge and culture.
6 For a catalogue of Mackenzie's manuscripts, refer to H. H. Wilson's. 1828. *The Mackenzie Collection: A Descriptive Catalogue of the Oriental Manuscripts and Other Articles*. Chennai: Higginbotham and Co.
7 For a detailed analysis of this work, see 'An Early Nineteenth Century Vade Mecum for India', by Sutapa Dutta in the themed issue on *Desire and*

Deceit: India in the Europeans' Gaze, edited by Maria-Ana Tupan. *Rupkatha Journal*, VII (2): 105–13, 2015.
8 A review 'The East India Vade Mecum', *The Eclectic Review*, VI (I): 421–7. London: Longman, Hurst, Rees and Orme, 1810.
9 An early reviewer of Williamson's *Vade Mecum* considered it to be beneficial for youths who are introduced 'into a new world, and to new temptations.' 'The East India Vade Mecum', *The Monthly Review or Literary Journal*, LXXII: 159. London: Becket and Porter, 1813.
10 McClintock's *Imperial Leather* (1995) highlights the paranoia and the fascination that white, male colonizers had of the native female generative authority.
11 For a study of how the British experience of India had an impact on their body, clothing and food habits, see Collingham 2001.
12 For more details of Cook's life and travel handbooks see Hamilton 2005.
13 Madhav Rao (1828–1891) was the chief minister of the princely states of Travancore, Indore and Baroda. See Kerr 2007.
14 The *Lonely Planet* series on India regularly feature the 'traditional', 'spiritual', 'unpredictable' aspects of India that need to be 'demystified'. For a semiotic analysis of this guidebook and accompanying photographs, see Bhattacharyya 1997.

References

Primary sources

Baedeker, K. 1873. *Southern Germany and Austria, Including the Eastern Alps* (Third Edition). Coblenz and Leipsic: Karl Baedeker.

Bradshaw, George. 1864. *Handbook to the Bengal Presidency and the Western Provinces of India*. London: W. J. Adams.

Curtiss and Sons. Publication year not mentioned. *Sons' En Route Military Handbook for India and the East*. Portsmouth and London: Curtiss & Sons.

Gilchrist, John Borthwick. 1825. *The General East India Guide and Vade Mecum*. London: Kingsbury, Parbury, & Allen.

———. 1826 [1798]. *Dialogues, English and Hindoostanee, Calculated to Promote the Colloquial Intercourse of Europeans, on the Most Useful and Familiar Subjects, with the Natives of India, Upon Their Arrival in That Country*. London: Kingsbury, Parbury, & Allen.

Hull, Edmund C. P. 1871. *The European in India; or Anglo-Indian's Vade-Mecum. To Which Is Added a Medical Guide for Anglo-Indians*. Edited by R. S. Mair. London: Henry S. King & Co.

Johnson, James. 1813. *The Influence of Tropical Climates on European Constitution*. London: J. J. Stockdale.

Martin, James Ranald. 1856. *The Influence of Tropical Climates on European Constitution*. London: John Churchill.

M'Cosh, John. 1841. *Medical Advice to the Indian Stranger*. London: H. Allen & Co.

Murray, John. 1904. *A Handbook for Travellers in India, Burma and Ceylon* (Fifth Edition). London: John Murray.

———. 1920. *John Murray III, 1808–1892: A Brief Memoir*. New York: Alfred A. Knopf.

Murray, John and Edward B. Eastwick. 1859. *A Handbook for India, Part I – Madras*. London: John Murray.

Roberts, Emma. 1835. *Scenes and Characteristics of Sketches of Anglo-Indian Society*. London: W. H. Allen & Co.
———. 1839. *The East India Voyager: Or 10 Minutes Advice to the Outward Bound*. London: J. Maden & Co.
Stocqueler, J. H. 1844. *The Hand-Book of India: A Guide to the Stranger and the Traveller, and a Companion to the Resident*. London: W. H. Allen & Co.
Williamson, Thomas. 1810. *The East India Vade Mecum; or, Complete Guide to Gentlemen Intended for the Civil, Military, or Naval Service on the Hon. East India Company* (2 Volumes). London: Black, Parry, and Kingsbury.

Secondary sources

Arnold, Matthew. 1869. *Culture and Anarchy*. London: Smith, Elder and Co.
Barthes, Roland. 1972. *Mythologies*. Translated by Annette Lavers. New York: Farrar, Straus & Giroux.
Bhattacharyya, Deborah P. 1997. 'Mediating India: An Analysis of a Guidebook'. *Annals of Tourism Research*, 24 (2): 371–89.
Breckenridge, Carol. 1989. 'The Aesthetics and Politics of Colonial Collecting: India at World Fairs'. *Comparative Studies in Society and History*, 31: 195–216.
Burton, Antoinette. 1996. 'Making a Spectacle of Empire: Indian Travellers in Fin-de-Siècle London'. *History Workshop Journal*, 42 (1): 126–46, September.
Carey, William (ed.). 1814. *Hortus Bengalensis or a Catalogue of the Plants Growing in the Honourable East India Company's Botanic Garden in Calcutta*. Edited by William Roxburgh. Serampore: Mission Press.
Chatterjee, Ratnabali. 2016. 'Prostituted Women and the British Empire'. *Sage Journals*, 1 (1): 65–81, June 1.
Cohn, Bernard S. 1996. *Colonialism and Its Forms of Knowledge: The British in India*. Princeton, NJ: Princeton University Press.
Collingham, E. M. 2001. *Imperial Bodies: The Physical Experience of the Raj, 1800–1947*. Cambridge: Polity Press and Blackwell.
Epelde, Kathleen. 2004. 'Travel Guidebooks to India: A Century and a Half of Orientalism'. Ph.D. Thesis, University of Wollongong.
Foucault, Michel. 1991. *Discipline and Punish: The Birth of a Prison*. London: Penguin Books.
———. 1998. *The History of Sexuality: The Will to Knowledge*. London: Penguin Books.
Grewal, Inderpal. 1996. *Home and Harem: Nation, Gender, Empire, and the Cultures of Travel*. London: Leicester University Press.
Hamilton, Jill. 2005. *Thomas Cook – the Holiday Maker*. London: The History Press.
Jones, William. 1799. *Works of Sir William Jones*. Edited by Anna Maria Shipley (6 Volumes). London: G.G. and J. Robinson.
Kerr, Ian J. 2007. *Engines of Change: The Railroads That Made India*. Westport, CT and London: Praeger.
McClintock, Anne. 1995. *Imperial Leather*. New York and London: Routledge.
Mill, James. 1817. *History of British India*. London: Baldwin, Cradock, and Joy.
Peel, Victoria and Anders Sorensen. 2016. *Exploring the Use and Impact of Travel Guidebooks*. Bristol; Buffalo: Channel View Publications.

Pratt, Mary Louise. 1992. *Imperial Eyes: Travel Writing and Transculturation*. London and New York: Routledge.

Said, Edward. 1978. *Orientalism*. New York: Pantheon.

Sinha, Nitin. 2012. *Communication and Colonialism in Eastern India: Bihar, 1760s-1880s*. New York: Anthem Press.

Spear, Percival. 1998. *The Nabobs: A Study of the Social Life of the English in Eighteenth Century India*. Oxford: Oxford University Press.

Urry, John. 1995. *Consuming Places*. London and New York: Routledge.

2

SCOTTISH RESONANCES IN JAMES BAILLIE FRASER'S TRAVEL ACCOUNTS

Nilanjana Mukherjee

Travel literature is an inherently interdisciplinary form. Its cross-generic status emerges from its intermixing of fiction, autobiography, history, reportage and natural history. All this make it a form of survey literature or literary cartography in practice. Factually, the 18th and the 19th centuries Britain saw the highest proliferation of travel literature, which is indicative of its connection with the empire. In continuation, various parts in the world which were under British occupation were also subjects of many English travelogues. Many scholarly studies on travel writings in India and the colonial world in general have demonstrated the imperial agenda that belied the purportedly innocent cultural activity of recording travels (Pratt 1992; Duncan, James and Gregory 1999; Driver 1999; Ogborn and Withers 2004). As Mary Louis Pratt observes, travel literature during this period is fundamentally linked to the colonial gaze. It is engaged with the metropolis's obsession with presenting and representing its peripheries and its others to itself. In this, it constructs not only the space of the "contact zone" but also the metropolis itself (Pratt 1992: 6). In this essay, I shall try to draw connections between the ways in which the nation and its colonies are spatially constructed through travel narratives. I shall take the case of James Baillie Fraser's *Journal of a Tour through Part of the Snowy Range of the Himala Mountains, and to the Sources of the Rivers Jumna and Ganges* (1820) to study cultural specificities within a system of orientation. Through this work, I shall try to trace key underpinnings behind colonial travel as a scientific vocation, which frames and harnesses geographical locations to the metropolitan nucleus. My article will also try to unravel a sub-text based on an ethnic Scottish streak in the travel writings of James Baillie Fraser (who was of a Scottish origin), which worked in collusion with and often masqueraded as British colonialism. Fraser's work, arguably, is an immediate

offspring of the early 19th-century scientific consciousness, which was very specific to his Scottish birth and upbringing.

Representations of space

The concepts of spatial production or 'imaginative geography' involve the assignment of systematic and differentiated attributes to places in order to designate in one's mind a familiar space which is 'ours' and an unfamiliar space which is 'theirs'. This can be enacted through what Derek Gregory calls the 'spatial metaphoric' (Gregory 1994: 355) or Bachelard calls the practice of the 'poetics of space', whereby a space acquires emotional and even rational sense by a kind of poetic process with the help of language (Bachelard 1969; Barnes and Duncan 1992: Introduction). Vacant and anonymous distance and land are granted meaning and materiality through an active attachment with figurative or imaginative value. As emotions like anxiety, fear, desire and fantasy enter into the production of imaginative geographies, memories too have a role to play. Memories of a place, which are undoubtedly social in nature, are shared and constructed over years, mostly through institutional commemoration which silences alternative memories of the past and place (Withers 2004). John Urry argues that places are not just seen but are grappled with using diverse senses, which are then modified and consolidated over time. Nature itself is perceived, associated and appreciated through a spectrum of culturally constructed conditions. Travel similarly plays up to this construction and appropriates the dominant perspective towards a space. According to Urry, images of places are fashioned according to the selective memories surrounding the place (Urry 1995). I shall add to this that distant places may be articulated from a memory of the traveller's native homeland, which, in turn, is shaped by institutionalised practices. In the present case, I shall talk about the strategic representation of the Scottish Highlands in English travel narratives in the 17th and 18th centuries in connection to James Baillie Fraser's memoir of his travels through the Himalayan regions in the Indian subcontinent. By doing so, I shall be able to point out the multipolar nature of colonialism, which often goes unnoticed in the context of South Asia. To this effect, Kapil Raj's argument that colonialism was an interface between and among varied groups from the British Isles and different segments of people in the subcontinent precisely draws attention to the existing multidimensionality (Raj 2000: 121).

Especially significant here is the colonial experience of the Scots, which united them to the British territory. One must draw attention to the critical role Scotland had to play in framing the British Empire across the globe. Whether it be in military or administrative services, data collection and field sciences, or in framing policies, the Scots have prolifically participated in the colonial project and significantly contributed to its expansionist agenda.

Curiously, however, in doing this, Scots have often employed rhetoric and lens to control and govern foreign spaces similar to the ones deployed by the English to appropriate the Celtic peripheries into the larger imagination of the British nation, which can be seen as England's first colony (Klein 1997: 16). James Baillie Fraser embodies the quintessentially Scottish configuration whereby, on the one hand, he adopts aesthetic modalities which construct Scottish Highland scenery through an established tradition and, on the other, negotiates his own subject status in trying to manoeuvre his career through a range of activities in the ergological space of the Himalayas, which could earn him a suitable advisory role in the colonial services.

Travels in the Scottish Highlands

Fraser was an enthusiastic traveller and painter who built his career upon the strength and reputation of his travels in India and especially those undertaken in the Himalayan region. He hailed from a Scottish family of the land-owning branch of the Fraser clan, who had been lairds since the 15th century and also held cotton and sugar plantations in Berbice in Guyana. Born in Edinburgh in 1783, he had a perfect colonial upbringing. His father, Edward Satchwell Fraser, had been an officer in the Grenadier Guards and in the American War of Independence, while his paternal grandfather had spent 17 years in India as East India Company personnel and was a Persian Oriental enthusiast who wrote the *History of Nadir Shah* and collected Persian manuscripts but never made it to Persia. (This was probably under Warren Hastings's policy of granting handsome incentives to those officials willing to study Indian languages and culture.[1]) With the patronage and help of Charles Grant (1746–1823), all of James's four brothers too were employed with the East India Company in India (Wright 1994). Interestingly, Kapil Raj points out how Scottish education was much more broad-based than that in England, covering disciplines like geography, history, navigation, mensuration and natural and moral philosophy apart from classical languages like Greek and Latin. In fact, Scotland had a tradition of survey and cartographic activities even before England had its first map (Fleet, Wilkes and Withers 2011). However, the lack of adequate opportunities in Scotland itself forced the youth to spill over to the remainder of the United Kingdom or Britain's ever-expanding empire in search of suitable occupations. This kind of curriculum and ethos made them tailor-made for colonial services. In fact, it was predominantly the Scots who manned the highly successful operational, scientific and technological aspects of British activity in India (Raj 2000: 123–4). The survey mode initiated and implemented in India by Wellesley after 1793 also drew heavily on the statistical method pioneered in Sir John Sinclair's *Statistical Account of Scotland (1791–99)* (Leask 2002: 163). In a letter to Lord Montagu on 1 July 1821, Sir Walter Scott famously talks of the Indian colony as 'the Corn Chest for

Scotland, where we poor gentry must send our younger sons as we send our black cattle to the south' (Leask 2002: 176).

In 1799, as a lad of sixteen, James Fraser visited Berbice to manage his family's sugar and cotton plantations. The venture, however, was a failure and was sold off later in 1817. Having returned to Scotland from Berbice in 1811, he set out on extensive tours of the Western Highlands and Skye with a cousin. Unable to find a suitable occupation in Britain, India, where all his brothers had gone, seemed to promise him a better prospect. It was Charles Grant who once again helped him find passage on board *Daedalus* to India at the end of January 1813. After five months at sea and having narrowly missed shipwreck, he finally landed in Madras in July the same year. He spent a short while travelling in and around south India aimlessly before heading for Calcutta. In Calcutta, he tried his luck in business (probably in indigo) in partnership with a Mr Beecher without seeing much luck. Even though he suffered losses in the business, when the partnership was finally dissolved, he received Rs. 35000, which he could use as capital to pursue his own personal interests.

Although the upbringing that he had had was not sufficient to take up science as the chosen occupation of cartographer, botanist or geologist, it, however, provided the prerequisite condition to undertake travel with all its cultural values which could shape interactions with the natural world. The Enlightenment climate which permeated into the education system in Scotland granted him a mastery over a scientific, rational language, which, like maps and surveys, could empirically reconstruct a place. Together with his own inherent place sense, it brought in his personal responses, attitudes and assumptions to the places he was to visit in the distant Himalayas. The diversity of disciplines he straddled ranging from sketching to natural philosophy, made him ideal for absorption in colonial services. At this point, it well behoves one to recount a history of the aesthetic and geographical imagination of Scottish landscapes as national peripheries, which resulted from the Anglo-Scottish union after the successful subjugation of the Jacobite Rebellion.

Mapping and aesthetic reconstruction of Scotland

Mapping and travelling in Scotland began simultaneously after its successful subjugation, as any other place would have under colonial occupation. This began along with General Roy's mapping of the Highlands and the eventual production of the map of Scotland. The aesthetic and literary construction of the national peripheries too took on an identical trajectory. So, in Britain, "on the conclusion of the peace of 1763, it came for the first time under the consideration of the Government to make a general survey of the whole island at a public cost". In this project, "the map of Scotland" was to be made "subservient, by extending the great triangles quite to the

North extremity of the island, and filling them in from the original map" (the original map being the map of England) (Close 1969: 12).[2] Travel writing, in this respect, became an important site for construction of the idea of Britishness and for fashioning the nation 'as an imagined homogeneous community' (Close 1969: 12–31). Earlier, in the 17th century, John Taylor (1578–1653), popularly known as 'the Water Poet', from his occupation as a London waterman, wove marvellous tales of difficult journeys across the British Isles. Taylor's account of his journey to Scotland informed his audience about a region which was still largely unfamiliar to the English, even if the two dominions had been merged under a common monarchy since 1603. Therefore, Scotland, which was seldom toured during this time, was described in all its resplendent grandeur with its castles and teeming social life and economy. Laid bare are a contested terrain and rifts between ethnic groups hidden beneath an apparent shroud of unity created by a political abstraction of a nation. Scotland was still not a place where one would go for leisure. Writers who wrote about their visits to the Scottish Highlands at around this time had made their trips as traders or soldiers and had all mentioned it as a terrain fraught with difficulties. Scotland was still a place waiting to be discovered, waiting to be emplotted into the British cartographic schema. The picture was to alter markedly in the 18th century, when Scotland attracted numerous tourists after the pacification of Culloden, the advent of the cult of the Ossian and the travels of Samuel Johnson and Boswell would popularise it as a picturesque and safe place to travel (Womack 1988).[3] By the 18th century, the significant expansion of territory brought about by the Act of Union with Scotland meant that home tour did not merely restrict itself to travelling within England or Britain but what increasingly came to be known as Great Britain. The 'heterogeneous patchwork' of ethnicities like Scottishness, Welshness and Englishness, which existed at the beginning of the 18th century, gradually gave way to an overarching unifying structure of the nation called the United Kingdom or Great Britain. The differences which existed during the time of Taylor's journey were gradually ironed out with the progress of communication, connectivity and internal trade. Daniel Defoe's (1659–1731) *Tour through the Whole Island of Great Britain* (1724–6) demonstrates these transitions and the unifying cultural forces at work in what is generally seen as his economic travelogue containing a detailed survey of the roads in England in the light of the new Turn Pike Acts (Feldman 1997: 32).[4] It is meant to operate at a level similar to a virtual tour, a 'facsimile representation', where the armchair traveller is able to traverse the entire nation and participate in public discourse based on his fictive travel:

> We give the reader . . . a view of our country, such as may . . . qualify him to discourse of it, though he stayed at home.
> (Defoe 1927: Preface, vol. 2, 239–40)

Even though the *Tour* tries to keep up the semblance of an authentic first-person travel narrative, for the most part, Defoe derives his knowledge from other written documents, most of which were guidebooks on which he relied heavily for information on the Celtic fringes. There is yet the dominance of London as the centre of Englishness, from where the journey ensued and to which one would return. This created a distinctive type of domestic travel literature which involved the touring of Britain's length and breadth but was consciously or unconsciously underscored by an imaginative compass point of a clear demarcation of circumference and the centre. This centrist bias is very obvious in the work of Defoe for whom London remains his benchmark of worth (Baylis 2003: 395).

With Romanticism in the offing, nature travel or scenic tourism became an important part of travel itself, which became more and more elaborate and subjective. Following the literary and artistic tradition of the times, the home tour became entrenched in the aesthetic paradigms of the age, and descriptions of landscape became an essential part of such literature. Long before, the works of Edmund Spenser (1552–99) and Philip Sidney (1554–86) had already provided a model for conceptualising the English nation as an Arcadian Edenic space. In the 18th century, such travels continuing the long-established tradition of the English pastoral brought to the fore for the first time the so long ignored spaces and helped to consolidate them within the meta structure of the nation. The ideas of the 'sublime' and the 'picturesque' were already in circulation, imported via the Grand Tour.[5] Touring the Scottish regions nativised these theories and helped shape British aesthetics on nature. The same is exemplified in Samuel Johnson's *A Journey to the Western Islands of Scotland* (1775). This was the time when the Celtic fringe of the British Isles was brought to the attention of the wider public through a plethora of travelogues. Johnson's *Journey*, the most popular among these, participated in this movement. In fact, an antiquarian spirit is common in his writing and in records of other travellers, which tried to capture the final phase of the fast-vanishing antique charm of the Scottish Highlands. Scotland was thought to be rapidly modernising; therefore, travellers were eager to catch a last glimpse of the swiftly transforming society before it ultimately disappeared altogether. Ironically, similar anxiety is to be noticed in the perceptions towards 'pre-modern' societies outside Europe and in its colonies, which Bernard Cohn articulates as the 'museological modality' of travel (Cohn 1997: 9). Interestingly enough, there was a conspicuous 'othering' perceivable even while carving out the home territory. According to Thomas Curley,

> Johnson's tour was very much a part of the exciting geographical exploration taking place in 1773. Johnson was surveying Scotland when Cook crossed the Antarctic Circle for the first time, Constantine Phipps sailed for the North Pole, and James Bruce returned

from Abyssinia ... the Highlanders are treated as if they were Eskimos, Siberian nomads, American Indians, and Pacific Savages.
(Curley 1997: 184–5)

Johnson's detailed ethnographic descriptions of the Highlanders are identical to accounts of the exotic places and people overseas. His travelogue hovers on the margins of anthropological treatises on the 'savage' Pacific Islands of the kind Cook wrote. Murray G. H. Pittock talks of the 18th century as a time when British identity emerged, albeit fraught with uncertainties: there occurred a conscious or unconscious alienising and othering based on regional differences ending up in the dominance of London, the English Southeast and the East Midlands, with all other locations shoved to the periphery (Pittock 1997). However, John Brewer is of the opinion that the travels to remote areas with the rise of regionalism were not to effect a cultural separatism of the kind that Pittock mentions but were part and parcel of the act of imagining the nation in its variety (Brewer 1997).

The 19th century saw Edinburgh, the intellectual hub of Scottish Enlightenment, develop as a centre for field sciences, whereas London and the English universities still retained a stronghold on classical liberal disciplines. Institutionalised knowledge thus disseminated was incorporated in the colonial workforce with the Scots being the first to make meteorological recordings in Great Britain and the East India Company–occupied territories. After acting as informants, mapping settlements and tabulating topographic features in the Gaelic landscape in the ongoing 19th century Ordnance Survey of Scotland, the qualified and specialised personnel churned out by Scottish universities were appropriated in multifarious activities in the colonies. They were by then specially equipped to grant distant places permanent legibility through tables, catalogues and maps (Devine 2017; McKenzie 2017).

Scotland had become an important site for knowledge gathering and control after the final successful curbing of the Highland uprising. It was soon acknowledged that there was a definite lack of knowledge on those untraversed terrains and the cultural constitution of the inhabitants of those places. England awoke to the awareness that without adequate information, it was difficult not only to strategise wars but even pacify and hegemonise dissenting ethnic communities. Therefore, military malefaction often joined hands with cultural counteractive processes. As was the case with Culloden, war zones have a special ability to reveal to sight long unknown and neglected spaces. Maps, in contrast, reflect the image of a "rebel free landscape", so cartographic campaigns are taken up after successful subordination of rebellions like the Highland uprising (Klein 2001: 63). This then became the model which had to be duplicated in other regions of the world. In order to draw unambiguous connections, we shall now trace similar linkages related to the geographical construction of the British Empire in India and its frontiers. In this light, one can talk about the fallout of

the Gurkha War of 1814–16, which disclosed to the company officials the importance of knowledge about the hostile landscape of the Tarai and the Himalayas and its potentially rebellious local residents.[6] The establishment of the Himalayas as a frontier arose from numerous cartographic and exploratory activities, foremost of which was James Rennell's *The Map of Hindoostan* (1782). One may easily identify the formulaic replication of the Anglo-Scottish exchanges with similar effects, together with the noteworthy coalition of imperial injunctions and vociferous Scottish rejoinders.

The Gurkha war and Fraser's *Journal*

A passage from the *Edinburgh Review* proclaims, the Gurkha War of 1814–16, unravelled before the British vision fresh new prospects:

> The Gorkha War subjected to us a large extent of these mountains; and the smaller Seikh chieftains on the south of the Sutlej having placed themselves under the British protection, the range of our influence has been widely enlarged; the farthest western boundary of our dominions now corresponding with the farthest eastern advance of Alexander the Great – a striking proof of the superiority maintained by the nations of Europe at an interval of two thousand years.
>
> (*The Edinburgh Review* 1833: Vol. 57, 360)

The Himalayas soon provided a vast stage where Europeans explored, measured and sought and acquired scientific renown. The impregnable geography posed a definite challenge to colonial missions and personnel. A spate of Himalayan travel narratives thus appeared. The first of these was James Baillie Fraser's (1783–1856) *Journal of a Tour through Part of the Snowy Range of the Himala Mountains and to the Sources of the Rivers Jumna and Ganges* (1820). Only a year before this, in 1819, was published Francis Buchanan's (another Scotsman) highly systematic survey account of Nepal, which was perhaps the first in the line to set the tone for other geographical surveys and narratives on Himalayan regions to appear.[7] As a result of this war, Fraser writes a 'belt of low, wooded, and marshy, but rich land, known by the name of the Turrāee or Turreeānā' [p. 3] first fell into the notice of the British, and

> The conduct of this war, with its consequences, offered to us sources of information regarding Nepal and the countries contained in the mountainous belt that confines Hindostan, of which heretofore there was but little known.
>
> [p. 4]

The Gurkha encroachment of the Tarai, which was a region thought to 'chiefly belong(s) to the British government, or to those under its protection' [p. 3], required a rebuttal. Further, having already conquered 'Jeesta to the Gograh', the Nepalese ambitions to proceed westward 'to gain possession of even the rich and beautiful valley of Cashmeer' [p. 30] posited a definite threat and insult to the British and needed to be crushed mercilessly through a military campaign. While the topography of the space thus accidentally exposed had to be studied in order to be controlled, anxiety about other rebellion-prone tribes residing in adjacent hills required the British to take adequate measures to pacify and subdue them.[8] Taking precautionary measures against them would also involve gathering sufficient information about their society, ethos, livelihood and polity as a first step. Most important, these peripheral spaces were thought to contain the British Empire in the subcontinent, with the Himalayas posing as a natural frontier. Restlessness at the fringes could not be permitted for the sake of the stability and security of the colony. Fraser's travel accounts and his picturesque landscapes in the laps of these mountains are to be seen not only as acts of gathering intelligence about the region but also of shaping the larger imagination of the British colony and presence in South Asia.

James Baillie Fraser left Calcutta for Delhi in January 1815 to join his third brother, Alexander, who was employed there. From Delhi, Fraser travelled north to Nahan in the hilly tracts of Punjab, where he was joined by another brother of his, called William, who was the political officer with the East India Company's forces and was, at the time, engaged in the British-Nepalese War, or the Gurkha War. While he initiated sketching in India with scenes of Nahan, he was also at the same time a firsthand witness of the siege of nearby Jytock, which he writes about in his journal. Soon, William was appointed the commissioner of Garhwal, and the duo embarked on a three-month tour of the lower Himalayan provinces. It was not merely travel for pleasure or out of curiosity but had a serious political motivation. Escorted by about six hundred irregulars, it was meant to be a spectacle of sorts, a 'military movement' [p. 6], a demonstration of British strength and invincibility among the rebellious hill people in order to subjugate and pacify them as a preventive measure against further insurrections like that of the Gurkhas. The travels thus undertaken during the three months in the so long unknown terrains of the Himalayan foothills are the subject of Fraser's travelogue, which according to its author, as written in the preface, was induced 'chiefly by a desire to add his mite to the general stock of geographical knowledge; the more so, as any information respecting a tract of country so very little known, promised to be somewhat interesting, however imperfectly conveyed' [p. v.].

Though Fraser is somewhat apologetic in his preface (written in third person) due to 'the consciousness of a fatal deficiency of information of every

branch of physics, which deprived him entirely of the *power* of adding to science in those branches; which are now so interesting as geology, minerology, botany etc', [p. vi, my italics] he nevertheless compensates for that loss of 'power' with a

> secret feeling of satisfaction, at being recognized as the first European, who had penetrated to several of the scenes described, as well as by that universal and powerful tendency of our nature to gratify its vanity by relating the strange, the uncommon, or dangerous enterprises in which we have engaged.
>
> [p. v]

Though he was 'by no means insensible to his own want of talent', nevertheless he

> enjoyed the means of procuring a tolerably accurate survey of the country, and of amassing materials for a map, in the general accuracy of which, as far as relates to its greater lines, and a considerable portion of its detail, he places great confidence.
>
> [p. vi]

Underneath his facade of perfect modesty about his capabilities, which happened to be a 19th century gentlemanly posturing, Fraser clearly enough realises that the dissemination of scientific information is a control over the knowledge archive, which translated to 'power' in a modern Enlightenment world order and was that on which the fate of colonialism ultimately rested. The same logic made him draw a detailed treatise about the physiological and topographical character of the region. In the other passage, that which he outlines as a 'universal tendency' is no more than a Eurocentric colonial impulse to fan one's pride by narrating extraordinary feats in exotic geographical locations, a well-established popular formula in travel narratives of the 19th century. There is also an individualist romantic urge to immortalise one's own name – becoming a contender to the status of a national hero (of the likes of Captain Cook), by citing the importance of the task performed. The negotiations of the 'social' and the 'scientific' were the same as between 'philosophical' and 'professional'. The 19th century British gentry, faced with a sudden onslaught of urbanisation and corresponding anonymity, aspired to define their identities as connoisseurs, naturalists and men of science. However, rather than project this as a profession, they 'negotiated their way through the uncertain and shifting relations between social and scientific status' to deliberately adhere to the term 'philosophical' (Endersby 2008: 20). It was in vogue to draw attention to the passion and interest for science as a 'gentlemanly vocation' rather than as a means

to earn. By professing themselves as naturalists, travellers like Fraser could access admission to the wider, learned intellectual class and be acknowledged as a 'man of science'. Under these circumstances, being an amateur was a particularly enabling stance, since it shifted attention away from the agent's economic interest of earning a livelihood.

Ideally, the production of the information and its transmission had to be perfectly timed before 'interest lately created by circumstances . . . subsided, and curiosity . . . ceased' [p. viii]. Since time was at a premium, Fraser had to expedite the publication of the knowledge that he gathered before it was rendered redundant. He was already aware of highly specialised survey activities being undertaken in the region during the interim period between the completion of his travel and the publication of his work. For this reason, he 'judged it best no longer to delay the publication of his work' [p. viii] for his own endeavour would have fallen futile once information about this area, aided by advanced technological equipment, was made public.

> [T]hough the country may now be visited with little risk or difficulty, and though gentlemen of science have been appointed to survey it from the Sardah to the Sutlej, . . . to make their observations, together with far greater ability to take advantage of them, and talent to describe their result, still the physical difficulties of the country are so great, and the obstacles to making such results available to the public are so numerous that a very long time will, in all probability, elapse before any description of it can appear, and till then, even so unsatisfactory an attempt as the present may be received with indulgence.
>
> [p. vii]

While at the end of the preface, Fraser is hopeful of an ensuing long tradition of colonial enterprises in the region, he however puts himself at the forefront for having revealed the space as a rich field of investigation. He claims 'intellectual property right' as it were, for his vocation and for the knowledge resource of the space exposed by him to the western world:

> the author will be gratified and proud if the effort at all succeed in satisfying or in awakening curiosity and inducing those who are better qualified than himself, to explore the field on which he has barely gazed from a distance.
>
> [p. ix]

The preface to the *Journal*, though written in the third person, resounds with a voice of individual achievement, the tone in the journal proper orchestrates seamlessly with the British collective imagination of India.

Scottish resonances

As discussed earlier, being Scottish by birth and having travelled in the Highlands intermittently, Fraser's modes of deriving essences and of drawing comparisons remain restricted to his Scottish sensibilities, while making him suitable for the mountainous journey. In an attempt to explicate the general structure of polity among the hill tribes, he cannot restrain himself from drawing references to Scotland:

> On the whole, there seems at least a strong resemblance to be traceable between the state of this country and that condition of things which existed in the highlands of Scotland during the height of the feodal [sic] system, where each possessor of a landed estate exercised the functions of a sovereign, and made wars and incursions on his neighbours, as a restless spirit of ambition or avarice impelled him.
>
> [p. 4]

The region was still clasped within petty rivalries and disputes among small-time feudal lords, a state which Scotland had long overcome, and therefore, he managed to see its natural spatial apotheosis through a 'modern' spatial reorganisation, namely that of a nation-state. Therefore, the lack of an overarching political unity among these tribal societies, to which all of them would bow down, was the main difference with the contemporary Scottish structure:

> Indeed, the chief political dissimilarity between this country and those in which the feodal system obtained seems to have been in this – that there did not exist even a nominal sovereign in this mountainous district to whom these independent barons acknowledged a feodal subjection.
>
> [p. 4]

An overlord was what was required, to whom all would bow down, to maintain peace in the region. By subordinating themselves to the British, the region could see its natural culmination.

The region was otherwise comparable to European landscapes worthy of capturing in a picture of no less than the master-painter. The cultural diversity and the antiquity of the people in their ethnic costumes would make the painting suitably picturesque:

> Around us the fantastic forms of the old trees, their rich masses of foliage contrasting with the gray bare crags, and the blasted pines and withered oaks, formed a foreground for a picture worthy the

pencil of a Salvator. Nor would our attendants, the Ghoorkhas, the hill-men, and the Patans, formed into groups reclined around, or loitering on the rocks and cliffs, have disgraced the composition.

[p. 158]

In a fashion modelled after the picturesque journeys of English predecessors, one of his projects was

> to exhibit a picture of its inhabitants, as they appeared before an intercourse with Europeans had in any degree changed them, or even before they had mixed much with the inhabitants of the plains.
>
> [p. v]

This is an oft-repeated familiar colonial trope, which Cohn calls the 'museological mode.' It sought to museumise people and places as specimens thought to be primordial and primitive in nature. It was an urge to capture people and places in their pristine, pre-modern state before corruptive influences of modernity caused them to disappear forever (Cohn 1997: 9–10; Pinney 1997).

Once back in Delhi, he and William commissioned Indian artists to paint Indians of all classes in their infinite varieties of dresses. The people he met in the course of his travel were only collectibles, racial types just like botanical specimens which could be enumerative in the rich and expanding field of study called 'statistics'. During his travels, he himself often made native men or women stand before him in order to obtain their sketches to maintain records of their physiognomy and outfits. It was part of the Enlightenment worldview, of which Fraser obviously was a child, to celebrate the variety of the human genus on the surface of the globe as long as their 'place' in the spatial order was unambiguously known. A certain conception of otherness flourished in enumerating taxonomic categories simultaneously with hierarchising spaces (Harvey 1989: 250). His own artistic temperament, which was as yet raw and untrained, processed natural scenery in terms of painterly subjects of the Gilpinesque kind. Such ideas reverberate throughout his voluminous work. For example, at another place, he says,

> The day was clear, and only here and there a black cloud rested on the highest peaks. The scene was majestic, and if the epithet can justly be applied to any thing on earth, truly sublime.
>
> [p. 159]

The version of the 'sublime' and the 'picturesque' that developed based on travels in the Celtic fringes played its part in articulating and appropriating the Indian highlands in similar terms. For a Scotsman, comparison with his native place was a means 'of an associative ligature which mapped the exotic scene onto a nostalgic landscape of childhood and of home' (Leask

2002: 176). This became a popular and established idiom especially with artists and travellers. The discursive reiteration of the frame of reference stabilised the comparison, so much so that when Fanny Parkes (1794–1875), a Welsh traveller, tours the Himalayan region 'in search of the picturesque', she initially finds her not having travelled to the Scottish Highlands a definite handicap in appreciating the great mountain belt of India:

> when we arrive at the hills, I hear we are to be carried back, in imagination, to the Highlands of Scotland. I have never been there; *n'importe*, I can fancy as well as others.
>
> (Parkes 2001: 60)

Being an avid reader of Walter Scott, who famously represented Highland culture in his historical romances, her power of imagination soon makes her overcome her deficiency of never having been there. Memories of the suburban Celtic and Gaelic peripheries are frequently recalled in narrating foreign landscapes. For example, Borderer Dr. John Leyden discovers in Coorg (a hill station in the southern part of India), 'the grotesque and savage scenery, the sudden peeps in romantic ridges of mountains bursting through the bamboo bushes, all contributed strongly to recall to memory some very romantic scenes in the Scottish Highlands' (Leyden 1819: Vol. 83, 417); while for Bishop Heber, the Himalayan landscape constantly brings back memories of Wales (Heber 1829: Vol. 2, 389). Along with the *Journal*, twenty aquatints of Fraser's water colours done from 'on the spot' sketches were published in a folio edition entitled *Views in the Himala Mountains* the same year. For these, he took special training from renowned professional artists like William Havell and George Chinnery in Calcutta during the interim four years until he felt fully confident to publish them.[9] The paintings too emanate a strong evocation of the Scottish Highland environment and light. In his writings, there is a constant search for familiar signs amidst the unfamiliar as he tries to orient his geography:

> Here we found a birch-tree for the first time, precisely similar to that of Scotland in all respects. The bark, leaf, twig, and buds were quite the same; the leaf was somewhat larger, but seemed to possess no fragrance; yet we had been struck at a scent exactly like that of the birch after a shower, . . . we did not pluck even a bough, although ancient recollection almost tempted us to do so. We found sweet briar in great plenty, and giving a perfume perfectly the same as that from the home plant.
>
> [p. 158]

The sensory ecstasy of the revelation of familiar characteristics that Fraser delineates is the reason behind the establishment of numerous hill stations

on the foothills of the Himalayas, to make the Britons feel at home in an otherwise alien land. The mountains underwent landscaping on a massive scale under the aegis of a European-styled aesthetic improvement. As academic associations and societies in the metropolis tried to grapple with the newly emerging field of phyto-geography experiments, cross-fertilisation and hybridisation of flora and fauna across regions found a rich receptacle in the Himalayan region.

Though parts of the natural surroundings might have seemed familiar and even 'sublime', it was sooner or later realised as essentially 'other'. For developing the idea of spatial alterity, Fraser adopts the trope of moralising geography, an oft-repeated technique of spatial differentiation on lines of religious principles and inherited dogma, to outline a negative character that lies beneath the illusory exalted visual landscape (Teltscher 1997: 16–20). The idea of the Arcadian space he inadvertently generated had to be morally maligned to restrain it from attaining an idyllic or utopian status. Through his travels 'throughout those regions now fallen, or likely to fall into the British power', [p. 167] he unravels a dominant moral landscape which unifies and binds spaces as varied as the plains and the hills:

> Such was the conduct of the hill people on this occasion, and it will probably be found of a piece with the whole tenor of that uncertain, vacillating, mean, and narrow policy, which marks and stains the Asiatic character. From such men no steady or good course of conduct can be looked for; on them no reliance can be placed. Even the tie of interest seems unsteady when viewed through so uncertain a medium.
>
> [p. 129]

On the whole, these people were not perceived differently from the people to be encountered in the rest of the known regions of Hindustan. Also, an abundance of superstitions, heathen mythologies, idol worship, the caste system, Brahmin priests, temples and numerous other practices in the region (all familiar Eurocentric distinguishing tropes to view the primordial society of India with) are evidence enough to relate and unify spaces across a topographically varied area. These were eventually tropes to decide affinities based on identifiable similarities and to determine who the inmates and insiders of the Indian colony were.

Despite Fraser's shamefacedness at not having received proper training in the field sciences, his work nevertheless aspired to the textual status of a geographical narrative – an encyclopedic digest about the Himalayan region. His desire to 'discover' the sources of the main rivers of the subcontinent parallels one of the most popular cartographic impulses of the time reflected in figures like James Rennell, one of the most prominent geographers and mapmakers of the times. He sent specimens of minerals, insects

and ethnographical curiosities, collected during his Himalayan travels to the Geological Society in London, together with notes about them. These were subsequently published first in the *Transactions of the Geological Society* (1819) and in many other issues later on (Wright 1994: 126). He was soon elected a Fellow of the Society on the merit of his Himalayan travel, the first among many others he undertook later, especially in the Central Asian belt (another strategic area for the British about which little or nothing was yet known).[10]

According to John M. Mackenzie, the Scots viewed the empire as a space to carve out a unique identity and character for themselves, as distinctive from the English. They often viewed the colonies as prospects for playing an important role on the world stage. In fact, Mackenzie also points out a pre-existing Scottish imperial desire preceding its union with England, in tune with other nations in the continent (Mackenzie 1993: 714–39). Having met with a different trajectory after the battle of Culloden, Highlandism, however, was never completely silenced and took multifarious forms, and Celtic pride continued to be expressed through surreptitious mechanisms.

Notes

1. James Baillie Fraser's grandfather's work was to have a lasting impact on his own work later on in his career. See note 10 for details.
2. Triangulation was a new technological innovation in cartographic survey based on trigonometrical calculations, which sought to measure distances and locii of points through the intertwining mesh of triangles drawn and measuring angles.
3. Battle of Culloden (16 April 1746) was the last battle fought on British soil between French-supported Jacobites comprising Scottish Highlanders seeking to restore the House of Stuart to the British throne and the Hanoverian British government. Charles Edward Stuart, the pretender to the throne, was eventually defeated and fled to Rome.
4. From the first in 1663 and with an expansion in 1750–70, there were thousands of trusts and companies established by acts of Parliament with rights to collect tolls in return for providing and maintaining roads. A General Turnpikes Act (1773) was passed to speed up the process of expediting these arrangements.
5. William Gilpin, Richard Paine Knight, Uvedale Price, Edmund Burke and Humphry Repton were some of the major proponents of these aesthetic ideals of the 'picturesque' and the 'sublime'. Repton and Lancelot 'Capability' Brown implemented these artistic ideals to fashion English country houses and English landscapes.
6. The accession of Awadh brought the company-occupied territory in close proximity with the kingdom of Nepal. The intervening membranous strip of fertile lowlands called the Tarai fell under border disputes as a zone of combat between the two self-seeking warring factions with expansive aspirations. The two-year-long Gurkha War saw several mountainous campaigns until, in 1816, Nepal was forced to cede its occupied provinces of Kumaon, Garhwal and Tarai and accept a British resident in Kathmandu, the capital of Nepal. Despite the defeat, the spectacular show of Gurkha martial prowess impressed the British, and Gurkha regiments have played a crucial role in British military campaigns throughout their imperial tenure at various places on the globe.

7 George Bogle was perhaps the first in a line of Scotsmen who traversed the Himalayan region for various goals. His journey to Tibet in search of prospects for trade was commissioned by Warren Hastings in 1774.
8 The British were certainly taken aback by the valour and might with which the Gurkhas fought back. The later incorporation of the Gurkha regiment into the British Army is proof of the appreciation they commanded as well as their much required co-option into the mainstream of the empire, in the same manner as the Scots were hegemonised.
9 Fraser also made some excellent drawings on Calcutta, 24 of them being published in eight parts between 1824 and 1826. Some of them exist in the collections in Victoria Memorial Hall in Kolkata.
10 James Baillie Fraser wrote *An Historical and Descriptive Account of Persia* published in 1834 as Volume XV in the Edinburgh Cabinet Library. Apart from this, he was the author of numerous romances set in Central Asia and often based on his grandfather's tract *History of Nadir Shah*. Some of these are *The Khuzzilbash; A Tale of Khorasan* (1828) and its sequel, *The Persian Adventurer* (1830); *The Highland Smugglers* (1832); *The Tales of the Caravanserai; and The Khan's Tale* (1833).

References

Primary sources

Fraser, James Baillie. 1820. *Journal of a Tour Through Part of the Snowy Range of the Himala Mountains and to the Sources of the Rivers Jumna and Ganges*. London: Rodwell and Martin.
Heber, Reginald. 1829. *Narrative of a Journey Through the Upper Provinces of India from Calcutta to Bombay, 1824–25* (Vol. 2). London: John Murray.
Leyden, John. 1819. *The Edinburgh Magazine and Literary Miscellany*, 83: 414–22.

Secondary sources

Bachelard, Gaston. 1969. *The Poetics of Space*. Boston: Beacon Press.
Barnes, Trevor J. and James S. Duncan (ed.). 1992. *Writing Worlds: Discourse, Text and Metaphor in the Representation of Landscape*. London: Routledge.
Baylis, Gail. 2003. 'England, Seventeenth and Eighteenth Centuries'. In Jennifer Speake (ed.), *Literature of Travel and Exploration: An Encyclopedia* (3 Volumes, Vol. 1). London: Fitzroy Dearborn.
Brewer, John. 1997. *The Pleasures of the Imagination: English Culture in the Eighteenth Century*. London: Harper Collins.
Close, Charles F. 1969 [1926]. *The Early Years of the Ordnance Survey*. Great Britain: David and Charles.
Cohn, Bernard. 1997. *Colonialism and Its Forms of Knowledge*. New Delhi: Oxford University Press.
Curley, Thomas M. 1997. *Samuel Johnson and the Age of Travel*. Athens: University of Georgia Press.
Defoe, Daniel. 1724–27 [1927]. *Tour Through the Whole Island of Great Britain*. London: Peter Davis.

Devine, T. M. 2017. 'A Scottish Empire of Enterprise in the East, 1700–1940'. In T. M. Devine and Angela McCarthy (eds.), *The Scottish Experience in Asia c. 1700 to the Present: Settlers and Sojourners*. London: Palgrave Macmillan, 23–49.

Driver, Felix. 1999. *Geography Militant: Cultures of Exploration in the Age of Empire*. Oxford: Blackwell.

Duncan, James and Derek Gregory (eds.). 1999. *Writes of Passage: Reading Travel Writing*. London: Routledge.

Endersby, Jim. 2008. *Imperial Nature: Joseph Hooker and the Practices of Victorian Science*. Chicago: University of Chicago Press.

Feldmann, Doris. 1997. 'Economic and/as Aesthetic Constructions of Britishness in Eighteenth-Century Domestic Travel Writing'. *Journal for the Study of British Cultures*, 4: 31–45.

Fleet, Christopher, Magaret Wilkes and Charles W. J. Withers. 2011. *Scotland: Mapping the Nation*. Edinburgh: Birlinn in Association with National Library of Scotland.

Gregory, Derek. 1994. *Geographical Imaginations*. Oxford: Blackwell.

Harvey, David. 1989. *The Condition of Postmodernity: An Enquiry into the Origins of Cultural Change*. Oxford: Basil Blackwell.

Klein, Bernard. 1997. 'Constructing the Space of the Nation: Geography, Maps and the Discovery of Britain in the Early Modern Period'. *Journal for the Study of British Cultures*, 4: 11–28.

———. 2001. *Maps and the Writing of Space in Early Modern England and Ireland*. London: Palgrave Macmillan.

Leask, Nigel. 2002. *Curiosity and the Aesthetics of Travel Writing, 1770–1840: From an Antique Land*. Oxford: Oxford University Press.

Mackenzie, John M. 1993. 'Essay and Reflection: On Scotland and the Empire'. *The International History Review*, 15 (4): 714–39.

———. 2017. 'Scottish Orientalists, Administrators and Missions: A Distinctive Scots Approach to Asia?' In T. M. Devine and Angela McCarthy (eds.), *The Scottish Experience in Asia c. 1700 to the Present: Settlers and Sojourners*. London: Palgrave Macmillan, 51–73.

Ogborn, Miles and Charles W. J. Withers. 2004. *Georgian Geographies: Essays on Space, Place and Landscape in the Eighteenth Century*. Manchester: Manchester University Press.

Parkes, Fanny. 2001. *Wanderings of a Pilgrim in Search of the Picturesque*. Edited by Indira Ghosh and Sara Mills. Manchester: Manchester University Press.

Pinney, Christopher. 1997. *Camera Indica: The Social Life of Indian Photographs*. London: Reaktion.

Pittock, Murray G. H. 1997. *Inventing and Resisting Britain: Cultural Identities in Britain and Ireland, 1685–1789*. Basingstoke: Palgrave Macmillan.

Pratt, Mary Louis. 1992. *Imperial Eyes: Travel Writing and Transculturation*. London: Routledge.

Raj, Kapil. 2000. 'Colonial Encounters and the Forging of New Knowledge and National Identities: Great Britain and India, 1760–1850'. *Osiris*. Series 2: 15. Special Issue *Nature and Empire: Science and the Colonial Enterprise*, 119–34.

Teltscher, Kate. 1997. *India Inscribed: European and British Writing on India 1600–1800*. New Delhi: Oxford University Press.

Urry, John. 1995. *Consuming Places*. London: Routledge.

Withers, Charles. 2004. 'Memory and the History of Geographical Knowledge: The Commemoration of Mungo Park, African Explorer'. *Journal of Historical Geography*, 30: 316–39.

Womack, Peter. 1988. *Improvement and Romance: Constructing the Myth of the Highlands*. Basingstoke: Palgrave Macmillan.

Wright, Denis. 1994. 'James Baillie Fraser: Traveller, Writer and Artist (1783–1856)'. *Iran*, 32 (1): 125–34.

3

THE CORRECT VIEW

Ethnographic representation of Darjeeling hill tribes, from drawings to photography

Agastaya Thapa

During the 18th and 19th centuries, with the expansion of British commercial and territorial interests throughout the world, the establishment of colonial enclaves within tropical colonies served purposes like cantonments for the army, plantations for large-scale production of cash crops, supply stations for cheap labour and hill stations for British civilians and officials. These hill stations were special British conclaves which were landscaped from native terrains in order to make them conform to their ideal of picturesque beauty. Accordingly, Darjeeling, as one such hill station, came up in the early 19th century from the areas bordering the north of colonial Bengal as a landscape created for the British to recuperate and conserve their Saxon energy and race. The mapping of this newly acquired territory also involved the auxiliary scientific activity of ethnographically profiling the native population. The ethnographic profiling of the hill tribes was an undertaking with an epistemological agenda. This scientific and empirical temper of the 19th century of unmitigated seeing and showing had consequences for the domains of both art and anthropology.

On 23 January 1869, Dr. A. Campbell, the late superintendent of Darjeeling, read out a paper at the Ethnological Society, wherein he furthered the cause of 'bureau ethnology', the aim of which was not just to promote stringent scientific or linguistic study of the 'wild tribes of India' but also to offer guidelines to British officers in their 'intercourse' with such wild tribes by focusing on what Campbell terms 'their idiosyncracies' [sic] (Campbell 1869–1870: 143). Aiding this scientific temperament of objectivity and facts was the development of a representational technology that would render older techniques like that of painting and sketching redundant. With the coming of photography in 1839, it was believed that it was possible to capture and convey reality. The correctness to form and content could be established, the photographic eye being an impartial, objective surveyor.

Thus, the illustrations that Joseph Hooker renders in his *Himalayan Journals* (1855) of the various natives of Bengal and Sikkim were considered to be too Europeanised and not true representations.

In 1898, in his preface to *Among the Himalayas*, L.A. Waddell was to dismiss the 'typical of the tribe' representations of Hooker's *Himalayan Journals* as too 'Europeanised' and a failure in conveying the 'correct impression' owing to the fact that these lithographs of foreign scenes were printed in England. Instead, he points to the authenticity and correctness in the illustrations rendered in his book, wherein a certain 'Himalayan artist', Mr. A.D. McCormick is supposed to have rendered 'sympathetic drawings' from the photographs taken by him on his journey through the Himalayas, which were then reproduced by 'photo-mechanical processes'. Hence, the reliance on the mechanical processes of photography and printing, free from any human mediation, is supposed to guarantee truthfulness of representation. In this chapter, I will be charting the journey of transformation that came about in ethnographic illustrations and representations of native people in the 19th century with the coming of photography. The questions of science, objectivity and representation will be phased out against the backdrop of the 19th century ethnographic complex in the hills of Darjeeling.

The colonial discovery of an attractive place

The history of Darjeeling is intimately connected with what transpired between the Sikkim court and the British agents in 1835. The deed of grant of Darjeeling is a mystery that has persisted to this day, and there are many different versions of what came to pass between the British officers and the Sikkim Rajahputee in 1835, leading to 'misconceptions, wrong beliefs, misguided attitudes, harmful actions and erroneous statements' (Pinn 1986: 118). 'British Sikkim' had to be acquired by the colonial power in order to reinforce their position in this sub-Himalayan terrain as a military outpost to further their trade ambitions with the obstinately secluded Tibet. Hence, the official history of Darjeeling starts with its British colonial moment when two British officers were sent to broker peace between Sikkim and Nepal after a dispute arose regarding boundary issues ten years after the conclusion of the Treaty of Titalya (1817). Captain G.W.A. Lloyd, along with J.W. Grant, commercial resident of Malda, is said to have 'penetrated the hills, which were still a *terra incognita* to the British, as far as Rinchingpong and during this journey was *attracted* (italics my own) by the position of Darjeeling' (O'Malley 1907: 20). They are said to have arrived near Ghoom, recognised by the British as an old Gorkha station.

In a report dated, 18 June 1829, Captain Lloyd was to make the 'pioneer' claim on Darjeeling as the only European to have trod on the hill tract and as a seasoned 19th-century traveller of the function-follows-the-form tradition 'was immediately struck with its being well adapted for the purpose

of a sanitarium' (O'Malley 1907: 20), also keeping with the tradition of establishing convalescence pockets for military personnel along frontier zones. He backed up his report with further resort to pressing practical concerns as 'he strongly urged the importance of securing the possession of the place, and, in particular, pointed out its advantages as a centre which would engross all the trade of the country, and as a position of strategical importance, commanding the entrance into Nepal and Bhutan', not leaving out the possibility for a missionary intervention: 'I don't suppose a single Lepcha would remain subject to the Sikkim Raja. I think it probable that they might also, in the space of a few years, prefer the Christian to the Lama religion'(O'Malley 1907: 20). The then governor general, Lord William Bentinck, is said to have promptly deputed Captain Herbert, then deputy surveyor-general, to examine the site with Mr. Grant. On the recommendation of the reconnaissance mission, Lord Bentinck directed then General Lloyd to open negotiations with the Sikkim Raja for the cession of Darjeeling in exchange for money or land. The negotiations were to take place for the site 'represented by Capt. Herbert to be destitute of inhabitants' (Pinn 1986: 120), described by Capt. Lloyd as

> Formerly occupied by a large village or town (an unusual circumstance in the country) and some shops were set up in it; one of the principal Lepcha Kajees resided here, and the remains of his house, and also of a Gompah or temple . . . both substantially built of stone are still extant; also several stone tombs and chytas of different forms, Kajees and Lamas. A stream of water issues from the hill; a short distance below, from the place having been so long neglected, the space which was formerly inhabited is now covered by a grass jungle.
> (Pinn 1986: 120)

'The place' identified as the Observatory Hill and its immediate vicinity, was where the sanitarium would be established. Only 'the place' was to be entered into negotiations with the Sikkim Raja. Accordingly, on 11 February 1835, in a personal letter to the Sikkim Raja, Lord Bentinck expressed his desire to possess Darjeeling:

> I am informed that the above-names place yields you no revenue nor is it any part of the object of the British Government to derive pecuniary profit from its possession. It is solely on account of the climate that the possession of the place is deemed desirable, the cold which is understood to prevail there being considered as peculiarly beneficial to the European constitution when debilitated by the heat of the plains.
> (Pinn 1986: 121)

This request was reiterated by Capt. Lloyd, who also in his formal request for Darjeeling presented the 'cool' fact of the place as the only factor in the British request for cession as a very modest cover for the desired colonisation process of trade, missions and militarisation. This could be seen as a steady start of the deception and trickery that was to befall the Sikkim Raja. For at the end of the negotiations, he would end up trading an orchard for an apple. It was a very cheap bargain for the British, indeed, where they ended up with a territory in excess of 138 square miles, all lands which would include

> the Durgeeling ridge as far north as the Great Rungeet River, and the ridge of the Sinchul mountains as far south as the plains and these leave other smaller ridges projecting from the East and West, bounded by the principal streams, the Balasun, Kuhail, and little Rungeet on the West and by the Runno and Mahanunda on the East.
> (Pinn 1986: 123)

when the explicit instruction had been to only request for the small tract around Observatory Hill.[1]

The graphics of colonial exploration

In 1849, a small exploratory trip was made by the superintendant of Darjeeling, Dr. Archibald Campbell and the botanist Dr. J.D. Hooker to Sikkim, which eventually led to some serious reconfigurations in the relationship between the British and the Sikkim Court, 'for one hundred years the story of Dr. Hooker's arrest by the Rajah as described in the *Himalayan Journals* has coloured, or blackened, all accounts of the Rajah's character'(Pinn 1986: 119). In the preface to his extensive travel journal, Hooker mentions how no British missions had penetrated the snowy Himalayas to the east since the Turner diplomatic mission to Tibet in 1789. The greatest inducement for him to undertake the exercise had been to further the cause of physical geography by travelling to Tibet and

> ascertaining particulars respecting the great mountain Chumulari, which was only known from Turner's account . . . but it was not then known that Kinchinjunga, the loftiest mountain on the globe was, situated on my route, and formed a principal feature in the physical geography of Sikkim.
> (Hooker 1854: vi)

This was to be a highly scientific endeavour with the collection of plant specimens and an elaboration of the physical terrain, and his journals would

provide illustrations and maps of the surveys undertaken. When he reached Darjeeling in the early summer of 1848, he spent most of his time in taking a collection of plant species, ably assisted by a host of Lepcha youths at his disposal, and making meteorological observations. He was residing at the bungalow of Brian H. Hogdson, whom he considered to be a great man of science. He is rightfully considered to be a great man of science,[2] as his mission in the Himalayas was to go beyond the call of a colonial ethnographer stationed in the bureaucracy. He considered himself 'an Orientalist and naturalist trying to collect and record the vast diversity of the cultural worlds in very much the same spirit as when collecting and recording the diversity of the natural world' (Gaenszle 2004: 206). Hodgson's contribution to Himalayan ethnography is attested by Martin Gaenszle (Gaenszle 2004: 206) in the way his papers are still quoted in reference to Himalayan studies and how a study of his approach is valuable in understanding the early history of anthropology. Hodgson's methodology is said to be very much enmeshed in the scientific fashion of the early 19th century. His orientation was built around the milieu and debates of the time, like the discovery of the Sanskrit language and an Aryan race. Gaenszle identifies his methodology as Prichardian –after the British ethnologist James Cowles Prichard (1786–1848), who advocated a monogenetic theory of human history, in his belief that a common aboriginal element existed amongst the South Asian populace. Hodgson is said to have placed greater stress on linguistic identity than what was to later consume the fledgling discipline of anthropology, the close examination of physical features to describe race. He was a keen observer of the culture of study, displaying qualities which would warrant him the title of the founder of Himalayan anthropology (Gaenszle 2004: 208). Hodgson might have been a child of early 19th-century anthropology, but his views on the transference and migration of Aryan civilisation differed from the standard account, as he posited that the Aryans had pushed back the original populations to the margins, into the forests and hills, and that with them resided the true civilisation of South Asia, which could now be studied from the marginalised, or what he called 'broken', tribal groups lodged especially in the Himalayas (Gaenszle 2004: 208). In 1833, his first serious ethnographic paper on the Himalayan groups titled 'Origin and Classification of the Military Tribes of Nepal' was published, which was unlike the second-hand reports of colonial agents and Christian missionaries and was based on his own investigations. The issue of classifying the Nepalese tribes was of special import to the East India Company in terms of identifying particular tribesmen as valuable soldier recruits, and earlier, Colonel William Kirkpatrick and Francis Buchanan Hamilton had already taken up the task of classifying the military tribes. According to Gaenszle, Hodgson's earlier pieces of ethnographic writing still carried traces of his training as a bureaucrat, and it was only with his retirement to Darjeeling in 1843 that he developed his mature phase, wherein his submissions to the Asiatic

Society of Bengal (the journal which carries almost all of his papers) showcase his methodological approach of integrating linguistic analysis with other components of physical description, location and geography –all very Prichardian in character –more clearly, and his papers not only appear to be lengthier but also highlight his interest in local history. One of the papers to appear during his mature phase in 1847/1848 was the comprehensive yet concise survey of the ethnic groups in the Central Himalayas, 'On the Aborigines of the Sub-Himalayas', which provided a classification of the groups into the Khas-speaking Parbatiya castes and the Alpine races of the sub-Himalaya-Bhotia, Sunwar, Magar, Gurung, Murmi, Newar, Kiranti, Lepcha and Bhutanese. Gaenszle points out that this classificatory system for the sub-Himalayas has been quoted several times (Gaenszle 2004: 214). In the accompanying addenda and corrigenda of the paper 'On the Aborigines of Sub-Himalayas', published in the December issue of the *Journal of the Asiatic Society of Bengal*, there appears in Appendix II ('On the physical type of the Tibetans'), a sketch of a young Tibetan man, twenty-three years of age, named Phuchung, from Digarchi in Utsang or Central Tibet (Figure 3.1).

The three-quarter profile sketch gives us two views of the subject's face –front and side. He is shown wearing the particular costume of his ethnic group with the *chuba* (robe) and long-dangling earrings on both ears. However, the focus is on the physical characteristics of his face,

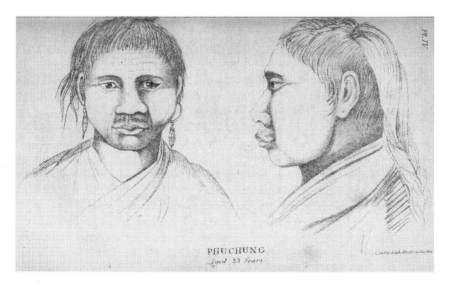

Figure 3.1 Phuchung, Brian H. Hodgson. 1847. Black and white lithographic print of a pencil sketch. Appendix II 'On the physical type of the Tibetans', *Journal of Asiatic Society of Bengal*17, 1848. Plate 4. www.biodiversity library.org/item/124005#page/1/mode/1up (accessed 10 March, 2019) Acknowledgement: Asiatic Society, Kolkata

which is anthropometrically rendered in the accompanying text. The sketch is labelled, 'Phuchung,' along with his age, and on the right side corner of the picture plate, one can find a paint inscription that could read as 'Asiatic Lith. Press(?) Calcutta.' The subject is delineated by strong lines and shading along the neck and cheek region. The one purpose of shading seems to be to effect volume, especially around the right cheek, since Phuchung has been described as a 'stout good humoured lad, fleshy and broad' (Hodgson 1847). The greatest care has been made to show all the physical characteristics on the face as faithfully as possible, which might have something to do with the way the frontal profile sketch seems to be burdened by all the details.

This style of representation is completely different from the one that appears in the depiction of Birna the Bodo youth in his lengthy monograph on the aboriginal population from the plains below the eastern part of the Central Himalayas. The essay is titled, 'On the Kochh, Bodo and Dhimal Tribes', and it was published in 1847 as a first part to a series of a comparative projects on the aboriginal groups of India. However, the project never materialised, and all that was published from the series was this ethnological monograph detailing the language, grammar, living conditions, customs and physical and moral characteristics of the people. The artist for this particular illustration has been identified. He calls him his Newar artist, Rajman Singh. Birna, a Bodo youth, has been chosen as a metonymic representation of all three nations, as Hodges notes that 'for the traits of face and form are so nearly alike in all that neither pen nor pencil could satisfactorily set them apart' (Hodgson 1849). The age of the subject has been surmised to be about twenty-one years of age, as '(for like a true Bodo, he knows not how old he is), so that we are obliged to give his age conjecturally. The mistake however cannot exceed a year or two' (Hodgson 1849). In the illustration, Birna is first identified as a Tamulian, and then the details of his name and age are provided. Tamulian ('Drawidian'[sic]) is a racial category that Hodgson came up with to explain the one origin theory of all aboriginal groups in the Indian subcontinent, the other groups being Mongolians ('Tartars') and Munda (Hodgson 1847–1849). Since Hodgson is mostly concerned with the linguistic analysis of these groups, he ascribes the difference of language in these aboriginal stocks to history. The artist has again rendered the subject in bold lines with light shading along the edges of the body to render volume. Birna is shown wearing a *langot*-(loincloth) like costume, with a long flap in the front and tied to the waist. His body, which has been described as proportionate and healthy, is shown likewise with a good broad chest on which hangs a chain with a pouch-like pendant. Birna is shown holding on to a long, thin branch, maybe representative of local vegetation. The manner in which he extends his right arm to hold the branch is very reminiscent of the later 19th-century anthropometric photography in which

mostly non-Western people were made to pose according to strict principles of measurement and containment. It would be a stretch to presuppose this instance as a proto-version of what was to come later, but what it can be said to throw light upon is the effort taken to represent every physical attribute as empirically observed. Going by the stylistic details of the Birna illustration, one can conjecture that the Phuchung sketch was made by the same artist.

In the preface to his *Himalayan Journals* (1854), Hooker, in expressing gratitude to Hodgson, enumerated the various services Hodgson had delivered to natural history in the vast collection of specimens that he had assembled over the years: 'His collections of specimens are immense and are illustrated by drawings and descriptions taken from life, with remarks on the anatomy, habits and localities of the animals themselves' (Hooker 1854: xii). Thus, the authenticity of the illustrations is vouched for by Hooker as is evident in the careful rendering of details in them. When Hooker arrived in Darjeeling, he stayed with Hodgson at his bungalow, Brianstone, for several months. During that time, in one of the letters that he wrote to his fiancée, Fanny Henslow, in 1849, he mentioned the endless retinue of servants at Hodgson's disposal, along with two artists (Arnold 2004: 193). Although not much is known about these artists, one of them could have been Rajman Singh, who also signed most of his paintings. Rajman Singh worked with Hodgson in completing natural history drawings and architectural illustrations in Nepal. He is said to have joined him in Darjeeling. In a letter written by Hodgson to Sir Alexander Johnstone, vice president of the Royal Asiatic Society, in 1835, he revealed some of the working principles of natural history drawing:

> The existing results of my research consist of a series of drawings (the birds all of natural size) executed by two native artists, carefully trained to the strict observance and delineation of the significant parts . . . my drawings amount to several hundreds; and almost every subject has been again and again corrected, from fresh specimens, with a view to the mature aspect of the species, in respect to colour and figure. Sexual differences, as well as those caused by nonage, have been fixed and portrayed when it seemed advisable; and various characteristic parts, external and internal, have been separately delineated. In regard to the latter, whether given separately, or combined with the general form, the use of the camera has been resorted to, to insure rigid accuracy; and, when it has not been employed, the draughtsmen have been perpetually recalled to the careful exhibition of characters by my supervision. Whilst abundance of fresh specimens have been thus employed by my painters, I have myself continued to draw from the same source notes of the structure of stomachs and intestines; of habits in regard to food,

as indicated by the contents of stomachs; and of other habits, of manners, location, and economy, derived either from observation or report.

(Datta and Inskipp 2004: 137)

Thus, what can be ascertained is the high demand Hodgson placed on correct representation, as he claims to have 'carefully trained to the strict observance and delineation of the significant parts', and the deployment of visual technologies like the camera lucida[3] to 'insure rigid accuracy' also speaks of the want to be scientifically rigorous in his research output, especially for a self-trained naturalist like himself. Datta and Inskipp (Datta and Inskipp 2004: 138) point out that the later paintings of Hodgson's artists were rendered in a more 'scientifically accurate' as well as 'lifelike' manner as they worked with fresh or live specimens to record the minutest details of colours, bill, legs, feet and eyes, and only a few of these wonderful paintings could find a place in Hodgson's publications because of the prohibitive cost of printing and the dearth of talented engravers and lithographers. The 'lifelike' quality of his painters' zoological work was also attested to by Alan Octavian Hume, an expert on Indian birds, in the biography, *Life of Brian Houghton Hodgson*, published by W.W. Hunter in 1896. The pictures were said to be produced by Indian artists under his careful supervision, 'from a scientific point of view', and pencil drawings and details of birds 'reproduced with photographic accuracy and minuteness' (cf. Datta and Inskipp 2004: 140). What we have here is a judgement placed upon the said drawings from the vantage point of photography; the older technique of ethnographic and zoological drawings had to be tested against the newer technology of visual representation. With the coming of photography in 1839, it was believed that it was possible to capture and convey reality. The correctness to form and content could be established, the photographic eye being an impartial, objective surveyor. Thus, the illustrations that Hooker renders in his *Himalayan Journals* (1855) of the various natives of Bengal and Sikkim were considered to be too Europeanised and not true representations. In 1898, in his preface to *Among the Himalayas*, L.A. Waddell was to dismiss the 'typical of the tribe' representations of Hooker's *Himalayan Journals* as too 'Europeanised' and a failure in conveying the 'correct impression' owing to the fact that these lithographs of foreign scenes were printed in England (Figure 3.2).

Instead, he points to the authenticity and correctness in the illustrations rendered in his book, wherein a certain 'Himalayan artist', Mr. A.D. McCormick, is supposed to have rendered 'sympathetic drawings' from the photographs taken by him on his journey through the Himalayas, which were then reproduced by 'photo-mechanical processes'(Figure 3.3).

Hence, the reliance on mechanical processes of photography and printing, free from any human mediation, is supposed to guarantee truthfulness of representation. Therefore, it was not only a question of transformation in vision

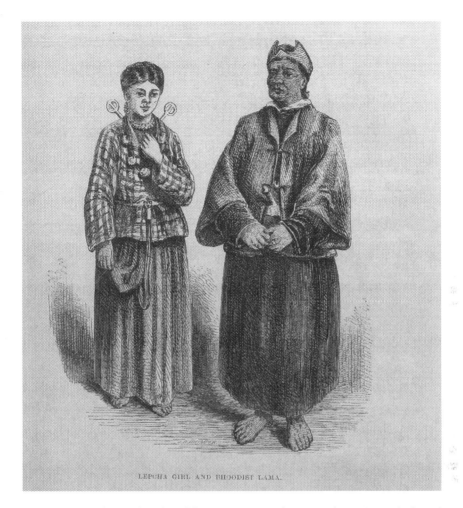

Figure 3.2 Lepcha Girl and Buddhist Lama, Joseph D. Hooker. 1854. Black and white woodcut. From: Joseph D. Hooker. *Himalayan Journals*, Vol. I. London: John Murray, 1854). Page 119. Available from https://archive.org/details/himalayanjourna00hookgoog (accessed 15 June 2018)

and visuality (Bryson 1983; Crary 1990; Jay 1993; Mirzoeff 2011), to borrow the terms from Hal Foster's edited volume, *Vision and Visuality* (1988), which attempts to expose or 'to slip these superimpositions out of focus' between 'the datum of vision and its discursive determinations –a difference, many differences, among how we see, how we are able, allowed, or made to see this seeing or the unseen therein'; through 'rhetoric and representations, each scopic regime seeks to close out these differences' (Foster 1988: ix).

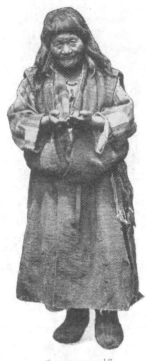

Figure 3.3 Baksheesh! L. A. Waddell. 1899. Black-and-white photographic print on paper. From: L.A. Waddell. *Among the Himalayas*. Westminster: Archibald Constable and Company. Page 26. Available from https://archive.org/stream/himalayas00waddamongrich#page/n0/mode/2up (accessed 15 June 2018)

Coincidentally, a vast number of transformations were also afoot in the 19th century, from the way certain disciplines were developing because of the monumental changes brought about by colonialism in the modern world. As Elizabeth Edwards points out, anthropology, 'despite its eclectic nature in its emerging years, adopted much of its method from the biological sciences, the stress being on observation, recording and classification. On this was erected a firm structure for positive, scientific, empirical knowledge' (Edwards 1992: 6).

The correctness of colonial photography in an ethnographical enclave

The scientific and empirical temper of the 19th century of unmitigated seeing and showing had consequences for the domains of art and anthropology.

With the coming of photography in 1839, it was possible to capture and convey reality. Correctness to form and content could be established, the photographic eye being an impartial, objective surveyor. Christopher Pinney unravels the connection between anthropology and photography in historical coincidence as

> The coincidence of the establishment of the Aborigines Protection Society in 1837 and the founding of the Ethnological Society in London in 1843 with Francois Argo's announcement in 1839 of Daguerre's photographic process, and Fox Talbot's declaration of his 'photogenic drawing' in the same year, draws our attention to the curious echo between the history of photography and that of anthropology.
> (Pinney 2011: 17)

This fated coincidence much energised the world of anthropology, as 19th century anthropologists went about recording and documenting the native body. In the colonies, the photographic technology was fast gaining ground as Dr. Archibald Campbell, the former superintendant of Darjeeling, exhibited photographs, along with articles of clothing, arms and tribal objects, of the tribes of Darjeeling like the Limboos and Lepchas at the Ethnological Society of London in 1868 (Pinney 2011: 17).

In his report to the Ethnology Society of London read on 7 April 1868 titled *On the Tribes Around Darjeeling*, he gives refrain to the anthropometric methodology prevalent in anthropology by stating that it was impossible to describe any tribe in Asia without conforming to the standard racial or linguistic categories 'identified with Caucasians, Mongolians, or other families; or lingually with Sanscritic, Indo-Chinese, Thibetan, or Aboriginal stocks of languages; otherwise observations are apt to be considered of little use to ethnology', and he stringently outlines the colonial anthropological undertaking in these terms:

> I am not anatomist or philologist enough to do this. I believe, however, that the British nation and this Society have other and very important interests in connection with Asiatic tribes besides the examination of their skulls, and the comparison of their languages, for the purpose of systematic classification. It is, I think, incumbent on the British Government, wherever its rule extends, to secure the means of knowing the idiosyncrasies of all the tribes with which it is in contact. Without this, the duties of legislation can be but imperfectly performed, and the power of affording protection to life and property in peace and prosperity may be greatly curtailed. It should, therefore, I think, be no small aim of this Society to be instrumental in disseminating this kind of information to the

Government, as well as in giving aid to science on more abstruse points connected with classification.
(Campbell 1869: 145)

The scientific rigours of ethnology were to be instrumentalised for the proper dispensation of colonial administration in this imbrication of knowledge with power. It was within this classificatory enterprise that the fixing and pinning down of the various tribes and communities was affected. A scientific portrait of all the tribes around Darjeeling was made with special emphasis on the Limboos and the Lepchas. They were considered closest to the Mongoloid register. The photographic portraits of these tribes were mobilised by the colonial power to further intensify and reinforce the racial profile, so the Lepchas would be the fair and attractive Mongoloid prototype and the aboriginal inhabitants of Sikhim and the Bhooteas would be raw, crude and violent brutes (Campbell 1869: 145). The deployment of such ethnographic portraits either for the advancement of colonial rule over natives or for the development of racial theories in the 19th century is well documented. Such photographs were mainly channelised towards the rapidly expanding field of physical anthropology. Before the advent of photography, it was the comparative science of anthropometry that furnished information on racial types and the prehistory of man. Hence, these studies, mainly the emergence of ethnology or the 'Science of the Human Races' in the mid-19th century would lead to the polygenetic conception of man as a multi-species and hence multi-racial organism (Stocking 1987: 47). Multiracial implicitly implied the division of races between the superior and the inferior; the evolved white-skinned Nordic race would be the lords over the primitive, darker-skinned races. The socio-political repercussion of such anti-Darwinian theory would be the justification of slavery in the southern states of the United States and the paternalistic extension of colonial rule over wide territorial swathes in the 19th century. The British colonial power in India undertook the massive and back-breaking task of anthropologically classifying the native population in India, utilising the latest scientific developments in the field of anthropometry to link physical characteristics with moral propensity. This led to the typification of certain races as criminal races based purely on the unshakeable faith in physical traits. With the development of photographic processes, the scientific value of biological or physical anthropology was broadened. What followed was the consolidation of a racial 'type':

> In these photographs, a non-European person under colonial scrutiny was posed partially or even totally unclothed against a plain or calibrated backdrop to create a profile, frontal, or posterior view. Or scientists measured and photographed the skeletons and skulls of people from far-flung colonized areas of the world. From

these photographs physical traits were gleaned and ordered so that different ethnic groups could be classified according to common characteristics.

(Hight and Simpson 2002)

These photographs were not only interested in documenting the physical specificities of a particular race; they also allowed for a spectacle of the races to be made whether they be in the costumes, native arts, trades and occupations or habitats. This form of spectacle-creation is also well-documented in their literary counterpart, the travel narratives and literature of the 19th and early 20th century. In the case of Darjeeling hills, travel narratives are replete with stock descriptions of 'picturesque' races and 'gaudy' costumes and jewellery.

Based on the proposed analytical category of the 'type', certain races would be ennobled and some cast as criminals. The photographic portraits of the 'types' would most certainly depend on the perception of the subject as ally or enemy. Thus, contingent on 'varied cultural attitudes and cultural motives of the photographers, clients, and viewers, type photographs can portray the colonial subject as in the guise of Jean-Jacques Rousseau's "noble savage," ferociously brave or exotically appealing, or in contrast, as indolent and cunning' (Hight and Simpson 2002). In his paper 'On the Lepchas', Campbell considered the Lepchas to be the most 'interesting and pleasing' of all tribes around Darjeeling and asserted that 'They were the first to join us on our arrival there, and have always continued to be the most liked by Europeans, and to be the most disposed to mix freely with them'. Campbell describes the temperament of the Lepchas as being 'eminently cheerful' and, in contrast to the other hill tribes and the 'listless, uninquiring natives of the plains', very fascinating, possessing intelligence and 'rational curiosity'. Waxing thick about their honesty and good, gentle nature, he provides vital information from the standpoint of colonial governance in the following 'bureau ethnological' analysis:

> I have never known them to draw their knives on one another, although they always wear them. For ordinary social purposes of talking, eating, and drinking, they have great unanimity, but for any more important purposes of resistance to oppression, the pursuit of industry or trade, their confidence in one another is at a low pitch; they fly bad government rather than resist it, and used to prefer digging for yams in the jungle, and eating wretchedly innutritious vegetables, to enduring any injustice or harsh treatment.
>
> (Campbell 1869–1870: 150)

He observed that although the Lepchas seem civilised enough, as they possess a script and distinct language, what cancels them out from this civilisation

reach is that 'they do not possess any recorded history of themselves, nor have they chronicles of any important events in which they have taken part' (Campbell 1869–1870: 145). In the case of Himalayan ethnology, the peace-loving and pleasant-faced Lepcha would be contrasted with the other Himalayan races that were adjudged to be ugly-featured and warlike, as reported by Campbell.

As pointed out earlier, these impressions were contingent on many diverse factors, the most pressing being the geo-political situation in the hills whereby the tribe could be either considered an ally or a foe. The negative representation of the Bhutias could be related to the frequent clashes the British administration had with Bhutan over boundary demarcation in the 19th century. In the *Illustrated Guide for Tourists to the Darjeeling Himalayan Railway and Darjeeling* (1896), the 'Lepchas, Bhooteas from Bhootan, Thibetan, and Nepalese' were identified as the 'most important portion of the hill tribes met with near Darjeeling'. The Lepcha, identified as the aboriginal inhabitant of 'Sikhim', was 'full of fun, very peaceable and has the reputation of being honest'. The Lepcha women are considered to be "almost pretty, and the little children are frequently so, reminding one somewhat of 'Italian children', while the Tibetan 'Bhooteas' were considered to 'better behaved and more amiable than their Bhootanese brethren' (*The Darjeeling Himalayan Railway* 1896: 15–17).

In the case of photographic depictions of the various tribes and races in the hills, the late 19th and early 20th century photographic prints that were being produced by photographers like John H. Doyle and circulated by studios like Bourne and Shepherd or Thomas Paar, often in the form of postcards, saw the hill people displayed in a scientific spectacle, diorama-like setting or within their so-called physical environment, often recreated in the studio space, with tools of trade. These commercial photo-portraits were definitely citing from earlier ethnographic portraits of tribes and castes, which were monumentalised in the massive, *The People of India* (1868–1875) series (Figure 3.4).

Besides serious academic work on native types, there were works which were being produced for a larger popular market, like the 1897 photo album *Typical Pictures of Indian Natives*, which supposedly ran for several editions. This work featured two dozen coloured studio portraits that were supposed to enable tourists to take back home perfect travel keepsakes of native people in their 'picturesque' costumes. According to Pinney, these pictures would 'define a genre of popular imagery that within a few years would be globally disseminated in the form of postcards' (Pinney 1997: 56).

The reproducibility of the photographic medium meant the fast proliferation of images, and this was exploited in the case of these photographs,

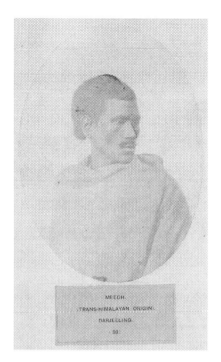 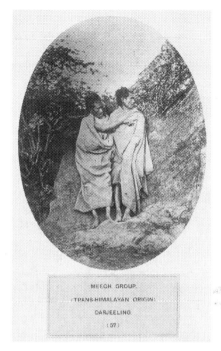

Figure 3.4 Meech and Meech Group. 1868. Black-and-white photographic print on paper. From: John Forbes Watson and Sir John William Kaye. *The People of India: A Series of Photographic Illustrations, with Descriptive Letterpress*. Vol. I. London: W.H. Allen and Company, 1868. Pages 56 and 57, https://archive.org/details/peopleofindiaser02greauoft/page/n11 (accessed 15 June 2018).

which began to be traded as picture postcards intrinsic to the tourism industry that developed in the hills. The picture postcard was invented in the 1880s, and views from the Indian hill stations were widely distributed, whether they were landscape postcards or natives-on-view postcards. Clare E. Harris, in *The Museum on the Roof of the World* (2012), mentions the Darjeeling-based studio of Thomas Paar catering to the tourist market with its 'Souvenir of Darjeeling' postcards, which included three essential views of Mount Kanchenjunga, a Bhutia family and two 'coolies' with loads on their heads.

These postcards presented exotic views of the native and non-native, and the coolies were emblematic of the tourism trade itself, as they were the palanquin bearers and load carriers in the difficult terrain, necessary to tourism. These postcards offered ethnographic information of the local inhabitants and the terrain, mostly in order to prepare future travellers. In the preceding photographic postcard from the Thomas Paar Studio, Darjeeling,

a 'Bhutia' family is represented, normalised to present a picture of a happy family. The crude and violent 'Bhootea' of Campbell's 1868 ethnological enquiry is here shown as a doting and caring family man, as he wraps a protective arm around his little daughter, while the elder daughter is comfortably seated on the floor. The wife is shown with a spindle, spooling wool, as mark of her station in life and more broadly at her ethnic claim. The *chubas* and jewellery would provide proper identification tools for the traveller, and the tools of their trade, in this instance the wool trade, would further deepen and concretize the ethnographic portrait. Most of the ethnographic postcard portraits of the early 20th century placed before the viewers were full-face shots of the subject in which the physical traits and costumes were well represented. This style of representation did not depart too much from the ethnographic portraiture to be found in works like L.A. Waddell's *Among the Himalayas* (1899), mentioned earlier. These postcards followed and very much perpetuated the ethnographic convention of 'typicality', wherein only generalised captions graced the postcard with markers of identification, like for instance, 'Tibetan Lady' or 'Bhootea Family', and the elaborate costumes and jewellery marked out the different hill tribes. These picture postcards often operate on the principle of token representation, wherein the image of one ethnic 'type' is expected to stand-in for the entire ethnic group.

The persistence and popularity of these images in the colonial world can be understood through what Edwards (1992) informs us lies in how meaning is structured in a photograph.

> Photographs suggest meaning through the way in which they are structured, for representational form makes an image accessible and comprehensible to the mind, informing and informed by a whole hidden corpus of knowledge that is called on through the signifiers of the image. This has profound implications for understanding how and why the native body has been repeatedly partitioned from its own culture, history, and geography as it is inscribed with typifying marks of difference in photographs.
>
> (Edwards 1992: 8)

The travel narratives of the late 19th and early 20th century, like the one provided by the American journalist and travel writer Eliza Ruhamah Scidmore (1903), followed the accepted narrative of

> illustrations found in travel narratives, expeditionary reports and journals, published folios, and later travel advertising, all of which were clearly designed to entice prospective colonialists to the foreign lands in question. For the British, and eventually for other Europeans and Americans, such written and pictorial representations

reconfigured and ordered the unfamiliar and often raw terrain according to the pictorial conventions of the picturesque view
(Edwards 1992: 8)

– and in some cases 'picturesque races'. All these 'restructurings' had a definite purpose of enabling the

> Western observer and potential traveller to enter a scene safely and to be charmed by its novelty or its awe-inspiring grandeur. At the same time, these aesthetic interpretations of colonial space could also circumscribe both natural and built environments with an invasive colonial presence that could scarcely be counted as politically neutral and benign toward the inhabitants.
> (Edwards 1992: 8)

Conclusion

In the introduction to *Empires of Vision: A Reader (Objects/Histories)* (2014), Sumathi Ramaswamy, while outlining the premise of the project as a visual history of the European colonial enterprise and their forms of ocularity, identifies five image-making technologies that have had consequences in both Europe and its colonies: (i) oil and easel painting, (ii) mechanically reproduced print (in its many forms), (iii) maps and landscape imagery, (iv) photography and (v) film (Ramaswamy 2014: 2). These ocular technologies have had quite a career in the Indian subcontinent, not only in their colonial vestments but more specifically in how they have been appropriated by the locals and the forms of self-making that have emerged out of them in the postcolonial context. In the context of the Darjeeling, all these technologies have had their respective runs in the colonial age and the ensuing post-independence phase with varying degrees of production, consumption and image-making. There have been quite a number of studies dedicated to the explication of this relationship between Western ocular regimes and colonial locations (Said 1978; Nochlin 1989; Fabian 1996; Tobing Rony 1996; Ryan 1997). Hight and Sampson, in their study of colonial photography, bring out the potent point that colonial photographs are 'complex discursive objects of colonial power and culture', wherein the images provide glaring instances of 'racial and ethnographic' differencing between the coloniser and the colonised in terms of how the photographers expressed, more often than not, the relationship as one of unbalance. They view

> their subjects as objects of both racial inferiority and fascination. The photographers' perceptions of their subjects were influenced and reinforced by a diverse array of familiar administrative practices, commercial enterprises, artistic and literary traditions, as well

as the ongoing scientific investigation and classification of racial types. That the photographers shared attitudes with other colonial structures made these images readily accessible to the imaginative conceits of a broad range of Western viewers.

(Hight and Simpson 2002: 1–2)

Darjeeling has, since its inception as a colonial health resort and later tea plantation enclave, been placed under a rigorous scopic regime. All the prescribed European visual technologies have been applied quite successfully by the colonial power to map and image the physical as well as the socio-cultural terrain, be it in the watercolours produced by Edward Lear (1818–1888) of the Kanchenjunga and the Darjeeling hills in the 19th century or in the photographic excursions of one Samuel Bourne (1834–1912). As pointed out by Hight and Sampson, the colonial constructions of racial, cultural and territorial differences in mainly 19th century photographs get channelised through various modes of production and consumption, from 'the "scientific" recording methods of physical anthropology, especially the hierarchical categorising of human specimens, to the popular commercial formats of collection and display: cartes-de-visite, tourist postcards, photograph albums, photographically illustrated books and magazine advertisements', such that they are put to both symbolic and scientific uses for 'the verification and justification of colonial rule' and further assist in the 'construction of a colonial *culture*' (Hight and Simpson 2002: 2). Eventually, these ethnographic photo-images of racial types would be transposed into other mediums like ethnographic films and popular films (Hight and Simpson 2002: 3). Hence, it is not difficult to imagine the somewhat easy slippages between colonial and postcolonial cultures. This becomes explicated and problematised in the paradoxical domain of the postcolonial hill station as they become preserves of the Raj. These 19th-century ocularities were embraced in the post-independence period with some variations, although the objectifying gaze was still retained as the former colonial hill station now became a postcolonial hill station.

However, it would be highly erroneous to just focus on the domination model inherent in most of the colonial photographs that speak for the privileged often European/American viewpoint. One can also look at the postcolonial reincarnations of such photographs, their afterlife. Even though racial and ethnographic colonial photographic portraits were to be instrumentalised in the development of racial theories in the 19th century in America and Europe (Edwards 1992; Wallis 1995; Hight and Simpson 2002; Pinney 2011), there are many instances of these images being reclaimed by the subjects to forge and fashion self-consciousness and a sense of identity – after all, these photographs would prove to be their connection to a past imaged in the bodies of their ancestors.

Notes

1 The sudden expansion of Darjeeling is attributed to the guile of Capt. Lloyd, who was supposed to have made changes to the document without informing the Sikkim Chogyal and gotten it ratified by him, his trickery coming to light with the fact that he back-dated the new document to the 1st of February 1835, while the proceedings with the Sikkim Court took place from the 12th of February onwards (Dutta-Roy 1984).
2 Brian Hodgson is said to have donated a huge collection of his Nepalese natural-history collection of mammals and birds to the British Museum in 1843, which consisted of 2,596 birds from Nepal and Tibet; around 500 specimens of skins, skulls, horns, bones and pickled animals; and 670 exquisite zoological drawings of birds and mammals (Datta and Inskipp 2004: 141).
3 The camera lucida, an optical device of the 19th century mainly used by artists as an aid was also relied on by Brian Hodgson's artists to capture accurate forms, as is mentioned in a letter that he wrote to George Birdwood, at the India Office, in 1879: 'I caused a native of Nepal to delineate assisted by the camera lucida a series of illustrations of Nepalese architecture' (Losty 2004: 103).

References

Arnold, David. 2004. 'Hodgson, Hooker and the Himalayan Frontier, 1848–1850'. In David M. Waterhouse (ed.), *The Origins of Himalayan Studies: Brian Houghton Hodgson in Nepal and Darjeeling*. New York: Routledge, 189–205.

Bryson, Norman. 1983. *Vision and Painting: The Logic of the Gaze*. New Haven: Yale University Press.

Campbell, Archibald. 1869–1870. 'On the Lepchas'. *The Journal of the Ethnological Society of London*, 1: 143–157.

———. 1869.'On the Tribes Around Darjeeling'. *Transactions of the Ethnological Society of London*, 7: 144–159.

Crary, Jonathan. 1990. *Techniques of the Observer: On Vision and Modernity in the Nineteenth Century*. Cambridge, MA and London: MIT Press.

Dalton Hooker, Joseph. 1854. *Himalayan Journals: Vol. I and II*. London: John Murray.

Datta, Ann and Cindy Inskipp. 2004. 'Zoology Amuses Me Much'. In David M. Waterhouse (ed.), *The Origins of Himalayan Studies: Brian Houghton Hodgson in Nepal and Darjeeling*. New York: Routledge, 134–53.

Dutta-Roy, Sunanda K. 1984. *Smash and Grab: Annexation of Sikkim*. New Delhi: Vikas Publishing House.

Edwards, Elizabeth. 1992. 'Introduction'. In Elizabeth Edwards (ed.), *Anthropology and Photography, 1860–1920*. New Haven and London: Yale University Press, 3–17.

Fabian, Johannes. 1996. *Remembering the Present: Painting and Popular History in Zaire*. Berkeley: University of California Press.

Foster, Hal. 1988. 'Preface'. In Hal Foster (ed.), *Vision and Visuality*. Seattle: Bay Press, ix–xiv.

Harris, Clare E. 2012. *The Museum on the Roof of the World: Art, Politics and the Representation of Tibet*. London: The University of Chicago Press.

Hight, Eleanor M. and Gary D. Simpson. 2002.'Introduction on Photography "Race", and Post-Colonial Theory'. In Eleanor M. Hight and Gary D. Simpson

(eds.),*Colonialist Photography: Imag(in)ing Race and Place*. London and New York: Routledge, 1–19.
Hodgson, Brian Houghton. 1847. 'On the Aborigines of the Sub-Himalayas'. *Journal of the Asiatic Society of Bengal*, 16: 1235–44.
———. 1848. 'On the Physical Type of the Tibetans'. *Journal of the Asiatic Society of Bengal*, 17:77–8, January.
———. 1849. 'On the Origins of the Kooch, Bodo and Dhimal'. *Journal of the Asiatic Society of Bengal*, 18(2): 702–47.
Jay, Martin. 1993. *Downcast Eyes: The Denigration of Vision in Nineteenth Century French Thought*. Berkeley and Los Angeles: University of California Press.
Losty, J. P. 2004. 'The Architectural Monuments of Buddhism: Hodgson and the Buddhist Architecture of the Kathmandu Valley'. In David M. Waterhouse (ed.), *The Origins of Himalayan Studies: Brian Houghton Hodgson in Nepal and Darjeeling*. New York: Routledge, 77–110.
Martin, Gaenszle. 2004. 'Brian Hodgson as Ethnographer and Ethnologist'. In David M. Waterhouse (ed.), *The Origins of Himalayan Studies: Brian Houghton Hodgson in Nepal and Darjeeling*. New York: Routledge, 206–26.
Mirzoeff, Nicholas. 2011. *The Right to Look: A Counterhistory of Visuality*. Durham: Duke University Press.
Nochlin, Linda. 1989. *The Politics of Vision: Essays on Nineteenth Century Art and Society*. New York: Harper and Row.
O'Malley, L.S.S. 1907. *Darjeeling*. Kolkata: Bengal Secretariat Book Depot.
Pinn, Fred. 1986. *The Road to Destiny: Darjeeling Letters, 1839*. Kolkata: Oxford University Press.
Pinney, Christopher. 1997. *Camera Indica: The Social Life of Indian Photographs*. London: Reaktion Books.
———. 2011. *Photography and Anthropology*. London: Reaktion Books.
Ramaswamy, Sumathi. 2014. 'The Work of Vision in the Age of European Empires'. In Sumathi Ramaswany and Martin Jay (eds.), *Empires of Vision: A Reader (Objects/Histories)*. Durham: Duke University Press,1–22.
Ryan, James R. 1997. *Picturing Empire: Photography and the Visualization of the British Empire*. London: Reaktion Books.
Said, Edward W. 1978. *Orientalism*. London: Penguin Books.
Scidmore, Eliza R. 1903. *Winter India*. New York: The Century Co.
Stocking, Jr. George W. 1987. *Victorian Anthropology*. New York: The Free Press.
Tobing Rony, Fatima. 1996. *The Third Eye: Race, Cinema and Ethnographic Spectacle*. Durham and London: Duke University Press.
Waddell, L.A. 1899. *Among the Himalayas*. Westminster: Archibald Constable and Company.
Wallis, Brian. 1995. 'Black Bodies, White Science: Louis Agassiz's Slave Daguerrotypes'. *American Art*, 9(2): 38–61.

4

PATTERNS OF MIGRATION AND FORMATION OF THE INDIAN DIASPORA IN COLONIAL INDIA

Amba Pande

Since the known history of the subcontinent, Indians, especially from the coastal regions, have been moving across the continents and the oceans. However, it was during the colonial period that sponsored migrations – sponsored by the government or the planters – in the form of labourers, officials and service providers started to take place in large numbers, which later resulted in permanent settlements. As the Indians became permanent settlers and an integral part of the economic and political landscape of the receiving societies, their connectivity with India continued giving rise to what is termed as the *diasporic consciousness*. This paper aims to analyze the colonial migration patterns in a critical manner and focus on how they resulted in the formation of an Indian diaspora.

Migration from the Indian subcontinent to Asia and Africa, too, has been taking place for all of known history. Indians travelled to different places as preachers, traders, sailors, gypsies', labourers, boatmen, syces, domestic servants and in several other forms. Ancient Indian texts, like the *Puranas*, *Arthshastra*, *Brihat Kathakosha*, the *Jatakas* and *Milindapanh*, and foreign historical sources, like the records of Alexander the Great and Periplus of the Arithrian Sea and those of the Greeks and Arabs, mention overseas journeys undertaken by the Indian preachers and traders to the West Asian, Central Asian, African and Southeast Asian regions. The merchants from Gujarat, Bengal and Tamil Nadu established important trading centres in several of these regions and often enjoyed considerable influence on the local rulers and societies. The dominance of Indians in mercantile activities and Indian cultural influence in Southeast Asian and African countries is a well-known fact that is visible even today.

However, the absence of a sizable distinctive Indian population of the pre-modern period in these regions (See Tinker 1977; Narayan 2008) indicates that either these movements were rotational and did not result in

permanent settlements or that racial, linguistic and cultural intermixing or blending with the locals left the Indian populations indistinguishable (Pande 2014, 2). Such circular migration patterns continued almost up to the 20th century, when changes in the world economy and trading activities further propelled overseas travels and migrations and a much more intensive circulation of people, goods, ideas, cultures and texts (see Lal 2007; Amrith 2009: 556). The coastal Indian cultures celebrated regular overseas journeys through festivals, like the Orriya festival of 'Bali Jatra', which ensured regular overseas journeys from these areas. Thus the overseas voyages from Indian coastal regions, up to the 18th and 19th centuries, were popular and brisk.

With the beginning of the British colonisation in India, major changes occurred in the existing migration patterns from India. The colonial government itself started sponsoring the migration of labourers to different colonies under various schemes, such as Indentured, Kangani and Maistry. In some cases, like the Caribbean, the government also started accepting the sponsorship by the planters to meet the labour requirements of the various plantation colonies. Such migrations occurred on the basis of contracts with the labourers for plantation colonies which were completely new, far-flung, and remote and were dependent on slave labour for centuries. The anti-slavery movement that began in Britain in 1783 had led to abolition of slavery 1833[1] and emancipation of all the slaves in the British Empire. Some of the pioneering names who played a significant role in this regard are Thomas Clarkson Jacques, James Ramsay, William Roscoe Pierre Brissot and John Scoble and organisations like the British and Foreign Anti-Slavery Society (which was later renamed as Anti-Slavery International). The British government had to buckle under the pressure created by these movements, but the business interests of the planters and labour requirement remained as one of the important concerns. The Act of 1833 provided for compensation for slave-owners for the loss of the slaves and business assets and also provided for a compulsory apprenticeship for the freed slaves against which protests started until a resolution to abolish apprenticeship was passed and *de facto* freedom was achieved. However, as a free labour force on plantations, freed slaves started collective bargaining with planters for better wages and working conditions. This further heightened the tension between the two and expedited the need for alternative arrangements.

Very soon, a new system was evolved to sustain the economy of the plantations that were producing coffee, tea, sugar and other items high in demand in the European countries. This system of indenture migration, which was theoretically a system of free labour movement, as opposed to the forceful trade of slaves, was a misnomer in reality. The system worked as a legal document and codified labour relationship that was binding upon

both the parties, but it ensured the priority of the concerns and interests of the planters whose political and economic powers extended high up in the colonial administration. The contract sustained the flow of labour and legitimised many restrictive labour practices. Without a doubt, the indenture system was designed to help the capitalist economy and the planters, who found a useful legal instrument to structure labour markets and fulfil their production and profit accumulation needs (see Ramsarran 2008). According to the *Encyclopedia of Indian Diaspora*, the colonial labour policy was governed mainly by three principles – plentiful, diversified and cheap supply of labour; a limited assurance of labour freedom of movement; and assurance of a limited amount of protection (Lal 2007: 157). The Anti-Slavery supporters, from the very beginning, claimed that the system was merely a revival of slavery.

Major migration patterns under colonial India

During the colonial period, large-scale, systematic, state-sponsored migration from the Indian Subcontinent began for the first time, along with the already in progress migrations of traders, free labourers, preachers and so on. Under the colonial rule, the migration patterns took new forms and scales. The major migration patterns that the Indian sub-continent witnessed during the colonial period can be categorised as follows:

1. Indentured labour – The indentured labour system started in 1837. This was considered to be a morally more acceptable system for the cheap supply of labour than slavery. Under the indentured system, labourers were recruited under an agreement for five years, extendable again for another five years, after which they were free either to return or to settle down in different colonies. The term 'agreement' got abbreviated as 'Girmit', and thus the indentured labourers came to be known as 'Girmitiyas'. However, the terms and conditions differed according to different colonies, and several new changes were also introduced during the indentureship period.

From the 1880s to the end of the indentured system in 1916, Uttar Pradesh provided 80 per cent of the migrants, followed by Bihar, Bengal, Madhya Pradesh, Punjab and elsewhere. The recruitment of these labourers was done through recruiters known as 'Arkatis', who received financial incentives to procure as many recruits as possible. The agents would locate likely candidates and often used unscrupulous and flawed methods and false information regarding the place, nature of work and wages. Migration started from India in 1834 to various British, French and Dutch colonies. See Table 4.1 for details:

Table 4.1 Major Indian indentured labour importing colonies

Name of Colony	Years of Migration	No. Of Emigrants	Indian Population in 1879	Indian Population in 1900	Indian Population in 1969
Mauritius	1834–1900	453,063	141,309	261,000	520,000
British Guiana	1838–1916	238,909	83,786	118,000	257,000
Trinidad	1845–1916	147,900	25,852	83,000	360,000
Jamaica	1845–1915	36,412	15,134	14,661	27,951
Grenada	1856–1885	3,200	1,200	2,118	9,500
St Lucia	1858–1895	4,350	1,175	2,000	–
Natal	1860–1911	152,184	12,668	64,953	614,000
St Kitts	1860–1861	337	200	–	–
St Vincent's	1860–1880	2,472	1,557	100	3,703
Reunion	1861–1883	26,505	45,000	–	–
Surinam	1873–1916	34,304	3,215	–	101,715
Fiji	1879–1916	60,965	480	12,397	241,000
East Africa	1895–	32,000	–	–	–
Seychelles	?–1916	6,315	–	–	–

Source: Lal 1983.

2. Kangani and maistry – Kangani and maistry (meaning overseer or headman) systems developed along with the indentured system in southern India. It was based on a network of headmen or middlemen who recruited and supervised the labourers. These labourers were not bound by a contract but were brought under a debt net by advance payment. Under this system, 1.7 million labourers were sent to Malaya, 1.6 million to Burma and 1 million to Ceylon. These systems ceased to operate by 1940. One positive aspect in this was that it included family recruitments more strictly than the indenture recruitments.
3. Other forms of government-sponsored migrations – Apart from indenture and similar migrations, there were also migrations of semi-skilled and skilled labour, recruited directly by the government as service providers and junior officers. This category also included a number of Pathans and Sikhs as security personnel and guards. British colonies in Southeast Asia received large number of such Indians, who later got into business and money lending. An alarming difference in the sex ratio shows that such migrations were mostly transitory with the families staying back in India (Lal 2007: 179). It is also indicative of the fact that money was being sent back to India in the form of remittances, probably through personalised channels. But after World War II, permanent settlements began.
4. Free migrations or passage Indians – Apart from the government-sponsored migrations, there were streams of people crossing India's borders through land or sea routes that were self-sponsored or self-paid

passage. The majority of them were from the trading communities from Gujarat, Punjab and other parts of India. Indian traders and entrepreneurs established highly successful businesses across Asian and African countries. Other than the traders, there were also semiskilled and skilled professionals who were 'pulled' for migration by better livelihood options in the colonies, where indentured labourers were present. This group included barbers, goldsmiths, teachers, lawyers and so on. They remained connected with their native places through caste and regional networks and played an important role in providing stability and reviving Indian cultural patterns in the indenture society (See Pande 2013). These migrations were largely rotational in the beginning, but in the later years, permanent settlements in their respective colonies took place in large numbers.

The exiting discourses on the indentured system

There are long-standing and polarised debates and stereotypical narratives about several of the aspects related to the indentured system and the movement of labour during the colonial period. For example, why did Indians migrate in such large numbers? What forced them to migrate? Were they really well versed with the contract, or were they just passive victims who were duped into the contract by the recruiters? Was the system same as African slavery? Or did it actually liberate the labourers from the tyrannies of the contemporary social atrocities and bring economic gains for them? All these aspects have been explored, debated and contested by scholars, shifting the frames of analysis over the years. Another look at the historical realities much more holistically indicates an interplay of varied factors that forced Indians to migrate. This discourse, however, should be handled with much care and should not appear to justify the colonial rule or insinuate its aftereffects, which generally the Revisionist scholars appear to be doing. As a matter of fact, the discourse on the indenture system has been dominated by two trends, one that equates it with slavery and views the recruited labourers as mere victims and the other that tries to highlight the positive outcomes, crediting it to the colonial system.

At the time the indenture system was introduced and the recruitments began, the British dominance in India had already been there for over a century. The British policies had caused a great deal of disruption in the economic and social conditions that had created strong 'push factors' for the outflow of labour. There was destruction of local industries, switchover to commercial agriculture, conditions created due to British revenue settlements, subdivision of the land holdings, famines, droughts, floods, indebtedness and so on. Large-scale internal migrations to the tea plantations of Assam, to jute mills in Calcutta and to collieries in Bihar were already

taking place because of these conditions (See Kumar 2015; Bates 2000). As a matter of fact, the migration of peasants and laboures, along with traders, was a historical trend, but the colonial conditions started the mobility of capital and labour in bulk for different destinations outside India. The labourers agreed to the contract for various reasons. No doubt they were eager to improve their life conditions, but one of the established interpretations is that they were mostly duped or kidnapped or agreed because they were mostly unaware of the destination and the conditions prevailing there. Scholars like Hugh Tinker (1974), Keith Laurence (1994), Brinsley Samaroo (1982) and Rosemarijn Hoefte (1987) have persuasively highlighted the deception, fraud, coercion and kidnapping that was involved in indentured recruitments and the abuse and oppression on the plantations.

The nationalist scholars, anti-indentured groups and the abolitionists insisted that the labourers recruited under the indentured system were just passive victims who were misled and duped, as they were misinformed about the system, destinations and the lengths of the sea voyages. One of the earliest opponents of the indentured system was the British abolitionist John Scoble, who equated the indentured system with slavery, based mainly on kidnapping. He was substantiated by scholars like Hugh Tinker, according to whom the only difference was that indenture was a temporary servitude rather than permanent like slavery. There are innumerable pieces of evidence in the form of government records, personal accounts and songs that assert that the labourers were even forcibly coerced into signing indenture contracts. The popular culture, songs, literature and poetry which were full of migration stories because large-scale seasonal/rotational migrations were already taking place throughout the Gangentic planes, started including the stories of indentured recruitment in their narratives. These songs were mostly in Bhojpuri and Awadhi, as these were the areas from where indentured recruitment was taking place. For example, in one of the popular pamphlets, as quoted by Ashutosh Kumar (2015: 510), people were cautioned.

> Save Yourself from Depot Wallas
> Be Careful!!!
> Be Careful!!!
> Be Careful!!!
> It is not service but pure deception.
> Don't get enmeshed in their meshes, you will repent.
> They take you overseas!!!
> To Jamaica, Fiji, Damra, Mauritius British Guiana, Trinidad and Honduras.
> They are not Colonies but jails.
> Save, be careful from depot wallas,
> They spoil your religion under the pretence of service.

Don't hear sweet talks, they are your enemies.
Dear brothers.

Another poem says,
साजन मत जाओ परदेस
इन गोरो की नति बुरी है
इनकी निर्दय रीती बुरी है
तुम्हे वह देंगे ये गोर तरह तरह का क्लेश
काम कड़ा ये तुमसे लेंगे
खर्च काट कर पैसा देंगे
बात बात पर ये आएंगे बुरी तरह से पेश
एक साल में झुक जाओगे
काम काज से रुक जाओगे
इन गोरो के कुटिल हरदय में नहीं दया का लेश

Its English translation is as follows:
Oh dear, do not go to a foreign country
White people's policies are very bad
Their traditions are heartless and bad
They will give you all sorts of problems
They will give hard work to you
Cut your money
And behave badly with you
You will bend in one year
And won't be able to work again
White people have no compassion in them
(Translated to English by the author from an Awadhi poem published in Pravasi Sansar Jan–June 2017: 123)

Another song described the plight of the peasant labourer as
उसकी तो दुनिया उजड़ गई, खून हुआ अरमानों का
जो अन्न खिलाता औरों को, मोहताज वही है दानों का
Its English translation is as follows:
The one whose world is shattered, whose desires have been killed
The one who was feeding the world is now craving for a piece of grain.
(Translated to English by the author from an Awadhi poem published in Pravasi Sansar Jan–June 2017: 123)

These songs and poetries played a big role in informing the people about the realities of indentured life and building the anti-indentured movement in the longer run. Images of vessels filled with cargoes of human beings were

circulated and invoked the popular anti-indenture feeling in India. While there is no doubt that there could have been many technical differences between the indentured system and slavery, in reality, life in indenture was as appalling and dehumanising as that of slavery. There are innumerable writings reflecting that the working conditions on plantations under the indenture system were as exploitative as under the systems of slavery.

Nevertheless, as the studies on the indentured system expanded and grew, different voices started to challenge the established concepts regarding the nature of the indentured system. Interestingly, many of these voices came from the progenies of the indentured labourers themselves. This point of view, mostly dominated by the revisionist, questions the one-sided branding of indentured migrations as only exploitative, akin to slavery. According to them, it was an exercise by choice which could bring benefits to the labourers and their families. The indentured system actually benefitted the labourers in several ways and was a voluntary process in which the labourers exercised considerable choice with the end result being the betterment of nearly all those involved (See Lal 1983; Emmer 1986).

Caught in these binaries of 'free' and 'unfree', coercive and voluntary, this debate has unfortunately disregarded a rational and nuanced understanding. The early anti-indentured voices came mostly from abolitionists and were heavily influenced by the 19th-century socio-political context and anti-slavery discourse. Notwithstanding the fact that the system was exploitative and dehumanising, it could not have continued for over a century just on the basis of coercion or deception or without any economic benefits. Critics like Rosemarijn Hoefte (1987), Basdeo Mangru (1996), Radica Mahase (2008), Lomarsh Roopnarine (2009) and Brij V. Lal among others, though not denying that the system was abusive for the labourers, insisted that the labourers manipulated the system, through techniques of physical and psychological resistance, to their benefit. The popular songs no doubt highlighted the tyrannies of indentured life but also show that information was flowing. Even if coercion was taking place, labourers were still getting recruited on their own, and as scholars like Smart (2000–2001: 3) and Carter (1992) point out, the depots were attracting crowds, and in some cases, competition for recruitment was stiff. In several cases, connections with the native places were preserved and the knowledge about employment opportunities was disseminated, impacting and encouraging the subsequent migrations.

Studies also point out that throughout the indenture period, there was a continuous inflow of second- and third-term Indian indentured labourers from India. Migrant labourers came back and again took second-term indentureships to the same or a different colony. Some migrants served five to fifteen years in the Caribbean and returned to India but decided to go back to the Caribbean. Other migrants served indenture in other parts of the world (Mauritius, Fiji, and Natal) and chose the Caribbean instead of returning to their original indentured destinations. These migratory dynamics make the

indenture system more complex and, above all, pose some serious challenges to earlier scholarship (Lomarsh 2009: 73). In the case of the Caribbean, from 1838 to 1920, an estimated 175,000 of 500,000 indentured Indians returned to India. Forty to fifty thousand re-migrants was a significant figure when considering that 500,000 left India, 350,000 stayed in the Caribbean and 175,000 went back to India. The return rate was around 8 per cent a year. The statistics for the Immigration Agent General report of 1881 indicate that from 1843 to 1881, 17,235 Indians left British Guiana for India (Lomarsh 2009: 75–6). In 1846, there were 15,328 estate labourers, and by 1853, that figure dropped to 12,865, of whom an estimated 3,000 were deemed unfit for work. Six years after emancipation, 25 per cent of the labour force was lost due largely to out-migration (Lomarsh 2010: 248).

Scholars like PC Emmer (1986) and Marina Carter (1992) point out that in the later years, the returnees themselves worked as recruiting agents, which means considerable information was flowing around. In such a case, the experiences of returnees must have influenced the potential indentured labour recruits. These factors also point out that indentured workers were able to exercise considerable agency and were aware of the economic benefit from the system. This was the reason that for over a century, labourers were available for recruitment with some places witnessing enthusiasm to get recruited. As Christine Smart (2000: 2) puts it,

> Questions arose concerning the ability of the Indians to understand these contracts of labor, but early importation gradually developed into a steady flow. Moreover, the British colonial regime was shipping tens of thousands of convicts overseas to work on overseas penal settlements in Southeast Asia and the Indian Ocean and there was awareness about overseas settlement generally referred to as 'Kala Pani'.
>
> (See Anderson 2009: 95)

Scholars like Anderson (2009) have also pointed out that indentured recruitments acted as an escape valve for un-convicted mutineers and rebels in the aftermath of 1857. They generally concealed the fact, but there was a rise in the number of recruitments during that time. The mutineers were soldiers of the British army and certainly aware of the happenings around.

The strong perception that the indentured labourers were mere victims against the powerful colonial regime left almost no room for their achievements, struggles and successes to be recorded or discussed. Therefore, it is important to highlight the achievements and resistances within the realm of their own context. The labourers were, in many cases, aware of the risks involved in signing the contract, often manipulated the system to suit their needs and resisted in almost all the colonies against the living conditions and the injustice meted to them.

Another pertinent question related to the indenture system is about the savings indentured Indians could make and send back to their homes and villages? After all that was the central reason why Indians migrated. There are several studies in the recent past to look into the possibilities of the remittances sent by the indentured labourers from overseas plantations (See Lomarsh 2010; Bates 2000; Carter 1992). These scholars have brought out letters and messages from labourers obtained from colonial records that mention remitting money and that those migrant labourers were in touch with their family members in India. Many who chose to migrate, for want of alternative livelihood options, relied upon friends and companions for information on where to go and the opportunities available. Often, the families in India and their relatives overseas corresponded on such issues. The returnees also came back with substantial sums of money, as has been pointed out by Grierson. Unfortunately, the facts about savings, jewellery and remitted money were not carefully documented, nor did they reach their destinations in every case. In the case of the Caribbean, on the ship *Malabar*, which sailed from British Guiana to India in 1879, the statistics showed that Indian labourers took back with them savings of $43,477 and a jewel worth of $49,477. The immigration agent James Crosby of British Guiana reported that from November 1850 to December 1877, twenty-seven ships sailed from British Guiana to the Port of Calcutta with 9,833 Indians, and among them, 5,680 deposited $903,556, an average of $159.00. From the same colony but to the Port of Madras, from 1851 to 1859, seven ships took 1,444 Indians, and among them, 333 deposited a total of $56,525, which is an average of $169.00 per person (Lomarsh 2009: 78–9). In spite of the attractive bounties offered, a majority of Indians opted to leave St Croix and return to India when their contracts expired. Some of these 22 persons had significant savings attached to the entry in the books concerning them, sometimes as much as $50. The *Coolie Journal* shows that 250 returnees brought back with them on their person and through the post office a sum of £2,463.13s.4d ($12,503.10) (Lomarsh 2010: 254).

Apart from the indentured, free migrants and service providers too must have brought considerable profit to their home. Nevertheless, such benefits cannot be used to cover-up the deceptions and the coercive methods that were used to recruit the labourers or justify the extreme atrocities and exploitative conditions the labourers faced even if they voluntarily got recruited.

Another existing debate related to the indenture system is about who migrated. The earlier claims that only the lower castes migrated, because of the atrocities of the upper castes, have been proven wrong by later studies (See Tinker 1074; Kumar 2013; Lal 1983). Scholars like Brij Lal have presented a detailed picture of the caste composition of indentured migrants to Fiji, which shows that it was a mixed bag, containing almost all the major castes from Brahmins to Shudras (See Lal 1983, 2000). Most of the indentured recruits came from the lower strata of society and were uprooted

people who had already left their villages because of various push and pull factors related to economic and social conditions of the time. I would like to narrate two interesting stories here told by two of the descendants of indenture labourers. One is that of Shridath Ramphal, former commonwealth secretary general, and the other is of Pandit Kamlesh Arya, president of the Arya Pratinidhi Sabha, Fiji.

According to Shridat Ramphal, when his great-grandfather passed away sometime in the late 19th century, his great-grandmother was being forced by the villagers to perform Sati, which she refused, as she had a young son. As a result, she was forced to leave the village, so she went to Benaras, where she got recruited as an indentured labourer.[2] Another story narrated by Pandit Kamlesh Arya was about his grandfather, who used to work in a shop owned by a Gujarati businessman and fell in love with his daughter. They decided to get married, so they had to run away, and with no other alternative, they got themselves recruited. So going to Fiji as an indentured labourer in the late 19th century was like the start of a new life and settlement for them.[3]

Permanent settlements and the formation of diaspora

The indentured contracts in general were for five years and again extendable for five years. At the end of ten years, the labourers were free either to return to India or to settle down in their respective colonies. Most of the Indians, after completing their terms (5 + 5 years), decided to remain in the colonies where they had immigrated and started agriculture and small businesses. The economic prospects also attracted the traders and other free migrants to settle permanently in these colonies. The indentured labourers who had returned to India in many cases opted to go back to their respective colonies, as they were mostly unable to reintegrate into traditional Indian society because of the existing social norms, like the caste system, untouchability, prohibition on crossing seas and so on. The permanent settlement of Indians in these colonies also suited the colonial rulers and was encouraged by them, as the settled labourers fulfilled the much-needed work force. International developments, like the immigration controls during the 1930s and the increasing assertion of national sovereignty and citizenship in the aftermath of the Second World War, further closed the space for free movement of people, leading to long-term settlements and the formation of diasporas.

With the beginning of the permanent settlements in the plantation colonies where the indentured labourers were migrating, several new issues related to rights, citizenship, space and cultural purity vis-à-vis the natives and other settlers began to emerge. The labourers who went to these lands as 'coolies' were now faced with completely new roles and related problems. The nature of exploitation and discrimination took new forms. The indenture contract led to both a symbolic as well as an actual breakaway from rooted traditions and impacted emerging social relationships. The institutions like 'caste' had

already taken a backseat in the process of migration and settlement (See Grieco 1998; Schwartz 1967). As the settled life in the adopted lands began, new social relationships were formed on the basis of residential propinquity, common experiences, immigration history, geographic area of origin in India and association at work. It also led to community consciousness and a sense of communal belongingness among the Indians. The associations of peasants, labourers, traders and professionals started to come up soon after permanent settlement began. Labour and peasant movements started and made the Indians aggressively fight for political space. In the plantation colonies, like Fiji, the Caribbean and Mauritius, peasant and labour strikes took place as soon as labourers started completing their five-year term and settling down.

Even as the Indian communities became settled permanently, they continued to be largely oriented towards India, with strong cultural and emotional links. India's independence movement remained close to their hearts, and they participated directly through organisations like the 'Ghadar party', Indian Independence League and Indian National Army in the later years, or indirectly through economic contribution or intellectual support. In fact, the movement against the indenture system and its tyranny got intertwined with the national movement. Gandhiji took the lead, and the matter was taken up in several of the Congress sessions, which resulted in the abolition of indenture in 1920.

Permanent settlements also brought forth the question of identity among the indentured labourers and other Indian settlers. The term 'coolie' was close to indenture identity and the term remained a part of their identity for a very long time. They also carried a sense of 'exile' and 'loss', which is reflected in their literary writings (Mishra 2005). Although the sense of belonging with India was strong, long isolation, complete breakdown of networks and institutions like caste (in most cases), association with new cultures and local conditions led to the evolution of sub-cultures and distinct hyphenated identities in these groups. 'Little Indias' were created with their own socio-cultural distinctiveness in terms of language, socio-cultural practices, food and so on. While religious and cultural forms circulated, they underwent transformation to accommodate the new environment and played a crucial role in keeping the continuity with home culture. Religious institutions like temples, Gurudwaras, Ram Krishna Mission, Arya Samaj and Sanatan Dharma Sabha had a significant role in preserving and nurturing the identities of various groups originating from India (See Pande 2013, 2017).

The indentured labourers and their descendants also achieved astounding successes in economic and political fields in their respective host lands, even becoming heads of state and government – Basdeo Pandey (Trinidad and Tobago), Mahendra Chaudhary (Fiji) and Aneerood Jugnauth (Mauritius). They became economic, political and social forces so much so that the story of indenture would be incomplete without the celebration of these successes and triumphs. Nevertheless, this debate again brings us to the same

polarised discourse about revisionist versus the rest. Here, it is important to point out that what the indentured labourers achieved for themselves was a triumph of the human spirit against extreme adversities, and it has nothing to do with justifying the colonial rule or its legacies. That Indian migrant labourers were oppressed, abused and subjected to extreme living and working conditions is an established fact. The indentured system was a tool of political, economic and psychological exploitation. The psychological trauma experienced by the labourers was so deep rooted that it resulted in severe mental illnesses, like suicidal tendencies, alcohol dependency and other forms of mental health disorders, not only of the labourers but also their descendants for many years to come (See Hassankhan, Roopnarine and Ramsoedh 2016; Marcie 2007).

But once historians and sociologists start deconstructing the system and the process, as well as the times and start looking at the people and their experiences instead of the conventional narratives about institutions and the politics of it, several other aspects come to the fore. The experiences of the migrants and their offspring reflect the ways in which they dealt with and adapted to the processes and situations. Their experiences also highlighted the modes of their resistance against coercion and the way they turned the circumstances to their advantage. The labourers faced exploitation at all the stages, starting from recruitment to migration and the plantation and even after they completed their term and became permanent residents of the respective colonies. But they took their destinies into their own hands, and what they built was certainly better than what they had left behind at the time of their migration. This is not to say that all the groups and sections are well off or have achieved successful lives, because in some countries, they are living in distress and continue to remain at the margins. What is more appreciable is they remained connected to their cultural roots, on the one hand, and met new cultures and situations with much openness and conviviality on the other. In the process, new identities were constructed that linked them to both India and the host countries, which has also enriched the already diverse Indian culture.

Conclusion

Migration from India has always been a historical phenomenon, but during the colonial period, it acquired a new form that resulted in permanent overseas settlement and formation of the Indian diaspora. The Indentured system was evolved by the British in the aftermath of the abolition of slavery, as they needed cheap and un-free labour to fulfill the economic needs of the empire. The system was exploitative – maybe not so much on paper – but in reality, the labourers faced almost slave-like conditions. Nevertheless, from the humble beginnings as indentured labourers, the Indians progressed to a point where they were playing a leading role in the social, political and

economic life of the countries of their settlement. In the new age of connectivity, their Indian connections have revived, but they continue to remain firmly rooted in the countries of their settlement. In the terms of diasporic analysis, in the present, we term them as the "old diaspora". They have retained their socio-cultural roots while at the same time integrating well in the host societies and play a major role in India's 'soft power' pursuit.

Notes

1 Slavery was abolished in the British Empire through the Slavery Abolition Act of 1933, except in the territories controlled by the East India Company and Ceylon, which was done in 1843.
2 As narrated by Mr. Ramphal in his speech on Pravasi Diwas in 2002.
3 Based on a personal interview with Pandit Kamlesh Arya in Suva, Fiji, during my visit, in November 2003.

References

Amrith, S.S. 2009. 'Tamil Diasporas Across the Bay of Bengal'. *The American Historical Review*, 114 (3): 547–72.

Anderson, Clare. 2009. 'Convicts and Coolies: Rethinking Indentured Labour in the Nineteenth Century'. *Slavery and Abolition*, 30 (1): 93–109.

Bates, Crispin. 2000. 'Coerced and Migrant Labourers in India: The Colonial Experience'. *Edinburgh Papers in South Asian Studies*, (13): 1–33.

Carter, Marina. 1992. 'Strategies of Labour Mobilization in Colonial India'. *The Journal of Peasant Studies*, 19 (3–4): 229–45.

Emmer, P. C. 1986. 'The Meek Hindu: The Recruitment of Indian Indenture Labourers for Service Overseas, 1870–1916'. In P. C. Emmer (ed.), *Colonialism and Migration: Indenture Labour Before and After Slavery*. Dordrecht: Martinus Nijhoff.

Grieco, Elizabeth M. 1998. 'Effects of Migration on the Establishment of Networks: Caste Disintegration and Reformation Among the Indians of Fiji'. *International Migration Review*, 32 (3): 704–36, Fall.

Hassankhan, Maurits, Lomarsh Roopnarine and Hans Ramsoedh. 2016. 'The Legacy of Indian Indenture: Historical and Contemporary Aspects of Migration and Diaspora'. https://books.google.ca/books?id=ERR6DQAAQBAJ&dq=mental+health+indentureship&sourcegbs_navlinks_s Last Accessed 12 March 2019.

Hoefte, Rosemarijn. 1987. 'Control and Resistance: Indentured Labor in Suriname'. *New West Indian Guide*, 61: 1–22.

Kumar, Ashutosh. 2013. 'Anti-Indenture Bhojpuri Folk Songs and Poems from North India'. *Man in India*, 93 (4): 509–19.

———. 2015. 'Songs of Abolition: Anti- Indentured Campaign in Early Twentieth Century India Kumar, Pratap'. *Indian Diaspora: Socio-Cultural and Religious Worlds*, 38–51, Brill online.

Lal, Brij V. 1983. *Girmitiyas: The Origins of Fiji Indians*. Canberra: The Fiji Museum Suva & The Australian National University.

———. 2000. *Chalo Jahaji*. Canberra: The Fiji Museum Suva & The Australian National University.

———. 2007. *Encyclopedia of Indian diaspora*. New Delhi: Oxford University Press.

Laurence, K. O. 1994. *A Question of Labour: Indentured Immigration into Trinidad and British Guiana, 1875–1917*. New York: St Martin's Press.

Mahase, Radica. 2008. 'Plenty a Dem Run Away: Resistance by Indian Indentured Labourers in Trinidad, 1870–1920'. *Labor History*, 49: 465–80.

Mangru, Basdeo. 1996. *A History of East Indian Resistance on the Guyana Sugar Estates, 1869–1948*. New York: Edwin Mellen Press.

Marcie, Grambeau. 2007. 'Causes & Perceptions: An Exploratory Study of Suicide in Indo-Fijian & Fijian Youth'. Independent Study Project (ISP) Collection. digitalcollections.sit.edu/isp_collection Last Accessed 12 March 2019.

Mishra, Vijay. 2005. *The Diasporic Imaginary and the Indian Diaspora*. Wellington: Asian Studies Institute Occasional Lecture 2. https://core.ac.uk/download/pdf/11243784.pdf?repositoryId=343 Last Accessed 12 March 2019.

Narayan, K. Laxmi. 2008. 'A Brief History of Indian Emigration During Ancient and Medieval Period'. In Ajaya Kumar Sahoo and K. Laxmi Narayan (eds.), *Narayan Indian Diaspora: Trends and Issues*. New Delhi: Serials Publication, 1–6.

Pande, Amba. 2013. 'Conceptualising Indian Diaspora: Diversities Within a Common Identity'. *Economic & Political Weekly*, 48 (49): 59–65.

———. 2014. 'Indians in Southeast Asia: Sojourns, Settlers, Diasporas'. *International Studies*, 51 (1): 1–12.

———. 2017. 'Diaspora: Identities, Spaces and Practices'. In Nandini Sen (ed.), *Through the Diasporic Lens*. New Delhi: Authors Press, 27–37.

Ramsarran, Parbattie. 2008. 'The Indentured Contract and Its Impact on Labor Relationship and Community Reconstruction in British Guiana'. *International Journal of Criminology and Sociological Theory*, 1 (2): 177–88.

Roopnarine, Lomarsh. 2009. 'The Repatriation, Readjustment, and Second Term Migration of Ex-Indentured Indian Laborers from British Guiana and Trinidad to India, 1838–1955'. *New West Indian Guide*, 83 (1–2): 71–97. http://hapi.ucla.edu/journal/detail/319 Last Accessed 12 March 2019.

———. 2010. 'Re-Indenture, Repatriation and Remittances of Ex-Indentured Indians from Danish St Croix to British India 1863–1873'. *Scandinavian Journal of History*, 35 (3): 247–67. www.tandfonline.com/doi/pdf/10.1080/03468755.2010.494006?needAccess=true Last Accessed 12 March 2019.

Samaroo, Brinsley. 1982. 'In Sick Longing for the Further Shore: Return Migration by Caribbean East Indians During the 19th and 20th Centuries'. In William F. Stiner, Klaus de Albuquerque and Roy S. Bryce-Laporte (eds.), *Return Migration and Remittances: Developing a Caribbean Perspective*. Washington, DC: Research Institute on Immigration and Ethnic Studies, Smithsonian Institution, 45–72.

Schwartz, B. M. 1967. *Caste in Overseas Indian Communities*. San Francisco, CA: Chandler Publishing Company.

Smart, Christine M. L. A. 2000–2001. 'Indians in Mauritius and Fiji'. www.hsu.edu/academicforum/2000-2001/2000-1afIndians%20in%20Mauritius%20and%20Fiji.pdf Last Accessed 12 March 2019.

Tinker, Hugh. 1974. *A New System of Slavery: The Import of Indian Labour Overseas 1830–1920*. London: Oxford University Press.

———. 1977. *The Banyan Tree: Overseas Emigrants from India, Pakistan, and Bangladesh*. Oxford: Oxford University Press.

Part II

REGIONAL FORMATIONS AND MOVEMENTS

5

STRUGGLE OVER A MUGHAL OFFICE

English response to Maratha expansion along coastal Western India in 1733

Vijayant Kumar Singh

The region of coastal Gujarat, home to some of the most prosperous commercial entrepots in the subcontinent, in the early 18th century, saw rapid transitions in its economic and political situation over the course of the first three decades.[1] The rapid withdrawal of the Mughal state after the death of Emperor Aurangzeb (c. 1707 CE) from the localities in the region saw attempts being made to supplant the spaces vacated by a multitude of local and regional political players. The local Mughal officials, in the face of continuous distancing from the regions, and because of their or their patron's involvement in the succession struggles at the court, were pushed out or were forced to find recourse to their immediate problems related to law and order and commercial crises in the region, outside the ambits of the Mughal system (See: Gupta 1994; Hasan 2006).[2]

The Marathas, under various commanders, who were attempting to pursue their own agenda within the loose structure of the confederacy (Subramanian 1981: 191–3; Gordon 1993; Seshan 2014: 42) and the European companies, the English especially, competed to gain as much traction as possible over the political and commercial life of the region.[3] In face of such rapidly shifting political and commercial posturing of the major forces in the region, the mercantile communities reacted and adjusted in order to survive and prosper (Gupta 1994).[4] This interaction, defined by the push and pull of socio-political and economic forces, determined new spaces, modalities of compromise and powerplays between various opposing forces.

One such interaction can be located in the year 1733, in the coastal waters of Western India, off the region of Gujarat, when the English tried to gain access to the office of the Mughal naval commanders, which until then was

held by Siddi Masud, who lost considerable influence in the wake of reverses he suffered along the coastline because of aggressive Maratha assaults.

The beginning of the decade of the 1730s saw a renewal in the rivalry between the Maratha and Mughal positions in the suba of Gujarat, the year 1733 especially, as Maratha forces under Peshwa Baji Rao I and the other commanders, such as Pilaji Gaikwad and Khanderao Dabhade, made aggressive manoeuvres against the position of various Mughal commanders centred around the towns and ports of South Gujarat, including Baroda and Surat (Gordon 1993: 123). Along with overland aggression, the Angrias,[5] who were recognised as the naval commanders, captured many of the fortifications previously held by the Siddis,[6] the Mughal naval officials, along the length of the coastline of Gujarat and the Konkan coast. These developments made the commercial traffic along the coast from Bombay up to Surat very vulnerable to Angrian piracy as well as to other pirates operating in the region. The consultations and the subsequent exchange of letters between the council at Bombay and the chief of the English factory at Surat shed interesting light on the political and commercial climate of the region of Western India, especially in coastal Gujarat during the early decades of the 18th century.

Looking through the eyes of the English East India company's officials in the region as they tried to negotiate and navigate their way through the increasingly uncertain political world of 18th-century South Asia, this chapter attempts to delve into and make sense of the actions of the four principal political and commercial participants – the Mughal officials in western India, especially at Surat; the English officials at Surat and company officials at Bombay; the Maratha factions as Angrias and Gaikwads; and the merchant marine of Surat and Gujarat in general, in the year 1733.

Consultation books and diaries of the English East India Company

The source materials for this analysis are the consultation books and diaries of the English officials residing at Bombay and Surat in the first three decades of the 18th century, particularly focusing on the consultation book of the president of the East India Company at Bombay of the year 1733.

The diaries and consultation books of the Bombay Presidency along with other records of the English factories, constitutes an important part of a vast collection of source material, which otherwise also includes private diaries and memoirs of the English and other European officials, traders and travellers, which are available for the study of English commercial activities in the Indian Ocean region (Gupta 2001b).

The consultation books are the records of problems and issues faced by the English traders and company officials in the course of their interaction with the Asian political and social environment. The distance of language

and culture stands out, as do the attempts on both sides to bridge this divide. The consultations betray the discomfort of English factors in their dealings with the ways of the regional nobility and administration of an early modern South Asian state. The personal tensions and angst amongst the English residents in the distant factories of Asia, away from home, facing the difficulties of survival with the desire to make a profit in the harsh Asiatic climate reflects strongly as one peers through the pages of these consultation books and records.

These records provide interesting details on the commercial records of the region, like the prices of commodities, the availability of goods, the conditions of roads and travel and regional and local geographies. Also, importantly, they bring to life the role and activities of obscure participants in the commercial and political world of South Asia. The merchants, bankers, brokers, ordinary labourers, porters and ship workers all find a voice in these records, a voice which is not available or recorded generally in the histories written from within these regions.

At the same time, the records need to be analysed with certain circumspections and care, especially when one attempts to recreate the narratives on South Asian polities exclusively through them. The opinions expressed with regards to the Asiatic states, the polities and participants are biased and seldom objective. Terms like 'pirates' and 'robbers' are frequently used to summarily categorise communities and polities. The descriptions of mercantile practises and the commercial conduct of the merchants and other participants are mostly prejudiced.

English East India Company in the early 18th century

The last decade of 17th century had been eventful with regard to the expansion of English commerce in Asia and specifically in western India. By the middle decades of the 17th century, the English company had stopped participating in the carrying trade between Asian markets. It left the field open for privateers, company servants who engaged in the Asian trade on their own volition. The rise of private trade often came in conflict with the interest of the company trade (Watson 1980; Marshall 1997; Rocher 1997; Maloni 2013).

Moreover, the profits earned by the company servants and the monopoly enjoyed by the company over India's trade became a major issue amongst the English political and mercantile classes. The tacit support of the English Crown in 1698 gave rise to a new enterprise – 'The New East India Company', which challenged the domination of the English company over India's trade (Prakash 2002: 2).

Private interests and increasing competitiveness by the privateers and interlopers through the course of late 17th century gave rise to 'piracy' in the Indian Ocean (Seshan 2013; Subramanian 1981; Elliot 2010, 2013).

Matters came to head towards the end years of 17th century, when the European ships and factors came to be increasingly accused of indulging in piratical activities. The imprisonment of English factors as a tactic to extract the money lost by Surat merchants to pirates became fairly common in our records towards the end of the 17th century (Rawlinson 1929: 239–44). One of the incidents involving a royal ship on the way home from Mecca, in fact, led to the Mughal assault on Bombay (Elliot and Dawson 1877: 355).

The decades of the 1720s and 1730s were eventful and can be considered as the period which laid the foundations for the expansion of English political power in South Asia. Drained by the Maratha invasions and demands from the imperial courts for successive succession struggles, the Mughal officials in Gujarat, especially those posted in the port towns, began to pass on the burden to the mercantile communities. The exactions and taxes increased many-fold and led to resistance from the merchant groups. This struggle between the aristocracy and regional mercantile groups provided an opening for the English company, along with the other European powers, to intervene in the political space of South Asia more actively than before.

The English company at Surat: the events of 1733

The defeat of the Siddi naval forces opened up interesting possibilities for the English to negotiate access to the benefits of the Mughal political structure. For the Mughal governor of the city, Teg Beg Khan, and his associates, the success of the Maratha forces was both frightening and possibly useful for procuring a better deal from the imperial centre. The Maratha success also opened up frightening possibilities for the mercantile communities, as the prospect of direct Maratha intervention in the affairs of the city became very real.

The developments have found mention in some of the most detailed scholarship on 18th-century Gujarat. The incident has been highlighted as a background to the parleys between the merchants of the town and the governor and the English, focusing on the shifting attitudes and insecurities of the Indian mercantile and political classes when faced with a situation as mentioned (Gupta 1994: 262–3; Hasan 2006: 120).

The initial news of the Maratha success was received with a sense of urgency on the part of the English. The Bombay council had very recently intervened in the affairs of Surat city, when it helped the merchants to get the governor Sohrab Khan removed and Teg Beg Khan appointed in his place (Gupta 2001c).

The news of defeat and various responses

The news of defeat of the Siddi and capture of much of his territory and naval flotilla made the English sit up and take notice. The consultation

book opens with the English president informing the council members that he has already asked the English chief at Surat, Henry Lowther, to approach the governor and negotiate for the takeover of Siddi's tanka. At the same, we are informed that the governor had already approached the English at Surat with the same intent and even offered to take up the matter and follow it up to its conclusion with the help of his patron, Khan-i Dauran, at the Mughal Court.

Thus, Henry Lowther, in a letter dated 26 May 1733, informs the Bombay Council that on the 24th of same month, the governor at Surat had sent for him and, on his own accord, proposed to him that

> since the 'Scidy had lost the greatest part of his country with his whole fleet, & was thereby no longer in a condition of protecting the trade of this coast against pyrates and pickaroons, he was no longer entitled to the jageer that was annually paid to him by the court out of the Surat customs on that account & as we are most capable of any power whatever in these parts to undertake that affair, if we were willing he would endeavour by means of his patron Candaura at court to obtain for us a phirmaund for a certain sum to be paid us annually.
>
> (OPPDD[7] No. 6: 2)

It's interesting to consider the locations from where the two sides approached the issue and reached the same conclusion (i.e., appoint the English East India Company as the Mughal Naval commanders in western Indian Ocean).

This act on the part of the officials of the English company need to be analysed in terms of the background of the political climate of the region. It also reflects very clearly on the new-found interest of the company officials to dabble in the political affairs of the region of their operations, to make the conditions more conducive to their trading operations.

Any office of the kind which comes along with a jagir was one solicited by the English, as over the years, because of increasing piracy along the coast, the cost of maintaining armed frigates and soldiers in the service of the company had begun to spiral out of control. So, in immediate effect, the office of the Siddi, which comes along with a sizeable jagir, was a good option to pay for the maintenance of the fleet along the western coastline. Thus, a committee, specially organised to deal with Henry Lowther on the issue of receiving the tanka, wrote to H. Lowther,

> against so great an evil (Angrias & Marathas) we can think on no remedy that can prove to be so effectual as enabling our Hon'ble masters by the punctual payment of a certain annual sum from the Surat government by way of jageer to equip and keep up a sufficient number of ships and vessels of war capable of protecting the trade

of this coast from the Pyracies & depredations of the Maurattas & Angrias or any other pyrates whatever.

(ibid: 9)

In South Asia, the attempts in the initial years of the 18th century have been primarily to find a lateral entry into the Mughal system by gaining service within the office of the state and by aligning and entering into negotiations with various regional powers who operated outside the ambit of the Mughal system and also at times challenged its authority in the regions. In the present case, we find the English, at the same time as they are attempting to take on the office of the Siddi to challenge the Angrias, are also negotiating with the Angrias as an alternative.

Further, the act seems to have been a unilateral enterprise of the Bombay council, and the prior permission from home seems not to have been taken. In fact, some of the initial correspondence between Henry Lowther and the Bombay council asks him to return on the possibility of the success of the affairs, so that the home council can be intimidated, and more resources in terms of money and manpower can be asked to be arranged for the undertaking (ibid: 13–14).

Not only the home council but also the regional agencies in Madras and Bengal were kept out of the loop, for the English at Bombay feared that if more people were let in on the affairs, the secrecy of which was of paramount importance for its success, the English may stand exposed to schemes of the regional powers as well as of the Portuguese, French and the Dutch, who also had a stake in the conduct and management of commerce at Surat.

> And as the success of this affair will in a great measure depend upon the secret management of it, since however willing the surat merchants may be to have the Hon. Company the guardian and protectors of their trade, we are sensible that the Portuguese, French and Dutch will oppose to it to the utmost of their power, especially the latter, since it will not only very much advance the Honour and reputation of our Hon. Masters on this coast above any European nation, but likewise in all parts of India.
>
> (ibid: 7)

It's interesting to locate Teg Beg Khan's offer, for it offers an interesting window into the management and conduct of the affairs in the Mughal court and the relationship with officers who are posted in the region in the early 18th century.

The interest in the affair also lies in fact that it's almost unique on Teg Beg Khan's part to think on the line of looking at a European establishment as

saviours of a Mughal port. Mughal officials had traditionally not seen the European companies as allies in managing their political affairs, let alone asked a European company to manage an entire office of the state. This comes out very clearly in the objections raised by the Qiladar of Surat during the course of the negotiations (ibid: 30). However, more than anything, the objection was also due to the experience of engaging with the English and other European powers by these officials who also engaged in matters of trade and commerce at a personal level.

Thus, the offer by Teg Beg Khan at once informs us on the precarious position of the Mughal officials in the region and also the levels to which they can resort to safeguard their affairs and positions in the chaotic political environment of 18th-century Gujarat. Teg Beg Khan had only very recently ascended to the office of the governor, after a period of a considerable animosity between the Surat administration and the mercantile community of the city, led by merchants, such as Ahmad Chellaby and others.

The spurt in Maratha activities along the coast and the aggressive manoeuvres of Baji Rao I in the region of Konkan and southern Gujarat made the position of the governor of the city increasingly precarious, considering that Teg Beg Khan had not even received his sanad, confirming him in the office of the governor until then. The complete failure of the Siddi in stemming the Angrian activities and controlling piracy complicated the situation further, for the Surat administrators were always dependent on such agencies for the defence of the city and its commerce.

The content of the letters contained in the aforementioned consultation book reveals how poor the intelligence apparatus of the Mughals was and how simple gossip and heresy could at times lead to situations of panic within the city and its administration. Henry Lowther informs us, in the course of his conversation, that the Surat administration is in a panic and sceptical of the Siddi's move to enlist more soldiers to fight the Angrias, as these can be used against the city itself if the Siddi is completely pushed out of his country by the Angria. It took a considerable amount of convincing from the English resident to placate these worries (ibid: 18).

The other factor, of him being in subordinate service of a leading Mughal noble, Khan-I Dauran, also needs to be kept in mind while assessing the response. The jagir of Surat at this time was being held by Khan-I Dauran, and he had appointed his representatives to take care of the management of the affairs of the office of the governor of the city. The process of the selection of a suitable candidate was often through the method of 'farming'. The one who promised to generate a larger revenue share than the previous incumbent was generally appointed. Thus, any danger to the commerce of the city would mean a considerable reduction in the revenues of the port.

Negotiations for the Siddi's Tanka: multiple claimants – the English and the governor

The English responded to the overtures of the governor with increasing enthusiasm. Considering the fact that it was something they were contemplating approaching the office of the governor for, the English response was ecstatic. For the English, the very fact that Teg Beg Khan had approached them meant that the onus of the success of the scheme was not on them, and it was the Mughal officials and not they who had approached and initiated the dialogue. Over the course of negotiations from the month of June to August 1733, the English retorted back to this fact multiple times, so as to convince themselves that they had nothing to worry about.

In a consultation at Bombay between the president and his council dated 7 June 1733, it was observed that since the governor, on his own accord, had proposed to Mr. Lowther that the English undertake the protection of the trade, they had reason to hope that he would be hearty and sincere in soliciting at the Mughal court and bring his own scheme and proposal to a speedy conclusion (ibid: 4). At another place in the course of the discussion on the merits of employing an agent or 'vakeel' to intercede on behalf of the English, Henry Lowther advises against such a move and reiterates that such a responsibility should be left to Teg Beg Khan to deal with, as he himself initiated the scheme. The Bombay council seems to concur with the observation (ibid: 19, 22).

As one combs through the consultation book, one realises most of the matter stuck on the monetary charge of the scheme. The English insisted on a higher payment, and the governor demanded a greater share from the proposed Jagir, while trying to keep the actual value of the jagir even less than what was being given to the Siddi.

The English opened the negotiations by gladly accepting the offer made to them and at the same time highlighting the singular ineffectuality of the Siddi's ships and fleet in doing the job they were supposedly commissioned for. In fact, the English pointed out that it was they, along with other European companies, who were managing and protecting Indian shipping, while the Siddi just stood and looked the other way (ibid: 2).

The English laid the ground for the furtherance of their demand for a larger jagir by highlighting the fact that the Angrias had captured the entire fleet of the Siddi and thus the size of their fleet had doubled. Also, it has been noted in the letters that it was customary on the part of the Surat governors to keep a share from the jagir for themselves and only forward a part of it to the Siddi, who often, in fact, had to extract it by force from the Surat government. This, along with the fact that the charges of the maintenance of ships, the fleet and soldiers had gone up over the years, would require the English to have a larger jagir than what was being offered to the Siddi hitherto.

Thus, in spite of being aware of the very real possibility of a scenario that the governor might ask for a lower amount from the court, in fear of rejection on account of the higher demand than previously given, in letters to Henry Lowther, the Bombay council consistently advised him to push for a jagir equivalent to the amount of 4 lakh of rupees, which could be shared in a 1:3 ratio between Teg Beg Khan and the company. They also feared that any jagir below 3 lakhs would make the whole project completely ineffectual (ibid: 5, 11, 13).

The council also desired that Henry Lowther convey to the governor the desirability to continue charging the Siddi's jagir over the accounts of Surat and pay the English for the expenditure incurred in the early stages, such as in augmenting the naval strength and the size of the contingents in the service of the English.

> The company needs to pre-empt and increase its naval strength by adding two new grabs of at-least 20 guns each, to be constructed at Surat. Also, the cost should be taken from the Siddi's jagir by asking Teg Beg Khan to continue charging on the jagir.
>
> (ibid: 14)

The Siddis and Angrias

Over the period of the next month, as Teg Beg Khan got confirmed in his office as the governor by the court, the situation underwent rapid shifts. The Siddi, not intending to sit back and lose his ground, entered into frantic parallel negotiations with the city's merchants and the companies and tried to obtain a general firman for Mughal officials and the companies in the region to assist him in gaining his territories back. The negotiations reveal the fragmentary nature of Mughal polity in the early 18th century, with multiple political interest groups with at times contradictory and antagonistic interests, trying to outdo one another over a singular issue.

Thus, as the news of Siddi's defeat began to trickle in, we find Siddi Masud at Surat, along with his vakeel, approaching the European companies to assist him in recovering the lost forts as the season improves. Although the English, along with the Dutch, do not show much interest, this approach in itself reveals that it was not uncommon for the Indian officials to approach European companies for the furtherance of a political or military agenda.

After initial parleys, it is revealed in our sources that the Siddi was finally able to obtain a farman from the court, directing the Mughal officials in the region to provide all assistance to the Siddi in regaining his lost territories. Similar orders were also issued to the European companies to assist, although the governor at Surat decided to look the other way and so did the companies.

The Angrian story is even more interesting. Ever since the victories over the Siddi, the Angrias had been attempting to find a way to access the

Surat trade. The English chief at Surat immediately reported the arrival of Angria's agents at Surat, looking to enter into a peace treaty with the English at favourable terms. In fact, Henry Lowther further mentions that they were willing to accept any English demand. The Angrias were negotiating with the English on any terms, which would allow their ships a free pass to the port of Surat.

They also approached the Surat merchants, specifically Ahmad Chellaby, asking him to accede to the Angrian demand to be stationed in the Siddi's tanka as protector of the Surat port and its trade, for their victories over the Siddi proved to be an act of divine providence, highlighting the Siddi's inability to hold on to such an important position.

The merchants and brokers

In the emerging situation during negotiation, the attitude of the mercantile classes towards the issue of an English company getting the tanka of Siddi becomes crucial. The opinions of the merchants were much sought after, and it seems that a favourable opinion was a prior requisite for any policy matter to be decided on. Henry Lowther, in his correspondence, especially highlighted the fact that the opinion of the merchants of the city towards the English was much favourable, and many amongst them were already of the view that the English should take over the protection of the shipping lanes.

In a letter to the Bombay Council, Henry Lowther wrote, "By visits I have from people of all ranks I find they begin to wish the English would oppose the present measure of the Maurattas' (ibid: 19). At another place, he again writes that the Indian merchants and officials have a very low opinion of other European companies, especially the Dutch, of whom 'nobody can have a worse opinion, than Indostannere' (ibid: 28).

At the same time, the English were also on guard against the schemes of the leading merchants because of the influence which many of them wielded amongst the great nobles of the Mughal court, through their private and business dealings. It was considered to be entirely plausible and within their reach to enter special conditions in the intended agreement, which might prove detrimental to the larger English interests.

Thus, Henry Lowther was constantly warned by the council to remain on guard so that the merchants would not be able to solicit with the nobles at court and get a condition inserted in the farman that

> The company shall be answerable for all losses which the Surat merchants may suffer at sea by Angria or any other country or European pyrates . . . as we can upon no consideration undertake any such thing . . . besides there is no manner of ground for insisting on any such condition, since the like was never required of the Scidy during the many years that he received the jageer, when the Surat

merchants sustained a great many losses at sea which he might have easily prevented.
(ibid: 12–13)

That the European companies were dependent on brokers and merchants to further the cause of their commerce in the region has been recorded and spoken about by various scholars. In this particular case also, one finds that the English broker emerges as a conduit of correspondence between the English and the governor, despite both sides insisting on extreme caution with regard to the leaking of information to Marathas or other agencies (ibid: 27).

Moreover, the command over the Persian language, which was used in official correspondence and for all business transactions at the court, remained a factor in hiring the services of the vakeels and brokers, who could write in Persian. Thus, we find the English being advised by the governor to hire the service of a particular vakeel who seems to have a reputation for drafting letters for imperial considerations.

> The Governor called Cursindass Vakeel, a man . . . of an unspotted character and great probity, as also knowledge in court affairs, & consequently great use to them, since the death of Meyram the Duan, & can also be to us in this great undertaking, both by his correspondence and interest with several duans (diwans) of the great Ombras (Umrahs) at court, & his skill drawing up writings and letters in the Persian language who gave his advice and opinion that no other method can be taken to stop Angrias ambition but the putting the Scidys post and tanka into the hands of the English.
> (ibid: 35–6)

Other than the brokers, several of the principal merchants of the Surat port also found themselves being pulled into the scheme of things, as their support was deemed important to push through the agenda at the royal court. That many of these merchants had business relations with the nobles at the court was not a secret. Hence, the opinion of these merchants were sought at the court to push forward on any agenda with regard to Surat, its trade and its management. The English were advised by the governor to get one of the principal merchants of the city – Ahmad Chellaby, on board just in case the opinion of the merchants was sought by the court on the matter.

> Teg Beg Khan advised me to let Ahmud Chellaby, the chief of the Turkish merchants into the secret, & to desire his assistance, for it may happen that the king may require the governors representations to be confirmed by a request from the merchants & as Chellaby bears a great sway among them his interest alone suffices to

carry the rest along with him, which, advice I approved of, as I have a particular intimacy & friendship with him, & can always depend upon his service.

(ibid: 39)

The influence of the city's merchants is also proven by the fact that both the Siddi and the Angria, although in conflict with each other, tried to solicit the support of the Surat merchants in order to further their agendas, as has been highlighted before.

The exchange and final proposal

The negotiations, as they moved on from the initial stage, hit immediate blocks as the perceptions of the issue were very different on the two sides. While the English always believed that since the initiative was taken by the governor himself, it was his responsibility to pursue it to its logical end. On the other side, Teg Beg Khan and his associates, although hard pressed in the face of a rapidly shifting political situation, were trying to make the best use of the situation.

The initial resistance from the governor came on the issue of the value of the jagir. As we know, the English were interested in getting a higher value jagir than was being given to the Siddi. Their perception was that the value of the jagir which was being given to the Siddi was about 3 lakhs of rupees, of which 1 lakh or even more at times was kept by the governors traditionally.

On the issue, the governor showed reluctance immediately as the matters of English expectations were placed before him. As soon as Henry Lowther mentioned the demand and expectations of a higher jagir, Teg Beg Khan replied that the maximum jagir which could be offered would be about two lakhs and not more. It was confirmed by an independent enquiry by the vakeels and diwans of the Siddi and the previous government at Surat that the allowed sum was only about two lakhs and even that was not paid in full to the Siddi at times (ibid: 38).

It seems that Teg Beg Khan had the already existing marine force of the English in mind when he made the offer, and he was not accounting for the increased demand to raise any extra force for the purpose. In fact, that was exactly what he offered to Henry Lowther, when he suggested that the English already had a ready force and a jagir of two lakhs would be enough to maintain the force. If the English took quick action against the Angrias and if they removed the threat as soon as possible, they might make a profit from the office in the longer run, even at a reduced offer (ibid: 39).

The response of the Bombay Council to the offer was thoroughly in the negative. In a letter to Henry Lowther, the council member responded that the governor's offer failed to recognise the changed political and military

reality, and the sum offered would barely be able to defray the basic charges and expenditure up to then (ibid: 42).

The other issue was on the expenditure and what amount and to what extent the English were willing to spend on the acquisition of the jagir. The governor and his council of advisors, which included his brother and the qiladar of the Surat castle, advised the English that as such an enterprise had never been undertaken before, one didn't know how much money would be required and what gifts would be spent on before any favourable conclusion could be arrived at. Moreover, they informed them that they would be required to submit an amount of security at the court, before such a firman was issued.

The English were reluctant to spend beyond a point, as they already had a standing offer from the Angrias to buy peace and any higher expenditure didn't make any good business sense (ibid: 36–7). Also, since the English considered it to be Teg Beg Khan's endeavour, they did not want to be seen spending too much on the master's account and be seen as being granted the favour of the Mughal at a price (ibid: 40–2). The Bombay Council further wrote to Henry Lowther,

> We can't imagine why Teg Beg Khan should apprehend that security would be required of us at the court or for what does he mean that we shan't make a wrong use of the trust designed to be put in us, this we imagine is rather a fetch of Teg Beg Khan or his brother or perhaps an insinuation of some of the merchants whom they have consulted on this.
>
> (ibid: 43)

The council further goes on to reiterate that the biggest security they have provided is to continue their presence at Surat despite facing extreme hostility from the state officials and the merchants of the city over time. Also, the English felt the onus for success of the proposal was on Teg Beg Khan, and they could, in case of any undue problem, very well walk away and enter into a negotiation with the Angria at a much more favourable term (ibid: 47–8).

The differences over the payment for keeping the negotiations on track at the Mughal court, precisely on who was going to foot the bill, continued to be a source of friction between the English and the Surat government. As mentioned earlier, Teg Beg Khan was not willing to foot the complete bill and desired the English to do so, as he felt that the arrangement in the longer run was for the benefit of the English. He believed he was doing them a favour by forwarding their cause. He in fact went on and demanded a sum of about 5 lakhs to effectually bring this business to a happy conclusion (ibid: 77). On the other side, the English, especially at Bombay, felt that these were delaying tactics on the part of the governor, as he was only waiting for the sanad to formalise his position. Also, given the fact that by

the end of June of 1733, his patron, Khan-I Dauran, had been elevated to the office of the vazir, it should not have been difficult for him to negotiate and obtain such a farman, without much expenditure.

On 29 July, Henry Lowther informed Ahmad Chellaby, who up to this time was acting as an arbitrator and an intermediary between the two sides, that he had been clearly asked by the council to back out of the agreement, if the expenditure demanded remained considerable (ibid: 80). Ahmad Chellaby, through hard negotiations, had been able to convince both the governor and Henry Lowther to agree on a sum of one and a half lakhs (ibid: 81).

The final letter, which was intended to be presented to the court, contained following clauses and demands on the part of the English, who promised to undertake the care and defence of the port and the shipping lanes against the activities of the Angria and other pirates on the high seas:

1. The annual sum of 2 lakhs will be computed in favour of the English company and will commence at the beginning of the '*Mahometan*' new year or on 16 September, without deductions.
2. The salary is to be paid out of the growing revenues of the custom house and the English be handed half of their daily collection until a sum of 2 lakhs is reached. In case of any deficiency by the year end, it is to be paid out of the royal treasury.
3. Fifty soldiers will be allowed for the service of the company, at the cost of the Surat government.
4. Carpenters, smiths and artificers, employed by the company, will be obliged to take the pay fixed by the royal decree on the matter and nothing more.
5. In case any vessel belonging to Surat merchants is taken by pirates and the English retake the possession through their endeavours, one-third of the value of the ship will be kept by the English. In the case of any other vessel, the treatment of the ship and distribution of the property will be in accordance with the English laws.
6. The ships, vessels and gallivates entering the Surat port and associated harbours would be subject to inspection by the English, and the English are free to treat any vessel which has evaded the checking as they see fit.
7. A space within city walls, close to the riverside, will be assigned to the English without charge, for warehouse storage and space for cleaning the vessels.

However, the terms were never agreed upon, as the English were reluctant about a clause being entered which entrusted upon them the responsibility to recover a looted and lost ship from the pirates. Also, just a day before most of the clauses were to be agreed upon, Teg Beg Khan made an unexpected increased demand on the English, citing an obscure clause from the earlier tanka to the Siddis.

The English tried to approach their agents at the royal court; however, it seems that Teg Beg Khan was playing a very different game. In a letter to the company, Henry Lowther expresses his disquiet and disgust at the conduct of the governor and says,

> We have reason to believe that Teg Beg Caun had in his view the utter extirpation of the Sciddees & on that account pretended to make us an offer of the tanka formerly paid them more than to serve the publick or out of regard to us judging that if the Sciddees had been entirely suppressed he would have been freed from their annual importunities & would have framed some pretence to have taken the Tanka from us, or why did he insist so strenuously on our signing so unreasonable a paper as that of his drawing up & sent us down.
> (ibid: 112)

Conclusion

The preceding narrative of an attempt by the English company lays bare some of the characteristics of 18th-century political and commercial space in the region of Gujarat. The multi-layered interaction between the agencies of state and commerce reveals the fault lines and modalities of engagement, which came across more vigorously as we moved further into the century. Teg Beg Khan's takeover of the administration of Surat marked an end to the era of direct Mughal control (Subramanian 1996: 41). He and his relatives, over the course of the next few years, were able to establish themselves firmly in the political and commercial life of the city of Surat. He entered into an alliance with Damaji Gaekwad (Subramanian 1996: 85) so as to safeguard his interests in the area and keep the commerce running. The Siddis continued to lose eminence over the years and soon were reduced almost to being a dependent of the English power in Western India. The Angrias suffered a major jolt in the same year, (i.e., 1733), when their leader died and the ensuing succession struggle ensured the space for Siddis and other competing agencies at the western coast as the English and Portuguese moved decisively against them. The Maratha power continued to grow in influence over the next few decades, with the capture of major towns and regions by such commanders as Gaikwads and Peshwa. However, by 1761, most of the regional officers of the Marathas had begun to act almost independently of the office of the Raja and the Peshwa. The English, although unsuccessful here, continued to attempt to exert influence over the region and were largely successful. The Bombay Presidency and its officers, such as Henry Lowther, formed alliances and developed political networks in the area, which were reflected in the success of the company in western India until its rise was checked temporarily with the conflict in Carnatic and the Anglo-Maratha and Anglo-Mysore conflicts.

Notes

1 The early 18th century in historical writings of South Asia has generally been seen as a period of transition between the high Mughal period of the 17th and the rise of colonial rule under the English East India company in the second half of the century. The period has been analysed from the vantage point of the Mughals, whence it's seen as one of decay and decadence, where the Mughal political apparatus crumbles as a result of continuous civil wars and factional strife between power sections of nobility. Seen from the regional perspective, the image which comes across is one of vibrancy and reorientation. The regional mercantile groups and the power potentates, such as the local zamindars, whose association with the Mughal state was based on a mutual assurance of security and assistance, now found better prospects outside the Mughal system (See Leonard 1979, 1981; Alavi 2002; Chandra 2002; Marshall 2003).

2 Lakshmi Subramanian's work with regard to the merchants and bankers in Gujarat in the 18th century and their transforming relationship with the East India company and the remnants of Mughal power in the region focuses primarily on the second half of the century (Subramanian 1996). Similarly, Ghulam A. Nadri deals with the developments in the region in the second half of the century (Nadri 2009).

3 One of the most authoritative works on the trading network of the English company and its commercial engagements in Asia is by K. N. Chaudhuri (See, Chaudhuri 1978). For an overview of the advance and engagement of various European powers in India, see Arasaratnam 1995; Prakash 1998; Hariharan 2006. For more recent writings on the advance of the company as a commercial and political agency in the Asiatic world, see Chaudhuri and Morineau 1999; Erickson 2014.

4 One of the earliest works to look into the association between medieval maritime merchants in Gujarat and the political classes in the region and their collective response to a European agency was by M. N. Pearson (Pearson 1976). Various scholars in their work on the merchants of Surat, have also attempted to highlight the different aspects of negotiations the local merchants had to engage in within the rapidly changing political climate in the region, vis-à-vis the agents of Mughal state, local zamindars and the maratha invaders. Time and again, the merchants in order to safeguard their mercantile interests, also took help from the European companies, operating in the waters of the western coast of India. (Gupta 1994; Gupta 2001a; also see Nadri 2007).

5 The Angrias emerged as dominant naval power on the western coast of India towards the end of the 17th century. Kanhoji Angria was awarded the title of *sarkhel* (admiral) of the Maratha navy by Rajaram in 1690 (Sen 1941; Malgonkar 1959). Hence, onwards, the Angrias proved to be a great challenge for European as well as Indian shipping. The fortification of the Bombay city in 1715 and the expansion of Bombay marine in 1716 were in part a response to the Angrian piratical activities (Elliot 2013: 188–9).

6 Siddis are the descendants of African slaves who found service in the courts and under ruling houses of South Asia. They came to hold dominant positions in the affairs of the Deccan towards the end of the 17th century; when tired of the piratical activities of the European interlopers and of Malabaris and Marathas, Aurangzeb appointed them as official Mughal naval captains and provided a tanka for the upkeep of their forces from the jagir of Surat. The Siddis have been found to occupy myriad roles in the history of medieval and early modern Deccan (Banaji 1932; Obeng 2003).

7 Original Proceedings in Public Department Diary No. 6 (A) of 1733 at Maharashtra State Archives.

References

Primary sources: unpublished

Original Proceedings in Public Department Diary No. 6. 1733. *Diary of the President and John Horne Esqr. Their Proceedings with the Governour of Surat for Procuring the Sciddees Tanka to the Honble Company*. Bombay: Duplicate No. 3 at Maharashtra State Archives.

Primary sources: published

Elliot, H. M. and J. Dawson (eds.). 1877. *The History of India as told by its own historians: The Muhammadan Period, Vol. 7 (extracts of Khafi Khan's 'Muntakhab ul Lubab')*. London: Trübner and Co., 207–533.
Rawlinson, H. G. (ed.). 1929. *A Voyage to Surat in the year 1689* by J. Ovington. London: Oxford University Press.

Secondary works

Alavi, Seema (ed.). 2002. *The Eighteenth Century in India*. New Delhi: Oxford University Press.
Arasaratnam, S. 1995. *Maritime Trade, Society and European Influence in Southern Asia, 1600–1800*. Aldershot: Variorum.
Banaji, D. R. 1932. *Bombay and the Sidis*. Mumbai: Palgrave Macmillan.
Chandra, Satish. 2002. *Parties and Politics at the Mughal Court, 1707–1740* (Second Edition). New Delhi: Oxford University Press.
Chaudhuri, K. N. 1978. *The Trading World of Asia and the English East India Company, 1660–1760*. Cambridge: Cambridge University Press.
Chaudhuri, S. and M. Morineau (eds.). 1999. *Merchants, Companies and Trade: Europe and Asia in the Early Modern World*. Cambridge: Cambridge University Press.
Elliot, D. L. 2010. *Pirates, Polities and Companies: Global Politics on the Konkan Littoral, c.1690–1756*. Working Papers No. 136/10 – Department of Economic History. London School of Economics.
———. 2013. 'The Politics of Capture in the Eastern Arabian Sea, c. 1700–1750'. *International Journal of Maritime History*, XXV (2): 187–98.
Erickson, E. 2014. *Between Monopoly and Free Trade: The English East India Company, 1600–1757*. Princeton, NJ: Princeton University Press.
Gordon, Stewart. 1993. *The New Cambridge History of India, II.4: The Marathas, 1600–1800*. Cambridge: Cambridge University Press.
Gupta, Ashin Das. 1994. *Indian Merchants and the Decline of Surat, c. 1700–1750*. New Delhi: Codarts and Manohar.
———. 2001a. 'Some Attitudes Among Eighteenth Century Merchants'. In Uma Das Gupta (ed.), *The World of the Indian Ocean Merchant, 1500–1800: Collected Essays of Ashin Das Gupta*. New Delhi: Oxford University Press, 102–9.
———. 2001b. 'Some Problems of Reconstructing the History of India's West Coast from European Sources'. In Uma Das Gupta (ed.), *The World of the Indian Ocean Merchant, 1500–1800: Collected Essays of Ashin Das Gupta*. New Delhi: Oxford University Press, 253–61.

———. 2001c. 'The Crisis in Surat c. 1730–32'. In Uma Das Gupta (ed.), *The World of the Indian Ocean Merchant, 1500–1800: Collected Essays of Ashin Das Gupta*. New Delhi: Oxford University Press, 351–68.

Hariharan, Shantha. 2006. 'Portuguese and English Country Trade from Western India in the Eighteenth Century: A Study in Contrast'. *International Journal of Maritime History*, 18 (1): 1–24.

Hasan, Farhat. 2006. *State and Locality in Mughal India: Power Relations in Western India, c. 1572–1730*. Cambridge: Cambridge University Press.

Leonard, K. 1979. 'The "Great Firm Theory" of Mughal Decline'. *Comparative Studies in Society and History*, 21 (2): 151–67.

———. 1981. 'Indigenous Banking Firms in Mughal India: A Reply'. *Comparative Studies in Societies and History*, 23 (2): 309–13.

Malgonkar, M. 1959. *Kanhoji Angrey, Maratha Admiral: An Account of His Life and His Battles with the English*. New Delhi: Asia Publishing House.

Maloni, Ruby. 2013. '"A Profitable and Advantageous Commerce": European Private Trade in the Western Indian Ocean'. In Rila Mukherjee (ed.), *Oceans Connect: Reflections on Water Worlds Across Time and Space*. New Delhi: Primus Books, 259–73.

Marshall, P. J. 1997. 'Private British Trade in Indian Ocean Before 1800'. In Om Prakash (ed.), *European Commercial Expansion in Early Modern Asia*. Aldershot: Variorum, 237–62.

———. 2003. *The Eighteenth Century in Indian History: Evolution or Revolution?* New Delhi: Oxford University Press.

Nadri, Ghulam A. 2007. 'The Maritime Merchant of Surat: A Long-Term Perspective'. *Journal of the Economic and Social History of the Orient*, 50 (2/3: Spatial and Temporal Continuities of Merchant Networks in South Asia and the Indian Ocean): 235–58.

———. 2009. *Eighteenth Century Gujarat: The Dynamics of Its Political Economy, 1750 to 1800*. Lieden: Brill.

Obeng, Pashington. 2003. 'Religion and Empire: Belief and Identity Among African Indians of Karnataka, South India'. *Journal of the American Academy of Religion*, 71 (1): 99–120.

Pearson, M. N. 1976. *The Merchants and Rulers of Gujarat: The Response to the Portuguese in the Sixteenth Century*. Berkeley: University of California Press.

Prakash, O. 1998. *The New Cambridge History of India: European Commercial Enterprises in Pre-Colonial India*. Cambridge: Cambridge University Press.

———. 2002. 'The English East India Company and India'. In H. V. Bowen, Margarette Lincoln and Nigel Rigby (eds.), *The Worlds of the East India Company*. New York: The Boydell Press, 1–18.

Rocher, R. (ed.). 1997. *Holden Furber: Private Fortunes and Company Profits in the India Trade in the Eighteenth Century*. Aldershot: Variorum.

Sen, S. N. 1941. *Early Career of Kanhoji Angria and Other Papers*. Kolkata: University of Kolkata.

Seshan, Radhika. 2013. 'Human Networks in the Pre-Modern World: Rumours of Piracy in Surat'. In Rila Mukherjee (eds.), *Oceans Connect: Reflections on Water Worlds Across Time and Space*. New Delhi: Primus Books, 249–57.

———. 2014. 'The Maratha State: Some Preliminary Considerations'. *Indian Historical Review*, 41 (1): 35–46.

Subramanian, Lakshmi. 1981. 'Bombay and the West Coast in 1740s'. *The Indian Economic and Social History Review*, 8 (2): 189–216.
———. 1996. *Indigenous Capital: Bombay, Surat and the West Coast*. New Delhi: Oxford University Press.
Watson, I. B. 1980. *Foundation for Empire: English Private Trade in India, 1659–1760*. New Delhi: Vikas Publishing House Pvt. Ltd.

6

PRE-MODERN COSMOPOLITANISM

A challenge to Ladakh's 'Tibetanness'

Riya Gupta

Introduction

When Kwame Anthony Appiah's father died, he and his sisters found a note that he had drafted and never quite finished (Appiah 1997: 618). In the note, his father wrote, 'Remember that you are citizens of the world' and went on to tell them that that meant that wherever they chose to live – and as citizens of the world, they could choose to live anywhere – they made sure that they left the place better than they had found it (ibid: 618). According to Appiah,[1] the favourite slander of the narrow nationalists against the cosmopolitans was that they were rootless. However, what his father believed in was rooted cosmopolitanism or cosmopolitan patriotism. His father, like Gertrude Stein, thought that there was no point in roots if one couldn't take them with oneself. He quotes Stein, "America is my country and Paris is my hometown" (Stein 1940: 61 cited in Appiah 1997: 618). Appiah writes,

> the cosmopolitan patriot can entertain the possibility of a world in which *everyone* is a rooted cosmopolitan, attached to a home of one's own, with its own cultural particularities, but taking pleasure from the presence of other, different places that are home to other, different people. The cosmopolitan also imagines that in such a world not everyone will find it best to stay in their natal patria, so that the circulation of people among different localities will involve not only cultural tourism (which the cosmopolitan admits to enjoying) but migration, nomadism, diaspora. In the past, these processes have too often been the result of forces we should deplore; the old migrants were often refugees, and older diasporas often began in

an involuntary exile. But what can be hateful, if coerced, can be celebrated when it flows from the free decisions of individuals or of groups.

(Appiah 1997: 618)

It is this kind of rooted cosmopolitanism that I argue in favour of in this chapter, along with asserting that 'cosmopolitanism, popularly associated with the "modernity" of globalisation, is even a part of the past in some communities' (Fewkes 2009: x). A case study of Ladakh has therefore been undertaken with the travel accounts of Ippolito Desideri, William Moorcroft and George Trebeck acting as primary sources. In addition, in order to highlight the various transitions and transformations that occur during the course of the 18th and early 19th centuries, the aim of this chapter is to corroborate the existence of what I call 'pre-modern' cosmopolitanism during this period and to discuss how it acted as a challenge to Ladakh's supposed 'Tibetanness' or Tibetan identity.

At the very outset, however, the usual way in which we think about a region needs to be questioned. Ladakh, in pre-modern times, wasn't the Ladakh of the present. One needs to take into consideration the unreliability of nomenclature where the region under study is marked by fragmented and confused boundaries. In doing so, exploring the world of connectedness or "connected histories" comes in handy. For example, Indrani Chatterjee tells us that, according to a history of seventh- and eighth-century Tibet, it was the *pandits* from India who helped devise the Tibetan script. Thus, there are many similar letters between the classical Tibetan and Bengali scripts. One needs to, therefore, move away from the shackles of 'not supposed to know' our common pasts (Chatterjee 2014: 100). Another way of understanding Ladakh, as a region during pre-modern times, is by drawing an analogy with James C. Scott's Zomia – an area traversing five Southeast Asian Nations and four provinces of China, situated at the periphery of nine states but at the centre of none and marked by great ecological variety yet distinctive enough to merit its own designation (Scott 2009: ix–xiv). In other words, evading the ideas of state-making and the stereotypical understanding of a region within the ambit of the state and its borders, attention needs to be paid to its obverse, and like Scott's Zomia, Ladakh needs to be understood in its statelessness – independent of the borders and sharing its past with more than one nation-state.

If the idea of a region needs to be questioned, so does the idea of cosmopolitanism. How is pre-modern cosmopolitanism different from its later modern manifestation? In my opinion, contrary to the statelessness of premodern cosmopolitanism, modern cosmopolitanism cannot be separated from its context of the state as well as the state's increasingly standardised institutions (like individual freehold property) and distance-demolishing

technologies (ensuring state invasion), such as railroads, all-weather roads, airpower, information technology and so on (ibid: xii, 324). In fact, the formation of borders as a result of the springing up of the state has resulted in the isolation of regions. Hence, the 20th century closing of Ladakh's borders with Pakistan and China has resulted in a decline of trade (for example with pre-partition Punjab and Central Asia) as well as the associated free flow of people, ideas and beliefs, a feature more prominent in pre-modern cosmopolitanism (Fewkes 2009: 132–3).

At the same time, in this study, an exclusive dependence on travel accounts can be questioned, for they are considered incomplete, unreliable and often biased historical sources, but I believe that

> In a way, all historical thinking and all historical writing deals with travel accounts. They do not necessarily involve the physical removal of historians' bodies to distant lands, but they require historians to engage with different interests and perspectives in the world of the past, which some scholars have likened to a foreign country. Even one's own society can seem foreign when a historian explores the changing political, social, economic, cultural, environmental, and technological conditions of earlier ages, not to mention different beliefs, values, and customs of times past.
>
> (Bentley n.d.)

Tide of Islamic influence from Kashmir, Central Asia and Baltistan[2] – the modification of Ladakhi 'Tibetanness'

According to Janet Rizvi, "For centuries Ladakhi life and ways of thought have been moulded by Buddhism, the particular form followed in Tibet and Ladakh being the Vajrayana, the Vehicle of the Thunderbolt" (Rizvi 1983: 150). This way of life and thought has been written about in detail by the Jesuit priest and missionary Ippolito Desideri. Desideri and his companion, Father Emanuel Freyre, came to Ladakh in the 18th century, living in 'Tibet' (present-day Tibet and Ladakh) from 1715 to 1721 CE. Desideri's *Relazione* contains the earliest general account of Ladakh by a Western observer and therefore is a valuable supplement to the Ladakhi and Tibetan sources (ibid: 57).

Describing the monastic organisation centred around the Gompas or Buddhist monasteries, Desideri writes that the religion of these areas was a peculiar one, a mixture of strange dogmas. The religious hierarchy wasn't secular but superior to all temporal and regular government. The head of the entire structure as well as all the chief Lamas was the Grand Lama, whom he compares to the Pontiff. One of the most sacred idols of the 'Tibetans' was called *Cen-ree-zij*, who in all his successive incarnations was born as the Great Lama for the good of the kingdom and the salvation of the

people. But there wasn't a belief in his immortality or invisibility. He would die, and they would mourn his absence, preserve his corpse, and venerate his relics. He made himself visible to his beloved 'Tibetans'. Twice a year, he was seen in public in the city of Lhasá, where he presided at the moon festivals. Moreover, at some festivals, he also went abroad and was seen by all in public. He also received visits from foreigners in his palace. His palace was vast and magnificent, situated on the rock of Potala, and a number of monks lived there. They officiated in the chapel and acted as the Grand Lama's attendants (Filippi 1995: 73).

More important, the Grand Lama not only ruled over religious but also temporal matters, as he was considered to be the absolute master of 'Tibet'. No doubt "abantiquo", he had instituted a king to attend to civil, military and criminal affairs in his place and in his name, but the king was only an administrator and wouldn't dare to oppose anything ordered by the Grand Lama. He was immensely rich, as direct taxes, customs and the general revenues of the kingdom were common to both him and the king. At the same time, he received large offerings and presents, which were entirely his property. Desideri adds that he derived great income from trade with China and other lands and therefore possessed a great quantity of horses and mules and large herds of mountain cattle. He also had a number of merchants working under his employment. He used his immense income on the decoration of his palace and the temple of idols called *Lha-Khang* in his palace, on his court and servants, but more in alms to monasteries and nunneries and for the moon festivals (ibid: 206, 208).

According to Desideri, there were three types of Lamas in 'Tibet'. Those with the highest rank were the most esteemed ones and were believed to be re-incarnated always as Lamas. Next were those who had estates and great riches and had married and had children to succeed to the dignities and office of the Lama. They were held in high honour as well. In accordance with the rules, they were supposed to put their wife aside as soon as a boy was born to make sure of the succession. In case the wife had no son, more young girls were chosen until the desired son was born, because they believed that the dignity of the Lama, by law, must descend in the same family. There were three such Lamas – at Secchia, at Thakpo and at Lungar. The third type were the numerous ones elected by the king and the Grand Lama, for their science, discretion and honesty. They were all venerated as masters of the law and directors of other men. Each Lama was a superior of some monastery and had his own administrative division, income and court. He lived in splendour. Desideri compared them to bishops and archbishops. He also goes on to write that even the European missionaries were regarded and respected as Lamas and were called *Gogar Ki Lama*. They were acknowledged as spiritual directors and masters of their law, and as monks, because of their unmarried status (ibid: 210–11).

Desideri also gives us an account of numerous monks and nuns who were respected by the 'Tibetans' and had large and equally numerous monasteries and nunneries. Each monastery was ruled by at least one Lama and another monk who held the office of *Ker-Koo* – the provost. There were four grades of 'Tibetan' monks. The first were the Lamas, already discussed. The second were the *Rangiamba*. They were doctors and teachers who had studied for twelve years in some monastery, which was also a university, and had held many public disputations. The third were the *Ke-Long*, who had not only taken monastic vows but swore to their Lamas to preserve absolute chastity, to obey them implicitly and to remain poor to the extent that they possessed nothing and begged for food every day. These were among many other severe vows that they undertook. They could be recognised by their yellow caps and yellow robes under the red cloak worn by all the priesthood. The last grade among the monks was held by *Traba* or *Zunba*, who were further divided into three classes – (a) those who hadn't studied in any university, either from incapacity or poverty or who hadn't been able to pass their examinations, (b) the numerous ones who had just begun to study in a monastery/university and (c) young boys who were taught to read, write and learn the prayers by heart. There was no definite age, but generally small children of four or five years were put into monasteries (ibid: 211–14).

As far as the nuns are concerned, Desideri first notes that there is no difference between the dress of monks and nuns, and their hair must be shaved. Monasteries and nunneries were absolutely separated, even though it is possible that they were ruled by the same Lama. Women were not allowed to enter a monastery, and the same rule applied to men in the case of a nunnery, except the Lama or the king and their attendants. While a monk could not leave the monastery without the permission of the Lama or the *Ker-Koo*, the nuns enjoyed more liberty, as they could even live in the house of their family, visiting the nunnery to attend sacred functions (ibid: 215).

Just as the 'Tibetants' believed that the Great Lama was an incarnation of *Cen-re-zij*, the principal Lama of Thakpo was believed to be an ever-continued incarnation of another of their idols named *Urghien*. He had several Lamas at his court and many monks and nuns under his jurisdiction and was in fact, the chief of all monks and nuns who wore the red cap of the *Trubba* and the *Trubbama* (ibid: 210). There were three kinds of monks and nuns in 'Tibet'. The first two principal ones were the Yellow Caps and the Red Caps. Among other differences between them, the major one was that while the Yellow Caps regarded the Grand Lama of Potala as their superior, the Red Caps acknowledged him as the supreme head of their sect and religion but regarded the Lama of Thakpo as their immediate superior. Besides them were the *Tubba* and the *Trubbama* – the male hermits and the female hermits (ibid: 224–5).

While one should accept Desideri's account with a pinch of salt, one can agree with Harjit Singh that "the abstract and symbolic religion of Buddhism

[in these areas] is expressed through the concrete, worldly objective reality of the Gompa" (Singh 1978: 215). However, despite the Tibetan influence, it is certain that Buddhism first entered the western parts of present Ladakh, not from Tibet, but from Kashmir (Rizvi 1983: 38). This happened perhaps as early as the first and second century CE when parts of Kashmir may have been incorporated into the Kushana Empire (ibid: 38). Rizvi writes that the rock engravings in deep relief, as opposed to the shallow relief ones of the later style, found in Kargil district, including the areas of Zanskar, Dras, and Mulbekh, are evidence enough to prove this argument. The best known evidence, however, is Bodhisattva Maitreya at Mulbekh (ibid: 38).[3] Tibetan rule in Ladakh began only after 842 CE as a result of the disintegration of the Tibetan empire because of religious friction between the Buddhists and the adherents of the older Bon religion. Thereafter, Nyima-Gon, along with some representatives of the nobility of Central Tibet, migrated westwards and established the Ladakhi Dynasty (ibid: 39). According to Rizvi, 'whatever Tibetanisation had taken place as a result of the earlier political relationship was now to be reinforced and confirmed by an immigrant ruling class' (ibid: 39). Thus, it was only after this that Ladakh, even though remaining politically independent, was to eventually become subordinate to Tibet in religion and culture.

One must, however, not ignore the fact that 'in the first two centuries or so after the conquest . . . the kings of Nyima-Gon's dynasty, intent on establishing Buddhism in their new dominions, looked not to Tibet, where there were not yet any old-established Buddhist traditions, but to northwest India, particularly Kashmir' (ibid: 40). It was only during the beginning of the 13th century that 'from the Buddhist point of view, India was ceasing to have anything to offer. Kashmir was falling into political turmoil; gradually, Buddhism was being eradicated throughout India, in the face of militant Hinduism; and from the north-west, the first ominous rumblings of the Islamic onslaught were making themselves heard' (ibid: 42–3).[4] Thus, there began a process by which Ladakh was to become part of the Tibetan religious and cultural empire so much so that Rizvi writes that if a traveller was to travel to Ladakh from India, in a geo-physical sense, he would feel that he had left India and entered Tibet (ibid: 2, 43). But 'there is so much more to Ladakh than only Buddhism and "Tibetanness"' (ibid: 4). In fact, 'The decline of Buddhism in north India may . . . have resulted in the immigration into Ladakh of numbers of Indian Buddhist monks, bringing their own traditions of iconography and worship' (ibid: 38).

Moreover, Buddhism has never been a homogenous entity in Ladakh. The area that we know today as Ladakh may have been colonised, at an early period, by the *Dards*, who find mention in the writings of classical authors like Megasthenes and Ptolemy. The original *Dard* way of life has been overwhelmed in central and eastern regions by the later dominant Tibetan race and culture and in the west by Islam (ibid: 36). Yet there is an existence

of a community of Buddhist *Dards* in lower Indus regions who have preserved culture and a way of life, very distinct from elsewhere in Ladakh. Their Buddhism itself is distinct from that of central and eastern Ladakh. Their different customs and an idea of the cosmic system find expressions in the hymns of their triennial *Bano-na* festival. They follow a pre-Buddhist animistic religion known as *Bon-chos* – more a collection of cults than a unified religion, pantheistic and shamanistic and perhaps including a form of ancestor-worship with Ibex as an important religious symbol denoting perhaps fertility (ibid: 36–8).

In addition, as Rizvi says, Ladakh was always open to influences other than Tibetan. A tide of Islam, as a result of continuous conquests (after the 15th century) from Kashmir, Central Asia and later Baltistan was unsuccessful in central Ladakh, which is believed to be the bastion of Buddhism, but the people of western Ladakh, the recognisable cosmopolitans, in my opinion, while not turning their backs on earlier ways of life and thought, accepted the new religion. Central Ladakh, in contrast, was a major entrepot and thus was situated at the centre of a network of important trade routes. This gave Leh in the old days, in the words of Rizvi, a cosmopolitan air, reflected even today in the mixed racial composition of its population (ibid: 4). The cosmopolitanism of Leh is also reflected in the speech of the people who have a basic Tibetan dialect, as everywhere else in Ladakh, enriched by an admixture of foreign words, mainly Persian and Urdu. The folk literature of Ladakh too is somewhere derived from the pre-Buddhist past of Tibet with some springing from the native genius of the people. Another noteworthy development was that of poetic form, like *ghazal*, in the context of Islamic culture, which influenced both western and central Ladakh.

The residues of this tide of Islamic influence, which helped in the modification of Ladakh's 'Tibetaness' find expression also in the early 19th-century travel accounts of William Moorcroft and George Trebeck. William Moorcroft, a professional surgeon and an English explorer, under the employment of the English East India Company, is known to have made 'the most enterprising, and, in a great measure, the most successful efforts to penetrate into central Asia from Hindustan'. He traversed the mountains along with his companion, George Trebeck, and his party and reached Leh in September 1820 by a route on which no European had preceded them (Moorcroft and Trebeck 2004: Vol. I, xvi, xxxv). During his stay in Ladakh, Moorcroft undertook an excursion to Dras (Moorcroft and Trebeck 2004: Vol. II, 1). On his way, he and his party were given accommodation by a hakim or the physician of a village. He writes,

> The hakim . . . cleared a couple of rooms in his house . . . my bed was placed in the viranda of a small mosque, the pillars of which were festooned with wreaths of flowers and ears of corn, presenting

a curious mixture of Lamaism and Mohammedanism, the bulk of people hence to Kashmir being Mohammedans of the Shiah sect.

(ibid: 19–20)

He was able to resume his journey later and while writing about the villages that he came across during his journey, he comments, 'Every village had its mosque, and not a single Lama's house, or sculpted pile, made its appearance. Islamism is evidently making rapid strides, and there is every reason to expect that before long Ladakh will be entirely a Mohammedan state' (ibid: 28). That the Islamic tide had modified the 'Tibetanness' of this region is further reflected in Moorcroft's following words,

> With the change from Lamaism to Islamism an alteration has taken place in the costume of the women. Instead of the argus jacket and patchwork petticoat, a loose brown or black woolen tunic with sleeves, open in front to below the bosom, hangs from the shoulders nearly to the feet. It is sometimes tied round the waist with a gridle, but is commonly left loose in warm weather; underneath it the common dark woolen trowser was retrained, but no boots were seen at this season. On the head the Tibetan lappet was displaced by a brown woolen cap; the hair was bound in a tress, and near the end was fastened a flat ornament, round or square, of coloured worsted-work, from which the usual tassels depended. Necklaces of coral or glass beads were worn, and amulets, of a piece of silk, with a verse from the Koran, were bound round the arm. The men had not deviated so much from the national garb, but wore fewer ornaments.
>
> (ibid: 28–9)

In my opinion, these changes must have been the result of the ongoing process of the development of cosmopolitanism over the previous centuries, which had found expression in the attiring methods of the people in the early 19th century.

Having reached Dras, Moorcroft writes that the population of the valley was small and in poverty because of incursions from Little Tibet (Baltistan). Moreover, the government was not taking any measures for the protection of its people, and their natural defences could be easily traversed through the borders of Tibet and Kashmir in winter, despite the snow. This negligence was also on account of the valley being a joint property of the Raja of Ladakh and the Malik, or chief landholder, of the neighbouring part of Kashmir (ibid: 41).

Therefore, Moorcroft's account helps us establish the argument that there was a clear modification of Ladakh 'Tibetanness' and so was the undeniable existence of pre-modern cosmopolitanism. In fact, after the 15th century,

Ladakh had continuously experienced a large number of Muslim conquests from Kashmir, Central Asia and later Baltistan (Rizvi 1983: 44). Apart from South-West Ladakh, from Dras to Fatu-la, which had always been open to infiltration and invasion, there is also a Muslim community in Leh. According to Rizvi, this community is descended either from immigrants or from marriage contracted by local women with Muslim merchants settled in Leh from Kashmir and Yarkhand. This mixed community of Sunnis has an influence in the town because their mercantile background makes them one of the most prosperous groups (ibid: 155–6). The most important of these immigrant-descended groups is the Balti community of the large village of Chushot. Although they are believed to have come from Baltistan as long as 350 years ago (or more), they retain to this day the consciousness that they are Baltis, in some way separate and distinct from the Ladakhis among whom they live. Like the Muslims belonging to the South-West area (Kargil), they too are Shias, and many of them follow the injunctions of their faith with uncompromising strictness. But unlike Kargil Shias, according to Rizvi, they haven't lost, or rather have imbibed from their Buddhist neighbours, the capacity to enjoy life. In other words, the Leh Muslims live in a way that is not so different from that of their Buddhist neighbours (ibid: 156).

Evidence of the impact of the Islamic tide also comes from the Suru Valley of Ladakh. According to Nicola Grist, in the 16th and 17th centuries, the area of Suru Valley was made up of small kingdoms, the most prominent of which was Kartse (Grist 2005: 175). By the 18th century, the chiefdom of Kartse was incorporated into that of Purig, covering most of western Ladakh and ruled by the younger brother of the king of Ladakh. Grist writes,

> The Ladakh kingdom was becoming more powerful at this time and consolidating its territory. It was both a centre for trade in *pashmina* wool from Western Tibet, used in the manufacture of Kashmir and other fine shawls, and an entrepot on the long-distance trade routes between Tibet, Central Asia, and India.
>
> (ibid: 175)

According to Luciano Petech, Ladakh and Purig frequently fought to control the Kashmir trade in the 17th and 18th centuries and, in their conflicts, the chiefs of Purig often allied themselves with the chiefs of Baltistan, who shared their Islamic faith. Nevertheless, by 1758, Purig was permanently incorporated into the Ladakhi kingdom, and Leh was established as the centre of power and trade in the region (Petech 1977 cited in Grist 2005: 175). The rulers of Ladakh normally professed Buddhism, and therefore, it is difficult to say when exactly Purig (and therefore the Suru Valley) came under the influence of Islam, but according to Grist, the spread of Islam into Purig was gradual and the result of Muslim preachers converting the ordinary

population as well the chiefs adopting Islam as a part of alliance building with the Mughals and the chiefs of Baltistan. Grist further writes that in accordance with the popular tradition in Suru, the conversion to Islam started during the rule of Thi Namgyal, who was the father of the last independent ruler of Suru-Kartse. He is said to have married Thi Lha Khatun, the daughter of the Muslim chief of Skardu, the main power in Baltistan. It is believed that she brought Muslim scholars to Suru, who converted the population of the valley (Khan 1939: 698 cited in Grist 2005: 176). She is also said to have built a mosque at Kartse Khar, which was burnt by the Dogras during their invasion in the 1830s (ibid: 697 cited in Grist 2005: 176). Their son, Thi Sultan, was a Muslim taught by a scholar called Mir Hashm. He is believed to have no legitimate heirs, so he bequeathed his chiefdom to the ruler of Purig (ibid: 698–702 cited in Grist 2005: 176).

According to Grist, the story was partly mythological, but the fact is that by the early 20th century, as A. H. Francke reported, Baltistan was largely Shi'ite; the majority of the people in the Purig area were Muslim, and Islam was still spreading rapidly eastwards in Ladakh (Francke 1914, 1926 cited in Grist 2005: 177). According to Abdul Majid Matoo, at that time, most Muslims in Purig were Shias or Noorbakhshi, a Sufi variant of Shi'ism (Matoo 1998: 133, 162 cited in Grist 2005: 177).[5]

Role of trade with Kashmir in fostering cosmopolitanism

Residing in Kashmir – the *Beheset* (*Bihisht*) or territorial paradise, Desideri writes,

> Besides the fertility and beauty of the land there is a very considerable trade, especially in wool, with Second Thibet or Lhatá-yul [Ladak], which is a source of great riches to Kascimir. You must know that in Second Thibet, the capital of which is six weeks' journey from Kascimir by a most precipitous road, there are untold numbers of sheep and geldings whose wool is very white, very long, and extraordinarily fine. The merchants of Kascimir keep a large number of agents in Second Thibet who collect the wool during the year, paying a most miserable price; and in May, June, July, and August, thousands and thousands of men go from Kascimir to Lhé [Leh], otherwise called Lhatá, the capital of Second Thibet, and carry back infinite number of loads of wool; this is spun in Kascimir to marvellously fine thread from which is woven the thin, very delicate Kascimir cloth, renowned all over India. Also the woolen kerchiefs for the head are highly valued, and the Pattea [Puttoo], long cloth-strips folded several times which serve as waistbands. But most precious and magnificent are the cloths called *scial* in both Hindustan and Persian. Here *scials* are cloaks which envelop

the head while the ends fall on either side of the body; thus the head, neck, shoulders, arms, breast, the back till below the hips and nearly to the knees are protected. These cloaks are so fine, delicate, and soft that though very wide and long they can be folded into so small a space as almost to be hidden in a closed hand. At the same time, although so fine and thin, they not only keep out the cold, but really warm the body; they are therefore much worn in winter. The very fine and large ones are very dear, indeed in remote regions the price may be called exorbitant.

(Filippi 1995: 73)

He also writes that in Second Tibet or Ladakh, 'a number of merchants from Kascimir engaged in the wool trade live . . . and they are allowed to have mosques and openly to hold their religion' (ibid: 78). Clearly, trade in wool between Ladakh and Kashmir was well established in the 18th century. This was also testified through Moorcroft's record that

> The manufacture for which Kashmir is celebrated throughout the world, is that of the light, warm, and elegant article of dress which, from its native appellation, is known as shawl. . . . The wool that is employed in. . . [its] manufacture is of two kinds – the fleece of domestic goat, called Pashm Shal (or shawl-wool) and that of the wild goat, wild sheep, and other animals named Asali Tus. . . . The wool was formerly supplied almost exclusively by the western provinces of Lassa and by Ladakh; but of late considerable quantities have been procured from the neighbourhood of Yarkhand, from Khoten, and the families of the Great Kirghis horde. It is brought chiefly by Mogol merchants, who exchange it for manufactured shawl-goods in Kashmir, which they dispose of advantageously in Russia.

(Moorcroft and Trebeck 2004: Vol. II, 164–6)

The importance of this trade even before the 18th and 19th century is reflected in the political history of Ladakh. Sengge Namgyal,[6] who was to become the most famous ruler of Ladakh, adopted policies towards the strengthening of Buddhism, but he doesn't seem to have gained much success against the Muslim powers of the west. In 1639, he met with a defeat at the hands of a combined Mughal-Balti army. Rizvi writes that Sengge had to sue for peace on the promise that was never fulfilled (i.e., of paying tribute to the Mughal Empire through the governor of Kashmir). However, it marked the beginning of the Mughal claim to suzerainty over Ladakh. According to Francois Bernier, as an offence, Sengge closed the trade route from Kashmir. Rizvi is of the opinion that, if Bernier is to be believed, then to close any important route obviously cost Ladakh a large part of its revenue because

it was situated at the centre of a network of trade routes (Rizvi 1983: 50). Indeed, the decline of Ladakh's fortunes that set in after Sengge's death in 1642 may be attributed to the 'economic suicide', to use Luciano Petech's phrase,[7] committed by Sengge Namgyal (ibid: 50).

Moreover, during the time of his successor, Deldan Namgyal, relations with Tibet worsened, resulting in a conflict during the 1670s. In 1680, when the Tibetan army arrived in Ladakh, a relief army was advanced from Kashmir in response to an appeal from Deldan. In return, Deldan was made to confirm the half-hearted acceptance of Mughal suzerainty. The tribute, which was apparently never paid, was exactly laid down as 18 piebald horses, 18 pods of musk and 18 white yak tails every three years, while, in return, 500 bags of rice were to come annually from an estate granted to the king in Kashmir. In addition, Deldan had to accept Islam, under the name of Aqibat Mahmud Khan – by which name the Mughal and Kashmir authorities continued to address the kings of Ladakh. One of his sons was sent to Kashmir as a hostage and to be brought up a Muslim. The most substantial concession was that which gave Kashmir a monopoly of the purchase of raw pashmina (shawl-wool), Ladakh's only product of any value, as well as other kinds of wool (ibid: 49–55). Rizvi, however, clarifies that though Islam continued the gradual advance from the west, this further attempt to make Ladakh a Muslim country ruled by a Muslim dynasty was as unsuccessful as previous ones had been. The royal house, the majority of the people and Ladakh's heartland, as well as eastern parts, remained faithful to Buddhism. The Muslims found in these regions, according to her, are descendants of immigrants and not of converts (ibid: 55).

The modification of the Ladakhi 'Tibetanness' as a result of this trade, whose by-product was cosmopolitanism, is reflected in many Kashmiri dishes, such as *gosht kebab*, *yakhni* and *samosas*, which are popular in Ladakh. Ladakhi folk music also shows Muslim influence, and the mosques and *imambaras* of Ladakh are important examples of architectural cosmopolitanism. Moreover, several Kashmiri words, like *thul* (egg), *handing* (dumb) and *chanda* (pocket), have entered the Ladakhi vocabulary. Persian words in common use include *surna* (a type of musical instrument) and *daman* (drum), while Turki words include *charog* (shoe) and *chaqman* (cloth) (Sheikh 1995).

In fact, the languages that found their way to the society of Ladakh from Kashmir were themselves marked by cosmopolitanism. Chitralekha Zutshi engages in the study of a variety of narrative practices in Kashmir, including *tazkiras*, *tarikhs*, stories, poetry and plays beginning from the later 16th century. According to her, 'just as Kashmir itself was a place defined by the imprint of successive waves of migrations, so too was history-writing defined by the impress of external and internal influences that combined to produce a stable, yet mutable, tradition of narrating the past' (Zutshi 2014: 1–4). Thus, not only was Kashmir a cosmopolitan space influenced

by waves of migrations, even the practice of history writing seems to be cosmopolitan in nature. She tries to redefine Kashmir's historical tradition by shifting the focus from Sanskrit texts like *Rajtarangini* to Persian and Kashmiri oral traditions. Moreover, Persian narratives are often considered continuations of Sanskrit texts, but according to Zutshi, Persian texts were not merely passive imitations. They were actively engaged with the Sanskrit texts in claiming and redefining the tradition of historical composition in Kashmir (ibid: 6). She writes that the three languages performed different functions between the 16th and 19th century – Sanskrit became the language of tradition; Persian, the language of literary-narrative culture; and Kashmiri, the language of intimacy and poetry. Sanskrit and Persian were two cosmopolitan linguistic traditions, and Kashmiri was regional vernacular. Zutshi is in favour of not studying them independently but exploring interconnections and interactions between them.

Along with showing how Persian was a cosmopolitan language as the Persian narratives adopted and adapted the regional myths outlined in the Sanskrit texts and the local myths of the Kashmiri tradition, Zutshi also gives us a nuanced look at Sufism and Sufi institutions and their role in the further cosmopolitan-isation of language. She writes,

> Persian narratives . . . were not produced simply by court elites, but rather by a variety of individuals and a range of institutional contexts that were not limited to the royal court. Sufi Shrines were a significant location for the composition of narratives that framed Kashmir's spiritual and political past in tandem. Equally importantly, it was a space of the shrine and its patronage network that allowed for the interfertilisation between the cosmopolitan-vernacular Persian and the regional-vernacular Kashmiri, as well as between textual and oral forms of narration. The shrine not only provided the space for the production of narratives, but also enabled their dissemination throughout a vast cross-section of society as Sufi shayks and *pirs* wandered the countryside reciting songs and stories in praise of the land and the spiritual stalwarts who had converted it into a paradise [i.e., the land of Kashmir]. Storytellers and other performers, who operated mainly in the Kashmiri language, also drew their legitimacy through an association with particular Sufi shrines and the network of writers, scribes, wandering mendicants, and ordinary devotees patronized by them.
>
> (ibid: 11–12)

While this was the case in the 16th century, during the 17th and 18th centuries, the texts composed in Mughal Kashmir self-consciously drew on earlier Sanskrit and Persian textual narratives as well as Mughal *tarikhs* to produce a specifically Kashmiri *tarikh* tradition, which was undoubtedly

cosmopolitan in nature. While narrating its past, this tradition, through texts, tried to define and assert 'Kashmir's uniqueness' and its 'distinctive position' within the larger Mughal Empire (ibid: 73). According to Zutshi,

> these texts cast a longer look at Kashmir's past in the context of the Mughal conquest, which led to Kashmir's inclusion into a larger empire centred in South Asia, and after Mughal decline, its incorporation into the Afghan Empire. Even as they drew on Mughal historiography and political traditions, the texts asserted their autonomy both by putting forward their own ideas about historical narration, as well as the relationship between political and spiritual authority. A continued dialogue in these narratives among local, regional, universal, and imperial cultures, and multiple genres, as well as history and memory, led to the constitution of Kashmir as a literary paradise – a space created by the narrative imagination where, in turn, the narrative imagination was nurtured and flourished.
> (ibid: 75)

Therefore, undoubtedly, Persian language as well as the narratives produced in it during the medieval period, drawing from Sanskrit and Kashmiri oral traditions, is evidence to support the existence of pre-modern cosmopolitanism in Kashmir along with a gradual shift to Ladakh. At the same time, the people who actively engaged in the composition of these narratives, in my opinion, must have had a cosmopolitan ideology.

Missionary Activities and Christianity in Ladakh

'Of the three religions represented in Ladakh, the Christians form a tiny minority, not much more than 100 persons, almost all of them in and around Leh' (Rizvi 1983: 150). Desideri was among the first of the Christian missionaries to reach Ladakh in the 18th century. Like his predecessors, he found no trace of Christianity in Ladakh. He was of the opinion that that Christianity was never introduced in these areas (the three 'Thibets' – First Tibet or Little/Lesser Tiber or Baltistan, Second Tibet or the Great Tibet or Ladakh with Leh as capital, Third Tibet or the Greatest Tibet or Ustang with Lhasa as capital) was a natural doubt and could arise because of the following reasons. Firstly,

> There is a great resemblance in the Thibettan sect and religion to the mysteries of our Holy Faith, to the ceremonies, institutions, ecclesiastical hierarchy, the maxims and moral principles of our Holy Law, and the rules and teachings of Christian perfection. Thus for example, although the three complex objects of adoration: the primary Saints (Sangh-ghiêe-Kŏn-cciôá) (or Sanghiée); the books and

the laws given by them to the world (Ccioo-kŏn-cciôá); and the faithful observers of those laws (Ke-n-dun-kŏn-cciôá) are absolutely different from the three persons of the Holy Trinity: Father, Son, and Holy Ghost, yet if you consider the principal attributes of the three Divine Persons, and the qualities recognized by the Thibettans in the said three complex objects, a doubt may easily arise whether the trinity of the latter may not be an obscure symbol or fabulous symbol or fabulous legend of the true, august and Divine Trinity.

(Filippi 1995: 301)

The second reason can be

when we read their books of prodigies and marvels attending the incarnation and birth of their Legislator Sciacchiá-Thubbá or are told that Urghien was born in a flower in the midst of a sea, that he remained unhurt in the flames of a pyre and burning oil, that he caused the sun to remain stationary in the sky, that he was seen by his disciples and faithful followers to ascend to heaven, and other similar tales, we are tempted to ask whether this people may not in former days have had some knowledge of the incarnation, birth and ascension to heaven of our Lord Jesus Christ; of lives and miracles of various Saints; and of the Old as well as of the New Testament.

(ibid: 301)

Finally,

The position of the head of the Thibettan religion who is acknowledged and revered by many and divers nations, the rank and condition of the other Lamás, the monasteries of mendicant and other monks, the nunneries, hermitages, vows of poverty, chastity, obedience, and similar things, may well raise a doubt as to whether in former days there was not some knowledge of ecclesiastical hierarchy or perhaps a certain number of followers of the Christian religion came into the country.

(ibid: 301–2)

However, Desideri confesses that 'in none of the Thibettan histories, memories or traditions, have I found any hint that our Holy Faith has at any time been known, or that any Apostle or evangelical preacher has ever lived here' (ibid: 302). According to Filippo De Filippi, Desideri then proceeds to declare that Christianity cannot possibly have been introduced from China into Tibet but suggests that the religion that was imported from Hindustan may have been tinged with Christian teachings (ibid: 302). Though Desideri fits into 'larger trends among missionaries, who were fascinated by vestiges of the

Holy Trinity that they discovered in ancient European, Indo-Tibetan, and Chinese religions' (Pomplun 2009: 97–9), he, like his predecessors, did not make Ladakh the field of his labours, and Christianity was in fact brought by the missionaries of the Moravian Church, who arrived in Leh in the later 19th century (i.e., in 1885) (Rizvi 1983: 157). Wilhelm Heyde and Eduard Pagell became the first Moravian missionaries to travel to Ladakh. They and their successors successfully founded mission stations in Lahul (1856), Kinnaur (1865) and Ladakh (1885). Heinrich Augustus Jäschke, who led the Moravian mission from 1857, is famous for his ground-breaking Tibetan translation of the New Testament and his *Tibetan-English Dictionary* (1881) (Bray 2005: 249). According to John Bray, 'all three men were genuine pioneers, but they were also heirs to a longer missionary tradition which anticipated – and in many respects prepared the way for – their own work' (ibid: 249).

Bray is of the opinion that one of the most striking points of continuity between different Moravian missions concerns the word used to translate the Christian understanding of 'God'. In Buddhist thought, there is no conception and so no word corresponding to a self-created almighty God. The word 'Buddha' in the context is inappropriate. Moreover, many local deities do not correspond to the demands of Christian theology. Desideri used *dkon mchog*, meaning 'the precious one', to translate 'God' in the sense of the 'highest', as well as *kun gyi slob dpon che* for 'grand master of all' and *jig rten gyi dbang po* for 'Lord of all the World' (Toscano 1981: 325–6 cited in Bray 2005: 267). Jäschke, in his dictionary, notes the Buddhist associations of *dkon mchog* but argues that

> as to every Tibetan '*dkon-mchog*' suggests the idea of some supernatural power, the existence of which he feels in his heart and the nature and properties of which he attributes more or less to the three agents (Buddha, Dharma, Sanga) mentioned above, we are fully entitled to assign the word *dkon-mchog* also the signification of God, though the sublime conception which the Bible connects with this word, viz. that of a personal, absolute, omnipotent being, will only with the spread of the Christian religion be gradually established and introduced.
>
> (Jäschke 1881: 10 cited in Bray 2005: 267–8)

According to Bray, the Moravians continued to use *dkon mchog* in – for example – the 1948 Tibetan Bible (Bray 1991) and in church services in Ladakh (Bray 2005: 267–8).

Nevertheless, considering this historical background, Leh seems to always have been the most cosmopolitan place in Ladakh where there exists

> a long tradition of intermarriage, dating right back to the days of caravan trade when its bazaar was home to colony of foreign

merchants and this has surely strengthened the good relations between the different religions. It is quite common for a particular Muslim or Buddhist . . . to have relatives belong to the other community, while among the Christians, converts of only a hundred years' standing and in a decided minority, it is universal.

(Rizvi 1983: 158)

Moreover, apart from the tide of Islamic influence, the role of trade with Kashmir, and the Christian missionary activities in the period right from the 15th to 19th centuries that caused the modification of the Ladakhi 'Tibetanness', a further aid in the establishment of cosmopolitanism was provided by the Dogra conquest of 1834–42 CE, that on the political level brought Ladakh within the orbit of India. As a result of this, a new generation of secular Ladakhis (who are also in my opinion cosmopolitan in their characters) started going to Srinagar and the universities of British India for higher education. Ladakh, thence, became an integral part of the Indian polity in 1947 with the accession to India of the princely state of Jammu and Kashmir (ibid: 5).

Conclusion

Based on a primary argument that Cosmopolitanism, popularly associated with the modernity of globalisation, was in fact very much a part of the pre-modern past of some communities, in conclusion, this paper is inspired by the work of Jacqueline H. Fewkes. Fewkes, who argues that the existence of an Arghun community in Ladakh was in the form of a cosmopolitan elite through intermarriage, and relationships to commercial goods during the 19th and early 20th centuries, provides a possible framework for identifying similar cosmopolitanism during the 18th and early 19th centuries. Taking Ladakh as a case study and the travel accounts of Desideri and Moorcroft as primary sources, therefore, in this chapter, I have not only argued the existence of pre-modern cosmopolitanism during the 18th and early 19th centuries but also discussed how it acted as a challenge to Ladakh's supposed 'Tibetanness'.

Notes

1 Kwame Anthony Appiah is a British-born Ghanaian-American philosopher, cultural theorist and novelist who is influenced by the cosmopolitanist philosophical tradition, which stretches from German philosophers such as Hegel through W. E. B. Du Bois and others.
2 The geographical entity called Baltistan includes the Gilgit-Baltistan area of Pakistan and some parts of Jammu and Kashmir. The districts include – Skardu (Pakistan), Ghanche (Pakistan), Shigar (Pakistan), Kharmang (Pakistan), Kargil and Ladakh.

3 According to Buddhist tradition, Maitreya is a Bodhisattva who will appear on Earth in the future, achieve complete enlightenment and teach pure dharma. According to scriptures, Maitreya will be a successor to the present Buddha, Gautama Buddha, also known as Sakyamuni Buddha.
4 Contrary to the view that in the beginning of the 13th century, from the Buddhist point of view, India was ceasing to have anything to offer, Chatterjee argues that 'British colonial scholars in the early nineteenth century constructed a chronology in which a "Hindu epoch" was followed by a "Muslim one" and so on. . . [they also] retrofitted Buddhism into this chronology. Accordingly, Buddhism was believed to have "died" in India and lived outside it after the thirteenth century. . . [But] elsewhere, scholars of Tibetan-language records have, however, found that Tantric Buddhist and Bon teachers – disciples and adherent households continued to thrive on the plains of eastern India . . . This was especially true of places along the foothills of the Himalayas (Kamarupa, western Assam), but it was also true of places further south, such as Kumilla (centre of colonial Tippera . . . Tripura in modern India), Chittagong, and the region that modern maps identify as Arakan' (Chatterjee 2013: 1–2).
5 The Noorbakshi order was started in the 15th century by a preacher called Noorbaksh, meaning 'gift of light'. He was a Sufi follower of Sayyid Mahmud Hamadani, who is credited with bringing Islam to Baltistan and Purig.
6 According to Rizvi, he probably ascended the throne in about 1616 as a minor, his mother acting as a regent (Rizvi 1983: 49).
7 Luciano Petech writes, '[T]o take recourse to the extreme step of closing the routes [was] an economic weapon of decisive power . . . Ladakh. . . [took] that fateful step in the 17th century, in the pitiable hope to put in this way pressure on the Moghul empire, then at its zenith. As far as we can see, Sen-ge-rnam-rgyal condemned to death the little mountain empire he himself had built, by committing economic suicide' (Petech 1977: 163).

References

Primary sources

De Filippi, Filippo (ed.). 1995. *An Account of Tibet: The Travels of Ippolito Desideri 1712–1727*. New Delhi: Asian Educational Services.

Moorcroft, William and George Trebeck. 2004. *Travels in the Himalayan Provinces of Hindustan and the Panjab; in Ladakh and Kashmir; in Peshawar, Kabul, Kunduz, and Bokhara, from 1819 to 1825, Volume I and II*. New Delhi: Asian Educational Services.

Secondary sources

Appiah, Kwame Anthony. 1997. 'Cosmopolitan Patriots'. *Critical Inquiry*, 23 (3): 617–39.

Bentley, Jerry. n.d. 'Travel Narratives'. *World History Sources*. http://chnm.gmu.edu/worldhistorysources/unpacking/travelmain.html Last Accessed 1 January 2018.

Bray, John. 1991. 'Language, Tradition and the Tibetan Bible'. *The Tibetan Journal*, 16 (4): 28–58.

———. 2005. 'Early Protestant Missionary Engagement with the Himalayan Region and Tibet', in John Bray (ed.), *Ladakhi Histories: Local and Regional Perspectives*. Leiden: Brill's Tibetan Studies Library.

Chatterjee, Indrani. 2013. *Forgotten Friends: Monks, Marriages, and Memories of Northeast India*. New Delhi: Oxford University Press.

Chatterjee, Indrani and Andrea Gutiérrez. 2014. 'Remembering Pasts: An Interview with Indrani Chatterjee'. *SAGAR*, XXII: 96–121.

Fewkes, Jacqueline H. 2009. *Trade and Contemporary Society along the Silk Road: An Ethno-History of Ladakh*. London: Routledge.

Francke, A. H. 1914 and 1926. *Antiquities of Indian Tibet*. Kolkata: Archeological Survey of India.

Grist, Nicola. 2005. 'The History of Islam in Suru'. In John Bray (ed.), *Ladakhi Histories: Local and Regional Perspectives*. Leiden: Brill's Tibetan Studies Library.

Jäschke, Heinrich Augustus. 1881. *A Tibetan-English Dictionary: With Special Reference to the Prevailing Dialects*. London: Routledge and Kegan Paul.

Khan, Hashmatullah. 1939. *Traikh Jammun, Kashmir, Laddakh aur Baltistan*. Lucknow.

Matoo, Abdul Majid. 1998. *Kashmir Under the Mughals 1586–1752*. Kashmir: Golden Horde Enterprises.

Petech, Luciano. 1977. *The Kingdom of Ladakh c. 950–1842 AD*. Rome: Intituto italiano Per IL Medio Ed Estremo Oriente.

Pomplun, Trent. 2009. 'Buddhist-Christian Dialogue in Ippolito Desideri'. *Buddhist-Christian Studies*, 29: 97–9.

Rizvi, Janet. 1983. *Ladakh: Crossroads of High Asia*. New Delhi: Oxford University Press.

———. 2001. *Trans-Himalayan Caravans: Merchant Princes and Peasant Traders in Ladakh*. New Delhi: Oxford University Press.

Scott, James C. 2009. *The Art of Not Being Governed: An Anarchist History of Upland Southeast Asia*. London: Yale University Press.

Sheikh, Abdul Ghani. 1995. 'A Brief History of Muslims in Ladakh'. In Henry Osmaston and Philip Denwood (eds.), *Recent Research on Ladakh 4&5*. New Delhi: Motilal Banarsidass Publishers Private Limited, 189–92.

Singh, Harjit. 1978. 'Ladakh – Problems of Regional Development in the Context of Growth Point Strategy'. Unpublished Ph.D. Dissertation, Jawaharlal Nehru University.

Stein, Gertrude. 1940. 'An American in France'. In Gertrude Stein (ed.), *What Are Masterpieces?* Los Angeles: Conference Press.

Toscano, Giuseppe (ed.). 1981. *IL Torangs (L'Aurora). Opera Tibetanne di Ippolito Desideri S J*. Rome: Istituto Italiano Per IL Medio Ed Estremo Oriente.

Zutshi, Chitralekha. 2014. *Kashmir's Contested Pasts: Narratives, Sacred Geographies and the Historical Imagination*. New Delhi: Oxford University Press.

7

THE 'COW PROTECTION' DISCOURSE IN INDIA

The making of a 'movement'

Ridhima Sharma

This chapter takes a historical route to understanding the 'becoming' of the cow as a potent socio-religious-political symbol in the Indian context. I do this by (re)visiting several moments in a rather long period, from the early 1700s to the1890s, where the 'holy cow' makes an appearance. I examine the reasons for and the manner and desired goals of the process of carving out politics in and around the figure of the cow at various moments in history and across regions, in order to understand not only the work that the cow is called upon to do as a symbol but also to explore the making of what has come to be unproblematically called the 'cow protection movement'.

Exploring the 'holiness' of the 'holy cow': the origins question

Any attempt to historicise the story/ies of cow protection must be preceded by an understanding of the context in which the cow came to be (construed as) holy. The emergence of the concept of the 'holy cow' remains an interesting problem of Indian cultural history since the modern notions of sanctity and unassailability of the cow differ significantly from those of earlier times (Simoons and Lodrick 1981).

An important debate was initiated in the 1960s by Harris's controversial thesis that the sanctity of the cow in India must be understood as a techno-environmental issue, a taboo grounded in scientific principles which helps maintain a 'low-energy, small-scale, animal-based ecosystem' (van der Veer 1994). Harris (1966) argued that the problem of the 'holy cow' is found to unravel itself not in the domain of the religious but the economic-ecological, that is, the sanctity of the cow in India owes its existence primarily to its functional importance to the Indian peasant-farmer. In other words, the importance of cattle in the Indian context is determined by the role it plays

in breeding male traction animals and providing subsistence to the farmer and in leading a more economically sustainable life in the long run in an overwhelmingly agrarian economy. Even though he was responding to Orientalist positions that dismissed the Hindu belief in the cow as 'irrational', his functional approach was severely criticised for what was called a simplistic 'calculus of calories' (Glucklich 1997). A substantial part of the response to Harris's (1965, 1966, 1974) argument was based on either economic and techno-environmental premises (Bennett 1967; Dandekar 1969) or an 'analysis of class conflict, power equations, appropriation of surplus and the rise of Indian empires' (Oberoi 1992 on Diener, Nonini and Robkin 1978). In order to 'correct' this 'imbalance', which completely overlooked the domain of religion, Simoons and Lodrick (1981) placed the 'sacred cow concept in a broader cultural perspective by examining its varied and interesting expressions in Hindu religion, folk thought and everyday behavior'.

Most scholars, as I demonstrate in this chapter, attribute the emergence of the concept of the 'holy cow' to the Vedic period and cite the Vedas as the original authority on the matter. The Aryans who settled in northwest India during the second millennium BC were pastoralists, and cattle played a significant role in their economy – as sources of food (both milk and meat), means of traction and transportation, currency and a source of wealth. The Vedas, the sacred literature of the Aryans in India, are a testament to especially the economic importance of cattle. However, the Vedas do not mention prohibition on cow slaughter or beef eating. In fact, animal sacrifice, a major ritualistic practice of the period, relied heavily on cattle. This has been observed by many scholars. Simoons and Lodrick (1981) point out, 'In sacrifice, for example, the cow as well as the ox was offered to the gods, and its flesh ritually consumed by the celebrants (Rig-veda VIII. 43. 11, trans, in Wilson 1866 1888; Oldenberg 1894: 355). Cows were sometimes slaughtered and eaten in honour of the arrival of special guests (Atharva-veda III. 21. 6, trans. in Bloomfield 1897) and at the time of marriages (Rig-veda X. 85.13)'.

D. N. Jha's seminal *The Myth of the Holy Cow* (2009) is laden with archaeological evidence to support that Hindus, including Brahmins and even deities consumed beef in ancient India. According to Jha, cow slaughter and beef-eating continued well into modern times. He posits, 'As late as the 18th century, Ghanasyama, a minister for a Tanjore ruler, states that the killing of cow in honour of a guest was the ancient rule' (Jha 2009: 102).

Ambedkar arrived at this thesis as early as 1948 in his work *The Untouchables: Who Were They and Why They Became Untouchables?* where he demonstrates beef-eating to be the root cause of untouchability (Ambedkar 1948). He argues that the Brahmins were the 'biggest beef eaters' until the rule of the Guptas, when beef-eating was declared to be sacrilegious, and the roots of this new development were located in the tussle between Brahminism and Buddhism. It was to establish supremacy over Buddhism that

the Brahmins had to not only adopt their ways but also practise them in their 'extreme form'. It was as part of this 'extreme form' that the Brahmins did not just stop slaughtering the cow and eating it but also established its inviolability by giving it the status of the 'sacred'.

While most scholars link the deification of the cow to the Vedic period, some dispute the theory and argue that the disproportionate emphasis on the Vedic period and practices obfuscates other possible sources of influence. However, broadly speaking, there is consensus that by the early medieval period, there is increased veneration of the cow among the Hindus. There is also the impression that before the arrival of the British, the Mughal rulers were 'respectful' towards Hindu beliefs. For instance, Emperor Akbar's strict prohibition of cow slaughter in his reign is often evoked in this context.[1]

I argue that pinning the holiness of the cow to a single 'cause' is a futile attempt. The holiness of the cow derives its meaning and legitimacy not from a singular mystical point of origin but a network of related, albeit sometimes distinct practices, institutions and conceptual frameworks that work to maintain, reinforce and perpetuate certain notions of the 'sacred' and the 'profane', of the 'holy' and the 'unholy'. We see different forms of exemplification of this in the following section where I tour several moments from the 1700s to the 1890s to examine the various ways in which the cow emerges as a potent symbolic force.

Mapping 'Gau Raksha' (Cow Protection): the 'becoming' of the 'Gau Mata' (Cow-Mother-Goddess)

To understand the 'becoming' of the cow into a holy figure of the 'mother-goddess', the symbolic force of the 'holy cow' needs to be put to scrutiny. Apart from the holiness enshrined in sacred texts, it is useful to visit moments in which the cow makes an appearance and ask the following: What are the occasions on which the 'cow' is invoked? By and against whom? To what end, and what role does the cow perform in each of these instances, not just in literal terms in the context of initiating or exacerbating a conflict but also as a symbolic force? In semiotic terms, what is the cow a signifier of? My contention is that an attentive engagement with these questions will be useful in appreciating the rhetoric of cow protection, in all its textures, while also alerting us to the error of attributing homogeneity to all instances of cow protection and their convenient slotting into a uniform 'movement'.

The Holi Riot of 1714: the 'first' documented riot involving the cow

In his 'A 'Holi Riot' of 1714: Versions from Ahmedabad and Delhi', Haider (2005) describes at length two versions of a riot that took place in Ahmedabad with primary reliance on two Persian chronicles – one contained

in a local history of Gujarat, the *Mirat-i Ahmadi*, and the other in a general history of the Mughal Empire, the *Muntakhal ul Labab*. For the purpose of my argument here, I will refer only to the second version.

As Haider tells us, the *Muntakhal ul Labab* is a history of the Mughal Empire from the date of its establishment (AD 1526) to the 14th year of Muhammad Shah's reign (AD 1723), written by Khafi Khan, who 'worked in Gujarat as a news writer but moved out to the Deccan, as the diwan of the viceroy, Chin Qulich Khan Nizam ul Mulk, a year before the incident' (Haider 2005: 28).

To summarise the events that transpired, as per Khan's version: In the first regnal year, Daud Khan Panni became the governor of Ahmedabad, Gujarat. He was known for his 'soft spot' for Hindus. In the second year, AD 1714, one of the Hindus who lived across from some Muslims wanted to light the Holi fire in front of his house. The Muslims in the locality objected strongly to this. Since the Hindus were well aware of the support they enjoyed from Daud Khan, they lit the fire despite many arguments and disagreements; the Hindu man in question declared that he would do as he pleased since it was his house. The next day, one of the Muslims in the same area decided to commemorate the eve of Prophet Mohammad's death anniversary and slaughtered a cow for the same, much to the resentment of the Hindus. This angered the Hindus so much that they came in very large numbers, dragged out the adolescent son of a cow butcher (*gau qasab*) and slaughtered him. As a response, the Muslims raised the cry of an onslaught and prepared for battle with the Hindus. A few thousand Afghan soldiers (who were servants of Daud Khan), against the will of their master, along with Afghans from the suburbs of Ahmedabad and the Bohras of the city, knocked on the doors of the qazi. The qazi, however, locked his doors in the face of the gathering, perhaps on account of the knowledge of Daud Khan's favourable attitude towards the Hindus. Angered further, the Muslims set fire to the qazi's house along with the houses and shops of the Hindus. They then set out to burn the house of Kapur Chand, 'the ill-famed jeweler, who was a companion of Daud Khan, and an intensely bigoted Hindu'. He was, however, forewarned and took to fighting. The riot was so intense, having killed many and destroyed the houses and shops of numerous cloth merchants and other traders, that the city was shut for about three or four days. Eventually, both parties decided to make representations to the imperial court. Shaikh Abdul Wahid, Shaikh Muhammad Ali Waiz and other Muslims were arrested and eventually released upon the intervention of Khwaja Muhammad Jafar, who was renowned among hermits and recluses.

Many aspects of the Delhi version of the 'Holi Riot' merit attention. Apart from the fact that the houses and shops of primarily traders and merchants were attacked, Haider draws our attention towards the religious-caste-professional identities of some of the actors involved. For instance, Abdul Aziz, one of the primary organisers of violence, was the leader of a

THE 'COW PROTECTION' DISCOURSE IN INDIA

sub-group of Ahmedabad's mercantile population, the Sunni Bohras, who were junior partners of the Banias in the trading network of Gujarat. As per Haider's reading of (the two versions of) the event, the riot was a manifestation of conflict between two mercantile communities, an indication of a point of crisis in the market economy of Gujarat. He notes,

> A downturn in the hinterland, rising transaction costs due to fear, uncertainty and lack of certainty for goods and money in transit, and Maratha expeditionary raids which began in AD 1703 and reached their high point in the second quarter of the 18th century boded ill for the vigorous conduct of business. Stiff competition for the shrunken markets and concern for a greater stake in the city affairs may have lowered the threshold of tolerance that existed between communities with complementary interests.[2]
>
> (Haider 2002: 139)

Bayly (1985), in his commentary on communal conflicts in India in the period 1700–1860, shows that while many of the earliest incidents of religious conflict in India took place over renegotiation of 'boundaries of local religious practice', most of them were a reflection of a local situation of economic change or flux, aggravated by a religious or ceremonial dispute often involving a festival or place of worship (Bayly 1985: 194). The participation of mercenary soldiers from outside the locality or even from outside India is a noteworthy feature of many of these disturbances, including the 'Holi Riot' in Ahmedabad in which Afghan soldiers of the Mughal governor of the city took part. Rizvi (1980) further observes that in all conflicts of this nature, where Holi, Id or Muharram festivities were at the centre, a consistent feature was the participation of new Muslim leaders, such as Arabs, Abysinnians, Turks from Istanbul and Afghans. This period in the 18th century witnessed a replacement of old Irani and Turani officials, who were more favourable to Hindus, by these new military leaders, often from areas of Sunni orthodoxy. Bayly has attributed the participation of Afghans in the period to their unruly and 'mercenary' character, but as Haider argues, 'more findings on the exact nature of their professional status, command structure, and religious persuasions are needed before their motives can become fully explicable' (Haider 2002: 140).

Bayly challenges the notion that communal conflict in India was inaugurated in and through the colonial encounter and argues that the

> syncretism of rural religion, which received encouragement from the state in the course of the 18th century, by no means excluded the possibility of communal conflict where lines of religious division happened to coincide with deep economic antagonisms. Communal

violence was not incompatible with eclectic religious practice as the orthodox nationalist view of communalism has so often contended.

(Bayly 1985: 193)

It may therefore be flawed to see the well-documented and theorised oeuvre of communal violence in the 19th century as part of a different paradigm, as symptomatic of a new era of communal identity; instead, the events of the 19th century must be viewed as extensions of the goings-on of an earlier period. This is a departure from an established body of work that attributes communal conflict in India to the arrival of the British and thus runs the risk of romanticising an imagined 'pre-modern' syncretism.

Often in scholarly accounts, the discourse of cow protection in India is dated to the 19th century, with its emergence linked with Dayanand Saraswati's insistence on cow protection and formation of *gaurakshini sabhas* (cow protection societies) in the northern parts of the country, aspects pursued later in the chapter. While the rhetoric of cow protection begins to acquire a coherent and organised shape in the late 19th century, it will be instructive, I argue, to view this process in relation with and as connected to earlier instances of the invocation of the 'holy cow'. When seen against episodes in the 18th century, interesting comparisons and contrasts can be made with the 19th-century events, which add significantly to our understanding of the cow protection 'movement'.

One of the oppositions at the heart of the 1714 riot was the Hindu notion of the holiness of the cow and the Muslim practice of cow slaughter on the occasion of Prophet Mohammad's death anniversary. We see here an interplay of what is deemed 'sacred' and 'sacrilegious'; the slaughtering of what is the 'sacred' for the Hindu becomes an act of sacrilege on the part of the Muslim and thus merits punishment. The Muslim butcher as the recipient of Hindu wrath is a recurring thread that we will witness consistently. Apart from the Muslim butcher, the objects of anger included the 'partial' forces of the incipient state represented by the governor.

Bayly views the riot as stemming from an interaction of the religious with the economic. He writes,

> [I]t is perhaps significant that mercantile groups, and Jains above all, appear on several occasions as the champions of anti-Muslim parties. Jain and Vaishnavite merchants from Rajasthan ... were building up their power throughout the Ganges valley in the 18th century.
>
> (Bayly 1985: 198)

In this context, it is significant that the chief actors in the Ahmedabad riot, Abdul Aziz and Kapur Chand, were merchants – the former, a cap merchant and the latter, a jeweler – and leaders of the Sunni Bohra and Hindu communities respectively.[3] Kapur Chand was, in fact, Jain.

These accounts suggest that already delicate economic relationships reached a point of ultimate crisis when a potent religious symbol (the cow) and a contentious religious practice (cow slaughter) entered the picture.

The Calcutta riot of 1789

Another mention of a conflict involving the cow appears in 1789 in Calcutta, a city believed to be free of Hindu-Muslim strife until the 19th century. On the event of the collision of Durga Puja and Muharram, some Muslims attacked the procession of a wealthy businessman, who in response gathered "fifty or sixty armed peons and demolished all the Mahomedan *durgahs* they could find in the neighbourhood of Boitacannah" (Bayly 1985: 199). Later, a mob of Muslims plundered several Hindu houses and burnt and killed a couple of cows.

Both in the Ahmedabad and the Calcutta riots, the cow is used as a site for revenge. Offence is taken by one community over the actions of another and as an act of revenge, the 'sacrilege' of cow slaughter is committed. The body of the cow, much like that of the woman, is one laden with 'purity' and 'honour' and in the 'violation' of this 'honour', revenge is sought. Two other similarities can be noted between the Calcutta and Ahmedabad incidents, apart from the involvement of the cow in very different capacities – the occasion of a religious festival and the participation of businessmen/traders and merchants. In Ahmedabad, cow slaughter as revenge led to the riot, whereas in Calcutta, the riot culminated in cow slaughter as revenge. However, these appear to be scattered and spontaneous outbreaks over ceremonial rites on religious festivals or processions where cow (slaughter) is one of the elements in the riot situation and not the conclusion of an organised, sustained, long-term mobilisation overtly in the name of the cow. Nonetheless, these constitute significant moments in (re)telling the story/ies of the beginning of the becoming of a 'movement' in the name of the cow.

We now move towards an examination of moments where the mobilisation in the name of the cow begins to acquire a more explicit character.

The revolt of 1857[4]

A moment that has often been chronicled in another context, that of the freedom struggle – the Revolt of 1857, also known as the 'First War of Independence' – also features in the story of the cow. There were many factors that culminated in the Revolt of 1857, but a major trigger was the introduction of the new Enfield P-53 rifle in the regiment, which had pre-greased cartridges. Unconfirmed rumour spread that the cartridges were coated with the fat of cows and pigs, the former being a sacred symbol for the Hindus and the latter being taboo for the Muslims respectively. Hibbert (1978) records an altercation between a 'high-caste' sepoy and a 'low-caste'

labourer; the labourer had taunted the sepoy that by biting the cartridge, he had himself lost his caste status. On 27 January, Colonel Richard Birch, the military secretary, ordered that all cartridges issued from depots were to be free from grease, and that sepoys could grease them themselves using whatever mixture they may prefer (David 2003). This somehow strengthened the suspicions of the sepoys that the cartridges had indeed been coated with animal fat and led to the East India Company facing a rebellion in May 1857 of such vast proportions that their very existence in India was threatened.

In this case, we see that the Hindu (and Muslim) anger is jointly directed towards the British, for causing a violation of their sacred code. Contrary to the riots described earlier, the figure of the Muslim butcher is completely missing, and the cow takes the shape of a strong anti-colonial symbol, a symbol of Hindu resistance against and resentment towards British imperialism. In fact, attempts for Hindu-Muslim unity were made during the revolt; the king of Delhi banned cow slaughter in Delhi to forge unity between the two communities (van der Veer 1994). This is one of the first manifestations of the sanctity of the cow posing a threat to the British existence in India, a fact that starts to register in the British consciousness much later, with the riots of the 1890s.

The Brahminical 'purity' encoded within the cow emerges quite clearly from the reported altercation. So significant is the role of the cow to the Brahminical ethos that a violation of its sanctity by high-caste Hindus could symbolically translate into the loss of caste status. Conversely, and we shall see this later, an adherence to and propagation of the code could also promise elevation of caste status. This only reinforces the Brahminical character of the idea of the 'holy cow', which is already evident in the links of its origins and spread within the Brahminical priesthood and with the inauguration of untouchability, as discussed in the earlier sections of the chapter.

The Kuka agitation

While the holiness of the cow to Hindus is understood well, a perplexing moment in our tale of the cow is that of the Kuka agitation, when the cow was taken up by Kukas or Namdharis, a Sikh sect. Some accounts of the cow protection discourse in India, which acknowledge the Kuka agitation as a starting point of a somewhat organised 'movement', refer to it only fleetingly, without delving into its structure and politics. To understand the role played by Kukas in the discourse of cow protection, it is essential to first get a broad sense of who the Kukas were and the place that the cow occupied in their moral universe.[5]

The Kukas, also known as Namdharis, were a millenarian community in the Punjab. Although broadly considered as a sect of Sikhism, the Kukas are not entirely the same as the sectors of the Sikh tradition. Oberoi (1992) refers to them as 'Kuka Sikhs' since 'differences between the Kukas and

Sikhs had not fully crystallised in the 19th century and the two categories often overlapped'. From the mid-1860s, the Kukas became notorious in the British view for largely two sets of activities – desecration of shrines and sacred ancestral sites in the countryside and attacks on Muslim butchers and their families. Unable to comprehend their 'irrational' violence, the British relegated them to the domain of the 'barbaric' or the 'foolish', while nationalist historians viewed their activities as part of the larger umbrella of the anti-British imperialist struggle. However, both these perceptions, which slot the Kuka actions into familiar frameworks, obscure the particularity of the meaning of their cosmology and do not tell us what made the Kukas take upon themselves the onus of protecting the Hindu sacred symbol of the cow, especially at a time when many of their "brethren would soon be proclaiming Hindu-Sikh distinctions" (Oberoi 1992: 173). The answer to these questions lies in carefully examining the moral and spiritual cosmos of the Kukas against their specific socio-economic circumstances.

The Kukas' world was one laden with miracles, symbols, prophesies and rituals, tied together by their firm belief in the order of holiness. The Kuka order rested on the distinction between the 'pure' and the 'impure'; to be and pursue that which is 'pure' and to eliminate the 'impure' was what summed up their actions. It was as part of this purity principle that the Kukas had several dietary prohibitions, a dress code and many other commandments that governed their social behavior. Food taboos formed a very important part of their belief system and the consumption of meat, liquor and tobacco was strictly forbidden, as these substances were viewed as sources of pollution. The cow occupied a special place in this purity-pollution schema; it was placed in so reverential a place that even drinking water from a leather pouch was prohibited.

Oberoi seems to suggest that in an agrarian economy like Punjab and in a cosmos like that of the Kukas that relied on the preservation and deification of the 'pure' as its fundamental premise, the cow's significance increased manifold. As he points out,

> The most crucial aspect of the cow is its capacity to act as a channel of purification ... the exudations of a cow are not only pure in themselves but also have a power to purify impurer elements. ... For the Kuka Sikhs who are much more preoccupied than their fellow Punjabis with the boundaries of the ritually clean and unclean, the importance of the cow can hardly be exaggerated.
> (Oberoi 1992: 181)

In this context, it is easy to understand why butchers and slaughterhouses formed the object of the moral indignation of the Kukas. For the Kukas, they were not just carriers of impurity but signifiers of impurity themselves and needed to be eliminated.

In April 1871, one of the Sikh zealots claimed to find a beef bone within the premises of the Golden Temple in Amritsar. This caused an outrage among the Sikhs and Hindus in the city, who then started a campaign against the sale of beef and demanded a complete ban on cow slaughter in Amritsar. In the following months, many riots between Hindus-Sikhs and Muslims broke out. When the British administration paid no heed to the vociferous protests, the Kukas decided to take matters into their own hands and struck against the butchers at Amritsar and Raikot and planned the march to Malerkotla. The Kukas felt that the British authorities completely violated their symbolic universe, by eating beef themselves and not being 'harsh enough' on the Muslim butchers.

Unlike the Ahmedabad and the Calcutta riots of the 18th century, where religious conflict exacerbated the economic strains of the period, the Kuka agitation in Punjab was primarily marked by what was perceived as an erasure of the Kuka symbolic structure at the hands of the colonial administration. As Oberoi informs us, in the years in which the Kuka movement took shape, Punjab was fairly economically prosperous and was not undergoing anything like an agrarian economic crisis (Oberoi 1992). However, the common targets in both cases were Muslim butchers and slaughterhouses, with the Kuka agitation also solidifying the already inaugurated identification of the British imperialists as the enemy.

The formation of cow protection societies and the riots of the 1890s

Most popular and scholarly accounts of the cow protection 'movement' in India attribute its origin and spread to the formation of *gaurakshini sabhas* (cow protection societies) by members of the 'reformist' Arya Samaj, led by Dayanand Saraswati (Freitag 1980; Robb 1986; Upadhyay 1989; Van der Veer 1994; Pinney 1997; Gupta 2001). However, work of this kind has often declared Dayanand Saraswati's commitment to the issue of the cow a 'natural given', without a careful examination of what could have made him organise around the 'holy cow' and how the issue could be placed vis-à-vis other agendas championed by him and the Arya Samaj in general. Useful clues are, however, available in other historical works that primarily focus on the role of Dayanand Saraswati in Arya Samaj politics.

Dayanand's biographers and historians have now come to the conclusion that he was born to a Gujarati Brahmin family in Kathiawar, in the town of Tankara.[6] Kathiawar was firmly embedded in a Vaishnava-Jain ethos, which emphasised the principle of *ahimsa* and strictly condemned animal slaughter, thereby propagating a code of vegetarianism. This is perhaps crucial to understanding Dayanand's complete opposition to animal slaughter, with the cow occupying a heightened place. Elaborating on *ahimsa*, which

emerged as another conceptual framework to view the sanctity of the cow, Jordens (1960) writes,

> The initial impetus for the growth of that ethos (of cow protection) came from the ancient doctrine of *ahimsa*, shared by Hindus, Buddhists and Jains, but stressed and promoted most vigorously by the last. The ethos had been strengthened in the Middle Ages by the bhakti movement, in particular by the cult of Krishna, the divine cow-herd, so popular among the Vaishnavites.
> (Jordens 1960: 14)

Jordens (1960) contends that while Dayanand was bound to have been influenced by the Jain-Vaishnavite ideal of non-violence, his Shaivite background 'insulated him from the emotional aspect' of cow protection. His observation is based on Dayanand's writings that suggest a fiercely economic approach to cow protection.[7] Locating the cow question in Dayanand's life and politics, Jordens posits,

> Dayananda's concern for cow-protection appeared early in his career. In 1866, on his first visit to Ajmer three years after leaving Virjananda, he talked about it to Colonel Brooks, Agent to the Governor-General in Rajputana. His argument was already clearly established: the killing of cows was bad because of its economic consequences, as a dead cow provided little food whereas a live one provided for many.
> (Jordens 1960: 219)

However, it was in 1877 that cow protection became an extremely significant issue in itself and Dayanand began to devote special lectures and tours to the subject. It was in the beginning of this year that a group of Hindus sent a plea to the government asking them to ban cow slaughter. When the government took no steps, a bitterly disappointed Dayanand noted in a statement in Farrukhabad, 'There is no unity among us, that is why cow-slaughter keeps going on. If we petitioned the government all together, could it not come to an end?' (Jordens 1960: 220). The 'us' here clearly stood for the Hindus, defined in opposition to all those who slaughtered the cow.

But it was not until 1881 that he launched a systematic agitation against cow slaughter. The trigger for this was an incident in Mirzapur, UP: The Hindus of Mirzapur got to know that a cow had been procured for slaughter by a Muslim. In their determination to save the cow, they managed to get an injunction from authorities that forbade the Muslim man from slaughtering the cow. However, a new magistrate overruled the decision; he granted that a legal owner could dispose of his property but also gave the Hindus the

right to appeal in court within six weeks. This brought both the Hindus and Muslims into action. Dayanand was at the time in Agra and on receiving the knowledge of the events that transpired, immediately launched a national cow-protection movement. He quickly penned the pamphlet *Gokarunanidhi* (Cow: The Ocean of Compassion), a work published within a few weeks, which sold out quickly and was republished within a year. It is in this very pamphlet that he also enumerates the laws and principles of his *gaurakshini sabha* (cow protection society). Many members of the Arya Samaj were inspired by Dayanand and started cow protection societies in their own areas. It was these societies that became the fulcrum of the riots in years to come.

At this point, let me take a slight detour to discuss what made Dayanand launch the cow protection movement in the 1880s in such an organised and belligerent a fashion. In other words, what triggered him to streamline his speeches and sermons on cow protection into a coherent movement?

Jordens (1960: 218) offers a plausible explanation. Sometime before the afore-mentioned Mirzapur episode, on 22 January 1881, a council called the Arya-Sanmarg-Sandarshini-Sabha was convened in Calcutta by orthodox Hindu organisations. One of the issues to have emerged in the council was the growing popularity of the Arya Samaj among the masses. The orthodox Hindus differed bitterly with the Swami on many fronts and tried their best to label Dayanand a threat to 'authentic Hinduism'. The Swami was aware of the attempts of the orthodox Hindus to exterminate him from the 'body of Hinduism'. Jordens argues that in the Mirzapur event, Dayanand saw an opportunity to advance an issue that would garner him the support of his enemies and would in fact unite the 'orthodox' and the 'reformist' Hindus – the issue of cow protection. Scholars have consistently noted the harmonious co-existence of the 'orthodox' Sanatan Dharma and the reformist 'Arya Samaj' on the issue of the cow. Jordens indicates that this co-existence was perhaps not accidental but a matter of careful strategy.

It would be useful to examine the nature and texture of Dayanand's discourse of cow protection, which was, needless to say, qualitatively different from that of the Kukas. Dayanand's rhetoric of cow protection derived from the elevated place of the cow in the Vedas, his belief in the principles of *ahimsa* and vegetarianism and perhaps most significantly, the economic value of the cow. In this context, let me briefly examine his pamphlet, *Gokarunanidhi*. Although not exhaustive, this analysis should adequately indicate the broad contours and nature of his doctrine on cow protection.

The pamphlet is primarily an economic argument in the defence of a ban on cow slaughter. Dayanand lays out the (questionable and methodologically suspect) arithmetic of how a living cow can feed more people than a dead one, in addition to demonstrating the benefits of products that can be obtained from the cow (Saraswati 1881: 8). The economic reasoning is

backed by the invocation of the Vedas. As per my translation of the original in Hindi, he writes,

> Do not kill or cause harm to animals; protect animals that bring you happiness and usefulness, for it is in their protection that you will be protecting yourself . . . it is for this reason that starting from Brahma to the Aryas, it is considered a sin or *adharma* to inflict violence on animals.
>
> (Sarawati 1881: 8)

It is striking here that a rather instrumental economic logic of saving the cow fuses almost seamlessly with the ethical principle of not hurting another life. Soon after, he also brings up the importance of the cow in maintaining the 'natural order of the universe', suggesting that cow slaughter can disturb the natural ecology (Saraswati 1881: 9). He argues against animal slaughter in general but makes it clear that given the need of the times and the economic usefulness of cattle, it is most urgent to save the cow. It is therefore evident that his writing is a response to the very dominant practice of cow slaughter in the period. In a few excerpts, we see, once again, a fusion of the economic benefit with the invocation of the vulnerability of the cow to make an emotion-laden case for the protection of the animal. For instance, he writes,

> Look, animals who eat grass, fruits and vegetables, provide us with precious milk and other nourishing products, help generously in ploughing lands and farming, live with and love human beings like their own children and friends, are so docile that they remain where asked to, go where instructed to, come close when called with love, rush to their nourisher-protector when under attack . . . who can be more treacherous, cruel and criminal than a person who kills such animals to feed himself?
>
> (Saraswati 1881: 7)

This is not meant to be just an innocent list of attributes of a docile animal but a moral injunction against those who would deem it fit to slaughter an innocent, vulnerable animal. As the text unfolds, we see this moral order strengthening and the inauguration of a clear binary between the 'ethically sound' rakshak (protector) and the 'depraved' hinsak (perpetrator of violence). A careful reading of the text foregrounds a veiled reference to the 'degenerate, cow-killing Mughals': he says with utmost contempt, '700 years back, alien, cow-killing, flesh-eaters stepped on this soil' (Saraswati 1881: 5). References like these are useful in establishing who the aggressors were in Dayanand's imagination.

The second part of the pamphlet puts forth the objectives, manner of working and organisational structure of the cow protection society. 'All men

who wish to devote their effort and help by body, mind, or riches, to this work for the benefit of all' were invited to become members, and any society with similar aims was urged to associate itself. This society was immediately started at Agra, and many were opened all over Northern India. They were especially active in the northwestern provinces and in Oudh, Bihar and the central provinces (Van der Veer 1994).

Did the Swami's commitment to cow protection make it an Arya Samaj agenda? It would be erroneous to answer this simplistically, as if to suggest that there existed one position on the subject at all times in the organisation. Jones (1976) argues that while many Aryas followed the Swami's example – they cited his arguments in the Samaj's publications and provided support and leadership to the movement, by 1885, the issue of the kine came to be 'fused with the question of meat eating'. This is when differences of opinion began to emerge within the organisation, and by 1890, there was a clear split between 'vegetarians' and 'non-vegetarians' in the Arya Samaj. The signs of fissures along the line of meat eating began to erupt earlier in 1887, when questions were raised on the porosity between the Arya Samaj and the cow protection movement and the organisational position on meat eating. Formally, they were separate, but the presence of the defenders of vegetarianism in the Samaj, led by Durga Prasad, Lala Atma Ram and Lala Munshi Ram, was strong, and they ensured that cow protection and vegetarianism came not only to be seen as the Samaj's agenda but membership would be provided to those who were strict vegetarians (Jones 1976). The issue erupted a few more times, concluding in the eventual victory of the vegetarians.

By the late 1880s and early 1890s, the agenda of cow protection had been established as an end in itself, rather than appearing covertly as means to other ends. The organisational aspects and mobilisation of the movement in this period have been well-documented by scholars (Yang 1980; Robb 1986; Pandey 1983; Freitag 1980). Freitag (1980) has observed in her analysis of cow protection in the United Provinces that the strength of the movement lay in the fact that it was not just limited to urban locations but also percolated to the countryside, owing to the mobilisation and communication networks; she divides the movement into two neat phases, a rural phase to the 1890s and an urban phase from the 1890s to the early 1900s.

The most rigorously-recorded aspect of the cow protection movement is a series of communal episodes, in the 1880s and early 1890s, associated with quarrels about kine killing – Multan 1881; Bombay and Benares 1883; Lahore 1885; Ludhiana, Delhi and Ambala 1886; Rohtak 1889; Gaya 1891; and Azamgarh, Mau, Saran, Prabhas Patan, Bombay and Rangoon 1893 (Groves 2010). Historians have studied some of these riots specifically, especially the ones in the United Provinces, Bihar and Bombay and attributed those to various factors. Yang (1980) looks at the rural market networks and the repeated tours and sermons by *gau swamis* in the Saran

district of Bihar that created the circumstances for the riot; Patel (2011) cites the influence of a large body of work produced by the Hindi intelligentsia that linked national identity with the figure of the cow; Upadhyay analyses the growth of cow protection societies which, through their aggressive anti-Muslim campaigning, made the riot possible in Bombay. Groves (2010) looks at the Allahabad High Court judgment in particular, which declared that the cow was not a sacred object and aggravated communal hatred. All of these works place the cow protection riots within the larger register of communal violence in the late 19th century and link the riots in different parts to the common thread of cow protection societies.

Gupta (2001), in her work on the iconography around 'mother/motherhood/motherland' in late colonial North India, discusses the manner in which the trope and icon of 'mother' bolstered the national/ist project in UP. The economic usefulness of the cow, her 'motherly instinct' to nourish her sons through milk and ghee and her sacred role in Hindu ritual was repeatedly emphasised to mobilise the 'nation', through the loaded figure of the *gau mata*.

Scholars like Pinch (1996) have traced links between cow protection and the *goala* movements in the 1890s and early 1900s. He argues that *Ahirs*, the caste generally involved in the labour of cattle-rearing collaborated with high-caste Hindus, especially Kshatriyas, in their call for cow protection to be able to claim Kshatriya status. The period witnessed many makeshift alliances between Kshatriya landlords and Ahirs, often at the expense of 'lower castes', notably *Chamars*, who were forced into occupations relating to dead animals by the Hindu caste order. Freitag (1980) notes,

> Chamars, often cultivators for upper caste tenants and landholders as well as tanners of hides, were obviously outside the twice-born Hindu matrix, as were Muslim butchers and weavers. The wandering 'tribe' of Nats, like the peripatetic Banjaras (cattle graziers and carriers) too could not fully participate in the local Hindu culture. Moreover it may be that anti-Chamar activity was in part a reaction to Arya Samaj appeals to convert and incorporate the lower castes.
>
> (Freitag 1980: 622)

Both Pinch and Freitag observe that in many parts of Northern India, it was Chamars who were under heavy attack by the Hindus for their 'impure' occupation and selling cows to Muslims. The participation of the lower castes in cow protection is often read as an attempt to elevate their status in the caste hierarchy. While this may be partly true, works like Pinch's and Freitag's indicate the coercive pressure that they were in, to partake in the rhetoric of cow protection, failing which they often had to face the dire consequences of exclusion and attack.

Conclusion

We have seen how the cow took on the shape of a strong anti-colonial, nationalist, anti-Muslim symbol. What began as few, scattered, localised attacks against butchers for 'violation' of a 'sacred code' became, by the 1890s, an organised and well-thought-out agenda to protect the cow, which had solidified itself as a symbol of Hindu identity, defined in opposition to the colonial government and the Muslim community. Initially perceived by the British as a law-and-order problem created by a few familiar sources of 'nuisance' (such as the Kukas), the political ramifications became clear by the 1890s when the cow had spectacularly transcended socio-political lines and the movement was far from the handiwork of a few miscreants. Even though the cow had become a palpable problem by the 1870s, it took the riots of the 1890s for the colonial administration to fully register the magnitude of the problem. The cow could no longer be dismissed as just one of the elements in the Hindu-Muslim communal register; it had become an institution unto itself with a 'movement' launched in its name and was emerging as a rallying point for the struggle against the British. Many scholars are of the view that the British policy of 'neutrality' is to blame for the exacerbation of the conflict in the name of the cow, but it has also been posited that for all practical purposes, the British, at least until the late 1880s, were more inclined to side with the Muslims on the matters of the cow (Copland 2005; Groves 2010).

The symbolic appeal of the cow in the Hindu order lies at the heart of any mobilisation in the name of this milch animal. This symbolism has links with (and, many say, origins in) the sacred Hindu texts. But what is of more interest and relevance is the manner in which the sanctity inscribed in the Vedas is 'activated' or 'heightened' to perform the political task of 'standing in' for a community and even a nation. What could have been a dormant or inactive presence in ancient texts is picked up time and again and infused with life and vitality, so it can be called upon to constitute a *community's and nation's sense of self-definition*. It emerges clearly that this becomes possible through an elaborate network of *institutions, conceptual frameworks and practices* that keep alive the symbol of the cow. In fact, it is with the institutionalisation of cow protection in the 1890s, with the formation of cow protection societies, that it acquires the form of a 'movement'. It is through the *institutions* of cow protection societies and *practices* such as lecturing on the merits of the cow, writing incessantly on cow worship and so on that the figures of the *gau rakshak* (cow protector) and the *gau hinsak* (cow violator) are established and certain practices like cow slaughter and beef selling and eating are vilified. Transport and communication networks, rural market relationships, certain aspects of British policy such as the Allahabad judgment of 1887 and production of a large number of pamphlets and other visual materials contribute to the process. Central to

this enterprise is the production of a universe that gives us relevant concepts or frameworks. In my reading, two such *concepts* are central to the maintenance of the 'holy cow' – the installation of a clear binary between what is 'sacred' and 'what is sacrilege' and the gendered imagery of the *gau mata*. We have seen these two ideas at work, consistently, from the early 18th to the late 19th century.

The interplay of the 'sacred' and the 'profane' is central to the cow conflict. Ambedkar has argued that the nature of the 'sacred' is such that

> things sacred are not merely higher than or superior in dignity and status to those that are profane. They ate just different. The sacred and the profane do not belong to the same class. There is a complete dichotomy between the two . . . interdictions relating to the sacred are binding on all. They are not maxims. They are injunctions. They are obligatory but not in the ordinary sense of the word. They partake of the nature of a categorical imperative. Their breach is more than a crime. It is a sacrilege.
> (Ambedkar 1948: 123–125)

Thus, the cow is constituted as a sacred symbol and the act of cow slaughter or beef eating as a sacrilegious practice. It is this tussle between the 'sacred' and the 'sacrilegious' that delineates the contours of the 'cow protection movement'.

The figure of the *gau mata* is as interesting as it is potent. Dissatisfied with the scholarly exercise in deconstructing the trope of the *gau mata*, Van der Veer remarks, 'what is left to be (at least partially) understood is why people would want to die and kill for the protection of cows. Much of the research begs the question of what the cow's body meant to the Hindu protectionist'. The power of the *gau mata* lies in, at once, evoking the trinity of the mother, the goddess and the nation – all of which provide protection to the 'Hindu sons' but also seek protection on account of their vulnerability and an ever-present threat from the 'other'. A failure to protect the nation-mother-goddess (all represented by the 'cow') not only means an assault on the honour of the mother, the goddess and the nation but also signifies a crisis of masculinity for the 'Hindu sons'. To be able to protect the *gau mata*, the Hindu *gau rakshak* must constantly vilify the Muslim (and the British) 'other' and work to eliminate them, so that the glory and honour of the virtuous *gau mata* can be restored.

Even though the 'organisation' around the figure of the *gau mata* starts in the 19th century, we have seen how events and processes starting from the 18th century onwards work towards its crystallisation. I argue that these events must not be placed outside the register of the 'cow protection movement' in India, for that obscures the continuities and shifts in the process of deification of the cow. The figure of the Muslim butcher as the aggressor,

who, over a period, comes to stand in for the entire Muslim community, the active participation of the trading classes, the contentious practice of cow slaughter on a religious festival (typically Bakr Id), fraught caste dynamics and the formation and solidification of boundaries over 'sacred symbols' and 'sacred spaces' are aspects that have characterised instances involving the cow as early as 1714. It will therefore be flawed to view the goings-on of the 19th century as part of a new paradigm or episteme; they are at best more organised germinations of the seeds sown earlier. Further, I have demonstrated that prior to the late 19th century when cow protectors began to organise qua cow protectors, events involving the cow came from distinct registers – the socio-economic relationships of 18th century Ahmedabad and Calcutta under Mughal rule, the revolt of 1857 against the larger backdrop of British rule, the cosmology of the Kukas and so on. The actors involved in these agitations may not have identified specifically as cow protectors or *gau rakshaks* even though cow protection was a significant part of their symbolic moral order. The vignettes that I have analysed here must not be seen as the components or parts that simply add up together to produce a singular, cohesive 'whole' of the 'cow protection movement'; instead, it would be productive to see them as pieces of varying shapes and textures that are embedded in their own contexts and histories and therefore constitute stories in themselves that can nonetheless be stitched together to form a mosaic that can tell us *one of the stories* of cow protection in India.

In contemporary times, when the figure of the cow has once again made a spectacular reappearance, it is extremely important to contextualise the current moment through a historical route to better understand how the cow came to be what it is and what/who made it so. This chapter hopes to contribute to precisely this act of rendering the present intelligible through a critical scrutiny of not only the past but also its scholarly narrativisation.

Notes

1 There exist other, even if sparse, references to Muslims who not only venerated but also laid down their lives for the holy cow. Amin (2015) shows how Saint Ghazi Miyan, known to be a warrior in the 11th century, was a protector of cows and gave up his own life to save those of his cattle. This narrative is however complex, with Ghazi Miyan also depicted as the spokesperson of Islam who was interested in cows only for their meat.
2 For explanation of the intricacies of the economic context and relationships of the period, see Najaf Haider, 'The Monetary Basis of Credit and Banking Instruments in the Mughal Empire' (2002).
3 For the castes and sub-castes included in the umbrella category of 'Hindu' here, see Haider (2005).
4 There is much to be said about the construction of notions of 'riot' and 'revolt' and a series of allied ideas – 'mutiny', 'protest', revolution, 'uprising' and so on. I do not delve deep into the politics of naming in this chapter, though suffice it to note that the labeling of a certain event as one and not others has much to do with

who is naming and for what purpose. In this case, the naming of certain events unproblematically as 'riots' perhaps has to do with our understanding being mediated largely through colonial records.
5 For this section, I am particularly indebted to Harjot Oberoi's (1992) incisive analysis of the 'Kuka Sikhs', their history, political economy and symbolic order.
6 This fact has been arrived at by scholars through much painstaking research, which involved visits to Kathiawar, interviews with witnesses and their comparison with fragments from Dayanand's accounts of his own life on two occasions. This has been an area of scholarly struggle because of his deliberate and open attempt to conceal his identity. See Jordens (1960) for reasons for the same.
7 Jordens (1960) makes a distinction between Dayanand's economic and Gandhi's emotional-symbolic attitude to cow protection. For Gandhi, the cow was a 'symbol of the entire sub-human world', and cow-protection was the 'essential ritual of his religion'.

References

Amin, Shahid. 2015. *Conquest and Community: The Afterlife of Warrior Saint Ghazi Miyan*. New Delhi: Orient Blackswan.
Ambedkar, B. R. 1948. *The Untouchables: Who Were They and Why They Became Untouchables*. New Delhi: Amrit Book Company.
Bayly, C. A. 1985. 'The Pre-History of "Communalism"? Religious Conflict in India, 1700–1860'. *Modern Asian Studies*, 19 (2): 177–203.
Bennett, John William. 1967. 'On the Cultural Ecology of Indian Cattle'. *Current Anthropology*, 8: 251–2.
Copland, Ian. 2005. 'What to Do About Cows? Princely Versus British Approaches to a South Asian Dilemma'. *Bulletin of the School of Oriental and African Studies*, 68 (1): 59–76.
Dandekar, Vinayak Mahadev. 1969. 'India's Sacred Cattle and Cultural Ecology'. *Economic and Political Weekly*, 4 (39): 1559–66.
David, Saul. 2003. *The Indian Mutiny: 1857*. London: Penguin Adult.
Diener, Paul, Donald Nonini and Eugene E. Robkin. 1978. 'The Dialectics of the Sacred Cow: Ecological Adaptation Versus Political Appropriation in the Origin of India's Cattle Complex'. *Dialectical Anthropology*, 3 (3): 221–41.
Freitag, Sandra. 1980. 'Sacred Symbol as Mobilising Ideology: The North Indian Search for a "Hindu" Community'. *Comparative Studies in Society and History*, 22 (4): 597–625.
Glucklich, Ariel. 1997. *The End of Magic*. Oxford: Oxford University Press.
Groves, Matthew. 2010. 'Law, Religion and Public Order in Colonial India: Contextualising the 1887 Allahabad High Court Case on "Sacred" Cows'. *South Asia: Journal of South Asian Studies*, 33 (1): 87–121.
Gupta, Charu. 2001. 'The Icon of Mother in Late Colonial North India: "Bharat Mata" "Matri Bhasha" and "Gau Mata"'. *Economic and Political Weekly*, 36 (45): 4291–9.
Haider, Najaf. 2002. 'The Monetary Basis of Credit and Banking Instruments in the Mughal Empire'. In Amiya Bagchi (ed.), *Money and Credit in Indian History*. New Delhi: Tulika Books, 181–205.
———. 2005. 'A "Holi Riot" of 1714: Versions from Ahmedabad and Delhi'. In Mushirul Hasan and Asim Roy (eds.), *Living Together Separately: Cultural India in History and Politics*. New York: Oxford University Press, 127–44.

Harris, Marvin. 1965. 'The Myth of the Sacred Cow'. In A. Leeds and A. P. Vayda (eds.), *Man, Culture and Animals*. Washington, DC: American Association for the Advancement of Science, 217–28.

———. 1966. 'The Cultural Ecology of India's Scared Cattle'. *Current Anthropology*, 7 (1): 51–9.

———. 1974. *Cows, Pigs, Wars, and Witches*. New York: Vintage Publishers.

Hibbert, Christopher. 1978. *The Great Mutiny: India 1857*. New York: The Viking Press.

Jha, Dwijendra Narayan. 2009. *The Myth of the Holy Cow*. New Delhi: Navayana.

Pandey, Gyanendra. 1983. 'Rallying Around the Cow: Sectarian Strife in the Bhojpuri Region, c.1888–1917'. In Ranajit Guha (ed.), *Subaltern Studies II*. New Delhi: Oxford University Press.

Patel, Hitendra. 2011. *Communalism and the Intelligentsia in Bihar, 1870–1930: Shaping Caste, Community and Nationhood*. New Delhi: Orient Blackswan.

Pinch, William. 1996. *Peasants and Monks in British India*. Berkeley: University of California Press.

Pinney, Christopher. 1997. 'The Nation (Un) Pictured? "Chromolithography" and Popular Politics in India'. *Critical Inquiry*, 23 (4): 834–67.

Jones, Kenneth. 1976. *Arya Dharm: Hindu Consciousness in 19th Century Punjab*. Berkeley: University of California Press.

Jordens, J. T. H. 1960. *Dayanand Sarasvati: His Life and Ideas*. New Delhi: Oxford University Press.

Oberoi, Harjot. 1992. 'Brotherhood of the Pure: The Poetics and Politics of Cultural Transgression'. *Modern Asian Studies*, 26 (1): 157–97.

Oldenberg, H. 1894. *Die Religion des Vedas*. Berlin: W. Hertz.

Rizvi, S. A. A. 1980. *Shah Wali-Allah and His Times*. Canberra: Ma'Rifat Publishers.

Robb, Peter. 1986. 'The Challenge of Gau Mata: British Policy and Religious Change in India, 1880–1916'. *Modern Asian Studies*, 20 (2): 285–319.

Saraswati, Dayanand. 1881. *Gokarunanidhi*. Allahabad: Vedic Yantralay.

Simoons, Frederick J., Frederick I. Simoons and Deryck O. Lodrick. 1981. 'Background to Understanding the Cattle Situation of India: The Sacred Cow Concept in Hindu Religion and Folk Culture'. *Zeitschrift für Ethnologie*, 106: 121–37.

Upadhyay, Shashi Bhushan. 1989. 'Communalism and Working Class: Riot of 1893 in Bombay City'. *Economic and Political Weekly*, 24 (30): 69–75.

Van der Veer, Peter. 1994. *Religious Nationalism: Hindus and Muslims in India*. Berkeley: University of California Press.

Yang, Anand. 1980. 'Sacred Symbol and Sacred Space in Rural India: Community Mobilisation in the "Anti- Cow Killing" Riot of 1893'. *Comparative Studies in Society and History*, 22 (4): 576–96.

Part III

GENERIC ALTERITIES OF REPRESENTATION

8

ARISTOCRATIC HOUSEHOLDS DURING THE TRANSITION TO EARLY MODERNITY

Representation of domesticity in an Indo-Muslim 18th-century biographical compendium

Shivangini Tandon

The 18th century in South Asia saw a qualitative profusion in the manuscript culture, accompanied with a diffusion of multiple forms of literary traditions. While the tradition of memorialising lives in the Islamic world goes way back in time, the 18th century saw the tradition taking a distinctive shape in South Asian history. A large number of biographical compendia were written in the period, reflecting an effort to appropriate literacy to reproduce social memory and forms of remembrance. Written with the intention of creating a repository of the collective memories, these biographical compendia, called *tazkirahs*, represented individual lives in idealised terms, as models of remembrance and imitation. While the rich empirical details are indeed historical, the overall life-narratives are didactic and are intended to serve as models of ideal manhood and norms of civility and deportment in Indo-Muslim aristocratic culture. One of the objectives of this chapter is to recover similarities and shifts in the norms of manliness and social perceptions of ethical life during the period of the transition to early modernity between the 18th and 19th centuries. Focusing on a particular genre of Indo-Islamic writing – the *tazkirah* – my chief concern is with the literary representation of these shifts in the norms of manliness and gender relations in the household.

The word *tazkirah* means a 'memorial' or a 'memorative communication' (Hermansen 2002: 3). Etymologically, *tazkirah* is derived from an Arabic root meaning 'to mention, to remember' (Pritchett 2004: 64). *The Encyclopedia of Islam* defines it as a memorial, memorandum, derived from *dhakara*, which means 'to record'. The early modern *tazkirahs* were organised

and structured with the objective of constructing and representing an Indo-Islamic space in South Asia. In recalling the lives of influential persons, they reconfigured a new discursive space – urbane and cosmopolitan, exclusive and elitist and transcendental and sacred. These collective biographies were usually hagiographical in nature and were largely concerned with representing the lives of the elites in a manner that served to legitimise their social and political dominance in society. At the same time, operating within a shared normative system, the *tazkirahs*, as has been argued by Bulliet, 'preserved the view from the edge,' as it were, incorporating details about the lesser human beings (Pritchett 2004: 64), particularly in cases where they reinforced the ideologies of dominance and control.

Limited in their perspective to the investigation of the lives of individuals, biographies are presumed to be of little relevance in exploring the larger forces of historical change. With the waning of the teleological, unilineal view of history, historians are now beginning to realise the need to place human experiences, emotions and subjectivities in the historical narrative. And with it has come the realisation that biographies are not simply individual life stories but are studies of the incessant interaction of the individual self with the wider socio-cultural forces, in diverse temporal and spatial contexts (Nasaw 2009: 576). In fact, the recent writings on the genre of biographies refer to it as a narrative that is more collective than individual – less about the carefully crafted public self and more about the self-in-society (Malhotra and Hurley 2015: Introduction). The Mughal *tazkirahs* are an extremely useful, if relatively unexplored, source for understanding Mughal court culture, its norms and values, in active interaction with the relations of power.

For a long time, the 18th century was viewed as 'a dark century', a period of stasis and decline. During the last couple of decades, historians have been arguing that the period was marked by considerable socio-economic development and expansion in production activities, merchant capital and manufacture. The 18th-century growth led to the emergence of new social classes, in particular a homogenous merchant community, autochthonous service gentry and enterprising artisans[1] (Hasan 2004: 94). It also prompted the emergence of new socio-political formations, such as the Marathas, the Sikhs, the Jats, the Satnamis and so on.[2] Indeed, this was a period of considerable flux and change in South Asia, and the biographical dictionaries written in the period capture these changes in their biographical sketches. One of the changes that is indicated in these *tazkirahs* lies in the organisation of familial and household spaces. It is these changes and their literary representation that I explore in this chapter.

In exploring these issues, I have chosen a North Indian *tazkirah*, *Ma'asir-ul-Umara*,[3] that was written in Persian by a high Mughal official, Shah Nawaz Khan, in the 18th century. Shah Nawaz Khan belonged to the family of the Saiyids of Khwaf. His real name was Mir 'Abdur- Razzaq, and his

ancestor Mir Kamalu-d-Din came to India from Khwaf in the time of Akbar and became one of his chief servants (Fazl 1993: II, 34). In the beginning, he had an office on the establishment of Nawab Asaf Jah, and sometime after, he was appointed to the imperial *diwani* of Berar. He was long in this office and discharged the duties well. He was a good poet and was well versed in the Persian idioms (Shah Nawaz 1999: I, 12–27). *Ma'asir-ul-Umara*, which was a biographical dictionary of the Mughal nobles and bureaucrats from AD 1500 to about 1780, could well be described as a political *tazkirah* in that the focus here is on the lives of nobles, aristocrats, high bureaucrats and petty officials. I have chosen this biographical dictionary because it not only throws light on their activities in the political sphere but also on their personal and domestic activities. The detailed description in the work on aristocratic households allows for an investigation of the emotions and affect in the households,[4] suggesting important continuities with the modern, domesticated households in the 19th century. At the same time, the insistent articulation of the household as a political space in the *tazkirah* helps us recover the political agency of the elite and aristocratic women and the shifting gender relations in the domestic spaces in the 18th century.

For us to understand these shifts, it would not be without merit to compare and contrast the 18th-century *tazkirah*, in our case *Ma'asir-ul-Umara*, with one written earlier in the 17th century, as for example, Shaikh Farid Bhakkari's *Zakhirat-ul-Khawanin* (written in 1651).[5] Both the Persian *tazkirahs* are written by nobles of the Mughal Empire, and both of them are 'political *tazkirahs*' in the sense that they are predominantly concerned with recording the lives of the nobles, aristocrats and state officials. Shaikh Farid Bhakkari, the author of *Zakhirat-ul-Khawanin* belonged to a respected family of Bhakkar (Sind). The exact year in which Bhakkari joined the Mughal service is unknown, but in 1592, Emperor Akbar had granted *mansabs* to him, his sons and his relatives. In 1614, Shaikh Farid was appointed by Emperor Jahangir as *diwan* of the *jagir* of Nur Jahan, a post which he held for a long period. Finally, in January 1649, he was appointed to the post of *Amin* and *Waqianawis* of a dozen fortresses in the Deccan, where until the completion of his book (i.e., 1651), he remained posted. Bhakkari was well versed in Arabic, Pushto and 'Hindavi'. His literary accounts reflect a sense of objectivity, being free from any personal prejudice (Rezavi 1986: 24–36). Comparing the two texts would help us better understand the 18th-century transformations and transitions in the organisation, gender relations and emotions in the household.

Representing individual lives, households and emotions

The *tazkirahs* are not simple biographical narrations but discuss the life stories of individuals in their rooted social contexts. In the biographies written in the early modern period, the household, and the relations within the

household spaces, provided a socially significant and perhaps the primary context to the narration of lives. They reveal interesting details about the structure and organisation of households and, in particular, help us recover transformations (and continuities) in the articulation and representation of emotions in the intra- and inter-household spaces. Indeed, the 18th century in South Asia saw important shifts in the nature and organisation of the household. The *tazkirahs* are an important genre of sources that can help us recover these shifts.

In the early modern political biographies, life stories are narrated within a community-centred frame of reference. They do not describe the lives of their subjects in isolated, de-contextualised terms, removed from the wider social world, but rather as stories of persons whose lives were enriched by household and familial relations. In their description of the political process and the activities of the ruling classes and the aristocracy, the *tazkirahs* reveal the complex imbrications of household with imperial sovereignty. Indeed, in our anxiety to present the state as a 'centralised-bureaucratic' structure, we have tended to focus on the formal institutions of rule and have ignored the strength of informal alliances and intimate relations emerging from the spaces of the household in shaping imperial sovereignty (Ali 1978: 38–49; Habib 1999; Moosvi 1987).

Looking at these *tazkirahs* as providing idealised representations of manhood, I read them within a diachronic frame of reference and looked for shifts in representation when we move from one text to the other. I explore these *tazkirahs* as sources to study the shifts in mentalities and the social and cultural processes from the 17th to the 18th century. In attempting to do so, one of the concerns of this chapter is to examine the shifts in the representation of the household and emotions within its spaces. One of the noticeable themes in these biographical dictionaries is that state formation and household activity are both represented as part of the same process; the household and the state are depicted as deeply entwined with each other. In studying the *tazkirahs* as cultural texts discursively reproducing power relations, my study reveals important shifts in representations that one witnesses in the 18th century. These shifts, I argue, were a result of profound socio-economic changes occurring in the period, marked by, as suggested earlier, the decline of the Mughal Empire, the emergence of autochthonous gentry and homogenous merchant communities and new forms of political formations (Alavi 2002; Alam 1986; Bayly 1983).

Bhakkari's biography presents the household space as open ended and diffused, marked by the incorporation of servants, slaves and concubines into the structure, organisation and meanings of the household. Here, the pride of place is assigned to the life stories of the influential nobles, saints and scholars. It often makes incidental, if still significant, references to the networks of clients and servants that sustained their prestige, authority and lavish lifestyles. The evidence in this *tazkirah* indeed suggests that the

ARISTOCRATIC HOUSEHOLDS

master-slave relations were imbued with intense emotional investment in the prevailing social norms (Bhakkari 1993: I, 223). For instance, Bhakkari writes,

> It is often said that apart from giving huge sums in charity or in the form of salary to her slaves, Nur Jahan also took the responsibility of marrying the lady attendants (*saheliyan*) of the royal harem ranging in age from twelve to forty to the *ahadis* and *chelas* of the king.
>
> (Bhakkari 1993: II, 15)

Services of some of these groups, in fact, get a detailed treatment in these biographical narratives. These peripheral groups are remembered in these *tazkirahs* for their loyalty, steadfastness and service towards their masters and the empire in general. In addition to the mention of nobles being granted high ranks, the *tazkirahs* are replete with detailed descriptions of the slaves and eunuchs who were appointed in the service of the Mughal kings and nobles, ensuring the memorialisation of their lifelong service and personal sacrifice to their masters. The biographies refer to several instances where the devotion of the slave and the master-slave bond led to the elevation of the slave to high positions in the political dispensation. For instance, 'Baqi Khan Chela Qalmaq was a slave (*chela*) of Shah Jahan, who because of his loyalty was given a rank of 100 *zat* and 1000 horse and was eventually made the *faujdar* of Catra' (Shah Nawaz 1999: I, 380–1).

Similarly, there is mention of one I'timad Khan Gujarati, a Hindu slave of Sultan Mahmud (the ruler of Gujarat). Shah Nawaz states the following: 'as the sultan had full confidence in him he appointed him in his harem and assigned to him the adorning of women' (Shah Nawaz 1999: I, 93–100). Then there is mention of Firuz Khan, the eunuch who was one of the trusted servants of Jahangir and was awarded with a high rank of 3,000 *zat* and 1,500 *sawars*. *Ma'asir* states that 'he had charge of the palace, and he was respected and honoured in Shah Jahan's service. He even built a garden on the banks of the Jhelum (Shah Nawaz 1999: I, 564–5).

Even lower-caste servants and menial groups are represented in our *tazkirahs* as moving up the social ladder. Interestingly, there is evidence of some among them ending up as high bureaucrats and petty nobles in their own right.

> A significant case is that of Mihtar Khan *khassa-khail*, a simple gatekeeper of the harem during Humayun's time and a 'bufoon'. He neither had the sophistication nor the 'high culture' that was the pre requisite for becoming a *Mirza*, yet he is praised by Bhakkari for his manliness and bravery.
>
> (Bhakkari 1993: I, 223)

Similarly, there is mention of Miyan Gada Kalal, a wine seller. While referring to him, Bhakkari says that 'he had earned a good name in respectability and worthiness. (Bhakkari 1993: I, 181). These details from the *tazkirah* undermine the picture of objectification and total subjection that we get from the legal documents of the period (NAI 2382/43).[6] There is, instead, evidence of considerable investment of emotions in the slaves in the domestic establishments. One of the reasons, perhaps, for this lies in the fact that in the prevailing norms of manliness, marked by consumption and connoisseurship (Hanlon 1999: 47–93), domestic servants and slaves were necessary for the maintenance of the norms of civility and deportment. Around 18th-century India, the norms of masculinity were articulated within the spaces of the household by the maintenance of gentlemanly prestige; elite hospitality; shared attractions for personal refinement, which drew like-minded men to one another; and intense concern to establish spatial and physical boundaries with the culture of servants, menials and the bazaar (Hanlon 1999: 47–93). The concern for proper deportment lay behind the huge charitable activities that are described in great detail by our *tazkirahs*. It also informed the patronage that the aristocratic households provided for cultural activities; indeed, they spent a large part of their resources in patronising poets, musicians, dancers and so on.

In the detailed descriptions that the *tazkirahs* provide about the cultural activities that were undertaken in the households of the nobles and aristocrats, they are actually seeking to represent these households as modest imitations of the imperial court, carrying the concerns of the court forward into the localities. In the 'expansive household' model, therefore, services were sought from various groups and ties of patronage and dependency were not limited to slaves and servants working within the household but were also extended to the professional community of musicians (*kalawants*), courtesans, hawkers and so on. Their services were solicited in household feasts and festivities, and their presence was crucial to lend civility and grace to aristocratic households. Other servants were also maintained for display, which was a crucial feature of the early modern period in India:

> one servant for marching on the side of the palanquin holding a spittoon, two more to fan the master and to drive away the flies, four footmen to march in front to clear the way and a number of decorated horsemen; and a *kafshbardar* to keep or carry shoes.
> (Bhakkari 1993: II, 143)

Comparing the two biographical dictionaries, we notice a gradual shift in the organisation and representation of the household and relations within the household spaces. During the 18th century, one notices a firmer redrawing of the boundaries of the household, and the slaves and servants are now increasingly seen merely as service providers and no more a part of

the household relations. There is a corresponding shift in the representation of the household servants, and, in some of the texts written in the 19th century, they are either treated with absolute indifference or contempt and disdain. For instance, it is evident in the 19th-century novel *Mira't-ul-'Urus* by Deputy Nazir Ahmad, which is a tale of two sisters, Akbari and Asghari. Though Asghari was a valued member in her in-laws' home, she runs into trouble because of a female servant of the household, Mama Azmat. Nazir Ahmad writes, 'Azmat was presiding over the household for decades, controlling all purchase, all loans and debts, all transactions involving the women's jewels and, in the process, cheating and stealing to her heart's content' (Ahmad 1869: 68).

The shifts in discourse, as can be gleaned from a comparison of the two *tazkirahs*, were a result of changes in the socio-economic and cultural environment. I do not treat discourse as autonomous, nor do I see the political and social institutions as autonomous either. Instead, one of my efforts is to reveal discourse and socio-political forces as being mutually constitutive, one moulding and reshaping the other. Indeed, the *tazkirahs* validated certain elements of aesthetics, literary refinement and socio-cultural structures, but they were also discourses of power and identity formation, reproducing the categories of the socially inferior 'other' in the process of reiterating the self-identity of the elites in Mughal India. The representation of the marginalised and inferior social groups in these works thus served the objective of highlighting the structures of control and domination.

Re-defining manliness, loyalty and imperial service

There are prominent shifts in representation when we examine the two political *tazkirahs* together. To take one instance, *Zakhirat-ul-Khawanin* assigns a lot of significance to the architectural activities of the nobles and talks at length about the construction of mosques, tombs, *sarais*, forts and mansions as if to represent these activities as constitutive of an ethical life. The importance assigned to building activities disappears in *Ma'asir-ul-Umara*, and there is scarcely ever a discussion about the construction of a mosque or a *sarai* by a noble or an aristocrat (Hermansen and Lawrence 2000: 168–9). It could be argued that this shift in narrative reflected a change in notions of ideal manhood and appropriate norms of elite deportment. By the 18th century, manhood in the elite Indo-Muslim world was no more congruent on building places of worship or public benefit. This was because, as I argue in this chapter, norms of manliness were now less dependent on 'public performances' but were tending to become largely a function of appropriate behavior and disciplined sexuality within the domestic spaces. Martial behaviour within open, outside spaces was no more constitutive of manhood, but manhood instead moved within the domestic domain (Hanlon 2007a: 500). Manliness in the 18th century had come to be defined

not just by what elite men did in the world outside (*birun*), in homosocial spaces, but also by their conduct in the domestic sphere (*durum* – comprising a large number of slaves, attendants and eunuchs, apartments of wives, external apartments and kitchens) as well.

There are interesting details in our *tazkirahs* about feasts at home, the decoration of homes, guests and their entertainment and so on. This obviously gave the 'household' a privileged place, as it constituted a space inhabited by actors; a pattern of social, economic and ritual activity; and a system of social relations, economic arrangements, cultural meanings and moral and emotional patterns. It is, therefore, not surprising that the *tazkirahs* are replete with detailed descriptions of the Mughal culture of feast and the grand parties that were hosted by the nobles in their households. For instance, Bhakkari, in his *tazkirah*, gives details of the elaborate preparations that a Mughal noble Zain Khan Koka made when he hosted a party in the honour of Akbar. For instance, 'tanks were filled with rose water, preparations of a syrup of milk mixed with sugar blended with *yazd* roses was served to the guests, and the entire sitting space was sprinkled with *yazd* rose water' (Bhakkari 1993: I, 123–4).

Knowledge about music was another attribute of manliness that was desirable in a *mirza*, or an ideal man. A *mirza* had to have both aesthetic tastes and bodily discipline. *Zakhirat-ul-khawanin* mentions a large number of nobles who were patrons of musicians and men of letters. Isa Beg Tarkhan composed Hindi and Sindhi songs and was well versed in vocal and instrumental music (Bhakkari 1993: II, 207). Shah Nawaz Khan, the author of *Ma'asir-ul- Umara*, himself had a special liking for music, and arranged for musical gatherings where a large number of kalawants and players of *rubab* (lyre) and *bin* (*vina*) would come to display their skills (Bhakkari 1993: II, 217; Schofield 2010: 490).

With the centralisation of the Mughal Empire, the emperor's body had become the location of sovereignty, and the king had come to be seen as a patriarch and the kingdom as his personal household (Blake 1979: 278–303). This state-household compact, in the 18th century, gave rise to a novel sense of manliness that involved maintenance of gentlemanly prestige, elite hospitality and shared attractions of personal refinement, which drew likeminded men to one another (Hanlon 1999: 68). There arose an intense concern to provide a context for interactions between the elites, the working class (servants, menials) and the *bazaar*. This notion of masculinity was indeed very different from the one of the 17th century; defined as *khanazadi* (Metcalf 1984: 255–89), it meant devoted, familial, hereditary service to the emperor. Though the term defined proper behaviour and attitudes for the Mughal nobles or *amirs* and so was basically elite in character, these codes of elite chivalry, courage and honour had trickled down to the wider society. These elite norms of manliness tied to imperial service, which undergo a sustained shift in the 18th century, find their resonance in *Ma'asir-ul-Umara* as

well. Congruent upon the decline of the Mughal Empire and the emergence of such political rivals as the Sikhs, Marathas, Jats and so on, the norms of manliness lost their entangled connections with imperial service, but more important, it was not martial vigor or bodily strength that defined manliness, but, as has already been discussed, it was refined tastes, literary skills and aesthetic appreciation and knowledge that did so.

The rapid diffusion of the culture of poetic assemblies, or *mehfils*, was another important consequence of the shift in norms of manliness. *Ma'asir-ul-Umara* refers to the patronage to these poetic assemblies by the notable men, and one gets a sense from the work that this had become an elite norm of deportment during the period. The development of *mehfils* as sites of cultural and literary interaction reflected the newfound emphasis on culture and literary pursuits as constituting the norms of manliness in the 18th century. Interestingly, the elite *mehfils* posed a challenge to spatial divisions based on class and gender (Orsini 2006: 67). Mughal elite spaces were sharply segregated by class, status and gender, where a woman's domain was circumscribed and sealed off visually and physically by the wall of the *haram*. This created the idea of a forbidden space where men could exercise their domination/control by keeping their women veiled and away from the gaze of other men (Schofield 2012: 150–71). However, at these *mehfils*, men and women came in contact with each other through the figure of the courtesan (Orsini 2006: 62). Court chronicles, like *Tuzuk-i – Jahangiri*, refer to them as 'charmers of India', who 'kept up the excitement of the assemblies' (Beveridge 1909: 48–9). Both *Zakhirat-ul-Khawanin* and *Ma'asir-ul-Umara* make interesting references to the courtesans, and different classes of dancing girls appear in the biographical accounts – the *Domnis*, *Patars*, *Kumachnis*, *Pari-Shans* and *Lulis* (Bhakkari 1993: 110). These formed distinct caste groups, and there were specific castes of male entertainers, such as *bhagatiyas*, *bhands* and *kalawants* (Bhakkari 1993: 214). Even so, comparing the two texts, one gets the sense that the role of the courtesan in shaping the literary culture had come to be viewed as crucial only in the 18th century. We return to this issue in the following section, when we try to chalk out the transitions in the norms of masculinity during the period of early modernity.

Masculinity in transition: normative codes during early modernity

In Indo-Persian historical narratives, a reference to the protagonist's love of wine, women and music is often used to signal his imminent downfall (Orsini 2006: 63). To cater to these 'irrational' whims of the lower self (the *nafs*) was considered to be a potential threat to masculine control. Elite masculinity was defined in opposition to the shortcomings that women and people of lower status suffered from (i.e., passivity, powerlessness and lack of control)

(Hanlon 1999: 53). Emphasising discipline and self-control as constitutive elements of masculinity, Shah Nawaz Khan in *Ma'asir-ul-Umara* says,

> [W]ine should be consumed only during certain seasons and in fixed quantity. Similarly, music should be selectively consumed, only when one feels melancholic and lonely. Wine and music should not be made the great objects of life, and nobody should be wasting away precious hours on it.
>
> (Shah Nawaz 1999: I, 394–5)

In Mughal court culture, an explicit expression of one's emotions was considered to be an unmanly and a feeble act. Since to love was 'to lose control' and to be seduced by the erotic power of the passive partner, it was perceived as a threat to the social and political order. Shah Nawaz Khan in *Ma'asir-ul-Umara* attributes the defeat of Baz Bahadur by Rani Durgavati and a decline in his overall power to his habit of drinking and engagement in all kinds of pleasures. He says,

> He [Baz Bahadur] let the foundation of his power go to the winds and the waves, that is, he became so addicted to wine and music... employed all his energies in collecting dancing girls, particularly Rupmati [the head of the troop] for whom he wrote Hindi love songs.
>
> (Shah Nawaz 1999: I, 394–5)

Similarly, Aurangzeb had to renounce music (and his love for a courtesan, Hira Bai Zainabadi), as he thought that it was leading him astray, leading to his political downfall (Shah Nawaz 1999: I, 806–7).

However, an interesting point to note here is that as long as the markers of gender/class difference remained undisturbed, expression of intimate feelings even towards the lower classes, slaves or dancing girls, was not considered unacceptable (Orsini 2006: 71). *Ma'asir-ul-Umara* mentions the love of Faqirullah for his intimate male companion, the poet Miyan Shah Nasir 'Ali (Shah Nawaz 1999: I, 686). For the same reason, even as the courtesans / dancing girls were seen as a potentially subversive force, capable of destroying familial order, they were tolerated in the household spaces, as long they did not threaten the social arrangements and intra-household hierarchies. Even so, the social acceptability of the courtesans and dancing girls only seems to have increased during the 18th century, and this is not only suggested by Shah Nawaz Khan but other sources as well. Shah Nawaz Khan's *tazkirah*, as mentioned earlier, makes repeated reference to the aristocrats and nobles providing lavish patronage to dancers and courtesans (Shah Nawaz 1999: I, 806–7). Similarly, Ghulam Mushafi makes multiple references to the dancing girls and courtesans participating in the literary

culture in the 18th century (Mushafi 1980: 316–18). In addition, Dargah Quli Khan, in his *Muraqqa-i-Dehli* gives a detailed description of the socio-cultural life in the city of Delhi during the 18th century and provides vivid and detailed descriptions of dancers and concubines entertaining audiences in the busy markets of Chandni Chowk. (Khan 1982: 36).

Interestingly, the *tazkirahs* refer to the elite household as centres of cultural activities, in particular dance and music. In fact, both *Zakhirat-ul-Khawanin* and *Ma'asir-ul-Umara* highlight the fact that around the mid- to late 17th century, elite men in the Mughal milieu were actively patronising Hindustani music (Bhakkari 1993: I, 217). The *kalawants* were the favoured imperial musicians who received the highest prestige of all musicians in North India (Bhakkari 1993: I, 218). *Zakhirat-ul-Khawanin* mentions a large number of nobles who were patrons of musicians and men of letters. For instance, 'Isa Beg Tarkhan, a Mughal noble, composed Hindi and Sindhi songs and was well-versed in local and instrumental music' (Bhakkari 1993: I, 207). Apart from musicians, poets too flourished at the court of the Mughals. One such poet was Bebadal Khan Saidai Gilani. He had come to India during the time of Jahangir. He received the title of *Bebadal* (Incomparable) for his poetic skills. When, in the course of seven long years, he finished the jeweled peacock throne, he was weighed against gold as a reward (Shah Nawaz 1999: I, 396–9).

Indeed, in Mughal court culture, the nobles and aristocrats lavishly patronised music, dance and poetry (Neuman 1990: 28). While this seems to have remained unchanged throughout the Mughal period, one notices some perceptible changes in the literary representation of these activities. When we compare the two *tazkirahs*, we notice that in the *tazkirah* written in the 18th century, there is a far more detailed description of the patronage to poetry and music by the influential elites than is the case with the one written earlier in the 17th century. Shah Nawaz Khan himself had a special fondness for music and arranged for musical gatherings in his house where a large number of *kalanwats* and musicians skilled in *rubab* and *bin* would drop in to display their skills (Shah Nawaz 1999: I, 217). At the same time, appreciation of the aesthetics of art is related to its knowledge, and awareness of the intricacies of dance and music are represented as crucial to notions of ideal manhood (Shah Nawaz 1999: I, 396). This could be related to shifts in the perception of manhood, for as has been argued by Rosalind O' Hanlon, the 18th century saw the growing displacement of martial valour (or *jawanmardi*) and loyal service (or *khanazadi*) with gentlemanly connoisseurship (or *mirzai*) as constituting ideal norms of manliness. In 18th-century India, the term *mirza* had a primary and a secondary meaning. In the primary sense, it has been defined by Arzu as 'used formerly in the titles of kings and princes, and now by noblemen and their sons; also used in Iran for the Sayyids' (Hanlon 1999: 70). It has been defined in the secondary sense by another 18th-century Indian lexicographer, Shad, as 'a

manly person held in esteem by people' (Ahmad 1975: 108). Apart from a pure and high pedigree, a high rank and dignified manners, a gentleman (or a *mirza*) in the 18th century was expected to be well-versed in ethics, history and poetry and adept in the etiquette of dining, music, speech, riding, hunting and bathing (Hanlon 1999: 68). For instance, *Ma'asir-ul-Umara* describes one (*mirza*), Abu S'aid, who was the grandson of I'timadu-d-Daulah as follows:

> He was famous for his beauty and princeliness, and he had great taste both in dress and food . . . in ornamentation and style and in all worldly matters he was distinguished . . . he was so haughty and mighty that he regarded neither the earth nor the heavens.
> (Shah Nawaz 1999: I, 141)

In a nutshell, therefore, an ideal man in the 18th century was not just defined by his martial valour or his loyalty to the empire but rather on the basis of consumption, cosmopolitan outlook and refined aesthetic tastes. These shifts in the notion of manliness prompted a restructuring of the household spaces in the 18th century.

As mentioned earlier, dancers, musicians and poets are remembered in the *tazkirahs* as receiving patronage from the nobles and aristocrats. This brought the elite in contact with the professional groups involved in dancing and music. Finding themselves excluded from the *musha'iras* (or poetry recitation assemblies which were usually inter-elite affairs and were convened in the houses of respectable and learned elites), the common people created alternative spaces – in the bazaars, the fairs, *qahwa khanas* (coffee houses), *mehfil* and the festivals (and later in the 19th century, the *kothas* [The place where the courtesan entertains visitors] of dancing girls or *tawaifs*) – to express themselves in the domain of art, literacy and aesthetics (Hasan 2005: 102–3). These were spaces where the common people could participate in instituting, maintaining and contesting the elite norms, and several historians have flirted with the idea of calling these spaces the 'public sphere'. Though its existence in pre-colonial India can be debated, there are innumerable examples of the existence of spaces of inter-subjective communication and dialogue in the form of *bazaars*, *mushairas* and so on.

These public spaces became arenas of debate on the events and policies at the Mughal court and provided an opportunity to the subordinate sections to discuss/institute/contest the elite normative structure and framework of values and in the process manipulate its ambiguities in their favour (Bhargava and Reifeld 2005: 84–105). Bhakkari mentions the appointment of one person to write down the public gossip circulating in the marketplace and in the lanes (Bhakkari 1993: I, 45). The author of *Ma'asir* also makes references to the spaces of inter-subjective communication, and

while these spaces were in existence earlier in the period, it was only in the 18th and early 19th centuries, perhaps, that such spaces were getting to become independent of the state and socially inclusive as well (Shah Nawaz 1999: I, 686).

Incorporating deviance and alternative normative frameworks

The references to marginal/deviant groups in the *tazkirahs*, intended to memorialise the elite men, shows that power does not always suppress the inter-subjectivity of human agency but instead also creates spaces wherein an individual can negotiate for spaces of personal assertion/autonomy. These *tazkirahs* testify, if reluctantly, to the presence of marginalised groups and communities in the aristocratic households. They are also depicted as playing a crucial role in the Mughal imperial court culture, as well. Bhakkari makes frequent references to servants like the *khawas* (personal attendants), *qurchi* (house-guards), *sharbatdars* (drink-servers), *abdars* (water-men) and *toshakis* (keepers of the wardrobe) on whose services the imperial court rested (Bhakkari 1993: II, 97).

A careful study of the *tazkirahs* reveals that eunuchs came to play a very prominent position in both the political as well as the domestic sphere of the Mughals. One could, for example, take the case of Itimad Khan, a eunuch-officer who was entrusted at Akbar's court with a very important charge of administering the finances of the state (Bhakkari 1993: II, 216). The stature a eunuch officer could achieve can be gathered from an episode from Jahangir's reign, of Khwaja Hilal with Said Khan Chaghta, a leading noble at Jahangir's court. He had built a lofty mansion and used to regularly call both the king as well as the nobles for house-warming feasts (Bhakkari 1993: II, 216–17). Though the sources of the period mainly speak about the special qualities of the chosen eunuch officers, we find that their slave status and physical condition came in the way of gaining wider social respectability (Mohammad 1961: 218), and while the biographical dictionaries refer to their multiple roles in managing imperial and elite households, they remain largely silent over issues concerning their social status and respectability.

The selective incorporation of the peripheral groups in the *tazkirahs* serves a twofold purpose. Firstly, it provides a voice/agency to the otherwise marginalised groups. Secondly, it helps us understand the role of the household in managing elite-subaltern relations. Charity played an important role here, for most households were centres of elite dispensation of resources to the socially inferior groups and communities. Many of these charities, in the form of gift-exchanges, established hierarchical relations between the elites and the marginalised groups. For instance, it is said that Murtaza Khan Shaikh Farid Bukhari routinely distributed tunics, blankets,

sheets and slippers when he rode to the royal court and cash stipends to the *ulema, mashaikh* and other needy persons (Bhakkari 1993: II, 138–40). In fact, another noble, Mir Abul Qasim Arghun in Sindh, used to cover forest trees with cloth and release herds of cows, buffaloes and horses, to be freely taken for their use by common people (Bhakkari 1993: II, 140). Ram Das Kachhwaha introduced another way of giving gifts. Whatever money he gave once to the community of charans (bardic communities based in Rajasthan), bards and courtesans, they could come again every year in the same month and receive the same amount of money from the cashier (Bhakkari 1993: II, 139).

The political *tazkirahs* show some nobles as being very particular in giving gifts to the people of their villages and towns where they were born and brought up. Bhakkari writes,

> Rai Govardhan, who worked as *peshdast* of Itmad-ud-Daulah and also looked after the *sarkar* of Nur Jahan Begum, built a new fortified township at his village home Khari and in it he constructed a *pucca* house for the villagers. He also constructed roads for the market and for the chowk. He also made endowments for the welfare of the residents of his village including artisans and peasants. He gathered three to four thousand oxen, buffaloes, cows, goats, sheep, mares and camels in his native town and let them loose on the bank of the Ganges for the free use of the people of his native village.
>
> (Bhakkari 1993: II, 203)

Similarly, Nawab Wazir Khan Alimuddin, who was *wakil* (agent) of Shahjahan, built a city at his native town Khabrot with a market, *sarai* (inns or guest houses), mosque, *madrasa* and dispensary and handed it over to its residents (Bhakkari 1993: II, 204).

All these examples show that even though the *tazkirahs* might not have individual biographies of the marginalised groups, they certainly contain a lot of information on the relations between the elite society and the marginalised communities. This was because elite households involved a large number of menial and marginalised groups, whose labour was crucial to the maintenance of the décor and privileges of elite men. In order to secure their consent and willing compliance, the rulers and the aristocrats presided over vast networks of charity dispensation. The aristocratic households were primary units for the dispensation of resources in charity.

Conclusion

By comparing the two biographical compendia, I argue that the representation of the household shows important divergences (and convergences)

in the *tazkirah* genre of writing. The elite households increasingly tend to lose their associations with the imperial court and derive their socio-cultural associations by the roles they play outside their courtly contexts and imperial associations. Defined by new norms of manliness (*mirzai*), the men in the household become active patrons of arts and letters, and most elite households prided themselves in the patronage they extended to poets, musicians, painters, dancers and so on. At the same time, elite households were becoming centres of feast-giving, poetic assemblies, social conviviality and so on, and these activities allowed the households to create enduring social and political linkages against the backdrop of the declining Mughal Empire and new challenges to imperial political authority.

The *tazkirahs* describe in detail the diffuse and diverse nature of early modern households. One of the things they repeatedly describe in detail is the presence of 'plebeian' communities and marginalised social groups in the elite households. Since these subaltern groups were indispensable for the maintenance of the luxurious consumption-oriented lifestyles of the elites, they were beneficiaries of the elite network of resource distribution. The elite households were centres of dispensation of resources in charity and were redistributive in so far as the plebeian groups were concerned. However, the 18th century largely saw a redrawing of boundaries within the household spaces, one in which the socially inferior groups, even if a necessary presence, were seen as inconvenient.

Notes

1 For details, refer to Seema Alavi (ed.). 2002. *The Eighteenth Century in India: Debates in Indian History and Society*. New Delhi: Oxford University Press; Christopher Alan Bayly. 1983. *Rulers, Townsmen, and Bazaars: North Indian Society in the Age of British Expansion, 1770–1870*. Cambridge: Cambridge University Press; Muzaffar Alam. 1986. *The Crisis of Empire in Mughal North India: Awadh and the Punjab 1707–1748*. New Delhi: Oxford University Press; Farhat Hasan. 2004. *State and Locality in Mughal India: Power Relations in Western India, c.1572–1730*. Cambridge: Cambridge University Press. Also look at Karen Leonard. 1979. 'The "Great Firm Theory" of the Decline of the Mughal Empire'. *Comparative Studies in Society and History*, 21 (2): 151–67. For a view, contrary to Leonard's, look at J. F. Richards. 1981. 'Mughal State Finance and the Pre-Modern World Economy'. *Comparative Studies in Society and History*, 23 (2): 285–308.

2 For details regarding the emergence of these martial races in the early modern period, refer to the works by J. S. Grewal. 1990. *The New Cambridge History of India, II.3, the Sikhs of the Punjab* (Revised Edition). Cambridge: Cambridge University Press; Andre Wink. 2007. *Land and Sovereignty in India: Agrarian Society and Politics Under the Eighteenth-Century Maratha Svarājya*. Cambridge: Cambridge University Press and others.

3 For the purpose of this chapter, I have looked at the English translation of this Persian biography (*tazkira*) done by H. Beveridge and Baini Prasad under the title,

Biographies of the Muhammadan and Hindu Officers of the Timurid Sovereigns of India from 1500 to About 1780 A.D. 1999. The translation is in 2 Vols. (Delhi).
4 Historians of emotions have alerted us to the wide range of emotions and feelings that defined relations in familial and household spaces. While emotional history highlights the different forms of love, 'affect' as an emotion is a form of attachment that is conceptually and rhetorically different from 'love.' For love in South Asia, see Francesca Orsini (ed.). 2006. *Love in South Asia*. New Delhi: Cambridge University Press, For shifts in affect and emotions in South Asia, see Indrani Chatterjee (ed.). 2004. *Unfamiliar Relations: Family and History in South Asia*. New Delhi: Permanent Black and Durba Ghosh. 2006. *Sex and the Family in Colonial India: The Making of Empire*. Cambridge: Cambridge University Press.
5 For the purpose of this chapter, I have looked at the English translation of this Persian biography (*tazkira*) done by Ziaud-din A. Desai under the title, *Nobility Under the Great Mughals*. 1993. The translation is in 2 Vols. (Delhi).
6 The National Archives of India (New Delhi) has several such legal documents of the sale and purchase of slaves in the Mughal Period. These documents refer to slaves as no more than an object of sale (*bai'*) and bear specifications of the price of the slave, age, distinctive marks etc. Called 'receipts of the sale of a slave' (*chithi barda faroshi*), the document indicates the appropriation of the body (and the agency) of the slave by the purchaser/master. In one such *chithi*, dated 18 February 1763, we come across an instance of a girl of just four years sold as a slave (*kanizak*) to one Husamuddin, for rupee one.

References

Primary sources

Ahmad, Maulvi Nazir. 1869. *Mira't ul-'Urus*. Translated into English by G. E. Ward, *The Bride's Mirror: A Tale of Domestic Life in Delhi Forty Years Ago*. Whitefish: Kessinger Publishing, 2010.

Beveridge, Henry. 1909. *Tuzuk-i Jahangiri*, or *Memoirs of Jahangir*. London: Royal Asiatic Society.

Bhakkari, Shaikh Farid. 1970. *Zakhirat-ul Khawanin*. Edited by Syed Moninul Haq (3 Volumes). Karachi: Pakistan Historical Society and translated from the Persian by Ziaud-din A. Desai. 1993. *Nobility Under the Great Mughals* (3 Volumes). New Delhi: Sandeep Prakashan.

Fazl, Abul. 1993. *Akbarnama*. Translated by H. Beveridge (3 Volumes). New Delhi, Reprint.

Khan, Dargah Quli. 1982. *Muraqqa-i-Dehli*. Edited by Nurul Hasan Ansari. New Delhi.

Khan, Shah Nawaz. 1888–91. *Ma'asir- ul- Umara*, Maulawi Mirza Ashraf Ali and Maulawi Abd-ur-Rahim (3 Volumes). Kolkata: Asiatic Society and trans. from the Persian by H. Beveridge and Baini Prasad. 1999. *Biographies of the Muhammadan and Hindu Officers of the Timurid Sovereigns of India from 1500 to about 1780 A.D.* (2 Volumes). New Delhi: Low Price Publications.

Mohammad, Sikandar Ibn. 1961. *Mirat-i- Sikandari*. Edited by S. C. Misra and M. L. Rahman. Baroda: Maharaja Sayajirao University of Baroda.

Mushafi, Ghulam Hamdani. 1980. *Tazkira-i-Shu'ara/Tazkira-i-Hindi*. Edited by Akbar Haideri Kashmiri. Lucknow.

Secondary sources

Ahmad, Aziz. 1975. 'The British Museum Mirzanama and the Seventeenth Century Mirza in India'. *Iran*, 13 (1): 99–110.

Alam, Muzaffar. 1986. *The Crisis of Empire in Mughal North India: Awadh and the Punjab 1707–1748*. New Delhi: Oxford University Press.

Alavi, Seema (ed.). 2002. *The Eighteenth Century in India: Debates in Indian History and Society*. New Delhi: Oxford University Press.

Ali, M. Athar. 1978. 'Towards an Interpretation of the Mughal Empire'. *Journal of the Royal Asiatic Society*, 1: 38–49.

Bayly, Christopher Alan. 1983. *Rulers, Townsmen, and Bazaars: North Indian Society in the Age of British Expansion, 1770–1870*. Cambridge: Cambridge University Press.

Bhargava, Rajeev and Helmut Reifeld (eds.), 2005. *Civil Society, Public Sphere and Citizenship: Dialogues and Perceptions*. New Delhi: Sage Publications.

Blake, Stephen. 1979. 'The Patrimonial-Bureaucratic Empire of the Mughals'. *Journal of the Royal Asiatic Society*, 29 (1): 278–303.

Habib, Irfan. 1999. *The Agrarian System of Mughal India, 1556–1707*. New Delhi: Oxford University Press.

Hanlon, Rosalind O'. 1999. 'Manliness and Imperial Service in Mughal India'. *Journal of Economic and Social History of the Orient*, 42 (1): 47–93.

———. 2007a. 'Kingdom, Household and Body History, Gender and Imperial Service Under Akbar'. *Modern Asian Studies*, 41 (5): 889–923.

———. 2007b. 'Military Sports and the History of the Martial Body in India'. *Journal of Economic and Social History of the Orient*, 50 (4): 490–523.

Hasan, Farhat. 2004. *State and Locality in Mughal India: Power Relations in Western India, c.1572–1730*. Cambridge: Cambridge University Press.

———. 2005. 'Forms of Civility and Publicness in Pre-British India'. In Rajeev Bhargava (ed.), *Civil Society, Public Sphere and Citizenship: Dialogues and Perceptions*. Helmut Reifeld and New Delhi: Sage Publications, 102–3.

Hermansen, Marcia K. 2002. 'Imagining Space and Siting Collective Memory in South Asian Muslim Biographical Literature (Tazkirahs)'. *Studies in Contemporary Islam*, 4 (2): 1–21.

Hermansen, Marcia K. and Bruce B. Lawrence. 2000. 'Indo-Persian Tazkiras as Memorative Communications'. In David Gilmartin and Bruce B. Lawrence (eds.), *Beyond Turk and Hindu: Rethinking Religious Identities in Islamicate South Asia*. Gainesville: University Press of Florida, 149–75.

Malhotra, Anshu and Siobhan Lambert-Hurley (eds.). 2015. *Speaking of the Self: Gender, Performance, and Autobiography in South Asia*. Durham and London: Duke University Press.

Metcalf, Barbara. 1984. *Moral Conduct and Authority: The Place of Adab in South Asian Islam*. Berkeley: University of California Press.

Moosvi, Shireen. 1987. *The Economy of the Mughal Empire, c.1595: A Statistical Study*. New Delhi: Oxford University Press.

Nasaw, David. 2009. 'Introduction'. *The American Historical Review*, 114 (3): 573–8.

Neuman, Daniel M. 1990. *The Life of Music in North India: The Organisation of an Artistic Tradition*. London: Chicago University Press.

Orsini, Francesca. 2006. *Love in South Asia: A Cultural History*. New Delhi: Cambridge University Press.

Pritchett, Frances W. 2004. *Nets of Awareness: Urdu Poetry and Its Critics*. New Delhi: Katha Publishers.

Rezavi, Syed Ali Nadeem. 1986. 'An Early Historian of the Mughal Nobility–Shaikh Farid Bhakkari'. Indian History Congress, 47th Session, 24–36.

Schofield, Katherine Butler. 2010. 'Reviving the Golden Age Again: "Classicization," Hindustani Music, and the Mughals'. *Ethnomusicology*, 54 (3): 484–517.

———. 2012. 'The Courtesan Tale: Female Musicians and Dancers in Mughal Historical Chronicles, c. 1556–1748'. *Gender & History*, 24 (1): 150–71.

9

DELHI THROUGH GHALIB'S EYES

Politico-cultural transitions in the aftermath of the revolt of 1857

Mohit Abrol

> Whenever I open my mouth you snap: And who are you?
> Is it your culture that I must not speak, only listen to you?
> (Ghalib quoted in Vajpeyi 2017: 81)

Essentially, it is Ghalib's humanist sentiment in the preceding lines which unmistakably served as the last bastion, the final frontier to be conquered in the face of the socio-religious transformations which had ruthlessly taken over 18th century Delhi from all sides. The resultant politico-cultural transitions in the aftermath of the revolt of 1857, which affected everything in and about Delhi, are at best reflected in the compositions of one of the greatest poets of the time, Mirza Asadullah Khan Ghalib. Ghalib's ghazals profess a much older mystical belief in the infinite potential of the human than the recent rising currents of religious fundamentalism of the 18th and 19th century, which sought to quash it and sever the cultural lifelines. The ensuing barbarism, schismatic cultural biases and violent religious clashes left a permanent scar on the city and indelibly convinced Ghalib that the great and the magnificent Delhi would now never serve as the site of lasting contentment. The revolt of 1857 led to the colossal collapse of the city life of Delhi. The urban city and all the metropolitan experiences and religious synergies along with it now reduced to rubble emanated a brooding, melancholic cry, which filled Ghalib's helpless heart with despair and deep resentment. It is then through the eyes of Ghalib that I intend to map the transitions and transformations which took place when the declining Mughal Empire made way for the emergence and establishment of the British Empire in the Indian subcontinent. The 18th century abounds with such melancholy tales of the decline and fall of the Mughal Empire. The romantic lament about the decline of the Mughal Empire encapsulates the cultural

transition and political transformation that engulfed the imperial city of Delhi. The political and social order established by the Mughal Kings had brought much of the Indian subcontinent that we inhabit under one rule, one sceptre. The Indo-Persian literary tradition carries significant traces of Mughal expansion, which began in 1556 under Abu'l-Fath Jalal-ud-din Muhammad Akbar's reign and ended in 1707 with the death of Alamgir Aurangzeb. The hitherto imagined entity, that is, India, fully realised itself and came into existence during the 18th century when the Mughal Empire was seen as the most powerful example of imperial rule in the popular imagination, ruling over vast swathes of Indian territory and provinces. The word 'imperial' signifies the dissolution of the many abstract forms of rule in the provinces with the major territorial consolidation under the Mughal Empire. It becomes imperative then to closely scrutinise the 18th century to identify the latent roots of what is now being called Modern India. The 18th century also marks the downfall of the three major cities which characterised the Mughal era, namely Agra, Delhi and Lahore. The total eclipse of the Mughal Empire happened in 1858 just at the time of the great Indian mutiny against another empire which was fast spreading across the Indian subcontinent and beyond and taking over the reins from the Mughal rulers.

At the time when that great sceptical product of the European Enlightenment, Edward Gibbon, was going through the ruins of Rome and descended to write the decline and fall of the Roman Empire, European observers in India witnessed the 'melancholy decay' of the great imperial city of Delhi, which has always enshrined its historical past with the mythical past. These European observers highlighted the turbulent events in the year of 1857 from a 'passive' and a detached historical perspective only. These observations then served as a far cry from Ghalib's city writings, which captured the pulse and the terrifying chill of the land soaked with Muslim-Hindu blood during the revolt of 1857. The mythical past of Delhi, the multi-layered fabled connections which interestingly imitate the structural elements of its many historical monuments, all come together in Ghalib's works and philosophy. The mythical past, as opposed to the historical past, exudes from the physical structures, spaces and monuments of the city (typifying social patterns and community models of a specific age or milieu) which gets erased to build the newer landmarks of modernity. The urban environment based on the modern axioms keeps the 'trace' of the mythical past intact by preserving and retaining the antique foundations over which the modern structures are then built. Delhi's cityscape contains many such traces of antiquity masked under its metropolitan outlook. These traces, in turn, paint the character sketch of the city of Delhi, providing numerous viewpoints from where a close scrutiniser can visualise and 'read' it. Unlike the linear historical past, the mythical past offers multiple entry points into the history of Delhi. And it is while mapping the political transitions and cultural transformations through the course of Delhi's history that the dissolution of

the mythical past into the historical one takes place. This provides the concrete, materialist representation (as witnessed in Ghalib's works) of what characterises Delhi's rich and enduring past. This is how the mythical past (through physical structures embodying modes of existence and social patterns) always remains synchronous and diffused within the historical past.

Delhi, the imperial seat of the Mughal Empire, beautifully captures the past and present in the same breadth. Within the ruins of Delhi lie the memories of the mythical past, which can potentially lead us on a trajectory back in time from the present time, leaving behind the Midnight's Children, the British, the Mughals, the Tughlaqs, the Guptas and the Mauryas, and effectively reaching the Dvapara-yuga or the Mahabharata epic era when the war was just about to conclude and Kali-yuga about to begin. Delhi has always found a means of reconciling with its past, a sort of treaty according to which past and present can walk hand in hand together. Delhi's history is crammed with dynasties which later morphed under the rubric of dynasty politics. Delhi demonstrates a continuity of experiences; therefore, looking at the 18th century becomes so important. The 18th century signals a transition where the political power over Delhi passed from one ruler (who represented the old and the majestic Mughal Empire) to the other (who represented the nascent imperial power on the horizon) quite abruptly. This argument entails that the forced transition at the political front tilted the Delhi imagination from secular ideas to radical practices; schisms erupted at all three (the political, the religious and the linguistic) levels. This ensured that the sequence of killings and violence continued until the beginning and middle of the 20th century. However, any recognition of Delhi's violent past remains incomplete without taking into consideration the agents of reconciliation or accommodation – be it at the time of the 1857 mutiny, 1947 partition or 1984 Sikh riots. Therefore, the main objective (as deliberated and discussed in the first half of the chapter) is to analyse the reasons for the complete erosion of the urban life of Delhi in the context of the politico-cultural transitions of the 18th and 19th centuries. The revolt of 1857 provides an interesting point in history to deliberate upon Delhi's revenge-filled past and the ensuing reconciliatory trends (based on the traces of the mythical past), which made it possible for multiple reigns and various cultures to thrive and survive in the Indian subcontinent. In this regard, an elaborate examination (through a literary analysis of Ghalib's verses, letters and diary during and after the revolt of 1857) is required to understand the multifarious causes which led to the severance of cultural bonds and regrettable rise of identity politics. The second half of the essay focuses on Ghalib's life and socio-cultural circumstances which shaped his ideas and perspectives. Here, Ghalib's deep-rooted beliefs and humanist philosophical positions are taken into consideration. The final half of the chapter puts special emphasis on his personal account in the form of *Dastanbuy: A Diary of Indian Revolt of 1857*, which describes that horrid reality of the 19th century, the revolt

of 1857. The larger aim of the chapter is to find an effective anchoring in Ghalib's *Dastanbuy* to map the politico-cultural transitions and transformations in the aftermath of the revolt of 1857.

Loss of urban life, the doctrine of reconciliation and the twilight period

Through centuries, the megapolis of Delhi has served as a container and transmitter of culture. The collective memory of a whole thriving civilisation rests on the contours of Delhi – a city where the political consciousness constantly feels overwhelmed by the glorious and momentous weight of the past, the imperial city which carries the weight of its historical and the mythical past together. Delhi as a city is best captured by Ahmed Ali in his novel *Twilight in Delhi*, where he states,

> [Delhi] was built after the great battle of Mahabharata by Raja Yudhistra . . . Destruction is in its foundations and blood in its soil. It has seen the fall of many a glorious kingdom, and listened to the groans of birth. It is the symbol of Life and Death, and revenge is its nature.
>
> (Ali 1940: 4)

The Delhi scene from 1800 to 1870, which emerges from Ghalib's consciousness, is largely characterised by the destruction and gradual decay of the urban life. Ghalib lived through the era of darkness when Chandni Chowk metamorphosed from a vital, radiant centre, exemplifying urbanness, to the hanging ground for the last Mughal princes. All the metropolitan indices of social activity were forcefully erased by the British forces under the direct command of General Wilson. The by-lanes which up to then symbolised the living, throbbing pulsations of symbiotic culture were forever altered to resemble the deathly silence of a vast mortuary. Deeply saddened by the loss of the vibrant metropolitan life of Delhi in the aftermath of the revolt of 1857, Ghalib wrote that the five things that gave Delhi its uniquely urban character disappeared once and for all and provided the main reason for the eventual deep-seated cultural biases and the revival of religious fundamentalism: the magnificent fort, the rich experience of walking in the by-lanes of the Chandni Chowk, the hustle and bustle of the daily bazaar near Jama Masjid, "the weekly trip to the Jamuna Bridge, the annual Fair of the Flower-sellers. These five things are no more. Where is Delhi now? Yes, there used to be a city of this name in the land of Ind" (Ghalib 1970: 76). The loss of the urban life in/of Delhi is closely tied to the resurgence of what Ali stated through his novel – the revengeful nature of Delhi. That is why the urban life of Delhi remains the quintessential concern while mapping the political transitions and cultural transformations in

the 18th and 19th century. This urban context vis-à-vis Delhi assumes more significance in the light of assertions made by the Scottish historian William Dalrymple.

Dalrymple writes in his famous novel, *City of Djinns*, that

> the fabulous city which hypnotised the world travellers of the 17th and 18th centuries, the home of the great poets Mir, Zauq and Ghalib; the city of nautch girls and courtesans; the seat of the Emperor, the shadow of God, the Refuge of the World, became a ghetto, a poor relation embarrassingly tacked on to the metropolis to its south.
>
> (Dalrymple 2004: 50)

The British occupation in the aftermath of the revolt of 1857 led to the painful sight of makeshift shelters (due to the loss of urban life) outside the city. This humiliating settlement and ghettoisation in and around Delhi followed from the severe restrictions the British officials had put in place for the re-entry of the city inhabitants; the ones who cherished Delhi as their home were rendered homeless and faced mortal danger as a telling sign of the collateral damage between the mutineers and the British troops. Amidst such upheavals, Dalrymple is quick to state the reason why he claimed Delhi to be the city of Djinns. He states that Delhi always consistently "rose like a phoenix from the fire" (Dalrymple 2004: 9). Such is the aroma of the blood splattered on its soil through the ages that it continues to keep us spellbound. Every instance in which Delhi has served as the capital of seven reigns with each being built on the top of the other (first city: Qila Rai Pithora and Lal Kot; second city: Siri Fort; third city: Tughlakabad; fourth city: Jahanpanah; fifth city: Ferozabad and Kotla; sixth city: Dinpanah, Sher Shahabad and Purana Qila; and finally, Shahjahanabad and Lal Qila) is a testament to its long, revenge-filled past and significantly shows how it always found the means to peacefully reconcile with the newer reign. It may be the case that revenge is its nature, but then it is my contention that the repeated, numerous acts of remarkable resilience are what truly defines Delhi and makes it look so magnificent in every sense. Ghalib didn't live long enough to witness the final reconciliatory attempt the city made to restore cultural ties and communal harmony at the end of the 19th century (which soon suffered from a major blow in the 20th century in the form of the tragic partition, which permanently fractured the identities and erased the fundamental modes of coexistence). However, there have been historical instances as early as the 12th century where we can see the glimpses of reconciliation between Hindu and Muslim sects immediately after the bouts of catastrophic destruction.

The following extract has been taken from Hassan Nizami's *Taju-l Maasir*, written in the early 13th century, describing how Qutubuddin Aibak,

the commandant of the Turkish ruler Muhammad Shihalruddin of Ghur, conquered Delhi in 1192.

> When he arrived at Delhi, which is the capital of the kingdom, and the centre of God's aid and victory, the crown and throne of sovereignty received honour and adornment in his kingly person, and the lords of the sword and pen hastened to pay their respects at the magnificent Court . . . triumphal arches were raised, beautiful to look at, the top of which a strong-winged bird could not surmount, and the glittering of the lightning of the swords and the splendor of the arms, which were suspended on all sides of them, inspired terror in the spirit of the beholder . . . Qutubuddin built the Jama Masjid at Delhi, and adorned it with the stones and gold obtained from the temples which had been demolished by elephants, and covered it with inscriptions in Toghra, containing the divine commands.
>
> (Singh 2001: 8–9)

What Qutubuddin did must have been seen as a religious duty; he had to smash the images of metal and stone in order to foster a belief in the universe's One God. If they performed their duty well, their sins in committing murder and plundering might be canceled. Allama Iqbal, the foremost Urdu poet, stated in his *Jawab-i-Shikwa* that 'to every vein of falsehood, every Muslim was a knife'. Thus, we see that to 'a presumed religious duty or the call of truth, the response, whether in deed or verse, was violent' (Gandhi 1999: 68). Dalrymple also states that 'Invaders like Timur the Lame were able to storm the high walls of the city only because the inhabitants were already busy cutting each others' throats' (Dalrymple 2004: 36). Because of the predominant caste system, one Kshatriya was pitted against the other while the rest of the castes didn't care about the fate of the ruling elite, but the Islamic fervour vehemently cast the non-Muslims as the 'Other', and they were butchered mercilessly. However, it is crucial to note here that the Sultans with the passage of time had become Indian, to loosely use the term, because they tried to ease and in some cases even cement the relations between Hindus and Muslims. This was greatly aided by Islam's mysticism, which preached piety rather than the sword. Dalrymple asserts that

> At a time when almost all Muslims – including Ibn Battuta – believed that non-Muslims were enemies of Allah and thus damned to an eternity in hell-fire, Nizam-ud-Din preached a gentler doctrine of reconciliation, maintaining that 'every community has its own path and faith and way of worship'. It was not just his tolerance of other religions that made Nizam-ud-Din popular with

non-Muslims: Hindus, Buddhists and Christians all found echoes of their own faiths in his teachings.

(Dalrymple 2004: 275)

Ghalib's own philosophy is remarkably modelled on the same doctrine of reconciliation and carries the mystical element which germinated centuries before him in the Indian subcontinent. His outright disbelief in the idea of institutional religion which advocates orthodox practices is finely illustrated in such couplets as the following: "The object of my worship lies beyond perception's reach/ To those who see, the Kaba is a compass, nothing more" (Russell 2000: 93). Using the same trope of a compass, I intend to state here that Ghalib wanted to 'reorient' the latently regressive and conventional mindsets to the deeper level of understanding of peaceful coexistence based on the principle of a unified vision for one and all. In all his Persian ghazals, one can trace the elemental leitmotif which suggests, in a profound manner, the transience of life and the limited scope of our earthly existence. Ghalib preferred the rich experience of the limited earthly existence over the 'universal' tenets preached by the orthodox, conformist belief systems, which time and again chained the human will and consciousness. A careful excavation to determine the source of such an apparent pluralism in Ghalib's philosophy further illuminates the wonderful parallels which have existed for centuries in the shadow of orthodox principles. For example, the Sufis followed the doctrine of *Whadat-ul-wajud*, or the unity of being, which is strikingly similar to the philosophy of the Hindus of Advaita or non-dualism; the oneness of all life. The principle of a unified vision dissolves the multiplicity of being, in the ontological sense, which tends to gravitate towards the notion of many realities. Both in Sufism and the Vedanta system, there is a strong assertion about the infinite consciousness grounded in one reality, which, at the human level, is grasped, acknowledged and named in many ways. However, this humanist approach and consequently the secular beliefs troubled the Ulamas, Islamic orthodox scholars in the 13th and 14th centuries (and is now the cause of concern for many right-wing Hindu fringe groups), who became concerned about the loss of their own identity. Eventually, the persistent torrents of soul-searching and smoothening of ties between the two communities led to the resurgence of peaceful times ahead, which found its ultimate culmination in the notion of *Din-i-illahi*, or the Divine Religion in 1582.

This shows that Delhi has been, from time to time, a witness to many cultural and political transitions. The general picture which emerges from such revengeful instances (followed by many reconciliatory attempts) suggests that Delhi has been a witness to many politico-cultural transitions throughout the centuries. The mythical past and its many manifestations in the shared socio-cultural patterns always provided an impetus

to the city and its inhabitants alike to strive, to move forward after these troubled times. All of this has given Delhi an aura of sanctity, where many cultures have thrived and survived the entire length of the Mughal Dynasty, the long waves of British colonialism and the independence struggle, and it exists, even now, well within the *nukkads* of the Modern India.

However, the Delhi of the late 18th century and mid-19th century was going through the 'twilight' period. At the end of the 18th century, the Mughal Empire was practically facing decline with the imprisonment of Emperor Shah Alam II (r. 1759–1806) by the Rohilla military leader, Ghulam Qadir, who had, by then, seized Delhi. By August 1788, Shah Alam and all his 19 children, deposed and imprisoned, watched with horror as Qadir practiced brutality on the Begums and the inhabitants of Delhi. On Shah Alam's death in 1806, his son Akbar II (r. 1806–37) and eventually his grandson Bahadur Shah II (r. 1837–58) were proclaimed to be the last Mughal emperors by the British policy makers. At the beginning of the 19th century, the British forces, led by Lord Lake, defeated the Maratha regiments at Patparganj to claim their control over Delhi. The British conquest of Delhi was nearly complete by the early 1850s. India, by then, was already declared the 'jewel in the crown' of the British monarch. In this regard, the 18th century theologian, Shāh Walī Allāh Dihlawi (1703–1762) propounded a theory of human civilisation in his philosophical work *Hujjat Allah al-Bāligbah* (The Conclusive Argument from God) to highlight the problems which engulfed the Mughal Empire into the twilight zone and the transition that Delhi witnessed in the 18th and 19th centuries. Shāh Walī Allāh asserted that it was because of the decline in the revenue collection and lacklustre defences, which entailed a large-scale fragmentation of old political structures and their remaining religious endowments. At the administrative level, feudalism, which was still grasping to maintain its foothold during Ghalib's time, witnessed the strong winds of capitalism that the British administration had brought along onto Indian soil. Once the whole subcontinent came under the direct rule of the British monarch in the aftermath of the revolt of 1857, the political, the administrative and the cultural transition was almost complete. Vaselios Syros, in her incisive article on Shāh Walī Allāh of Delhi, states,

> In his private writings and letters, Shāh Walī Allāh berates the fact that wealth came to be concentrated in the hands of Hindus. But, more importantly, he construes the malfunction of the Mughal government as a sign of moral decadence and overall failure to implement the teachings of Islam. In an eleventh-hour attempt to save the Mughal state from ultimate downfall, Shāh Walī Allāh called

on the Afghan ruler Ahmad Shāh Abdāli (d. 1772) to invade India. He offers fulsome praise of the Afghan warlord for his bravery and foresight and urges him to launch a full-scale operation against the Marathas and Jats and to wipe out polytheistic practices . . . Shāh Walī Allāh reproves the imperial administration for its inability to suppress sedition. He points to the Jats' taking over Gujarat and Malwa; the rulers' luxurious way of life, profligate spending, and self-aggrandisement; the irregular and disrupted flow of revenue provinces; the corruption of local governors and tax agents in the collection and administration of revenue; and the oppression of the lower social strata of the population. In addition to the letters which he sent to Ahmad Shāh Abdāli, Shāh Walī Allāh made a direct appeal to the emperor and the nobles and spelled out an elaborate program to ensure the stability and continued existence of the Empire.

(Syros 2012: 817–18)

Ghalib wasn't prepared to witness the downfall of the Mughal Empire, no matter what the relation between the last Mughal sovereign and his subjects had come to. The imperial decline and the political and administrative reasons that Shāh Walī Allāh stated in the context of the Mughals would not have made any sense to Ghalib, who increasingly viewed life as a burden after the failure of the revolt of 1857. Ghalib, as a figure deviant from the Islamic tradition, would not have appreciated the theological arguments (voicing violent oppression through unjust means in the name of religion) supplied to govern the state. He viewed the just ruler like the just God, residing always in the orbit of equity and stamping out oppression everywhere. This then makes it obvious as to why Ghalib termed the oppressive revolt of 1857 as "*rastkhiz-i bi-ja*" (an unnecessary calamity) and described it on such an aggressive note:

> this year [11 May 1857] . . . the gates . . . of the Fort . . . were suddenly shaken . . . a handful of ill-starred soldiers from Meerut . . . invaded the city – every man of them shameless and turbulent, and with murderous hate for his masters, thirsting for British blood.
> (Russell 2003: 117)

Amidst what has come to be seen as the 'twilight' period in the late 18th century and mid-19th century, the malicious taint left behind by the revolt of 1857 was so strong that both the city of Delhi and, along with it, Ghalib never made a full recovery from it. Ghalib transformed, and so did Delhi, in the face of these political transitions and cultural transformations in the aftermath of the revolt of 1857.

Ghalib, the Urdu phenomenon and the politico-cultural transitions

A devastated, fragile and mute witness to the aftermath of the revolt of 1857, Ghalib could not bear the destruction of his home in front of his own eyes as scores of Delhi citizens were hanged daily at the Chandni Chowk by the British officials. His state of mind stands revealed in the following couplet:

> An ocean of blood churns around me –
> Alas! Were this all!
> The future will show
> What more remains for me to see.
> (Varma 1989: 172)

Though Ghalib lived on merely for twelve more years after the 1857 revolt, his whole life is a living testament to this transition (the poet-laureate of the Mughal court was in time reduced to a mere British pensionary). The chapter will further investigate how even his gradual adoption of Urdu language as the medium of all his prose (which he considered beneath his stature) has to be seen as a bitter lamentation for the death of the princely Persian language and its bastardisation during the 19th century. Mirza Muhammad Asadullah Khan Ghalib not only witnessed the empire in decline, but the waves of cultural transition actually passed through him, his times, his thinking, his personality and his poetry are witness to that. The rapid expansion of the British Empire; the diminished power of the last Mughal king, Bahadur Shah Zafar; the missing grandeur of the past; the palpable anxiety of the natives in acceding to the nominal Mughal sovereignty; the insensitivity of the British residents, like Thomas Metcalfe, Edward Colebrooke and Francis Hawkins towards the old feudal aristocratic class to which Ghalib belonged; and the drastic devaluation of the Indo-Persian culture in the face of the utilitarian doctrines enshrined by the English civilisation – all this was swallowed by Delhi and Ghalib alike. Ghalib's Delhi became the site on which the politico-cultural transition took place from the Mughal Empire to the British, and his *Dastanbuy: A Diary of Indian Revolt of 1857* (a period of 15 months from 11 May 1857 to 1 August 1858) is the most remarkable literary reflection of such a paradigmatic shift.

As it so happens, it is especially during the times of crisis, be they political or cultural, that new forms of expression flourish. The conflicting tendencies of the Mughal subjects and the Evangelical Christians symptomatic of the cultural transitions set forth in process in the 18th century led to the setting up of the printing press in Benaras and the establishment of 'modern' schools and a collegiate system in Calcutta and Delhi (the refurbished school at Ghaziuddin madrasa in 1792 became the Delhi College) for the

rigorous and methodical diffusion of knowledge. This heralded the rise in literacy and the burgeoning of the print culture, which subsequently led to the rise in readership in Indian cities. The print medium brought out the culture of encounters where Christian missionary tracts and Islamic preachings were translated and published with great zeal. Such cultural encounters in the print form soon adopted a political hue and fermented strong affinities based on identity and community relations, which eventually erupted in the form of clashes during the revolt of 1857. The democratisation of knowledge brought out by the introduction of print culture soon provoked latent fears of appropriation, revisionist histories and rigid religious disputations, which gradually moved beyond the narrow, local confines and private spheres right into the middle of the public debate. The cultural appropriation by the masses also led to the erosion of the Urdu language, its natural taste, it sensibility and refinement without which it was left as crippled and feeble as Ghalib felt in the aftermath of the revolt of 1857. Ghalib never revelled in the use of Urdu, which he viewed as a plebeian and bastardised successor of the princely Persian language.

Urdu, which is a Turkish word meaning a 'camp' and its followers, signifies the linguistic transition by modelling itself on the Persian language (the court language, meant for administrative and religious purposes) and eventually becoming the language of the masses. By the early 1850s, Urdu had totally replaced Persian as the medium for literary expression. During Ghalib's time, Hindi basically meant Urdu language because it had assimilated from a large number of Indo-Persian languages (Arabic, Persian, Hindi, Prakrit), bridging the gap within India and beyond. This assimilating quality of Urdu has provided it with another title; Urdu is the language of 'lashkar': a language which flourishes with assimilation as its supreme quality. Urdu language in the late 18th century established itself as the language of religious and cultural expression with the translation of the Quran by the sons (Shah Abdul Qadir Dehlavi and Shah Rafiuddin Dehlavi) of the Muslim thinker Shah Waliullah of Delhi. By the 19th century, it had become the vehicle for disseminating rationalist discourse as well. Ghalib, who belonged to the feudal aristocratic class, resented the rise of the Urdu language; for him, Persian and Urdu reflected the cultural divide between *Shurfaa* (the aristocratic class) and *Awaam* (the masses), and he always made it a point to remain on the side into which he was born. Even *Dastanbuy: A Diary of Indian Revolt of 1857* is acutely critical about the role of the masses in the revolt of 1857; there is practically no resentment voiced by Ghalib for the last Mughal king.

It is interesting to note that 'Ghalib' (which means 'the vanquisher') itself is an Urdu poetic name, the *takhallus* which brings out the persona of the poet. Most of the Urdu poets (Mir Dard, Mazhar, Sauda, Mir, Insha and Nasikh) of the time were known by their *takhallus*. Even the last Mughal king, Bahadur Shah Zafar, used the *takhallus* 'Zafar' and regularly attended

the weekly literary symposium (*mushairas*) at the Ghaziuddin madrasa. The rivalry between Ghalib and Zauq on these literary events used to rivet the audience and the noble class in a similar fashion. It is specifically during these events that Urdu displaced and dethroned the language of the aristocrats, Persian. One such instance is when Farhatullah Baig comments upon the Persian recitation by the poet Sehbai:

> It (Sehbai's *ghazal*) received lavish praises too but to be honest, the audience did not much relish the Persian . . . those unfortunates who did not understand Persian merely looked on. The fact is that to force Persian poetry at an Urdu *mushaira* was not a good idea at all.
> (Varma 1989: 53)

Ghalib's Urdu ghazals seem to be a mere accident of sorts in comparison to his Persian verses. M. Shahid Alam states that 'if we are to take Ghalib at his word, he tells his readers that his Urdu ghazals are "colourless" compared to the "colourful images" in his Persian ghazals' (Alam 2015: 56). Since most of his Urdu ghazals were composed when he was young (from his adolescent period to his early youth), they carry the rich texture and the poetic panache which very few Urdu poets have been able to incorporate into their works. Literary critics in the first-half of the 20th century, such as Rasheed Ahmad Siddiqui, actually felt that the greatest gifts bestowed by the Mughals on India are the Urdu language, the Taj Mahal and Mirza Ghalib (Alam 2015: 57). From Ghalib's perspective, the linguistic transition from the elite Persian to British English and the advent of Urdu portrayed a melancholy decay of the social mores, cultural and community fragmentation and the loss of the mythical past. Ghalib wrote:

> If faith holds me back
> Disbelief tugs at me;
> The Kaaba is behind me
> The Church ahead of me
> (Varma 1989: 60)

The politico-cultural and linguistic transition from one noble empire to the other ignoble one deeply affected him. Ghalib personally felt torn between the feudal noble elite who owed allegiance to the Mughal order and the new hegemonic dispensation in the form of the British order. Ghalib felt repulsed by the mob violence which resulted during the mutiny and the severe backlash orchestrated by the British in its aftermath. Ghalib, the peace-loving individual, had friendly relations with the British residents and their subordinates. In *Dastanbuy*, what Ghalib bemoans is the loss and destruction of the normal, vibrant life of Delhi that he loved so passionately.

Ghalib admired the modern, scientific and rationalist discourse introduced by the British, but he took umbrage at a personal level whenever his pension was denied as a reward for his services. In a rather scathing indictment of the lieutenant governor of Agra and the previous governor-general Lord Bentinck, Ghalib wrote directly to the new governor-general Lord Auckland in 1836 about the disfavour done to him. Ghalib wrote,

Most Respectfully Sheweth,

1) That your Lordship's petitioner has received through the Agent at Delhi, Mr. Secretary Macnaughton's Letter of the 17th Ultimo, signifying 'that your Lordship in Council sees no sufficient ground for a reconsideration of your petitioner's claim which appeared to have been finally disposed off by the order of the Lieutenant Governor of the North Western Provinces past on the 18 of June last.
2) That your petitioner begs respectfully to state that having suffered manifold injustice from the Lieutenant Governor of Agra appealed against the decision of that Authority to your Lordship in Council; and afterwards submitted an illustrative statement of his case under date the 14 of July last, and ventured to offer seven points or queries to which he implore that replies be obtained from the Lieutenant Governor of Agra. . .
3) That your petitioner begs humbly to state, that should your Lordship deny compliance with the above supplication . . . he must be under the necessity of entreating most humbly that your Lordship will be graciously pleased to forward his case, with all papers therewith connected, to England, in order that it should be tried before King in Council. And your Lordship's petitioner will, as in duty bound, ever pray for your Lordship's long life and prosperity.

(Varma 1989: 23–4)

Ghalib's dismay at being rebuked by both the lieutenant governor of Agra and then by the governor-general is almost palpable in the strongly worded letter addressed to Lord Auckland. The letter is also indicative of the cultural tensions which were brimming up in the political cauldron of the 19th century. The British officials who maintained a polite, friendly relationship with the last known Mughal subjects gradually turned indifferent and eventually felt disgruntled with them in the aftermath of 1857. It wasn't Ghalib, the poet, alone who felt deeply disturbed by this indifference accorded by the British officials. Asadullah Khan, as a well-known representative of the Indian literati and nobility, took the gnawing pain to his heart.

Ghalib's *Dastanbuy* and the revolt of 1857

Ghalib's *Dastanbuy* is a private account of the happenings of and around the revolt of 1857. The trauma of 1857 radically altered the normalcy which characterised the city culture in Delhi up to then. The revolt brought the hidden fissures out in the open. As a result, the politico-cultural transition which was already taking place took a violent turn, and Ghalib found himself surrounded by divided loyalties on both sides. As a mute and lonely witness, the poet laureate stood numb to the carnage which resulted during the revolt of 1857. Ghalib never fully recovered in its aftermath. Ghalib had this to say about the nightmare which unfolded on the night of 11 May 1857:

> Smiting the enemy and driving him before them, the victors overran the city in all directions. All whom they found in the streets they cut down. . . For two to three days every road in the city, from the Kashmiri Gate to Chandni Chowk, was battlefield. Three gates – the Ajmeri, the Turcoman and the Delhi – were still held by the rebels. My house . . . is situated between the Kashmiri and the Delhi Gate, in the centre of the city, so that both are equidistant from my lane. . . At the naked spectacle of this vengeful wrath and malevolent hatred the colour fled from men's faces, and a vast concourse of men and women, past all computing, owning much or owning nothing, took to precipitate flight through three gates. As for the writer of these words, his heart did not quake, nor did his step falter. I stayed where I was saying, 'I have committed no crime and need pay no penalty. The English do not slay the innocent, nor is the air of this city uncongenial to me. Why should I fall a prey to groundless fancies and wander stumbling from place to place? Let me sit in some deserted corner blending my voice with my lamenting pen, while the tears fall from my eyelashes to mingle with the words of blood I write.
>
> (Singh 2001: 57–8)

The horror that Ghalib witnessed intermingled with his cries and oozed out as blood on the pages. *Dastanbuy* is not just a diary for a trained reader; it is a personal archive of an anguish which knew no bounds. Ghalib was ruthless in condemning the violence which engulfed his Delhi. He described the sepoys as barbarians who had come out to drain the walls of the glorious city of English blood. Ghalib's diary works as an instrument of resistance against those who were hell-bent on revenge. Although it seems pro-British, Ghalib's account in *Dastanbuy* should be read as a lament against the idea of violence. The diary definitely sets the neat binary between the Britishers and the natives – the ones who cultivated knowledge and the ones who represented its lack, the ones who were powerful yet human and the ones

who were powerless and turned inhuman. The revolt erupted between these lines and left Ghalib's Delhi in a non-determinate space from where it never recovered. The conjoined cultural space enjoyed and cherished by both the Hindus and the Muslims was severely partitioned and with the British re-conquest on 20 September 1857, any semblance of the 'Delhi Renaissance' which had emerged with the print culture, the newspapers, the journals, the pamphlets and the poetry books was nowhere to be seen. The next two decades 1857–77 mark a period of stagnation where the city life largely remained inactive and the Christian missionaries and their proselytising missions (which had immediately begun after the re-conquest) soon gave way to acute polarisation in the society. In the aftermath of 1857, Delhi transformed into a deserted corner from where Ghalib poured his lamentation onto pages; his poetry emerged from the tears which mingled with the blood-stained words he wrote.

The fault-lines which had permanently been etched on the face of Delhi remain in place even now. Many of the mutineers who had participated in the slaughter are now beyond recall. Most of the accounts of the mutiny of 1857 come from the British reports, diaries and letters. Therefore, the colonial disdain is quite strong in projecting the 'barbaric' natives against the poised British officials. Rudgranghu Mukherjee, in his book *Awadh in Revolt: 1857–58* (1984), states that the barbaric tendencies exhibited by the mutineers during the revolt of 1857 are in many ways a 'replica[tion of] the mercilessness and violence they (the sepoys) had seen in the sahib' (Gandhi 1999: 172). The cruel treatment bordering on racial and religious slurs, the public humiliation at frequent intervals, the retributive practices towards their fellows for the sake of pleasure, all these turned the sepoys against their *firanghi* sahibs over time. Then there were rumours of foreign rulers, like the Shah of Persia and the Russian Emperor Paul coming to aid the oppressed Muslims and other natives against the imperial practices and nefarious economic policies of the British officials in India. However, no such plan reached fruition. Amidst such accounts, Ghalib's *Dastanbuy*, which seemingly denigrates the mutineers and seems pro-British, needs to be read from an alternate perspective of a poet lamenting the ruins of the city that he loved so passionately and yet couldn't do much to protect from getting shrouded in the appalling violence of 1857. To reduce the purpose of this archival document to a means to project Ghalib's innocence in the eyes of the British (as has been suggested by Pavan Varma) seems rather too simplistic. Varma states in his book, *Ghalib: The Man, The Times* (1989), that in writing *Dastanbuy*,

> Ghalib's purpose was two-fold: first, to avoid any reprisal against him, the second, to establish his bona fides sufficiently to persuade the British to resume his pension. As we shall see, this too was a matter of survival. With the Mughal court wound up, Ghalib had

no other source of income to hope for and he was in desperate straits. The *Dastanbuy* was thus a means to an end.
(Varma 1989: 142–3)

Such a straightforward reading of Ghalib's motives in writing *Dastanbuy* divorces it from the cultural transition that had engulfed the city life much before the real reasons for the mutiny can be credibly gauged or established. Ghalib had already seen the bastardisation of the princely Persian language in his time. Significantly, he cultivated a strong disdain against the masses who revelled in the Urdu language. The mob violence which unfolded during the revolt of 1857 and Ghalib's strong condemnation of the mob in tearing apart the city life and taking a sadistic pleasure in mass looting and plunder needs to be seen as a continuation of the same sentiment. Varma's assertion that *Dastanbuy* worked as 'a means to an end' appropriates Ghalib's account and puts it with the other British narratives, which demonstrate the atrocities committed by the mutineers in terms of barbaric and savage tendencies. It also excludes Ghalib from the politico-cultural turmoil which took a violent turn in the form of the revolt in 1857. Ghalib's *Dastanbuy* needs to be analysed from a vantage point which posits it in between the revolt and the indeterminate space that Delhi came to acquire after the eventful year of 1857.

Ghalib's literary caravan got completely embroiled in the catastrophe which resulted from the revolt of 1857. The city offered the greatest symbols which Ghalib relished and wrote about:

> Here was the tavern, the *saqi*, the wine; the puritan with his frown and hypocritical sermonising; the street, the gateway of the beloved's house with its gate-keeper, the wall in whose shade the lover could sit or against which he could beat his head, the roof on which the beloved could appear, by accident or by deliberate act of self-manifestation; here, finally was the market-place in which the lover could invite contumely or the scaffold be set up for public executions which the lover could regard as demonstrations of what the beloved's heartlessness could inflict on him. It was in towns that assemblies were held, that candles provided illumination and moths immolated themselves in their flames, that encounter took place between lover and beloved.
> (Mujeeb 1969: 11)

There came more symbols from the British which added glamour to the city life but didn't impinge on the social conventions which strictly demarcated the zones of association between the elite class and the masses. The mythical past somehow remained preserved in these conventions and also in the city symbols of marketplace. Markets demonstrated the effluence, the synergy of

cultures which marked the entire period of the Mughal Dynasty. The remnants of the shared cultural past were still visible to those like Ghalib, who made it a point to turn their pen in the direction from where the marketplaces used to begin. The uneasiness, the unsure paths, the hidden anxiety which surfaced with the revolt of 1857 found frequent outlets in Ghalib's verses.

In the aftermath of 1857, Ghalib reconciled himself to the fact that now the old social conventions and ways of living had to make way for the British code of conduct. The personal rebukes directed by the British officials that Ghalib felt for the denial of his pension mattered less now when the whole social, political, cultural and psychological profile of Delhi had been transformed beyond recognition. Ghalib's *Dastanbuy* is about the city life and all its symbols which disappeared in the aftermath of 1857. His account about the city opens an exclusive zone where the private thoughts of a poet meet and describe the public sphere, which symbolically represented the city life. The harsh British treatment meted out to the natives and the disintegration of social mores which defined the Mughal Delhi filled Ghalib with despair and hopelessness. The Persian language in which the document was written shows Ghalib's affinities to the old elite order. However, the way the document works as both a personal lament for the ruin of the imperial Delhi and a public appeal to the British to differentiate him from the local thugs and barbarians shows the complexity of Ghalib's thought, his rich personality and his literary self-expression. The letter to Munshi Hargopal Tafta in which Ghalib expressed the desire to publish *Dastanbuy* shows how he believed his tract with a pro-British stand would differentiate him from the rest in the eyes of the British. In the letter addressed to Tafta, dated 17 August 1858, Ghalib writes,

> Now, listen to a project: I have written a fifteen-month account of the city (Delhi) and my own situation from May 11, 1857 till July 1, 1858. I have ensured that the prose is in classical Persian that excludes any Arabic words, including the poems cited within this work... There are no presses here; I have heard of one but their copywriter is not *Khushnawis*. Let me know if it can be printed in Agra.
> (Raja 2009: 43)

Since Ghalib wanted to send the copies of his *Dastanbuy* to both Governor General Bahadur and the Queen of England with his official name (Mirza Asadullah Khan Bahadur Ghalib) and not with his *takhallus*, it is suggestive of the fact that Ghalib had an intended audience for his lament written in Persian. It was a document written by the governed to the governors (both erstwhile and present), and this turns *Dastanbuy* into a political text. Thus, *Dastanbuy* needs to be read as Ghalib's political response towards the changing power equations which he had acknowledged long before the

catastrophic revolt of 1857. Ghalib's *Dastanbuy* does not elicit a random response to a candid account of the rebellion in the form of a diary entry detailing the fault lines which went well beyond the nationalist frames and became the starkest feature of urban life in Modern India. *Dastanbuy* is a very deliberate, radical political attempt by Ghalib for two reasons: first, to bring about a reconciliation with the changed circumstances and the new ways of looking at Delhi, a personal lament for the conquest of Delhi by the mutineers and then by the British, and second, to write beautifully in Persian for those who belonged to the upper echelons of the power-circle as the intended trained readers at whose behest the cultural transitions took place in the late 18th and the mid-19th centuries. *Dastanbuy* is Ghalib's ode to the 18th-century phase of revenge and reconciliation that Delhi witnessed and had, by then, become accustomed to. The excesses, the deceit, the revenge and the terrifying bloodletting which took place during the revolt of 1857 marked a new phase in Delhi's past that longed for reconciliation, but there was none to provide. The questions raised by the rebellion and the violent ways in which it unfolded have found very few takers, even during the decades that followed. Delhi, through Ghalib's eyes, through his *Dastanbuy*, is the site on which the religious and communal fissures erupted and thus proves to be the most accurate way to map the politico-cultural transitions in the aftermath of the revolt of 1857.

References

Primary sources

Ali, Ahmed. 1940. *Twilight in Delhi*. London. Hogarth Press, Google Books.
Dalrymple, William. 2004. [1993]. *City of Djinns: A Year in Delhi*. New Delhi: Penguin Books.
Gandhi, Rajmohan. 1999. *Revenge and Reconciliation: Understanding South Asian History*. New Delhi: Penguin Books.
Ghalib, Asadullah Khan. 1970. *Dastanbuy: A Diary of the Indian Revolt of 1857*. Translated by Khwaja Ahmed Faruqi. New Delhi: Asia Publishing House.
Mujeeb, M. 1969. *Ghalib*. New Delhi: Sahitya Akademi.
Russell, Ralph. 2000. *The Famous Ghalib: The Sound of My Pen*. New Delhi: Roli Books.
——— (ed.). 2003. *The Oxford India Ghalib: Life, Letters and Ghazals*. New Delhi: Oxford University Press.
Varma, Pavan K. 1989. *Ghalib: The Man, the Times*. New Delhi: Penguin Books.

Secondary sources

Alam, Shahid M. 2015. 'Ghazals: Intimations of Ghalib'. *Raritan*, 35 (2): 56–65.
Raja, Masood Ashraf. 2009. 'The Indian Rebellion of 1857 and Mirza Ghalib's Narrative of Survival'. *Prose Studies: History, Theory, Criticism*, 31 (1): 40–54.

Singh, Khushwant. 2001. *City Improbable: An Anthology of Writings on Delhi*. New Delhi: Penguin Books.

Syros, Vasileios. 2012. 'An Early Modern South Asian Thinker on the Rise and Decline of Empires: Shāh Walī Allāh of Delhi, the Mughals, and the Byzantines'. *Journal of World History*, 23 (4): 793–840.

Vajpeyi, Ashok. 2017. *India Dissents: 3000 Years of Difference, Doubt and Argument*. New Delhi: Speaking Tiger.

10

MAPPING TRANSFORMATIONS IN THE INDIAN PUBLIC SPHERE
An analysis of the *Punch* and *Oudh Punch* cartoons

Neha Khurana

Introduction

The 19th century saw several accelerated developments in the Indian public sphere, owing partly to the coming of the technique of lithography, which significantly increased the speed of printing, and in part also because of the growing awareness of the need for a postcolonial identity amongst Indians. At the same time, this century also witnessed a strengthening of stringent processes of British surveillance and censorship of Indian vernacular presses for the same reasons.[1] Back in Britain, a growing need to strengthen national identity through print culture was often accompanied by a muted undercurrent of somewhat critical views on colonialism. *Punch*, the British satirical magazine that came into circulation in Britain in 1841, could be seen as fallout of this paradigm, since the use of satire allowed the magazine to engage in an enriching manner with the current political issues: sometimes proudly mocking the competing colonial nations like Germany and France and at other times being critical of Britain's own forays into its expanding colonial territory. Further, graphic satire, as seen in the *Punch* cartoons, which were the highlight of the magazine, granted both the mockery and criticism a sense of immediacy by making them instantly accessible to a large audience. This satirical magazine triggered the publication of various adaptations of itself in India in several vernacular languages.[2] One such upstart was the *Oudh Punch*, which, like many of its followers, had to navigate the difficult scenario of wanting to exploit the forum to level a critique against British colonial forces and their Indian cahoots, on the one hand, and having to avoid the censorious British gaze, on the other. The *Oudh Punch* was an Urdu weekly which came into publication in 1877 in Lucknow and is seen as the very first Indian adaptation of the British *Punch*, even though

several other adaptations followed the lead. This chapter is intended to be an exploration of the transitions and transformations of the Indian public sphere in the 19th century brought about by a clash of these forces, and for this purpose, I will be comparing the satirical cartoons of the British *Punch* with the cartoons that appeared in the *Oudh Punch*. The *Punch*(es), if I may use the term to refer to the various versions, enjoy the reputation of being the first satirical magazines in almost all the regions that they came up in. Also, interestingly, in each of these cases, the satirical images that accompanied the text played a more than significant role in determining the nature, readability and perhaps also the popularity of these issues. The aims of this chapter are thus multi-faceted. First, by focusing on some of the cartoons that featured in the British *Punch* following the Indian Mutiny of 1857, this chapter will try to comment upon the role that satirical cartoons seem to have played in the formation and strengthening of colonial and Indian identities, coupled with satiric undertones that often manifest themselves in these cartoons. Second, by pointing out how the *Oudh Punch*, in particular, is far from a simple imitation of its British counterpart, this chapter will also briefly try to look at this adaptation as an allegory for the acceptance of 'modernity' in India. To this same effect, this chapter will also try to trace the pre-existing Indian literary and/or oral forms and traditions that may be considered as the predecessors of the satirical cartoon in India. Third, I will propose that the flavour that the interaction between censorship and cartoonists acquired in this phase of colonial rule continues to inform this interaction even post-independence. For this part, I will draw upon my own analysis of political cartoons during the Emergency years (1975–77), focusing on the works of R.K. Laxman. My final assertion will be that since political cartooning seems to have first flourished in India at a time ripe with political conflict and strict surveillance, the conviviality established between satire, cartooning and censorship remained a fundamental one for decades to come and seems to inform this interaction even in the 20th century when the Emergency years present a similar political and social scenario.

The Emergency years marked a very significant time in the history of independent India because it was perhaps the first time that the government imposed strict and elaborate restrictions on the citizens of independent India. When Indira Gandhi declared Emergency on 26 June 1975, one of the first institutions to be severely affected was the press and the freedom of speech of the people of the country. As is well known, a strict code of press censorship was brought in place, and there were restrictions not only on speaking against the government but on speaking at all about the government; about foreign relations with certain nations, like Bangladesh; about the Congress party; and about the law-and-order situation of the country among a hundred other restricted issues being added every now and then. Cartoons particularly came under the scanner, as they made people laugh at the government and were thus pre-censored and passed or rejected for

publication. A cartoon that has since become symbolic of censorship during the Emergency is one of R. K. Laxman's in which we see 'the common man' with his characteristic checked coat and dhoti lying face down on the ground while his head is covered with a newspaper on which the headlines read, 'FINE', 'VERY GOOD', 'VERY ROSY', 'VERY HAPPY', 'MARVELLOUS'[3] and the like to describe the state of affairs in the country. Obviously, the common man is perplexed and wondering where the news about the real conditions of the country lay. The government's fear of satirical cartoons and of people's laughter at their expense makes the state of affairs very reminiscent of colonial rule, when the British were wary of the laughter that satirical magazines were provoking. Indeed, several scholars felt that the Emergency years were worse than colonial rule in terms of the strictness of censorship, leading to the belief that while the stated reason for imposing the Emergency was protection of democracy, the ulterior motive was ensuring longevity of the 'sarkar' much as it was during colonial rule.[4] This similarity in the stated and ulterior aims of censorship, which continues to be prevalent even today with cartoonists being slapped with defamation charges, warrants a look back into the colonial 19th century and its censorship of satirical cartoons and magazines.

Perhaps a short history of the rise of satiric forms in England, which are often considered the precedents of their counterparts in India, is in order here. Mark Bills, in an interesting book titled *The Art of Satire: London in Caricature*, traces links of political (and social) caricaturing (initially coming from Italy and considered a 'high' art form) with the 'popular' form of literary satire (considered a 'low' art form) in 18th-century England (Bills 2006). Bills shows how an instinctive compatibility was possible between 'caricatura' with its exaggerations in features and characteristics and satire with its excesses and intention to attack and that from this unique blend of the high and low coupled with an interplay of text and image emerged a form that was distinctly English. The 'popular' aspect of satire is evident also from the upsurge of printing presses at that time so many of which relied on satirical works. It is from this tradition that there emerged the British magazine *Punch*, which inspired the *Oudh Punch* and several others of its kind.

As several analyses of the coming of print culture starting perhaps with Benedict Anderson have shown, one of the primary effects of print culture was the consolidation and strengthening of national identities through a sharing of national sentiment on matters of public interest. A similar position can be attributed to *Punch* as it began circulation in England in 1841 and was full of commentary on current political affairs and the like. Charles Larcom Graves, in his book *Mr. Punch's History of Modern England Vol. – III 1874–1892*, and Richard Scully, in *British Images of Germany: Admiration, Antagonism & Ambivalence, 1860–1914*, look at various cartoons about Germany and France published in *Punch* after it started circulation

in these countries (Graves 1922; Scully 2012). Both argue that scathing critique was levelled at these countries and their monarchs through the means of graphic satire so much so that on several occasions, the circulation of *Punch* was banned in both these countries. This levelling of critique on neighbouring countries strengthened and fuelled British pride in their own nation. Suitably then, within Britain, while *Punch* (personified in name, though not in figure) as Mr. Punch, sympathised with the oppressed of various kinds – the starving, the ill-paid curate, the ill-housed – and satirised the policies that gave rise to these problems in the country, the satire never became sharp enough so as to actually hurt the ones aimed at provided that they were British. M. H. Spielmann, in his noteworthy text *History of 'Punch'*, refers to Mr. Punch as 'a moral reformer', 'a disinterested critic' and a 'liberal-minded patriot' (Spielmann 1895: 3) and further points out,

> Truth to tell, *Punch* has been kindly from the first; and a man of mettle, too. None has been too exalted or too powerful for attack; withal, his assaults, in comparison with those of his scurrilous contemporaries, have been moderate and gentlemanly in tone.
> (Spielmann 1895: 3)

'The Indian Mutiny Series' in/and *Punch*

This aspect of the *Punch* cartoonists feeling the need to be less critical and more supportive of the home country becomes even more evident as we look at the cartoons that followed the Indian Mutiny of 1857. The Indian Mutiny, also known as the Indian Rebellion of 1857, was a violent revolt kick-started by a mutiny of Indian sepoys of the British army in Meerut, a town in the state of present-day Uttar Pradesh. The mutiny was ultimately unsuccessful but while it continued for about a month, it had spread to various parts of north and central India, including Awadh (the Lucknow region), where it took a particularly patriotic flavour and posed a serious threat to British rule in several parts. It was only after much bloodshed of various British officers, their families and others that the mutiny could be contained. This event forced the British to make several structural changes to their armies in India and also left others back home in Britain feeling wounded and yet victorious in their unity. The cartoons in the British *Punch* that came in the aftermath of this event were morally obliged to uphold and praise British nationalist feelings, on the one hand, and yet on closer analysis, seem to hold undercurrents of a slightly different view. One such cartoon is 'The Red Tape Serpent' in which we see a distraught Sir Colin Campbell trying his best but apparently failing to deal with a serpent that has enveloped him all over (Figure 10.1). This serpent is named 'red tape' and the cartoon itself is captioned: 'The Red Tape Serpent: Sir Colin's Greatest Difficulty in India'.

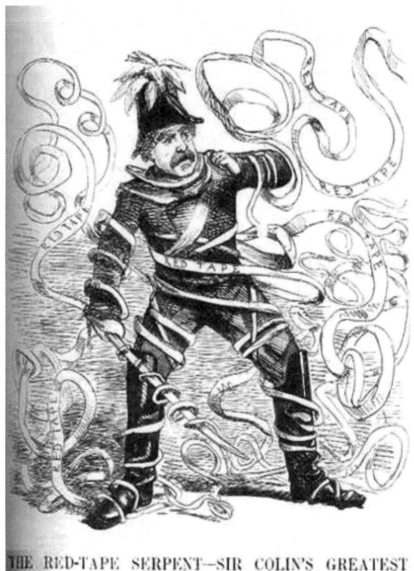

Figure 10.1 The Red Tape Serpent: Sir Colin's Greatest Difficulty in India
Image Courtesy: The Victorian Web

We know from historical records that Sir Colin Campbell became commander-in chief of British forces in India at an early stage in the Indian mutiny. He is known to have played an instrumental role in curbing the rebellion in Lucknow and reclaiming it. This cartoon then, which appears to have been published sometime later in 1857, at first glance, seems to present a Eurocentric picture of the British forces that are trying to civilise an uncouth east. The cartoon seems to be implying that had it not been for the red tape-ism prevalent in India, Sir Colin may have been able to curb the rebellion much faster and more easily. The symbolism of the serpent is significant here and could have two possible and varied interpretations. On the one hand, the image of the serpent is a stereotypical Occidental way of representing the Orient, characterised by snakes and snake-charmers. And in this context, the previous point about *Punch* cartoons serving to consolidate the image of Britain as a nation seems relevant: while the Orient is like a dangerous snake, the Occident is the civilised other that must tame the snake. If we are to go by this interpretation then, the cartoon seems to be fairly non-critical, in fact, supportive of Sir Colin-led British forces that are forced to deal with the abhorrent red tape-ism of India, which becomes the 'greatest difficulty'. However, another careful glance at the cartoon throws up a second possible interpretation of the symbol, which brings an interesting twist, as the serpent could be seen as the figure of the tempter or the temptress, which was particularly significant in the Biblical context most familiar to the British. Seen in this way, we must also consider the immense power of the serpent (representative of the Indian system) and its effect on the British. The fact that Sir Colin had to deal with red tape-ism in a country where the British influence was so strong suggests the possibility that the serpent has tempted and affected even the British in India with Oriental characteristics and made them more like the Indians.

This second reading complicates the simple understanding of the construction of British identity in clear opposition to the East. Red tape-ism then is not a problem in the 'other' to be dealt with by the British but a condition that has afflicted even the British. Perhaps this is why we see Sir Colin standing alone in this cartoon and not with a huge British force in the background. Seen this way, the text below the image also takes on a different undertone: Sir Colin's 'greatest difficulty' is not the Indians themselves but perhaps what we could refer to as British afflicted by the Indian bug. In this sense, the object of critique also shifts from being simply the 'other', the 'East', to a combination of India and the British. Thus an undertone of satire makes itself heard even as the veneer tries to consolidate the national British identity as that of well-meaning officers on a civilising mission.

A similar dissolution of satire in the favour of a consolidated national identity and a subsequently prevalent satirical undertone becomes evident through an analysis of three other cartoons about the Indian mutiny. In the cartoon titled 'The British Lion's Vengeance on the Bengal Tiger', we see

the lion being used to seek vengeance against the tiger that symbolises India (Figure 10.2). We see the lion occupying about sixty per cent of the frame as the tiger is pushed to the margin on the right with its lifeless prey, who is probably a dead white woman curled over her baby. The lion seems to be roaring while the tiger looks more like it is gritting its teeth. This cartoon seems to endorse the sentiment perhaps most popular at that time in Britain that attacks by Indian sepoys on British soldiers and their families need to be avenged.

What is also of interest to us here is the way in which these cartoons, their interpretations and the public's responses to these interpretations have become sources of historical records. Ritu Gairola Khanduri, in her illuminating 2014 book-length study on the *Punch* cartoons, titled *Caricaturing Culture in India: Cartoons and History in the Modern World*, points out that it is by initiating a debate, a discussion and sometimes even an opposition in the public sphere that cartoons allow us to understand the various nuances of a political situation in history (Khanduri 2014). Khanduri uses the hugely differing responses of scholars back in Britain to 'The British Lion's Vengeance on the Bengal Tiger' and other of Tenniel's cartoons from

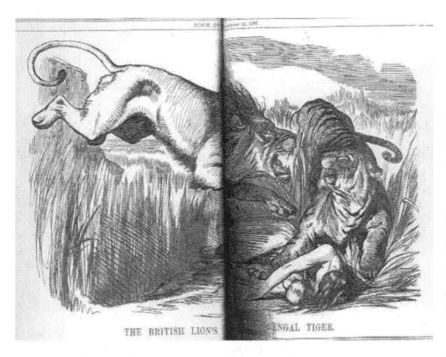

Figure 10.2 The British Lion's Vengeance on the Bengal Tiger
Image Courtesy: The Victorian Web

the Mutiny series to suggest how cartoons had begun to be accepted as sources of historical knowledge and contributed to shaping public opinion. The *Punch* cartoons thus seem to have functioned at various significant junctures: they are news as well as art; they are historical as well as fictional; they are polite as well as critical; and they are 'popular' as well as satirical of popular opinion at times. A case in point is the cartoon titled 'Justice', which shows a white-skinned woman personifying justice hurling a sword at the many dark-skinned men and women whom she also crushes under her feet (Figure 10.3). Other white-skinned men in the background with fierce and determined expressions on their faces seem to be similarly engaged.

While, on the one hand, this cartoon seems to dissolve all satire and tends to come across as a rather direct representation of the popular sentiment, a satiric undertone presents itself to the viewer even here. Are the British readers/viewers expected to simply feel victorious about having curbed the rebellion and proud about being able to take on this monstrous garb of vengeance? The discerning reader is likely to develop a more complex relationship with his or her British identity, which seems to rely on being able to curb rebellions of a people seeking their independence from colonial rule. These differing responses possibly also make us think more closely about the satiric gap between the title and image in this cartoon. The title 'Justice', for example, forces you to focus on the idea of violence meant to equalise the harm caused to the British in the Mutiny. As the reader/viewer looks for justice in the image she or he is unable to take this unapologetic endorsement of 'an eye for an eye' without a pinch of salt.

A similar satirical effect through varying responses is created by the satirical gap between the text and the image in the cartoon titled 'The Clemency of Canning', which shows Lord Canning, who replaced James Andrew Ramsay of Dalhousie as the governor general as a huge figure in comparison to the petit frame of an Indian sepoy he is seen petting. The text that accompanied this cartoon was Lord Canning's words: 'Well, then, they shan't blow him from nasty guns; but he must promise to be a good little sepoy' (Figure 10.4). The patronising tone becomes evident immediately as we read these words and observe the way in which Canning's hand is placed on the head of the sepoy. This patronising tone granted unabashedly to the governor general hints at the fact that this is perhaps meant to create a satirical impact on the readers even though pride in Britain as a nation remains at the heart of even this analysis. The 'clemency' of Canning is hardly clemency at all but rather a threat.

While the text read in isolation may seem to give the impression that the cartoon endorses what is meant literally by the words, the interplay between the text and the image that the image necessitates not only makes space for the satirical commentary but also makes censorship difficult. It seems that it is this discord that has made satire and cartoons as compatible as they are with each other. The combination of the visual register and the

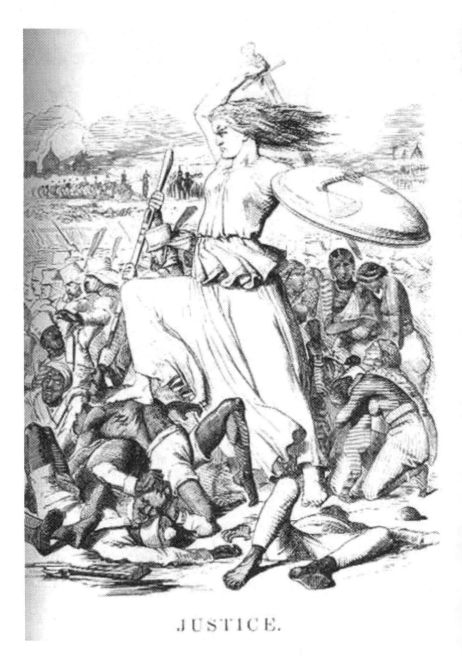

Figure 10.3 Justice
Image Courtesy: The Victorian Web

Figure 10.4 The Clemency of Canning
Image Courtesy: The Victorian Web

exaggerations of satire also often necessitates symbolism (like that of the snake), which renders political cartoons open to various layers of meaning, and once again, it is perhaps this ambiguity and slippage in the meaning that makes censorship all the more difficult. The small face and the long flowing garment of the woman in 'Justice' as well as the simple and not-so-detailed faces of the white-skinned men also remind us of how cartoons invite us to take the place of these figures and imagine ourselves in these scenarios. Scott McCloud, in *Understanding Comics: The Invisible Art*, demonstrates that when we interact with others, while we have a clear and detailed view of the person we are interacting with, we retain only a vague and basic conception of our own face – as basic as a cartoon, which indulges in 'amplification through simplification' (McCloud 1994: 30). Emphasising on the universality of figures in the cartoon, McCloud re-iterates, 'The cartoon is a vacuum into which our identity and awareness are pulled' (36). It appears to me that a similar pulling in of identities into the *Punch* cartoons forces the British readers/viewers to respond to the situation as if they were a participant and not simply as a bystander.

This discord between the text and the image also reminds us of Francesca Orsini's analysis in her essay 'The Hindi Political Sphere' of what she calls the 'politics of the street' versus the 'politics of the library', which also becomes our link between the present analysis and the Indian context (Orsini 2009a: 121–34). While commenting on the role newspapers played in constructing and reflecting 'popular' or 'public' sentiment in India, Orsini's focus has specifically been on the vernacular language press and its relationship with the English language press vis-à-vis the content that could appear in them in the presence of colonial surveillance. In her essay, Orsini associates the term 'constitutional' with popular culture shaped by colonial expectations (like the English language press) and the term 'non-constitutional' with relatively independent institutions (like the vernacular language press) through which the non-literate gained access to the political sphere and formed popular public opinion. While the former category is said to indulge in the 'politics of the library', the latter engaged in the 'politics of the street' (Orsini 2009a: 131). Orsini writes that 'non-constitutional politics emphasized the political role of the press as a vehicle of popular public opinion' (Orsini 2009a: 130), and as several Hindi editors and publishers got censored and went to jail, they became local heroes, news about whom further made the politics of the street more valuable.

Oudh Punch cartoons and the Indian public sphere

Though Orsini's analysis is specifically about the Hindi political sphere in colonial India, something very similar seems to have been at work during the publication of the *Oudh Punch* as well. The British are known to have kept a very close eye on the vernacular language presses, which proliferated

with the coming of the technique of lithography in the 19th century and published not only new texts but also translations of pre-existing texts from varied cultures. As the editors and cartoonists of *Oudh Punch* started satirising the British in India, the British could only make a half-hearted effort to curb the production primarily because the production was presented as an imitation of the British *Punch*. If the logic for colonialism was to make the natives more like the colonisers because they were better in every way, then the British could not have curbed the production of the *Oudh Punch* and other such adaptations without exposing their own agenda of liberal governance as a farce. No wonder then that the editors, writers and cartoonists of *Oudh Punch* always insisted on their magazine being a simple imitation of the British *Punch*. By using this garb of humble natives trying to become as sophisticated and clever as the colonisers (who were handicapped also because of their limited understanding of the vernacular languages), these editors managed to avoid the worst of British surveillance. Therefore, it is for two primary reasons that I associate political cartooning in India with the politics of the street: first, the representation of the popular sentiment, which presumably belongs to the average native, makes this genre a politics of the street, representing public space rather than that of the library, which represents an elite space. This average native is not an intellectual in a position to 'write back' and speak up to the empire directly but is aware of his unequal and unfair status as a colonised subject. In what may come across as a classic Spivak-ian dilemma, it is the intellectuals behind the newspaper who voice the concerns of the average native as a representative of them. Second, as cartoons tend to make the viewer a participant in the happenings (as already explicated), they tend to represent or appropriate the opinion of the average native. As a result, the average native becomes a participant in the happenings as a major stakeholder. The circumstances thus concern everyone and sometimes most of all, the average native on the street. Both of these points take us to an analysis of the figure of Mr. Punch in the *Oudh Punch*. In the British *Punch*, Mr. Punch was a personification of the magazine and an omnipresent observer of happenings around him. He never made himself visible as a figure in the cartoons. In the *Oudh Punch*, however, he becomes an observable figure who appears in the cartoons. Mr. Punch is a particularly eccentric figure with a feather or two in his *desi* hat, dressed in the traditional kurta-pyjama but with a clown's bib around the neck. His tongue hangs loose outside his mouth, probably indicative of how he does not even intend to hold back his tongue when it comes to making comments about the state of things around him, making him in part representative of the popular opinion of the public and in part influencing the opinion of the public (Figure 10.5).

This appearance of Mr. Punch of the *Oudh Punch* with his elaborate costume and hat with a feather also triggers a look into the possible sources of influence for this satirical figure in particular and the genre of satire in general and makes us therefore reconsider the extent of the imitation. While

Figure 10.5 Mr. Punch
Image Courtesy: Digital South Asia Library

several histories of the career of graphic satire in India trace its origin to the various versions of *Punch*, there have been other sources that contributed to this development. Monika Horstmann and Heidi Pauwels, in the introduction to their edited volume *Indian Satire in the Period of First Modernity*, suggest a range of possible sources for the genre of satire (Horstman and Pauwels 2012). The earliest sources in their volume are the satirical material circulated in Jain temples amongst other reading material, like *dharmakathas*, that was often circulated to followers around the 11th century. Other religious groups are also known to have followed similar practices in medieval India. Further, the couplets of Kabir (15th century) and other *sants* that were repeatedly sung across time periods were also often critical of orthodoxy and came close to what we call satire today. Another notable source listed has been the *bharud* genre of drama performances in Maharashtra of the 16th century, which are alive even today and are also often of a satirical nature. By talking about satire in colonial India in the same breath as these pre-existing satirical genres in India, Horstmann and Pauwels hint at the possibility of looking at these varied genres as the precedents of satire in India. About the aptness of satire in colonial India, they write,

> During the colonial period, however, caricature became a sharp satirical weapon, thanks to the new print media which portrayed the collision of values, attitudes and lifestyles produced by the colonial conditions. Satire now virtually operated as a safety valve against the social, cultural and mental asymmetry and incongruencies of the period.
> (Horstmann and Pauwels 2012: 4)

For the specific figure of Mr. Punch, I feel the inspiration may be located in the figure of the *vidushaka* from traditional Sanskrit drama prevalent mostly in the southern parts of India. The vidushaka of Sanskrit drama has variously been described as a fool, a court jester and a clown. The vidushaka presents himself in an elaborate costume and face makeup, and wisdom is hidden in his apparently foolish utterances. Thus, though no concrete evidence can be located for the influence behind making Punch a visible figure in the cartoons of *Oudh Punch*, it seems probable from the similarities that vidushaka could be one of those. Why did the editors, cartoonists and writers of *Oudh Punch* consistently deny any originality of their adaptation of the British *Punch* and go on insisting it was a strict imitation?[5] We also wonder about the assumed silence about these and other possible pre-existing genres from the Indian tradition as sources of the satire in this graphic content. The possibility and viability of this alternative historical development of satire in India strengthens our belief in the assertion of the editors of *Oudh Punch* and other adaptations being strict 'imitations' as a mask to evade censorship.

In this context, let us look at another significant image which was used as one of the cover photos of *Oudh Punch*. The image shows Mr. Punch presiding at a large dinner table with his allies and having a good laugh. The image immediately brings to our recollection the well-known fancy and noisy dinners that used to precede each issue of the British *Punch* to discuss and debate the articles and cartoons that were to form a part of the next issue. While this seems to push us towards an analysis that considers the British *Punch* as the centre and the vernacular versions as the margins that constantly try to imitate the centre, we must consider the dresses and so on of all the guests present at the dinner for a wider perspective (Figure 10.6). They are suitably 'desi', if we may use the term, as the guests who are accurately clothed in 'Oriental' garments visibly include a Lucknow Nawab (immediately to his right), a Sikh, a Maharatta, a Persian, a Bengali, a Parsi, a Jew, a Turk, and even an Englishman (immediately to his left). On the top, stick-like figures from populous India are used to make up the words 'Oudh Punch' and in a seemingly Urdu-like handwriting, the English words in bold read, 'Life is Pleasure'.

The nature of the guests representing varied different regional and religious cultures of India as well as the presence of an actual figure of Mr. Punch the president with a crown on his head suggest that the *Oudh Punch* was never a simple imitation. This interplay of satire, censorship and insistence on the imitative nature of *Oudh Punch* prompts one to pick on Ritu Gairola Khanduri's use of Michel De Certeau's concept of 'tactical modernity' to explain the development of the genre of graphic satire and the insistence on its intent as mere imitation to shield cartoonists and editors from censorship (Khanduri 2014). Khanduri also suggests that the insistence even in historical records and several literary analyses on the vernacular Punches as imitations of the British *Punch* could be seen as 'hegemonic remembering' (Khanduri 2014: 6), which she explains as a functional way of remembering that tactical step of the past. Both the concepts of 'tactical modernity' and 'hegemonic remembering' seem to be applicable even as we think about the coming of modernity at large in India, making the development of *Punch* versions somewhat an allegory for understanding modernity, its rise and spread in India. One is also reminded of the interesting comparison that Hans Harder draws in his prologue to the volume *Asian Punches: A Transcultural Affair* in order to emphasise that for a magazine to touch cords with its target reading public, it will have to do much more than just imitate:

> For even without going into the intricacies and 'identity politics' of drinks such as Pepsi, the Indian Thums Up, the Chinese Wahaha, Afri and Club Cola (West and East German respectively), or the latest German avatar, Fritz Cola, it seems certain that in these cases difference is nothing to be aspired to; rather, utmost similarity with

Figure 10.6 Punch Dinner
Image Courtesy: Digital South Asia Library

the perceived original has to be achieved. Not so in the case of Punch: even though one of the meanings of 'punch' is a mixed drink with a recipe, and one may suppose that some kind of recipe also underlay the Punch magazine and triggered attempts of copying, a magazine belongs to a different category of artifact than copying a drink. The cultural transaction of such an entity would have to make sense beyond the immediate senses; it would have to involve a very complex translation of the way a society and the world are perceived.

(Harder 2013: 5)

An example would be an illustration depicting an opium den in Lucknow in which we see that Mr. Punch turns his satiric glance inwards and focuses on the ill habit of consuming opium in various ways in Lucknow dens (Figure 10.7). People of varied cultures can be seen in this illustration consuming opium in various ways and also being affected by it in various ways – while some have already gone to the other side of consciousness, others are on their way to the same state. One apparently rich individual who is able to afford a little private cabin of his own and perhaps a larger amount of opium is

Figure 10.7 Opium Den in Lucknow
Image Courtesy: Digital South Asia Library

apparently lying in a state of coma, and Mr. Punch, with an amused and confused look on his face, appears to be drawing the curtain for him. With this boisterousness in mocking Punch's own countrymen in his part of India in a manner as evident as this, the *Oudh Punch* seems to by far surpass the boldness of the British *Punch*, which almost always evaded such overt mockery.

As we begin to consider what makes the British *Punch* so adaptable in the various contexts of the innumerable vernacular versions that came up, several features come to mind: like the presence of the word 'punch' with meanings in Hindi and many other Indian vernacular languages[6] and the compatibility of the visual register with the already existing satirical forms of writing, especially in the Indian subcontinent. The actual presence of the figure of Mr. Punch is the first such feature that points towards an adaptation. With his long tongue and nose, he dares not to let anyone high or low breathe easy when it comes to satire. He is everywhere he needs to be to observe closely and mock vociferously. I propose that this bewildered omnipresence of Mr. Punch perhaps develops through the ages into the omnipresence and bewilderment of R. K. Laxman's common man in his cartoons in the latter half of the 20th century. Since it is the common man's perspective that we see in Laxman's cartoons, these cartoons are far more strongly satirical of the powers that be than many of the British *Punch* cartoons and also several of the *Oudh Punch* cartoons. However, before we can make further comments on Laxman's common man cartoons, we must look deeper into the genre of satire to understand what makes it relevant and a suitable form in various different cultural and political contexts other than the colonial ones discussed here.

Satire and its graphic manifestations in contemporary India

The characteristics that Briana A. Connery and Kirke Combe associate with satire in the introduction to their edited collection of essays, *Theorising Satire: Essays in Literary Criticism*, are worth recounting briefly here (Connery and Combe 1995: 1–15). These characteristics, formulated through analyses of satire, satirical works and satire criticism across varied cultural and temporal contexts, will provide the working conceptualisation of satire nearly adequate for the purposes of this chapter. First, Connery and Combe point out that satire is almost always historically specific, referring to particular individuals and historical events/situations, and hence the reader needs knowledge from outside the text to absorb the insights the satirist offers. Second, satire, more poignantly than any other mode or genre, is defined by its intention (to attack), and hence again, the reader needs knowledge beyond what the text offers. Third, satire tends towards open-endedness, for endings would convert it into either tragedy or comedy. Fourth, satire's own formlessness allows it to lend itself easily to other forms and use by

other literary genres. Fifth, satire exploits oppositions and hierarchies for its functioning (Connery and Combe 1995: 4–7).

The last three of these characteristics (open-endedness, formlessness and exploiting oppositions and hierarchies) seem to be those particular characteristics that have made this long association of political cartooning and satire possible and viable. Political cartoons, appearing one at a time in dailies, must necessarily be open-ended, for neither can one cartoon 'tell-it-all', nor is it in the interest of the satirist to reach conclusions that either exhaust the need for further cartooning or are so categorical that they attract the meaner side of the wrath of those satirised. The reliance of satire on oppositions and hierarchies further contributes to this compatibility between political cartooning and satire, as oppositions and hierarchies can be most effectively represented pictorially – so much so that satire has become the very language of political cartooning, as constant struggles and turmoil make the most suitable environment for its thriving. It is perhaps this aspect of satire's status as what Connery and Combe call a 'living omnivorous organism' (Connery and Combe 1995), coupled with its association with cartooning and the exaggerations of caricature, that has made it flourish in the Indian context given that India's political scene has been particularly and unceasingly turbulent since any moment in history that one can recount. Interestingly, this is how Laxman recalls the fears of cartoonists like himself when Rajiv Gandhi came to power: 'we feared that the source of inspiration for cartoons might dry up. In a utopia there would be no scope for crisis and adversity, on which, after all, the art of satire thrived!' (Laxman 1989: 89). However, it seems reasonably hard to imagine a situation where the inspiration for cartoons could dry up even in relatively stable political situations. Thus, the need for satire never runs out, and with it, the need to protect satirists from censorship also persists. Here, it would also be appropriate to consider the view of Hans Harder in a 2013 collection titled *Asian Punches: A Transcultural Affair*, which he edited with Barbara Mittler and which seems to be one of the first and few collections dealing with the *Punch* phenomenon. The volume deals with versions of *Punch* not only in India or Asia but all over the world, including the Middle East (Harder 2013). Amongst other contributions, Harder extends Khanduri's exploration of how *Punch* served as a suitable format to respond to several issues within colonial rule and proposes that 'such a format was bound to become outdated once colonialism ceased to exist' (Harder 2013: 6). Harder adds, 'Strictly in terms of their life-span, the *Punch* versions therefore seem to belong to what one terms the age of colonialism and imperialism; and it may seem reasonable to seek an intrinsic link between them and the age' (ibid). By pointing out how satire, especially of a graphic nature, remains what Combe and Connery call an 'omnivorous organism' thriving on any political turmoil that may be found in the surroundings, I take issue with Harder's view about the datedness of satirical magazines. The continued trend of including at least one

political cartoon in each national daily of the country is the first testimony to the significance of satire (especially graphic) in reflecting and shaping the popular public imagination. The interaction between cartoonists and the censorship of the Emergency years is another significant case in point. Laxman himself recalls the imposition of Emergency as follows:

> We lost our freedom of expression overnight. The newspapers were at the mercy of the censors, who were at the mercy of the powers in New Delhi. Editorials, articles, news items, pictures, and short stories were scrutinized for seditious ideas and banned or allowed after deletions were made. Cartoons, of course, became the censors' primary target. . . . For a political cartoonist, the situation became a nightmare. Whatever I drew, I ran the risk of offending someone in power.
>
> (Laxman 1989: 85)

Laxman presents a rather cynical attitude about art and its potential in a time like this, and on being asked in an interview whether he intends his cartoons to morally educate the readers about their situation so that they can make an effort to improve it, Laxman vehemently replies, 'I don't make my cartoons so the people may learn. . . . To make people laugh and understand the ridiculousness of the situation, that's all, nothing more than that. . . . Yes, yes, it does make me very angry, but helpless' (Laxman 2008). Laxman also added earlier in the interview, 'What power do I have? Nothing!' (ibid).

Two issues immediately concern us here. First, if art and artists have no power, as Laxman claims, why would a prime minister trying to protect her post impose such restrictions on freedom of expression and give reasons to people to badmouth the government? The very fact that the authorities have always seen the mass media (and particularly the medium of cartoons) as something to fear indeed speaks volumes about the potential these are recognised to have. Despite this and other effective cartoons, why then would Laxman undermine the power of art? History appears to have repeated itself: in a bid to tackle extreme censorship, Laxman resorted to undermining his own power as an artist much like the *Punch* editors and cartoonists resorted to undermining their own originality. Once again, satire seems to have been possible only under the garb of its apparent ineffectiveness. In fact, it was under the pressure of censorship of political cartooning and cartoonists that Laxman had been forced to leave for Mauritius for some time during the Emergency. Though Indira Gandhi is known to have been supportive of cartoonists and satirists during the Emergency, her followers and ministers are known to have taken Laxman to task on several occasions, forcing him to leave the country. When Laxman returned to the country after the end of the Emergency, he had become the angry mocker that we recognise him as and, for times to come, insisted on emphasising the ineffectiveness of art on the

ground level. As Laxman continued to cartoon under this garb of the powerlessness of art, his journey becomes significant for us to trace the effect of censorship on political cartoonists. This tussle between the 'freedom to cartoon, freedom to speak' and state surveillance seems to have remained characteristic of the Indian political cartooning scene throughout the 19th and 20th centuries.

Conclusion

This chapter has tried to re-situate political cartooning in India by re-visiting the possible sources of inspiration (even sub-conscious ones present in the collective cultural memory) for cartoonists and their work. By analysing the interaction that political cartooning had with strict censorship in 19th-century India (more specifically, Lucknow), we see that many of the codes of that interaction manifest themselves even in contemporary democratic India. That led us to consider the conviviality between cartooning and satire and the suitability of graphic satire in times of censorship. Challenging the view of *Oudh Punch* as an imitation of the British *Punch*, this paper analysed the tactical reason behind artists trying to avoid being censored by presenting their work as an imitation of the colonial project in the 19th century and by denying any power that cartoons may possess over the masses in more contemporary times. This chapter has been an attempt to fill the apparent gap that has existed for a long time in scholarship on cartoons in the colonial age and even contemporary India as it draws upon the significant contributions of various scholars working on tangential lines. It was proposed that the interaction between the colonial authorities and satirical cartoonists of the time seems to have set the tone for this interaction for most of the 20th century. In the 21st century too, the case of the cartoonist Aseem Trivedi, who was arrested on sedition charges for a series of cartoons he did in 2011–12 ridiculing the democratic system of the country and a professor who was arrested for circulating cartoons ridiculing politician Mamata Bannerjee indicate a similar interaction between satirical cartoonists and the fearful government. Aseem Trivedi commented in 2015 about the increasingly censorious times: 'They started with [critics of the ruling party] and now they're shutting anyone who is critical of government'.[7] However it has not been possible here to delve into the effect that cartoons have and have had on the common citizen. Does satire really work by making people look at themselves and their situation afresh and pushing them to change it? Since humour is an essential part of satire (even if satire is not limited to it), how does it help in arousing the masses? Are the masses as passive and uncritical as they are often portrayed to be (like Laxman's common man), or are they 'emancipated spectators' as Jacques Ranciere would claim? We may therefore further theorise on leisure and laughter to understand the effect of political satirical cartoons on the public.

Notes

1 There have been significant and elaborate studies on the colonial and post-colonial Indian public sphere, focusing on popular art forms like *qissas*, the novel form and its evolution, songs, poetry, Hindi and Urdu *barahamasas* and others and these include *Print and Pleasure: Popular Literature and Entertaining Fictions in Colonial India* by Francesca Orsini (2009b) and *Pleasure and the Nation: The History, Politics, and Consumption of Public Culture in India* edited by Rachel Dwyer and Christopher Pinney (2001), among others. While this chapter derives an understanding of the arrival of several new genres in the colonial Indian public sphere and an insight into publishing and printing technologies from these books, these did not offer any insight into the production and reception of satirical political cartoons such as were printed routinely in *Oudh Punch* and its various counterparts.
2 A search for existing research on the British *Punch* and its interaction with its audience resulted in very few and dated texts. One such dated study, M. H. Spielmann's *History of "Punch"* (1895) takes into account only the British *Punch* in all its historical, artistic and literary aspects without touching upon its various offshoots in the colonies. Spielmann's text gives an elaborate account of the history of the commencement of *Punch*, the editors and the cartoonists with their agendas who founded the magazine and kept it going and even the process of the decision taken about the theme for the each weekly issue, which took place at the gala dinner meet that was organised for the purpose every week. Spielmann's text also discusses the monetary issues that plagued the publication of the magazine, leading to it going out of publication only to spring back into action some years later. However, an analysis of the offshoots of the British *Punch* in the colonies has been taken up seriously only in the 21st century with the publication of a collection *Asian Punches: A Transcultural Affair*, edited by Hans Harder and Barbara Mittler, and Ritu Gairola Khanduri's *Caricaturing Culture in India: Cartoons and History in the Modern World* in 2014. While Gairola's text focuses primarily on the Indian versions of *Punch*, Harder and Mittler expand the scope of their collection to include pan-Asian versions.
3 This cartoon also became the cover of a collection of R. K. Laxman's cartoons, 'Brushing Up the Years', and can be seen at www.goodreads.com/book/show/1484716. Brushing_Up_The_Years. Last Accessed 4 February 2018.
4 Christel Devadawson, in her book titled *Out of Line: Cartoons, Caricatures and Contemporary India*, presents this account of the Emergency years in a chapter dedicated to Abu Abraham's cartoons (Devadawson 2014). The Congress party of that time was referred to and perceived as the 'sarkar', which indicates a colonial hangover of power that was associated with those who had the reins of the country (127). Further, she cites Balraj Puri's article 'A Fuller View of the Emergency' to point out how censorship during the Emergency years exceeded that during colonial rule.
5 Interestingly, even Laxman, who makes a reference to the character of the vidushaka, in his article on cartoons (Laxman 1989: 69), mentioning how the vidushaka always had things to say about the current goings-on, continues to cite the art of caricature arriving in India through the British *Punch* as the precedent of cartoons in India.
6 *Panch* is a Hindi word meaning five. It has counterparts and precedents in other languages, like the Sanskrit word *panchan* and the Persian word *panj*. The word *punch/panch* is popular as the name of a drink which originated in the Indian subcontinent and typically has five (panch) ingredients.
7 www.abc.net.au/news/2017-10-22/indian-cartoonist-arrested-sedition-free-speech-under-threat/9069294. Last Accessed 11 February 2018.

References

Bills, Mark. 2006. *The Art of Satire: London in Caricature*. London: Philip Wilson Publishers.
Connery, Brian A. and Kirke Combe. 1995. 'Theorising Satire: A Retrospective and Introduction', in Brian A. Connery and Kirke Combe (eds.), *Theorising Satire: Essays in Literary Criticism*. London: Palgrave Macmillan.
Devadawson, Christel R. 2014. *Out of Line: Cartoons, Caricature and Contemporary India*. New Delhi: Orient Blackswan.
Graves, Charles Larcom. 1922. *Mr. Punch's History of Modern England Vol. – III 1874–1892*. London, New York, Toronto and Melbourne: Cassell and Co.
Harder, Hans. 2013. 'Prologue: Late Nineteenth and Twentieth Century Asian Punch Versions and Related Satirical Journals'. In Hans Harder and Barbara Mittler (eds.), *Asian Punches: A Transcultural Affair*. London: Springer.
Horstmann, Monika and Heidi Pauwels. 2012. 'Introduction'. In Monika Horstmann and Heidi Pauwels (eds.), *Indian Satire in the Period of First Modernity*. Wiesbaden: Harrassowitz Verlag.
Khanduri, Ritu Gairola. 2014. *Caricaturing Culture in India: Cartoons and History in the Modern World*. Cambridge: Cambridge University Press.
Laxman, R. K. 1989. 'Freedom to Cartoon, Freedom to Speak'. *Daedalus*, 118 (4): 68–91. www.jstor.org/stable/20025265 Last Accessed 4 November 2017.
———. 2008. Interview by Anuradha SenGupta. *IBN Live. CNN IBN*, 5 February. Web. http://ibnlive.in.com/news/its-nice-to-have-double-standards-r-k-laxman/58154-19.html Last Accessed 8 January 2012.
McCloud, Scott. 1994. *Understanding Comics: The Invisible Art*. New York: Harper Perennial. First Published by Kitchen Sink Press in 1993.
Orsini, Francesca. 2009a. 'The Hindi Political Sphere'. In Arvind Rajagopal (ed.), *The Indian Public Sphere: Readings in Media History*. New Delhi: Oxford University Press.
———. 2009b. *Print and Pleasure: Popular Literature and Entertaining Fictions in Colonial North India*. Ranikhet: Permanent Black.
Pinney, Christopher. 2001. 'Introduction: Public, Popular and Other Cultures'. In Rachel Dwyer and Christopher Pinney (eds.), *Pleasure and the Nation: The History, Politics and Consumption of Public Culture in India*. New Delhi: Oxford University Press.
Scully, Richard. 2012. *British Images of Germany: Admiration, Antagonism & Ambivalence, 1860–1914*. New York: Palgrave Macmillan.
Spielmann, M. H. 1895. *The History of "Punch"*. New York: The Cassell Publishing Co.

Images

Digital South Asia Library. http://dsal.uchicago.edu/digbooks/digpager.html?BOOKID=NC1718.08&object=10 Last Accessed 4 November 2017, http://dsal.uchicago.edu/digbooks/digpager.html?BOOKID=NC1718.08&object=12 Last Accessed 4 November 2017, http://dsal.uchicago.edu/digbooks/digpager.html?BOOKID=NC1718.08&object=14 Last Accessed 4 November 2017.

The Victorian Web. www.victorianweb.org/periodicals/punch/53.html Last Accessed 4 November 2017.
———. www.victorianweb.org/periodicals/punch/54.html Last Accessed 4 November 2017.
———. www.victorianweb.org/periodicals/punch/56.html Last Accessed 4 November 2017.
———. www.victorianweb.org/periodicals/punch/57.html Last Accessed 4 November 2017.

Part IV

TRANSIGENT CULTURES

11
MUSIC BEFORE THE 'MODERNS'
A study of the changing economy of pleasure

Vibhuti Sharma

Prologue

To begin the story of Hindustani music in 18th and 19th centuries, let us step back a little in time and start from a somewhat paradoxical position. The time is that of the late 17th century, and the paradox here surfaces in the context of the sovereign ban on music. A famous incident often narrated as indicative of the orthodox political and religious ideology of Aurangzeb's reign (1658–1707) is that of the 'burial' of music. The prohibition on music that Aurangzeb is said to have announced in the year 1668–9 is considered to be one of the markers of the repression that cultural forms of expression suffered during his puritanical regime. The story goes that as a reaction to the ban, the musicians took out a funeral procession carrying several decorated biers amidst loud cries of grief and lamentation. Aurangzeb, who was on his way to the mosque, according to chroniclers like Niccoloa Mannuci, seeing this procession, sent someone to enquire about the cause of such grief. To this, the musicians in mourning replied that 'the king's orders had killed Music, therefore they were bearing her to the grave' (Schofield 2007: 80). Mannuci further narrates, 'Report was made to the king, who quite calmly remarked that they should pray for the soul of Music, and see that she was thoroughly well buried' (ibid: 80).[1] In Khafi Khan's account of the same incident in *Muntakhab al-Lubab*, Aurangzeb's words reiterate with greater force the symbolic death of music articulated through the prohibition: To the musicians' response that they were going to bury music because 'Music (*rag*) is dead', he remarks, 'Bury it so deep under the earth that no sound or echo of it may rise again' (ibid: 88).[2]

The historical authenticity of the burial story has been the subject of extensive research by scholars like Katherine Schofield, who rigorously argues that it was for personal reasons of piety and religious integrity, rather than a public and political indictment against music, that Aurangzeb renounced the pleasures of music.[3] Showing the discrepancies in the

often-exaggerated versions of the story in different sources which reflect the chroniclers' prejudices against the emperor and by looking at several less-cited primary accounts, she argues that the effect of ban was more symbolic and that musical life during Aurangzeb's rule did not suffer as is commonly assumed. However, even if it was not very effective, this symbolic interruption to the continuing history of Hindustani classical music retains considerable importance when it comes to understanding the *discourse* of the so-called pre-modern Indian music. It is our intention to start this chapter, which deals with the transitions in Hindustani music in the 18th and 19th centuries, with the story of the ban for another reason.

Prohibition of art does not merely indicate the anti-artistic prejudice of a time. Historically, artistic censorship and prohibition has been symptomatic of the efficacy of art, of how much power an artistic object wields, such that the social, religious and even the political order starts to feel threatened by it, and soon certain forms of artistic expressions are pronounced as dangerous to the normal functioning of the said order. Sometimes such a condition leads to censorship, but sometimes it may also trigger a more severe response of being banned. The success or failure of such a response can be historically authenticated or argued. But the very possibility of banning art, in this case music, is inevitably symptomatic of this force or effect which is inherent to all genuine artistic expressions. Therefore, the problem of the ban on music is not to be evaluated in terms of its historical authenticity or the concrete historical and cultural effects it generates. It is rather to enter the discourse of Hindustani music from a threshold position, which though symbolic in nature, nevertheless (or perhaps because of this) testifies to the power and desire of music[4]. It is this question of desire and pleasure that the ban tries to abolish. However, paradoxically, it is through such a process of exclusion that the question of desire is included within the field of political, social and religious power and sustained as its negative condition. Therefore, the question of a ban[5] should not be seen as the affirmation of the power of the sovereign which can be authenticated – or rejected – by the historical evidence of success or failure of the ban.[6]

In other words, our point is not to verify the authenticity of the alternative socio-cultural experience of music which seems to exist during Aurangzeb's time. Our task is to enter the discourse of music from the singular vantage point of the statement of the ban to emphasize this question of power and desire which saturates the discourse of music. We know that the structure of a ban can very simply be expressed as the relation between sovereign power and that which is excluded by that power from the domain of that very power itself. In other words, the banned object is excluded from the domain of power by a sovereign exercise of that very power in terms of an exceptional decision. From this point of view, the ban designates a state of exception, in so far as something is symbolically included and affirmed within an order by excluding it from that very order. In this sense, the

MUSIC BEFORE THE 'MODERNS'

banned object is similar to the sacrificed object because the sacrificed object is made sacred by sacrificing and thereby negating it. In other words, the act of sacrifice sanctifies the sacrificial object by excluding it from the socio-religious domain. Similarly, music as an object of pleasure can very well be negated and excluded, which would in turn testify to its being included in the discourse of pleasure that the sovereign religio-political power creates for itself. Consider the following lines from sources such as *Mir'at-i 'Alam* and the *Ma'asir-i 'Alamgiri* (which Schofield considers as being closer to Aurangzeb's official stance on music):

> Mirza Mukkaram Khan Safavi, who was an expert in the musical art, once said to His Majesty 'what is your Majesty's view of music?' The Emperor answered (in Arabic) 'It is *mubah* [permissible], neither good nor bad.' Khan asked, 'Then what kind of it is in your opinion most worthy to be heard?' The Emperor replied, 'I cannot listen to music [without] instruments especially *pakhawaj*, but that is unanimously prohibited (*haram*); so I have left off hearing singing too'.
>
> (Schofield 2007:101)[7]

Clearly, pakhawaj produces the kind of pleasure without which music has no meaning for the emperor. However it is precisely at this point – this precise moment of pleasure – that music is prohibited. Music is permissible in so far as it does not participate in the production of pleasure. This shows that banning is a threshold point of a discourse which has to deal with the problem of enjoyment. Extending this line of argument, it is easy to say that music is 'permissible' if it can somehow govern this production of pleasure. The banning of musical enjoyment is the very limit of a discourse of enjoyment related to artistic production. Therefore, we see the formation of a discourse which can initiate a management of pleasure through which good and bad music can be decided. Such judgement not only includes an ethico-religious point of view but also an aesthetic perspective. We are arguing two points here based upon the single hypothesis that the enjoyment of music remains an excess: Firstly, we are saying that in Aurangzeb's court, music becomes the excess that can be controlled only by being included as an exclusion. This is the logic behind the ban. However, secondly, outside the imperial court, where it was not banned, a certain economy of pleasure[8] was produced in order to govern enjoyment produced by music. This governmentality of pleasure pushed music from an ethico-religious towards a more cultural and aesthetic discourse. This means that examples of music thriving despite the prohibition are not simple instances of exceptions to the rule, nor do they prove that we should not take the question of the ban seriously because it was not effective. Similarly, it does not lead us to believe that patronages outside the imperial court were liberal alternatives

to a conservative imperial policy towards music. Neither is it a simple fact of stating that the story of the ban is wrong. In fact, they show how, when viewed from the point of view of power and desire, the discourse of music during Aurangzeb's time offers these two opposing variations, of banning and governing music.

It would be the task of this chapter to show how in the 18thand19th centuries, the statement of the ban is displaced onto an aesthetic and cultural plane. While the problem of prohibition is sustained by a logic of absolute negation, indicating a categorical imperative against the pleasure of music, the discourse of patronage in the 18thcentury designates a new economy of pleasure based upon the asymmetrical (hierarchical) distribution of power and the pleasure of music. We will therefore have to frequently return to this question of pleasure and its various modes of production and governance in the history of Hindustani music of the time. In the complex field of transformation of styles and forms of music during this period informed by an even more complicated network of social, cultural and artistic relations, we will try to search for that latent economy of pleasure which determines the relations of power and knowledge.

The imperial court, mehfils and the mela: three economies of pleasure

"Az ma-st hamah fasad-i-baqi" ("After me, chaos"), these words of Aurangzeb set the tone for the last phase of Mughal rule in India. After Aurangzeb's death in 1707, the first half of the 18th century witnessed the political instability and the wars of accession, which, it is argued, were a natural consequence of the unrest that had already begun during the former's reign. His involvement in the Deccan and the political intrigues at the imperial court had started weakening the administrative structure and its various institutions. However, this precarious position of the sovereign rule and its gradual disintegration in the later years is often posited against the lively social and cultural life of the imperial city in the 18th century. The expansion of art, literature, philosophy and science stands out sharply against a background of political failures and the atmosphere of gloom caused by it (see Malik 1977:342).

During Bahadur Shah's rule,[9] sometime before his death in 1712, there is a passing mention of Dutch musicians who are called to perform at the royal court in Lahore before the king and his queens.[10] Following Bahadur Shah's death, with new wars among the princes contesting the throne, his eldest son, Jahandar Shah, emerges victorious. It is his eleven-month rule that offers us not only some strange and entertaining stories regarding the cultural and social reality of his court; it also allows us to recognise the strategic efficacy of relations of power which are embedded in the artistic and cultural life of his imperial court. That being the case, when Jahandar Shah moves his court to Delhi from Lahore in 1712 for a period of five months,

it is said that Delhi 'fell under the dominion of the Lord of Misrule' (Irvine 1922: 192). A major reason for this is believed to be his blind fondness for Lal Kunwar, a 'dancing girl', his favourite courtesan, whom he marries to the immense displeasure of the imperial household. She is raised to the status of the queen and 'dignified with the title of *Imtiyaz Mahal*, 'Chosen of the Palace' (ibid:193). Lal Kunwar is seen as someone who seduces the emperor into a life of pleasure and flippancy and exerts enough influence on him to get her demands fulfilled.[11] She is important to our story not merely because she belonged to the class of musicians called *kalawant*,[12] but because of her representation as a seductress, whose musical prowess could only be matched by her power of 'seduction' of the emperor. This supports the argument that art can very easily lead to ethical degeneration because it operates on a field of enjoyment which makes it susceptible to manipulation and exploitation. And women have historically been seen as key figures of such exploitation of artistic pleasure, which mostly corresponds to their role in a sexual economy oriented towards power. While talking about the transformation and rise of particular musical forms during the 18th century, we have to be constantly vigilant of the nature of power certain forms of music started exercising over others, not merely because of their formal characteristics, but because these forms were caught in a complicated relation of power expressed through what we are calling an economy of pleasure.

Lal Kunwar's prominent presence in the imperial court sheds light on the new tendencies that begin to appear around this time with respect to the status of music and the relation between musicians and the court. A gradual increase in the number of musicians is observed, with her brothers and other relations getting associated with the court. Moreover, to the disappointment of many, including certain chroniclers, she wins innumerable favours for her family, including the appointment of some musicians to high government posts.[13] William Irvine (1922) writes,

> During these months the fiddlers and drummers, who were Lal Kunwar's brothers and relations, swaggered through the streets, committing every sort of outrage. . . . Her whole family was ennobled, father, brothers, and brothers-in-law. . . . All the brothers were granted the naubat, or the right to play music at stated intervals, and the use of kettle-drums when on the march. Their titles were Niamat Khan, Namdar Khan, and Khanazad Khan. Some of the finest confiscated mansions in the city were given to them, and as Kamwar Khan says, 'the owl dwelt in the eagles nest, and the crow took the place of the nightingale'.
>
> (Irvine 1922: 193)

Therefore, during Jahandar Shah's reign, there are many instances that reflect the nobility's annoyance with the liberties enjoyed by the kalawant

community. At the same time, as days of unrestrained pleasure and imperial privileges continue for both Jahandar Shah and Lal Kunwar, all respect or fear of the sovereign begins to cease. He fails to establish himself as a sovereign fit to govern others and, most important, himself. At this stage, from these references, we can infer two things: Firstly, the instability that characterises the Mughal administrative elite symptomatic of their political decline is ethically traced back to their life of indulgence in 'lowly' pleasures where music occupies an integral space. The inability to govern others is therefore reduced to their inability to govern themselves in terms of the excessive indulgence in artistic and other forms of enjoyment. Secondly, and perhaps more interestingly, it follows the emergence of a musician class who will inversely start accumulating artistic and social power through exploiting this domain of pleasure particularly in the imperial court. This is not to say that the patron-musician relationship had once disappeared and now began to flourish again. On the contrary, a new orientation and a new network of interests gets manifested in this relationship, which makes it central to our examination of music in the first half of the 18th century. This brings us to the reign of the 12th Mughal emperor, Muhammad Shah (1719–1748), whose time saw some significant developments in the domain of Hindustani music which became the foundation for modern music practice. During his time, the city of Shahjahanabad (Delhi) emerged as an important centre for social and cultural activities. The artistic and cultural life became a concrete expression of the paradox that scholars have constantly pointed towards – where amidst the insecure political climate, Mughal culture evolved and continued to exercise an influence on the texture of the society (Malik 1977: 342). Muhammad Shah's 'Dehli' was a place thriving with different classes of people 'ranging from the saints, poets, members of the royalty and nobility to the common folk' (Khan 1996: v). It was a city bustling with different spaces like the '*bazaars, Sufi* shrines and hospices and musical and poetical soirees' (ibid: v), which came alive during the different festivities and ceremonies that constituted the social and cultural life of the people. Music emerged as the most popular and an integral part of the festivities. During the '*urs* ceremonies of renowned Sufi saints, the *mehfil-e-Qawwali* or *sama* were organised in the shrines (*dargah*) or tombs of the saints. The 'music of the cantors and the recitation of the holy scriptures' were heard during the birthday celebrations of Prophet Muhammad. A distinct style of recitation of elegies in the tradition of *marsiya khwani* created an atmosphere of mourning and lamentation during the month of Muharram. The festival of *Basant* became another occasion for some members of the nobility to organise *mehfils* (musical gatherings) and for indulging in a spirit of revelry. Besides, certain days and dates of the month were fixed for mehfils in the houses of nobles and some prominent musicians and dancers. Dargah Quli Khan presents a glimpse of the salacious life of the city, which he observed and experienced during his stay there from 1737–41.[14] Through

his descriptions in *Muraqqa-e-Dehli*, we see that this was a time when the number of professional artists from different musician classes was on the rise and a time which witnessed new innovations, development of musical forms and more avenues for their performances. In addition to the Mughal court, music enjoyed patronage 'in the establishments of the nobility, in the *Khanqahs* of the living Sufis, in the houses of the musicians and dancers and on the streets and common places' (ibid: xxxii).

Dargah Quli Khan in his description of musicians, poets and the erotic performances of male and female dancers of the Mughal capital in the 18th century introduces 'Ni'mat Khan Bin Nawaz' as a 'blessed gift' to Hindustan, whose musical innovations make him the 'master of all contemporary musicians of Delhi' and put him 'on par with the *nayaks*[15] of bygone days' (Khan 1996: 75). He describes the mehfils, or musical gatherings, that the musician organised in his house on the 11th day of every month, where through the night until the break of dawn the latter mesmerised the audience (which included nobles of high rank and other elites of the city) with his art of playing the *been*.[16] In addition to establishing the been as a solo instrument (as is commonly believed), Niamat Khan composed a range of compositions adopting the 'takhullus' (pen-name) 'Sadarang'. In our next section, we discuss the development of *khayal*[17] from earlier genres of singing and Niamat Khan's further stylisation of this form, which is noted as a turning point in the development of vocal music. But while we are talking about patronage, it is worth noting that Niamat Khan Sadarang's compositions are often small windows into this relation, explored through themes of love and praise and expressed with the force of his creative and artistic thinking. Here is an example of a composition in *Raag Miya Malhar* where Muhammad Shah is imagined in the role of a hero-lover:

> muhmadshah rangile re balma,
> tum bin maika,
> kari badariya nek na suhaave
>
> umad ghumad ghan aave
> naina nazar lagave
> tarsave, sadarangile ko
> sukh dai chamak bich darave[18]

The persona of the emperor imagined as the lover throws new light on the patron-client relation. Imagining the emperor as the beloved not only points towards a certain artistic intimacy that someone like Niamat Khan enjoyed in Muhammad Shah's court, but it also makes us return to our original argument of the emergence of new forms of music in an economy of pleasure and enjoyment, which was closely associated with a sexual economy.[19] A king is made into an object of desire of a court musician. The imperial

persona is substituted by the persona of the lover. Such inversion of power, which is played out through music, would be argued as perversion by many. The problem of music and aesthetic (artistic) enjoyment, therefore, cannot be seen separately as distinct from the question of sexual enjoyment in the imperial Mughal court. Apart from the usual logic of patron-client, where the client contributes to the glory and status of the patron through offering praises, there is a certain excess of intimacy at work here. And it is this excess of sexual and musical intimacy, with strong homoerotic and transgressive overtones, that lies at the core of the cultural life of the city of Shahjahanabad.[20]

Besides the Mughal court, what Dargah Quli Khan's account directs our attention towards and what is integral to the cultural efflorescence of this time are the mehfils organised in the houses of wealthy people like the noblemen and certain eminent musicians and the dispersion of music across the city in other spaces, like the Sufi shrines, which become popular among the local population. The mehfils of music organised by Latif Khan, son of a noblemen and a connoisseur himself, gives us an insight into the culture of entertainment and pleasure that was at the heart of these musical soirees. It is said that Latif Khan too was well-versed in the raag, and so popular was his style of singing that Niamat Khan also often visited his house. The atmosphere of intoxication, literal (from the wine goblets and beautiful *huqqas*) and metaphoric (from the performances), that made his mehfils delightful is beautifully captured in this couplet:

> In the *mehfil* of intoxicants there is no morning and night, for it is the cup that rotates here and not time.
>
> (Khan 1996:41)

The invasion of Delhi by Nadir Shah in 1739 marked a major shift in this dispersion because of the suspension of many activities in the court. The patronage at the court and in the imperial household suffered drastically. But interestingly, this made artists available to the population outside the court. Patronage now came from 'rich members of the ruling class and more importantly, presumably from a large number of the middling classes' (Khan 1996: xxxv). Thus new patrons now offered support to a wide range of artists, and the artists too responded to this changing patronage through different variations in their styles and art. For instance, there is reference to Nur Bai, whose performance of *Jangla*, a popular musical style in Delhi during this time, conquered many hearts in her mehfils. She organised these mehfils with the help of other female accompanists, and such was her position and allure among the nobles that she would write letters of introduction to them for favours and to advance the position of fellow female performers. Similarly, Behnai-Feel Sawar, a well-known dancer and the head of other dancing girls, was also on equal footing with the nobility and is

said to have been close to nobles like I'timad-ud-Daula, who gifted her 'a flagon and goblets studded with jewels, and worth seventy thousand rupees' (ibid:106). Performances in the house of female singers and dancers thus drew large crowds from the nobility and wealthy merchants. These 'riotous mehfils' give a glimpse of their enticing presentations, which mesmerised their patrons. However, when the mode of patronage is displaced from an almost exclusive imperial form to a growing nobility, the nature of reciprocal exchange also changes. The artistic pleasure of a mehfil could only be procured in exchange for huge sums of money and jewels that the patrons would bestow on them. Though mehfils like those organised by Latif Khan became subdued because the invasion greatly affected the fortunes of the nobles, the reciprocal exchange of artistic pleasure for material wealth continued. The patronage employing artists and courtesans, taking care of them through extravagant gifts and elaborate hospitality, not only contributed to the reproduction of a field of artistic pleasure but added to the growing status and image of a rising nouveau riche. Inversely, it also helped a declining aristocracy to hold on to its traditional patron image.

In contrast to the dominant patronage system, which saturated the artistic relation of the time, we find a few alternative spaces emerging in the musical culture of Shahjahanabad. Musical activity in the city was also greatly centred around the Sufi khanqahs, where contemporary mystics, turning down court patronage, led their ascetic lives and often held regular assemblies with musicians to experience a state of ecstasy. Jatta qawwal, for instance was a prominent qawwal in the mehfils of Sufis and in the khanqahs of Shah Basit (Khan 1996:101). Sufi shrines of venerated saints like Hazrat Qutb-ud-Din Bakhtiyar Kaki, Hazrat Nizam-ud-Din Aulia and Hazrat Nasir-ud-Din Chirag Dehli were sites of worship where qawwals regularly performed. A space of artistic enjoyment corresponding to mystical and spiritual pleasure prospered as huge crowds gathered here during the 'urs or other festivities. An atmosphere of worship and reverence unambiguously existed alongside pursuits of leisure and revelry. The local markets, or what Shekhar and Chenoy call the 'mela', during festivals catered to the perversities that common people and some members of the nobility indulged in equally. These carnivalesque sites were not at the mercy of any patronage. In some sense, they inverted the social-cultural and artistic norms prevalent in such codified spaces as the courts and mehfils. Young men and girls, trained in popular music styles, entertained people with their talents and charm. In this regard, Shekhar and Chenoy remark, 'No section of society had a monopoly over one set of values. The extreme values were a general and common phenomenon' (Khan 1996: xxiii).

The imperial court, the mehfils and the mela are the three sites among many others which are perhaps symptomatic of the musical culture of the time. The nature of artistic and social relations are not exclusively arranged according to the specificity of these spaces, though they do have their

distinctive features. The codification of an imperial patronage was not identical to the patronage developed under the nobility in the mehfils, though they have certain similarities. The carnivalesque space of Shahjahanabad on the contrary effectuated new artistic relations under the contradictory influence of the sacred and the profane.

The emergence of khayal: from an evolutionary perspective to an archaeology of style

The 18th century is particularly important in music history for the distinct style that khayal acquires with Niamat Khan's interventions. Khayal was already a prevalent form of music practice before Niamat Khan's time. This name – khayal – appeared in different musical treatises in a general sense (denoting 'similar regional genres') and subsequently came to denote a specific genre.[21] Niamat Khan's contribution lies in adding certain stylistic elements to this form which were further consolidated and carried over to the modern practice of Hindustani music. The fact that Niamat Khan seemed to have first learnt khayal from Tatari qawwal (who was also employed in the court of Muhammad Azam Shah to which young Niamat Khan was associated in the late 17th century) is an important thread in understanding the development of this musical genre –so is the fact that Niamat Khan is considered by some sources to be the first kalawant (who were hereditary dhrupad singers) to be regarded as a singer and composer of khayal. These references underline the creative interaction of forms such as qawwali and dhrupad, among many others, in the conceptualisation of a form like khayal, as we understand it today. But this interaction is not specific to his time. In fact, the musical ethos of the preceding centuries demonstrates how artistic processes appeared at the intersection between the court and other cultural practices outside the court, assimilating and modifying various Indian and Persian musical elements.

In its 'specific' sense, khayal, as we understand it today, emerged from the adaptation of the its 'classical' varieties like *chutkula* with the style of Amir Khusrau. The central role of Chisti Sufis like Shaikh Bahauddin Barnawa[22] in developing khayal as a single distinct genre by synthesising the classical and Sufi styles and introducing it in the repertoire of the Qawwals of Delhi has been noted by scholars like Katherine Schofield. Thus, she points out that in its style, it drew from *qaul* and *tarana* while the content and structure of the song text was borrowed from chutkula. Themes of love and separation and tropes from Vaishnava bhakti continued to remain central to its content. By the late 17th century, khayal established itself as a serious 'raag-based genre', and apart from being performed in devotional contexts in the sama gatherings (to facilitate spiritual ecstasy), it also created a place for itself in the Mughal court culture, where dhrupad, practiced by the kalawants, was a prominent genre. With increasing popularity and patronage

from the imperial court, in the hierarchy of musicians, the qawwals emerged as an important musical lineage specialising in singing khayal. In this context, khayal's rise to pre-eminence in the Mughal court has constantly provoked comparisons and connections with dhrupad. And this brings us back to Niamat Khan, whom we introduced in this section as someone in whom this musical interaction between dhrupad and khayal (between kalawants and qawwals) is beautifully manifested.

In *Sangeetagyon ke Sansmaran*, Vilayat Hussain Khan discusses Niamat Khan's conceptualisation of khayal or 'asthai' as his greatest contribution to Hindustani music. According to Khan, this 'new' style (*gayaki*), which became popular during his time, left behind older forms like *dhrupad*, *hori*, *channd* and *prabandh*. Further, what makes Niamat Khan's compositions special is the beauty that they retain from earlier forms, like dhrupad and *dhamar*, the only difference being that khayal was composed in two parts, 'sthai' and 'antara', as compared to the four-verse format of dhrupad. In pointing out Niamat Khan's 'originality' in developing the style of singing the khayal, he highlights various techniques of elaboration of the written text that he introduces to further complement the cyclicity of the taal. The *boltaan*,[23] he writes, is one such embellishment that Niamat Khan adapted from dhrupad and hori which adds to the beauty of this style. Another innovation attributed to Niamat Khan is that of the *bara khayal*, which was 'set in longer cycles and performed in slow medium tempo that provided a leisurely framework in which detailed improvisatory treatment of the raag became possible, while retaining the textual identity of the composition' (Barlow and Subramanian 2007: 1783). Vilayat Hussain Khan locates the reason for khayal's popularity in these innovative techniques that Niamat Khan introduced, which subsequently eclipsed the practice of dhrupad and hori.

The prominence of khayal in the 18th century always carries a trace of the disappearing or decline of dhrupad. Dargah Quli Khan's description of Bole Khan Kalawant in Muhammad Shah's court as having 'an antiquated style of singing' indicates the 'newness' associated with khayal as it pervaded the Delhi court. In the political environment of the 18th century, as we have discussed earlier, court patronage was discontinued. And elite artistes, as Madhu Trivedi notes, 'were obliged to seek patronage from persons who had leisure but little refinement'. In this scenario, the accessibility of those artistic practices which were limited to the closed circles of the court and established nobility were now open to 'new patrons who were rising in status'(Trivedi 2012: 108–9). It is in these transitions that circulation of dhrupad as a dominant musical genre gets affected. It is possible that certain stylistic aspects of dhrupad, such as its slow, elaborate *alaap*[24] techniques in addition to 'high pitched and vigorous tonal pronunciation' did not evoke much appeal with the local populace. Instead, vocal embellishments and techniques of rhythmic variations possible in khayal and other forms made

them more suited and pleasing for the burgeoning spaces of entertainment. Moreover, she points out that owing to fear and scepticism about the new changes, a 'tendency of concealment' among *dhrupadiyas* of their high art restricted their listening circles and kept the art within closed hereditary families (ibid: 119). At the same time, it is through these networks of transition that interaction between classical forms practised in the Mughal court and popular musical patterns of the city is initiated. This helps us understand the fact – a point that Trivedi highlights in her work – that while the 'old classical dhrupad fell from favour' and lost a significant amount of patronage, some of its techniques continued to be adopted in *marsiya khwani*.[25]

In the 18th century, along with khayal, there are a number of other forms that gain currency and draw their elements from both classical and other genres. *Kabbit*, for instance, is another popular form that was practised by both male performers and female courtesans. Dargah Quli Khan's account gives a sense that it was practised in various styles, borrowing from classical and other traditions. Apart from references to it being practised in the 'classical style' by Qasim Ali, one of Niamat Khan's students, there are other descendants of kalawants, like Shujat Khan who claimed mastery in this form. Though the latter's style, we are told, was not much endearing to his audience, Asa Pura, one of the female singers, is praised for her beautiful renderings of kabbit 'in the style of the old school of the kalawants' (Khan 1996: 104). The style of the kalawants hints at dhrupad influences while it emerges as a separate genre along with khayal, particularly in the mehfils of women performers. Thus between dhrupad and popular taste, it inscribes itself within the performance repertoire of this time. Similarly, we also find mention of *Jangla*, another form that appealed to the audience of this time. Many scholars believe that it was a Persian form that was Indianised during the earlier centuries, while others opine that it was a folk genre sung as an accompaniment to the courtesan dance. It is believed to have matured during the 17th century, when it was performed loosely based on certain raags, and according to Madhu Trivedi, 'jangla was the precursor of thumri which emerged out of its blending with the khayal' (2012: 116–17). *Tarana, Tappa* and *Qawwali* can be seen as further examples of interaction between different musical forms and khayal as they appear as distinctive genres.

It is evident from our discussion of the development of khayal, particularly focusing around the figure of Niamat Khan, that music history has been keen on finding a suitable evolutionary logic to the emergence of a new 'genre' of music, locating it at the intersection of a number of social, cultural and formal (related to musical technique) causalities. The many influences that contribute to the emergence of this new style of singing – from the formal and stylistic assimilation of 'chutkula' to socio-cultural reasons like the changing patronage system – are all centred around the central generic figure of dhrupad in terms of setting the ideal standard or

model for Hindustani music at the time. The centrality of dhrupad and its merit of being a more rigorous example of Hindustani music at the time can be identified not only from a stylistic and formal perspective but also from the ethical value attributed to it as the most serious form of Hindustani music. Khayal has therefore often been described as a simpler style which can perhaps be attributed to a growing cultural, socio-political and ethical corruption of the 18th century imperial court. However, if we suspend such a continuous and evolutionary method of understanding the emergence of khayal and look at it from the perspective of a certain economy of pleasure and its relation to existent artistic relations under the patronage system, we come to a more discontinuous logic of the emergence of a new mode of musical expression. Khayal can then be looked at as a form of improvisation on existent skills of music production, determined by its efficacy. In other words, the popularity of a simpler version can be attributed to a new form of enjoyment which seeks to invert the dominating power of dhrupad along with its practitioners and patrons. A new set of power relations based upon the knowledge of a new form of music therefore seeks to replace an earlier form. Of course, there is no smooth transition, and the earlier form with its relation of power and knowledge resists this transformation. The emergence of khayal from this perspective of a new relationship of power and knowledge which is based upon an economy of pleasure and enjoyment can best be illustrated when we consider some of the anecdotes circulated in music history about the origin of the genre. The point is not to find the authenticity of the origin in these anecdotes but to diagnose the transformation of the relation of power and knowledge and finally that of pleasure from within them.

Vilayat Hussain Khan (1959) narrates two anecdotes that he had heard about Niamat Khan's reasons behind inventing khayal. According to one anecdote, once Muhammad Shah ordered Niamat Khan to teach music to some women from the harem. The thought of teaching a difficult and heavy form such as dhrupad seemed laborious to him. And, therefore, he thought of creating something simpler, something in two parts, to teach them. He began by teaching them just the sthai and antara. Gradually, the women learned to improvise and elaborate on the short song texts, to which the Badshah takes a liking. Subsequently, as these songs gain popularity, more stylistic techniques are added and soon the form becomes more widespread.

In the next anecdote, Vilayat Hussain Khan recounts another possible reason for the invention. Apparently, there was some tension and differences between Niamat Khan and his brother or some close person. The reason for this friction was the latter's displeasure that Niamat Khan did not remember any of the great dhrupad compositions, and infact had never closely learnt the form. As a result, Niamat Khan decided to prove himself and create a form that everyone would like. He decided that it would incorporate all the techniques of the raag and taal. But, more important, it would have such

aspects that would lend it a strangeness which would be completely new to the world of music. Thus, he left out rhythmic patterns that were used in dhrupad and played on the mridang and instead set his compositions within rhythmic structures that were suitable to be played on the tabla.

In both the anecdotes, a new form of music production – khayal – which is simpler and easier to reproduce is argued to evoke a more general pleasure, which can be enjoyed by a larger section of the audience. This contributes to the popularity logic which need not be at the cost of novelty but rather introduces newness and a certain lightness in the form without compromising it. This newness, based upon simplicity and lightness, without compromising the formal essence of Hindustani music, seems to produce an efficacy which is far more intense, thereby creating a new economy of pleasure. This in turn upsets existing relations of power among artists, patrons, music connoisseurs and common listeners. The consequence of the transformations of these relations will evidently produce strong ethical resistance coming from the existant order and its relations of power and knowledge. The ethical vindication of the seriousness of dhrupad against which khayal is deemed frivolous is perhaps symptomatic of this. The musical culture of the 18th century can therefore be seen as this stratified field of power relations where a certain form of musical knowledge emerges within what we are calling an economy of pleasure and taste.

On the threshold of modernity: nomad artists and new patrons

Following Nadir Shah's invasion in 1739, the second half of the 18th century further witnessed the political disintegration of the Mughal Empire, which approached its culmination with the second invasion on the capital city by Ahmad Shah Abdali in 1761. The invasion left the city, struggling with the rapid decline of its material fortunes, practically desolate and in no position to sustain its socio-cultural environment. In light of these events, the last half of the 18th century saw a huge number of artistes migrate towards the regional courts. Musicians were leaving Delhi in search of patronage in these courts that were beginning to flourish as the new cultural centres. In this context, courts like Lucknow, Gwalior, Jaipur, Rewa, Banda, Benaras, Taunk and so on emerged as important sites of musical activity. This period bears the distinctive influence of the changes and the artistic innovations in the Delhi court which get further consolidated and crystallised in the new centres and under new socio-cultural conditions. The regional centres of patronage are noteworthy because they show how travel, away from Delhi, was becoming more and more common. However, Allyn Miner notes that while this period saw a major exodus of musicians from Delhi, the latter continued to remain a focus of formative activity for instrumental music like the sitar[26] until the end of 19th century. It is here that instrumental music

emerged independent of vocal forms with the *gat-toda* form, and the techniques of been and dhrupad gradually began to be applied to sitar. She notes that Masit Khan probably lived in Delhi, and considering the condition of the Delhi court, it is possible that he lived independent of royal patronage.[27]

In the context of vocal music, khayal gayaki (the style of singing khayal) of Niamat Khan flourished in the regional courts, which came to be known by the style of *Qawwal Bachche*.[28] It is said that Niamat Khan first taught his pioneering style to Taj Khan Qawwal's two sons, Ghulam Rasul and Mian Jani, who thus became the earliest forebears of Sadarang's style. They moved to Lucknow court in the latter half of the 18th century where they were under the patronage of Nawab Asaf-ud-Daulah (1775–1797). Lucknow during this time had emerged as the 'most elaborate court' of North India under the constant efforts of its nawabs into 'making it the equal of Delhi at its prime' (Boer and Miner 2010: 202). Poetry, music and dance therefore received extensive attention from the ruling and the city elite, and this enthusiastic patronage reached its peak under the rule of Nawab Wajid Ali Shah (1847–56) in the 19th century.

Niamat Khan's gayaki was popularised by Ghulam Rasool. The different styles of singing khayal that emerge in the 19th century and whose interactions constitute the musical ethos of this period trace their links to this Qawwal Bachche gayaki. Ghulam Rasool taught his son Ghulam Nabi, who played a founding role in the development of tappa as an independent genre in the 19th century. His other disciples were Shakkar Khan and Makkhan Khan. Shakkar Khan's son, Bade Muhammad Khan, was attached to the court of Gwalior under the patronage of Daulat Rao Sindhia (1794–1827). Bade Muhamamd Khan, who moved between the court of Gwalior and Rewa, played a central role in fashioning and interpreting *Qawwalbachhon ki gayaki* through his use of forceful *phirat tan*s.[29] Also attached to the court of Lucknow and Gwalior was Makkhan Khan's son Natthan Peerbaksh. He trained his grandsons Haddu, Hassu and Natthu Khan, who were also highly favoured by Daulat Rao Sindhia. According to anecdotes, impressed by Bade Mohammad Khan's *gayaki*, Daulatrao Sindhia appointed him as a court singer and arranged for Haddu, Hassu and Nathan Khan to imbibe his *phirat ka kaam* by hiding under his bed while he did his *riyaz*.[30] The brothers assimilated this technical quality of Bade Mohammad Khan to the tuneful and robust style of Nathan Peerbaksh, and this eclectic exercise is said to have formalised, in the early years, the distinct gayaki of the Gwalior school.[31] This eclecticism can be seen as being rooted firmly in the musical culture of the 19th century. Migration and movement of artistes between courts allows musicians at this time to interact across family lineages, and what gets formalised as specific styles or gayaki (more specifically, 'gharana') in the 20th century has its beginnings in this nomadism of the musicians. Gagge Khuda Baksh, who founded the Agra school, took his training from Natthan Khan of Gwalior. Tanras Khan of Delhi (the khayal singer who

was employed in the court of Bahadur Shah until the mutiny), Haddu Khan of Gwalior and Mubarak Ali, son of Bade Muhammad Khan, were the foundational figures of the Patiala khayal gayaki. Mubarak Ali himself was employed in the court of Maharaja Shivdansingh of Alwar. But when Alwar came under the 'Court of Wards', under the East India Company, Mubarak Ali moved to Jaipur court on Maharaja Ramsingh's invitation.

By the mid-19th century, the coming of the British put in motion another set of transformations and new modes of negotiation for the musicians.[32] The colonial rule brought into effect a different pattern of patronage, specifically in the context of princely states like Kolhapur and Baroda court and a dispersion of music towards the 'modernising' cities like Bombay and Calcutta. After the annexation of Awadh in 1856, the Nawab was relocated to Calcutta along with his entourage of musicians which 'proved fortuitous in providing Calcutta with an important cultural and artistic resource' that the new middle-class would nurture (Barlow and Subramanian 2007:1787). The court of Baroda under Sayajirao Gaekwad effectuated music's encounter with the forces of modernisation through new forms of pedagogy and the institutionalisation of music. In Maharashtra, the emergence of music organisations and scientific societies, publication of books and journals and attempts at instruction of music outside the hereditary family structure demonstrated the desire for the new educated elite to understand and engage with music 'intellectually' beyond the framework of performance. This new spirit of 'intellectualisation' of music, which can be traced back to a constellation of social, cultural and political reasons by the end of the 19th century, opens up the much-contested problem of music and modernity. The emergence of a self-conscious public sphere, the advent of better ways of circulation and dissemination of music, the influence of technological advances in the recording and production of music – all these set the tone for a new thinking of Hindustani music in the next century, which struggled between its traditional roots and the new scientific impulse to systematise and organise itself. This is accompanied by a desire to find a new ground for legitimacy through reinventing the traditional relations of artistic production, which expresses itself in the emergence of a new nomenclature for authenticity, which is gharana. Of course, this desire for systematisation which flourishes with the advent of Indian 'modernity' was further complicated with a growing political environment of a rising nationalist discourse with its communal and other complications. The economy of pleasure and its relation to artistic production, which enters this complex terrain of socio-cultural and political transformation by the end of 19th century, can be diagnosed with a general impulse of finding a 'science' of art or a passion for the aestheticisation of music. The power of art, which had to be banned through the use of an external force (sovereign decision) and which would be managed through an economy of pleasure and enjoyment under the patronage system, starts defining itself through procedures of systematisation which claimed to be

internal to the very nature of artistic production. This is the problem of aestheticisation as the science of art, which music so prominently exposes when it reaches the late 19th and early 20th centuries.

Notes

1 As cited by Katherine Schofield from Niccoloa Mannuci. 1907. *Storio do Mogor*,vol ii.
2 As cited by Katherine Schofield from Khafi Khan's *Muntakhab al-Lubab* (1977).
3 For a detailed understanding, see Katherine Butler Schofield 2007.
4 Michel Foucault often pointed to this inherent aspect of power and the corresponding discourse which it sustains by pointing to an economy of pleasure: 'Power consists of strategic games. We know very well indeed that power is not evil. Take, for example, sexual relationships or love relationships. To exercise power over another, in a sort of open strategic game, where things could be reversed, that is not evil. That is part of love, passion, of sexual pleasure'. See Foucault 1988: 18.
5 The question of the ban as symptomatic of sovereign power based upon a logic of exception has been the basis of Giorgio Agamben's work. Agamben, who claims to be extending Michel Foucault's work on a possible genealogy of power, proposes a structural analysis of sovereign power through his concept of exception. Power, he theorizes, comes into presence precisely at the moment when it suspends itself. This paradoxical moment when sovereign power constitutes itself through its own suspension – like in the case of emergency – Agamben argues, can be seen in the question of ban. So we should not treat ban as one more characteristic or predicate of sovereignty but the signifier of the constitutive basis of all sovereign power. For a detailed understanding of the relation of ban to the theory of exception, see, Agamben 1998.
6 Katherine Schofield's critique of the ban is based upon finding such evidence which speaks contrary to the success or implementation of the ban. The irregularities she finds in the historical claim stemming from a generalization of the ban leads her to the inevitable conclusion that in spite of the ban, music flourished under Aurangzeb. From a historical point of view, which tries to establish the authenticity of a particular time, this method of approach might well be feasible. Schofield tries to show how the actual practices (socio-cultural) contradict the legitimizing discourse of the ban. In other words, the question of the ban as a legitimizing discourse should have been actualised in the absence of music as a cultural and social practice during Aurangzeb's time. With considerable historical and archival rigour, Schofield demonstrates such a proposition to be historically inauthentic from the point of view of empirical data. However, it is our proposition that the evidence of musical practice (or its absence) does not indicate how the discourse of music functions. Moreover such a discourse is always saturated by a will to power and knowledge.
7 Originally cited from Bakhtawar Khan. 1877. *Mir'at-i-Alam*. And Saqi Musta'idd Khan. 1870–3. *Ma'asir-i 'Alamgiri'*.
8 Here, the idea of economy is not limited to the current disciplinary definition of economy, which identifies itself exclusively with the 'economic' domain, whose operative concept, following Marx, is that of value. As has been shown by Michel Foucault, what we today take for granted as the domain of political economy emerged only during the 17th to 18th century in Europe. Originating in the Greek word *oikonomia*, which has its basis in *oikos* (household) and

nomos (law), economy therefore gains a more general sense in the works of such scholars as Giorgio Agamben and Marie Jose Mondzain, who have traced its usage to other domains like that of religion. Here, economy is structurally articulated as any field of knowledge where the circulation and distribution of power is determined by a defined set of rules which are susceptible to change over time. This regulated dissemination of power might or might not belong to a consumerist logic. This is a genealogical approach to the problem of economy, which is the basis of modern notions of governmentality under capitalism but is not exclusively tied to material production and exchange. An economy of pleasure is therefore any field which deals with the governmentality of pleasure. In other words, economy of pleasure designates the governing of pleasure rather than its production and consumption.

9 He was Aurangzeb's second son. His name was Muhammad Muazzam, and he was conferred the title *Shah Alam*. Often known as Shah Alam Bahadur or Bahadur Shah, he is the heir to the throne after his father's death as the latter's first son, Muhammad Sultan, had already died during Aurangzeb's reign after many years of imprisonment. Bahadur Shah, however, ascends the throne only after the first war of accession fought against his younger brother Azam Shah (Aurangzeb's third son), who had proclaimed himself the emperor immediately after Aurangzeb's death.

10 These musicians were part of the Dutch envoy that is sent to meet Bahadur Shah. William Irvine writes that the Dutch East India Company had established its trading centre in Surat in 1616. In 1710, to earn certain concessions from the emperor, it was decided to send an embassy to the royal court (Irvine 1922: 147). He further describes, 'Bahadur Shah asked that the Dutch musicians might be sent to perform. Three men were accordingly sent at night and played on the violin, harp and hautboy before His Majesty and his queens, who were seated behind a screen . . . A visit to the eldest Prince Jahandar Shah followed, and he also asked for the musicians to be sent to him and witnessed the manoeuvres of the Dutch soldiers commanded by Ensign Nythart' (ibid: 153).

11 Stories abound of their public behaviour defying all norms of etiquette and decorum, especially required of an emperor. William Irvine recounts one story of Jahandar Shah passing out in his carriage after a day spent in debauchery with Lal Kunwar, causing great alarm in the palace. He is later found sleeping in his carriage two miles away from the palace. There is another one about both of them bathing naked in the tank at the shrine of Chirag-i-Dihli with the hope of being blessed with an offspring. See Irvine 1922: 192–7.

12 Lal Kunwar's father, Khasusiyat Khan, was probably a descendant of Akbar's chief musician, Tansen. Kalawants were the 'elite in the hierarchy of court musicians' (Boer and Miner 2010: 198) who specialised in singing *dhrupad* (the dominant form of court music) and played instruments like the *been* and *rebab*.

13 The opposition of those at the court to this promotion of her siblings to high positions comes out in the story of Niamat Khan Kalawant, one of her brother's appointments to the province (*subah*) of Multan. Despite Jahandar Shah's approval of this appointment, there is a certain delay in the issue of orders, regarding which Niamat Khan meets Zulfikar Khan, who was then the minister (*wazir*). The latter, as a fee to get the orders expedited, asks for one thousand guitars (*tambur*) instead of cash. In a week's time, Niamat Khan manages to send only two hundred guitars to Zulfikar Khan and complains to the emperor about the excessive bribe being demanded from him. When Jahandar Shah questions his vizier on this matter, the latter says that 'when musicians were sent to govern provinces, nobles must discard their weapons and learn to play on the guitar'.

Apparently, this remonstrance induced Jahandar Shah to cancel the appointment (Irvine 1922: 193).
14 Dargah Quli Khan, an official in the principality of Hyderabad, came to Delhi in the entourage of *Nizam-ul-Mulk* Asaf Jahan I from the Deccan. He penned his observations in a personal diary which was later edited and translated under the title *Muraqqa-e-Dehli*, which means an album of Delhi.
15 During the time of Akbar, musicians who were accomplished in both theory and practice were given the title 'nayak'. They were also excellent composers.
16 Bin (also spelled as 'been') is a North Indian stringed instrument (stick zither). It is considered to be one of the most ancient musical instruments and has now evolved into what we call the *vina*.
17 Khayal is a genre of Hindustani vocal music in which the song text, set in a particular raag and taal, has two parts, called *sthai* and *antara*.
18 In this traditional composition, addressing Muhammad Shah 'Rangile' as his lover, Sadarang expresses the sadness of the beloved in being away from her lover. The dark clouds and the lightning torment the beloved and nothing seems pleasant in this moment of separation.
19 By sexual economy, we mean an inter-personal relationship having sexual connotations, which is also symptomatic of a hierarchy. In other words, intimate inter-personal relationships (having sexual overtones) between individuals are also embedded within asymmetrical relations of power. Economy here denotes this codification of relations.
20 For a detailed understanding of the question of sexual economy that plays itself out through music relations in the mehfils and the court, see "Music, Masculinity and the Mughal *Mehfil*" in Katherine Schofield 2003.
21 In music scholarship, khayal's emergence is traced back to the 14th century to the Sufi traditions of Amir Khusrau (such as qaul and tarana). And its further development is attributed to Sultan Hussain Shah Sharqi of the Jaunpur court in the 15th century, who is said to have woven different aspects of the local genre 'chutkula' to the existing stylistic forms of Khusrau. In the 17th century, before khayal emerges as a distinct genre in the repertoire of the qawwals of Delhi, Katherine Schofield, through an extensive study of Indo-Persian literature, shows us that khayal appears broadly (in a generic sense) to refer to "similar regional genres" (which would also include both folk and classical genres, like qaul, tappa, tarana, chutkula and so on), which are usually composed in a two- to four-verse structure, in local languages and which explore themes of love and separation. She draws our attention to the different varieties of khayal, such as Hindi khayal, Gwaliori khayal, Marwari khayal and so on, which find mention in some music treatises of this time. Moreover, these regional genres appear within the tradition of 'Khusravi style', which is firmly rooted in the Sufi devotional practices. It is important to note that the music which comes to be known as Hindustani music in Mughal India, before it reaches the imperial Mughal patronage, traversed through a whole range of interactions between Sufi and Hindavi traditions. It is within this network of what Jon Barlow and Lakshmi Subramanian call 'creative sociability' that Sufi practices beautifully integrated Vaishnava bhakti traditions and yogic philosophy in addition to tropes from folk tales and indigenous literary traditions. Thus both religious and non-religious themes were interwoven in these genres, which were related to each other through the closeness in their stylistic techniques that drew from the 'ravish' or stylistic universe of Amir Khusrau. For a detailed examination of the early development of khayal, see Katherine Schofield 2010.

22 The Chisti saint Shaikh Pir Buddhan, a great patron and connoisseur, was also the pir of Hussain Shah Sharqi. It is probably through this connection that Chisti pirs were introduced to the traditional genre 'chutkula'. Schofield notes that Shaikh Bahauddin was the great-great-grandson of Shaikh Pir Buddhan and 'is the earliest composer of khayal listed in indo-persian literauture'. For a detailed study of how khayal emerged within the Sufi nexus that linked two important Chisti centres, Delhi and Jaunpur, see Schofield 2010: 159–94.
23 Boltaan can be understood as a technique of weaving the words of the song-text with melodic progressions in a fast tempo.
24 Alaap is the elaboration of the musical idea of a raag in order to capture its essential tonal features and melodic progressions.
25 Madhu Trivedi provides an interesting examination of how this musical genre developed in the 18th century. See Trivedi 2012: 119–22.
26 In the context of sitar, the mention of Niamat Khan's nephew Feroz Khan 'Adarang' deserves attention. Feroz Khan was one of the chief musicians in the royal court and is considered to be the first musician who introduced *Sitar* in the 18th century through the Delhi court. Dargah Quli Khan's description of his mehfils in *Muraqqa-e-Dehli* is taken as the earliest mention yet found of sitar in northern India (Miner 2010: 277). Integrating his training in both dhrupad and khayal styles, he adapted raag music to the sitar and developed a unique style of playing the instrument which is popular as the 'ferozkhani style'. He also composed compositions under the pen name 'Adarang'.
27 See Allyn Miner 1997: 92–4.
28 Qawwal Bachche traced their ancestry to that of Amir Khusrau. According to legend, Amir Khusrau taught his syncretic music to two brothers, Samat and Nigar (in some sources Sawant and Bula), of whom one was deaf and the other dumb. These two brothers are said to have established the lineage of 'Qawwal Bachche'.
29 A kind of *taan* that takes one note as the centre and weaves a pattern of notes around it.
30 The various versions of this anecdote differ only in the detail of the hiding. Some say they hid behind a curtain while others maintain that they continued to hide under his bed for many years. Alladiya Khan in *My Life* mentions that they hid under his bed for 12 years. See Alladiya Khan 2012: 72–3.
31 See, Arun Bangre 1995: 20–5.
32 An integral part of colonialism are the colonial writings on music that contribute to the formation of an orientalist discourse of Hindustani music. An elaborate discussion of these writings is not the object of this paper but a prominent tendency that these writings bring out is the problem of representation that 'Indian' music now poses once it is discovered by western scholars. Hence what followed were writings by orientalists like William Jones and Capt. N. Augustus Willard who write about various aspects of theory and practice of Indian music in relation to the musicological treatises in Sanskrit that evoked great interest in them. On the other side, colonial encounter also stimulated research from Indian scholars like Sourindro Mohan Tagore and Kshetra Mohan Goswami in Bengal for whom Indian music had to be affirmed at par with the western culture. These writings show the influence that western notation and the concept of harmony had on Indian thinkers, for them to conceptualise their music within a systematic framework like Western music. For a detailed reading of how these writings while opening Indian music to European thinkers also specifically marked out an idea of 'national music' as 'Hindu', see Capwell 2010: 285–312. Also for an extensive understanding of the place of Indian music in the context of colonialism, see Farrell 2004.

References

Primary sources

Khan, Alladiya. 2012. *My Life: As Told to His Grandson Azizuddin Khan*. Translated by Amlan Das Gupta and Urmila Bhirdikar. Kolkata: Thema.

Khan, Dargah Quli. 1996. *Muraqqa-e-Dehli: The Mughal Capital in Muhammad Shah's Time*. Translated by Chander Shekhar and Shama Mitra Chenoy. New Delhi: Deputy Publications.

Khan, Vilayat Hussain. 1959. *Sangeetagyon ke Sansmaran*. New Delhi: Sangeet Natak Akademi.

Secondary sources

Agamben, Giorgio. 1998. *Homo Sacer: Sovereign Power and Bare Life*. Translated by Daniel Heller Roazen. Stanford: Stanford University Press.

Bangre, Arun. 1995. *Gwalior ki Sangeet Parampara*. Hubli: Yashoyash Prakashan.

Barlow, Jon and Lakshmi Subramanian. 2007. 'Music and Society in North India: From the Mughals to the Mutiny'. *Economic and Political Weekly*, 42 (19): 1779–87, 12–18 May.

Boer, Jop and Allyn Miner. 2010. 'Hindustani Music: A Historical Overview of the Modern Period'. In Joep Bor, Francoise Nalini Delvoye, Jane Harvey and Emmie te Nijenhuis (eds.), *Hindustani Music: Thirteenth to Twentieth Centuries*. New Delhi: Codarts and Manohar, 197–220.

Capwell, Charles. 2010. 'Representing "Hindu" Music to the Colonial and Native Elite of Calcutta'. In Joep Bor, Francoise Nalini Delvoye, Jane Harvey and Emmie te Nijenhuis (eds.), *Hindustani Music: Thirteenth to Twentieth Centuries*. New Delhi: Codarts and Manohar, 285–312.

Farrell, Gerry. 2004. *Indian Music and the West*. New York: Oxford University Press.

Foucault, Michel. 1988. *The Final Foucault*. Edited by James Bernauer and David Rasmussen. Cambridge: MIT Press.

Irvine, William. 1922. *Late Mughals*. Edited by Jadunath Sarkar (Vol. 1). Kolkata: M.C. Sarkar & Sons, 1707–20.

Malik, Zahiruddin. 1977. *The Reign of Muhamamd Shah 1719–1748*. New Delhi: Asia Publishing House.

Miner, Allyn. 1997. *Sitar and Sarod in the 18th and 19th Centuries*. New Delhi: Motilal Banarsidas Publishers.

———. 2010. 'Sources on the Early History of the *Tambur*, Rabab, Sitar and Sarod'. In Joep Bor, Francoise Nalini Delvoye, Jane Harvey and Emmie te Nijenhuis (eds.), *Hindustani Music: Thirteenth to Twentieth Centuries*. New Delhi: Codarts and Manohar, 373–89.

Schofield, Katherine Butler. 2003. 'Music, Masculinity and the Mughal *Mehfil*'. *Hindustani music in the time of Aurangzeb*. Ph.D. Thesis submitted to SOAS, University of London.

———. 2007. 'Did Aurangzeb Ban Music? Questions for the Historiography of His Reign'. *Modern Asian Studies*, 41 (1): 77–120.

———. 2010. 'The Origins and Early Development of Khayal'. In Joep Bor, Francoise Nalini Delvoye, Jane Harvey and Emmie te Nijenhuis (eds.), *Hindustani Music: Thirteenth to Twentieth Centuries*. New Delhi: Codarts and Manohar, 159–94.

Trivedi, Madhu. 2012. *The Emergence of the Hindustani Tradition: Music, Dance and Drama in North India, 13th to 19th Centuries*. New Delhi: Three Essays Collective.

12
URBAN THEATRE IN NORTH INDIA DURING THE 19TH CENTURY
A study

Madhu Trivedi

The urban theatre of North India took its shape at the Awadh capital Lucknow towards the middle of the 19th century. The evolution of theatre here was by and large contemporaneous with that in Calcutta and Bombay but is distinct on many counts. While the urban theatre at Calcutta and Bombay had European roots, that at Lucknow had elements in common with traditional theatre. The story and theme were also essentially medieval. It originated from the Rās-līlā, a dance drama of the Braj region. However, themes of high Hindu culture streams were presented in a setting which had a strong Persian stamp, and it accommodated well the changing tastes of its audience, the society of a region well known for its ganga-jamunī tehzīb. In this chapter, we shall study the evolution of North Indian urban theatre in terms of language and idiom, content, dance and musical forms, patronage patterns and social setting with special reference to *Inder-sabhā*. This play represents well how the aesthetic values, the artistic vision and, more important, the vibrancy and compositeness of medieval North Indian culture contributed to the shaping of a new theatrical genre *sabhā*, which was distinct from the earlier and existing forms and brought a change in the concept of drama.

Tradition of theatre in North India (13th to 18th centuries)

The tradition of classical drama, which was endowed a form and a definite place in the religio-cultural life of the Indian people and which was taken to classical heights by eminent dramatists like Kālidās, Bhavbhūti, Shrī Harsh and many others ceased to exist during the medieval period. In the

Turko-Persian cultural tradition, the knowledge of stagecraft was not considered an essential attribute of the fashionable gentry, and theatre had no place amongst the majlisi hunar (chamber arts). As a result, the entire connotation of the term *sangīt*, or 'music', changed during the medieval period, and theatre was eliminated from *sangīt*. Now, it included the three arts of vocal music, instrumental music and dancing (Trivedi 2010b: 66–7). Sanskrit plays were written up to the 17th century but merely as literary exploits.

One should not assume, however, that the rich tradition of theatre disappeared completely; it survived in various forms: Rām-lilā, Rās-lilā, Swāng, Bhandetī, Bahurūp and Bhagatbāzī. Folk theatre, thus, kept on nourishing the tradition of theatrical arts, though in a muted form, as it was handed down to the communities of theatre artistes who were not part of the cultural strata of society. Amongst these the Rās-dhārī, more commonly known in our period as Rahas-dhārī, Bhānd, Bhagatbāz, Bahurūpiya and Sāngiya, were most prominent. With the exception of Rās-dhārīs, they belonged to both the Hindu and Muslim communities; those of Muslim denomination were more numerous.

After the rise of Vaishnavism, some of the performing communities of the early medieval period, such as Kushilavs and Kathaks, who used to recite the ancient ballads, were merged in the Rās-dhārī tradition. However, Chārans maintained their identity throughout the medieval period, though they assumed a different role in that they began to narrate the stories of the heroic deeds of their patrons with intonation and acting. It became a custom to patronise Chārans among the kings and the local aristocrats.

Rām-līlā and Rās-līlā thrived on religious ritualism related to the Bhakti cult. These shows were concluded in several days. Amongst these, Rās-līlā was more popular. It was a folk dramatic art prevalent in the Braj region, associated mainly with the depiction of the events of the life of Lord Krishna. Rās-līlā attained its theatrical vitality as well ritualistic character in the hands of the Vaishnava poets of the Braj region during the 16th and 17th centuries. In its new standardised form, Rās-līlā became an assortment of dance and music and an essential part of the Vaishnava cult in the Braj region. The temples provided an arena for the performance of Rās-līlā; the temple culture further contributed to the enrichment of its dramatic content (Trivedi 2012: 94). Rās-līlā was performed by the community of Rās-dhārīs. The song and dances were traditional and handed down from generation to generation through oral tradition, while prose commentary was improvised by the actors. Some traits of classical Sanskrit theatre such as Pūrvrang (the worship of various deities in the beginning of the play) also persisted in these līlā plays.

During the 18th and 19th centuries, it appears, the rās-līlā began to be performed as a form of swāng on festive occasions, wherein, besides the Rās-dhārīs, other professional theatre artistes and folk dancers, such as Bhānd, Bhagatiya and the Nachvaiyyas also participated; it was called rahas

(Khan 1974: 43). As Wājid Alī Shāh mentions, Hindus spent extravagantly on these performances (Shāh 1965: 152).

Other forms were popular pastimes. Swang portrayed social and moral issues. The expression 'Swāng bharnā' denoted expertise in acting as well as makeup wizardry. These plays were very popular among the masses and performed by a caste of stage artistes known as Sāngiyas. The art of bahurūp was that of makeup expertise. The Bahurūpiya used to imitate the voice and mannerism in a convincing manner.

The performance of bhandetī may be styled as a comic play. This art was performed by the Bhānds, a caste of comedians and mimic artistes (naqqāls), who also used to be good dancers and musicians. Bhand were also the professional story-tellers. Although they were found in both Hindu and Muslim communities, the Muslims seem to be more numerous (Crooke 1896: I, 256). Bhandetī was considered as essential to a gathering as a dance or a musical performance. Their show was based on the depiction of various choreographic compositions, characterised by brisk movements. The participants were males. Usually the mujra (show) consisted of eight persons, but the number could be less. One performer in the female attire used to dance, and the others contributed to the development of the climax by means of clapping and encouraging the dancer. This style of encouragement is technically known as chugga denā. In between, the Bhānds used to show their witticism and mimicry, highlighting an event or portraying a person in a humorous way. The music was provided by sitar, sarangi and drums (Trivedi 2012: 126).

Bhagatbāzī was similar to bhandetī or naqqālī in its essentials except with respect to makeup, and like bhandetī, it also integrated dance, music and dialogue. It was performed by Bhagatbāz, a caste of stage artistes who dressed up in many disguises and exhibited extraordinary mimicry, and their performance was staged at night. Many of the naqqāls (mimic artistes) of Delhi belonged to this community. This art survived as a favourite pastime of the upper classes in the Mughal capital Shahjahanabad, popularly known as Dehlī during the mid-18th century. Dargāh Qulī Khān, who wrote his travelogue *Muraqqa'-i Dehlī* in 1739, is all praise for one Taqī and considers him as one of the most accomplished Bhagatbāz attached to the royal court (az 'umdahai Bhagatbāzan ast). He had a huge collection of articles (sāmān-i bhagat) of every region and community (munāsib-i rasm-i har dayār u firqa) required for his shows (tamāshā), which he staged with great fanfare (Khān 1982: 127).

Patronage to the theatre in the Awadh Court (19th century)

The rulers of Awadh, under whom the centre of art and culture shifted from the Mughal capital, Delhi, to Lucknow, were certainly familiar with

western theatre. There were theatres in Calcutta as early as 1756, and the Bengal theatre was established on the western model (O' Malley 1941: 190). Lucknow had none, but evidence shows that performances were given by touring actors to European gatherings. In one of his letters to Phillip Francis (dated 7 August 1777), Claude Martin refers to a performance on an improvised stage 'though a make-shift arrangement in a European house' (Jones 1992: 76). It is also suggested in his letter that a Calcutta-based European touring troupe used to perform in this place. The upper-crust of Lucknow would have been familiar with social events and gatherings arranged in the residency and by prominent Europeans residing in the city, even though such theatre would not have had a direct impact (Trivedi 2010a: 89).

The performance of the rāgini ke jalse by a group of performing women called jalsewāliyan, in King Nasīr al-Dīn Haidar's time (r.1827–37) marks the beginning of court patronage to the theatre. A contemporary historian of the period, Rajab Alī Begh Surūr, distinctly mentions the rāgini ke jalse, and he records that a particular rāgini was the theme for a particular day and that these jalsas continued for a period of thirty days (Surūr 1957: 108). Rāginis or the offshoots of a raga or a musical mode were considered as his bhāryā, or spouse, in Indian musical tradition, and these were personified by the female artistes patronised by the king. It was securely within the Indian tradition, but the term *jalsa* is, in all probability, a new concept. Gradually, the term began to be used as a generic term for a play.

The lead in this direction came from the last ruler of Awadh, Wājid Alī Shāh (r.1847–56), who gave a fillip to the rejuvenation of Indian theatrical arts. He was a versatile writer and an accomplished musician and choreographer and took interest in the theatre to the extent that he is known as the founder of Urdu drama. An important cultural event of his reign was his establishment of the Parī-Khāna, which may be regarded as a prototype of a playhouse (Shāh 1965: 161). Highly accomplished performing women from diverse places were gathered there. They were trained in various branches of dance and music by eminent ustāds for years under the direct supervision of the king and divided into various groups (jalsa) in accordance with their skills (Shāh 1965: 71, n.d.: 71, 309, 310–11, 312, 315). The king informs that six groups of performing women in the Parī-Khāna were trained in rahas by Haidar Khān and Qalandar Bakhsh (Shāh n.d.: 317). The women trained here were designated as parīs (fairy).

One is prompted to point out at this juncture that the term *rahas* began to be used both for a dance as well as drama during this period. While the thirty-six compositions (chhattīs ijād-i rahas-i sultānī) choreographed by Wājid Alī Shāh, which were performed in serial sequences by going about in circles and semi-circles (halqa-o da'ira) in consonance with the original concept of rās were called rahas by him (For details see Shāh n.d.: 71–86, 1880: 108–60). Similarly, the plays staged under his own direction have also been referred to by him as rahas, jalsa-i rahas and rahas ke jalse (Shāh n.d.: 103–5).

The first play, *Rādhā Kanhaiyya kā qissa*, was staged in 1848 by the parīs, who played both male and female roles (Shāh 1914: 54, 123). It was written and produced by the king himself, who provided a new representation of Krishna according to his own fancy and with a plot of his own imagination. It had a theme and dialogues, and the king directed the stage setting, costumes and décor. The play was staged in the Qaisar Bāgh palace complex in the Rahas Manzil. Interestingly, the dialogue is in Braj bhāsha and Urdu according to who is speaking. Even though the dialogues are sketchy, Wājid Alī Shāh clearly specified that there should be no noise at the time they were spoken and that the musicians must fall silent (Shāh n.d.: 93,103–5, 106–7). Another significant feature is that the dialogues were in prose and not in versified form. Dance, however, was the most important feature of this jalsa performed by the Rādhā Kanhaiyya, who appeared here as ordinary dancers and not divine characters (Shāh n.d.: 93). Characters of Persian origin, the parīs, and the dev may also be found here. This play, which was modelled on the lines of the rahas (rās-līlā), was a great success and unique in that it was staged at night. The king claimed that he had not seen a jalsa of this kind. This play may be considered to represent an elementary form of modern Urdu drama.

After a gap of a few years, the king staged three other plays (jalsas), which were based on his own masnawīs: *Dariya-i ta'asshuq*, *Ghazāla-Māhru* and *Afsāna-i 'ishq*. Their script was written by Hakīm Asghar Alī Khān, which is certainly a new element that endows the plays the character of modern drama. Characteristic features of these jalsas, according to eyewitnesses, were the elaborate depiction of events at the same pace and in the same fashion as in real life. A courtier Iqtidār al-Daulah, who had witnessed the jalsa-i rahas of *masnawī Dariya-i Ta'sshuq*, gives a blow-by-blow account in his *Tārīkh-i Iqtidāriya* (as cited by Adeeb 1957, *Urdu drama aur stage – ibtidāyī daur kī mufassil tārīkh*: 251–68). The famous prose stylist Rajab Alī Begh Surūr also discusses these jalsas at some length (Surūr 1957: 186). As one gathers from their description, scenes were worked out precisely, to the minutest detail in these jalsas. A marriage would entail the entire preparation and arrival of bārāt and the nikāh ceremony; sweets and sharbat were distributed amongst the spectators also. As a result, the performance of the jalsas took a long time. According to the author of *Tārīkh-i Iqtidāriya*, the performance of the jalsa of *Dariya-i ta'asshuq* took a month and eighteen days, and it was staged in the Farhat Manzil in Qaisar Bagh Palace.

As one gathers from the *Tārīkh-i Iqtidāriya*, dancing and music were the most important aspects of these jalsas, for which hundreds of dancers and instrumentalists were employed (Adeeb 1957: 251). The element of dialogue is certainly there, but used only as a means to introduce the next dance item. The thumrī, dādra, ghazal and sāwan were rendered along with these dances. Wājid Alī Shāh was very particular about the expansion of *bhāv* (expressions) in these performances (Shāh n.d.: 87, 106). In these,

the influence of kathak was more recognisable than in the former form of rahas. Wājid Alī Shāh not only gave instructions to his dancers; he also defined their mudras (poses) and bhāv. Whenever the nāyak pronounced a certain bol (patterned sequence), the dancers depicted it in body language (ibid: 141).

Dance forms and musical genres employed in theatre

Kathak, it should be noted, was the most popular dance form of Lucknow during the 19th century. It was named after its performers, the Kathaks, who are mentioned as the most renowned of all the communities of musicians and dancers during the 19th century (Khān 1863: 173). It was developed and codified in the family of Prakash nartak, who is praised by the authors of the 19th century as a great exponent of kathak (Alī 1869: folio 227a; Khān 1863: 123), by his son Thākur Prasād and two grandsons Kālkā Prasād and Bindādīn. While Kālkā Prasād showed exceptional skill in the technique of nritt, Bindādīn enriched the lyrical side of kathak by composing numerous thumrī, dādra, ghazals and bhajans, and he developed the ang of thumrī in kathak, which became extremely popular among the courtesans of Lucknow and Banaras. He is also credited with the expressional form of kathak (bhāv-abhinaya), which is technically known as batāna at Lucknow. Mardān Alī Khān remarks, 'batānā Lucknow kā nāyāb hai. ek ek bhāv lājawāb hai' (Khān 1863: 123).

Various aspects of bhāv-abhinaya, such as sabhā-bhāv (creating a feeling in the viewer that the dancer is dancing in direct response to him); ang-bhāv (expressions conveyed through body movements); arth-bhāv (depiction of the textual sense of the literary composition which is being danced); nayan-bhāv (expression conveyed by movements of the eyes); and nritt-bhāv (depiction of various techniques of nritt) were developed at Lucknow (Khān 1863: 123–7). Almost all the characteristics of the kathak dance took shape at this time, such as thāt-bandī, gat-bhāv and bhāv-nikās. The beauteous opening postures of the dancer and the accompanying graceful movements executed with the eyebrows, neck, shoulders, arms and wrists or waist to the accompaniment of the slow rhythm played on the tabla is called Thāt-bandī; these attitudes or postures are taken before the āmad is danced. In gat-bhāv, the dancer represents an action or a theme through mime, and the tempo of the dance is also represented. In bhāv-nikās, the text of the song is represented by gestures. As kathak was designed for an audience exclusively from the court circle, it absorbed some of the court etiquette under āmad and mujra. The āmad (a Persian word meaning advent or coming) is danced in the beginning of the performance and 'composed of a characteristic pattern of natwarī bols and sound syllables of pakhāwaj' (Kalyanpurkar 1959: 26). Mujra is presenting anything with due salutation. However, it gradually became synonymous with kathak dancing. The two brothers thus developed

a mature and highly technical dance form under the patronage of King Wājid Alī Shāh. They also trained many artistes, including the courtesans and the Bhānds, in this dance form (Shāh n.d.: 309, 315, 318; Khān 1863: 124). It became commonly used in all sorts of theatrical performances.

Amongst the musical genres used extensively in the theatrical performances along with dancing were thumrī, dādra and ghazal. Functional songs, such as chaitī and sāwan, were also used along with kathak. The most popular amongst these was thumrī, which rose to its sophisticated and classicised status at the Awadh Court. The songs in thumrī rāg, popular in the Pūrab region, were fashioned in a refined form by Sādiq Alī Khān of the Qawwāl bachcha gharāna and also by Bindādīn Kathak (Unnāmī 1925: 43, 83). It is intricate music which amalgamates elements chosen from khayāl, dhrupad, ghazal and tappa (Shahinda 1914: 42). Peter Manuel traces the origin of thumrī to the courtesans' dance songs and opines that during the 16th century, these were set 'in loosely structured rāgs like birva and jangla', which were 'the typical local modes' of the Doab region. These began to be called thumrī and remained courtesans' dance songs during the 18th century. Surprisingly, thumrī as a musical genre is not mentioned in the middle of the 18th century by the author of *Muraqqa'-i Dehlī*. In 1834, Willard referred to thumrī as a distinct form which ranked after dhrupad, khayāl and tappa (Willard 1965: 64).

The development of thumrī is associated with kathak dance, wherein it was used by Bindādīn Kathak for the elaboration of bhāv (in the professional parlance in Lucknow, the elaboration of bhāv is termed as batānā). The Holī songs of the Braj region also contributed to the fashioning of this vocal form. During the Nawabi period, the rendition of thumrī became more common, owing to its capacity to elaborate the erotic sentiment in the song. By the middle of the 19th century, thumrī, along with ghazal, superseded all other musical forms in the region of Lucknow and Banaras. Initially, the thumrī followed the sthāyi-antara structure of khayal, and it also followed khayal in all respects except in rhythmic improvisation. Many bandish kī thumrī were in the form of chhota khayal. However, thumrī soon incorporated the layakārī of dhrupad and extensively employed the tappa technique; bandish kī thumrī in tappa-ang interwove the complex, abrupt and fast tappa tāns. In many instances, bandish kī thumrī were like gat, tightly woven into the text of the song (Trivedi 2000: 290–2). Bandish kī thumrī, however, remained in vogue during the Nawābī period and faded and virtually disappeared during the late 19th century, following the decline in the popularity of the dance among the new middle class. In the new scenario, the musicians from Benaras endowed it a new expressive form – the bol banāo kī thumrī, which has its stress on bol-bānī, denoting the process of improvisation of text through bol-tāns or rhythmic segments.

Ghazal, it should be noted, were also rendered as dance accompaniments in purānā andāz (i.e., in the style of tappa, a dhun-based regional pattern of

Punjab that evolved into an intricate and elegant musical pattern by Miyān Ghulām Nabī Shorī at Lucknow). He devised it as a unique blend of indigenous, classical and folk traditions with techniques used in Persian muqāms (i.e., ragas) (Unnāmī 1925: 39, 162).

Dādra, closely related to thumrī in musical, structural and thematic features, developed on classical lines on the pattern of thumrī for use as dance accompaniment during the reign of Wājid Alī Shāh. It existed as folk music in the dialects of Bundelkhand and Baghelkhand. Willard refers to its texts as extremely erotic, portraying 'the petition of the fond woman for the acquisition of the most trifling favours' (Willard 1965: 71). This would suggest that dādra songs were particularly popular among the dancing girls of the eastern and central regions at that time. Bindādīn employed these songs as accompaniment to kathak under lāsya-ang. Wājid Alī Shāh also employed this form in his rahas (Shāh n.d.: 87, 106). Dādra texts and techniques were further enriched by the interweaving of Urdu she'r and the dohra of Braj-bhāshā, which is particularly a point of distinction between thumrī and dādra. Dādra remained a semi-classical dance song throughout the 19th century (Fakhr-ul Kalām 1924: 143). There were prescribed ragas for it. Rhythmic patterns were employed in it, but the bols remained short. It was rendered in dādra and kaharva tāls. Chaitī, which is mentioned as rāgini of hindol raga in *Tuhfat al-Hind*, also developed as a distinct genre on the pattern of thumrī and dādra at Lucknow. It, however, remained a regional pattern throughout the 19th century. All these forms were used by Wājid Alī Shāh in his rahas performances and jalsas.

The urban theatre was, thus, in the process of evolution under the royal patronage with dance and music as its most vital elements. One may notice a departure from the traditional theatre in that in it the hereditary communities of theatre artistes were not employed. Instead, we find a new crop of female performers trained in the Parī-Khāna under the direct supervision of the king, who also used to perform male roles. Amānat, who had seen one of these jalsas, mentions in his *Sharah-i Inder-sabhā* that the swift and graceful appearance of the dancers in the attire of parīs clad in expansive attires and jewellery from behind the red screen bewildered even the assembly (akhārā) of Rāja Inder (Adeeb 1957: 162–3).

Theatre for the people: *Inder-sabhā*

The jalsas directed by Wājid Alī Shāh were elitist, belonging to a privileged class and too far removed from the reach of the common people. Yet their impact was immense, and they became the talk of the town to the extent that a similar stage play *Inder-sabhā* was written in 1851–1852 by Saiyid Agha Husain Amānat, a renowned poet of Lucknow, and performed outside the Awadh court. He has mentioned in *Sharah-i Inder-sabhā* that one of his closest friends, Mirzā Abid Alī Ibādat, suggested that he compose a jalsa in

the mode of rahas that would include ghazal, masnawī (a poem in rhyming couplets), thumrī, dādra, chhand (a specific poetic style of Braj bhasha), and nasr (prose), so that language and also imagination and creativity might be put to the test. Amānat took up the challenge and *Inder-sabhā* was composed (Adeeb 1957: 165). It was a bold idea in itself, and Amānat was not very sure about the success of his endeavour; therefore, he adopted the pseudo pen name Ustād for it.

However, contrary to his apprehensions, this play, the *rahas ki kitāb* as Amānat refers to *Inder-sabhā*, was a great success. Amānat himself has acknowledged the fact that people were crazy about this play and that it was staged all over the city: 'shahr mei chāron taraf ye jalsa hota hai' (Adeeb 1957: 166). The performance of jogan was so popular that people waited for her until late at night (ibid: 183). This play gave a definite direction to the theatre, and it was an advance on the jalsas in that it provided all-around entertainment and also in a short spell of time. The other distinguishing feature of this play was that it was an eclectic composition, combining the characteristics of rahas and jalsa with elements of folk drama. As a matter of fact, it denoted a change in the concept of drama, which was refined and codified in the perspective of the literary and musical requirements of the time. Moreover, it reflected contemporary concerns and experiences and was in no way associated with religious rituals of any particular community, even as it drew upon some mythological motifs.

The plot was mythical, but the play portrayed a living culture and was intended for an audience heterogeneous in background and secular in temperament. The play has Indian and Persian mythological characters, such as dev, Parī, and Rāja Inder, who appeared together on the same stage with their costumes defined in accordance with the contemporary fashion of Lucknow by the dramatist. Accordingly, the parīs were dressed in colourful peshwāz (a full-length gown reaching below the knee) embellished with gold and silver embroidery and filigree work as well as spangles and kulah- i zarīn, a golden head gear (Adeeb 1957: 168–70). Interestingly, some typical Indian folk motifs may be noticed in the play, and we find one of the parīs, the leading actress of the play who resides in Qoh- i Kāf beautifying herself with bārah ābhran solah singār (twelve ornaments and sixteen adornments) in Indian style (ibid: 171). Similarly, Raja Inder was attired in the style of the elites of Lucknow in a dress ensemble consisting of chapkan (a tight-fitted upper garment with a semblance to achkan) and a baggy pyjāma, a girdle, golden headgear and a shalī rumāl (stole) on the shoulders (ibid: 167). What makes him distinct in this play is that he is not presented as an Indian deity but shown as one who is well versed in etiquette with a strong Persian tinge, which was part of the composite courtly culture of medieval North India. The way he is addressed by his subordinates 'Khuda Rāja ji ko rakhe shādmān, jo ho jān bakhsh to kholu zubān' (Amānat 1968: 53) is a pointer in this regard. He observed the courtesies of the mujra (ibid: 59,

62–80); he is depicted as the king of the Singhal Dip, an important place, used as a metaphor in Sufi and Jogi tradition, and in charge (afsar) of the parīs who resided in koh-i qāf, a well-known place in Persian folklore. Raja Inder always moved with his akhārā (i.e., assembly of performers) and is exceedingly fond of dance and music (ibid: 55). His pariyon kā akhārā is a typical medieval concept. Also, jogan is a character which originated in medieval folklore. She is not the one who has renounced the world; instead, she has taken the guise of a jogan in the pursuit of his beloved, and she is presented in the play as an excellent singer and dancer (ibid: 51). *Inder-sabhā* thus incorporated medieval folklore and oral traditions, interweaving Indian and Persian myths.

The play shows a departure from the past in one more way that the female roles in it were played by the courtesans, who were singers and dancers of repute. The male actors were also expert dancers, accomplished vocalists and instrumentalists and did not necessarily belong to the hereditary communities of theatre artistes. These performers or actors are mentioned by Amanat in *Sharh-i Inder-sabhā* as Jalsa wāle (Adeeb 1957: 166).

Amānat has discussed in detail the procedure of setting the stage in *Sharh-i Inder-sabhā*, which he wrote a year after the completion of the play. It may be regarded as a book on contemporary dramaturgy because everything regarding the play was prescribed in it. The stage setting was simple: a raised platform was built on wooden planks in the ground, and a richly decorated red screen (surkh dupatta) worked with golden wire (zar tār) was hung for the musicians to sit behind. Costumes and décor were also defined (Adeeb 1957: 167–70).

The play commenced with āmad. The instrumentalists announced the arrival of the leading male and female characters on the stage. After the completion of the verses of āmad, the screen was raised and firecrackers (mehtāb) released, and the performers arrived on the stage dancing a gat or a torā. They introduced themselves, reciting sha'r (couplets), chhand and a verse from the folk stock called chaubola (Amānat 1968: 16–17, 25, 37, 41). Rāja Inder was the first to arrive on the stage, and as is apparent from *Sharh-i Inder-sabhā*, after exhibiting his skill in dance and clanking the ghungroos (Adeeb 1957, 167), he took his seat on the throne (takht). The screen was draped or raised to signify a change of scene or the entry of a new character on the stage. After the completion of their role, the actors used to sit on a chair on the stage.

Inder-sabhā has all the other ingredients of drama: dialogue, soliloquy and asides, histrionics and movement (Amānat 1968: 39, 48–9). Amānat claimed to have invented a new prose style, nasr-i ābdār, or majestic prose (ibid: 59); glimpses of it are found occasionally in the play. It was more or less similar to the spoken dialect of the urban middle class of Lucknow during the period under review. Dialogues are frequently devised, but these are versified (ibid: 41, 44, 49–50, 59, 62–3). After the commencement of the

play, the entire group of performers joined in a chorus. This practice was retained by the folk theatre artistes throughout the medieval period and adopted by Amānat with a new appellation: mubārakbād gānā (ibid: 64).

That the aim of *Inder-sabhā* was to entertain its audience with dance and music is clear from the opening lines of the play, which announce the āmad or the arrival of Rāja Inder along with his host of parīs and dev (fairies and demon; characters from Turko-Persian folklore) on the stage by the instrumentalists, who also make a request to the viewers to sit properly and attentively in their place to enjoy the excessively delightful and wonderful performance of dance and music:

sabhā mei doston Inder kī āmad āmad hai
parī jamālon ke afsar kī āmad āmad hai

duzānu baitho qarīne ke sāth mehfil mei
parī ke dev ke lashkar kī āmad āmad hai
ghazab kā gānā hai aur nāch hai qayāmat kā
bahār-i fitna-i mahshar kī āmad āmad hai

In *Inder-sabhā*, kathak dominates the entire performance; gat (to and fro rhythmic movement of the dancer), torā (a group of bols or syllables that starts and ends on the sum), tukra (a rhythmic or melodic phrase, composed as a portion of a tāl or composed within a number of beats), batāna, bhāv-batāna, arath (arth) batāna and arth-bhāv se kām lena – described earlier – are the elements of kathak present. The terms like *toron ka chakkar* and *nāch kā chakkar* (Adeeb 1957: 168–70, 174, 176) suggest the whirling movements of this dance form. Some terms such as *nāch kā chhal bal* (Adeeb 1957: 169, 176), which symbolises intricate and vigorous dance, were borrowed from the realm of desī dances.

Similarly, the parīs are even singing some archaic forms, like jangla, besides the contemporary musical forms of thumrī, dādra and ghazal (Amānat 1968: 56). According to the author of *Tuhfat al-*Hind Jangla was an Indianised version of a Persian muqām or mode zangūla, which was similar to tori (Khān 1950: I, 429) and later on developed as a distinct musical pattern of Delhi. Some scholars consider it a folk genre of the doab region and opine that it flourished as a courtesan dance song from the 16th century onwards (Manuel 1989: 50–61). In Awadh, it remained in the capacity of a courtesan dance song and was very rarely mentioned. There is an inclusion of some poetic forms from the folk theatre, such as chaubola and chhand. Thumrī and ghazal are, however, rendered in substantially large numbers in *Inder-sabhā*.

The musical instruments used in this play, as mentioned in *Sharah-i Indersabhā*, were sārangī, chinkāra, jorī (tabla) and manjīra (Adeeb 1957: 167, 183), all from the folk stock. Sārangī 'the most visible bowed instrument

of northern Indian music' 'omnipresent as an accompaniment instrument' to song and dance was generally used by folk performers and figured with some prominence only during the 18th century. Even though this instrument became very popular during the 19th century and began to be used for the ta'līm of the courtesans besides as an accompaniment, the sārangī players could not establish themselves as elite court artistes or soloists (Bor 2010: 448). Their number, however, burgeoned considerably. Chinkāra, jorī and manjīra were new additions to the orchestra. Chinkāra or chikāra, also known as kamāicha, was a bowed stringed instrument widely used in folk music during the medieval period, but Jorī or tabla, a pair of tunable hand-played drums, made its appearance in the paintings of the hill region around the mid-18th century. It also figured as dance accompaniment to a kaharva performance in one of the paintings of an eminent Awadh painter, Niwāsī Lāl, during the late 18th century at Faizabad. In kathak, it was, however, adopted very late, perhaps during the reign of Wājid Alī Shāh. Even at that time, as one gathers from the list of instrumentalists attached to the Parī-khāna (Shāh n.d.: 333), tabla was not used much in court music. Gradually, however, its use as a dance accompaniment became common as its clear-cut notes suited the kathak more than did the pakhāwaj. The manjīra, a pair of small hand cymbals that made high-pitched percussion sounds, was also commonly used in devotional as well as folk music and adopted from there in *Inder-sabhā*.

The impact of *Inder-sabhā*

Inder-sabhā paved the way for Urdu drama. This new variety of dance-music-theatre was such a success that it began to be emulated. Even though Amanat has used the term *jalsa* for this show in many places in *Inder-sabhā* (16–17, 42), the term *sabhā* became a synonym for theatre, and plays written on this pattern, such as *Farrukh sabhā*, *Rāhat sabhā*, *Bazm-i Sulaiman*, *Jashn-i Paristan* and so on were known by the generic term *sabhā*. There was even a play named *Inder-sabhā* by one Madari Lal, which also became quite popular. These plays were staged by a new class of male and female performers known respectively as rahaswāle and as rahaswālyan, the product of Lucknow and distinct from the hereditary professions of theatre artistes (Sharar 1965: 301). An urban theatre was thus in the process of evolution, which took notice of the tastes and cultural pursuits of a sophisticated audience of a cosmopolitan city.

The process of evolution was, however, interrupted by the extinction of the monarchy in 1856 and the political upheavals of 1857. These two events had an adverse effect on the court culture as a whole and on the fortunes of many who were enthusiastic about it. As a result, the urban theatre lost its elite patronage and sophistication in its infancy and fell into the hands of the masses. It came to be treated as a sub-culture. It survived in northern India

in the form of *nautankī* and *nāch* (nauch), both stereotyped and popular forms (Trivedi 2010a: 30).

Gradually, however, the *swāng*, representative of the traditional theatre, and its urban variant nautankī began to follow *Inder-sabhā* with respect to language, prosody, and musical forms as well as in its cultural ambience. This is reflected more in the nautankī, which has the use of *bahar-i tawīl* (a poetic meter used in Persian and Urdu poetry), used at the time of dialogue, the inclusion of Urdu verses, *ghazal*, *thumrī*, *rubā'ī* (a verse of four hemistiches known as *chaubola* among the masses), *masnawī* and so on. The dialogue, not always versified, was spoken in Urdu with a sprinkling of popular idioms. One important feature of these was that the scripts were written by eminent playwrights (Dibāibī 1983: 34–42).

Inder-sabhā inspired the Parsi theatre to a great extent. The Parsi Dramatic Core (Parsi Natak Mandli), established about 1853 in Bombay, adopted this form of drama for which eminent Urdu playwrights from North India were employed. The Parsi Natak Mandli also commercialised this form, which was an assortment of dance, music and theatre. The lineage of *Inder-sabhā* extended, to some extent, into the films of up to the middle of the 20th century as well, which also aimed at providing an all-around entertainment to an audience with diverse cultural groups.

References

Primary sources

'Alī, 'Azmat, *Muraqqa'-i Khusarawī*, an unpublished Manuscript. 1869. Urdu. Lucknow: Tagore Library, Lucknow University.

Amānat Lucknawī, Saiyid Agha Hasan. c. 1853, *Sharah- i Inder-Sabhā*, Urdu. The detailed Introduction of *Inder-Sabhā* written independently by Amānat is produced in *Urdu drama aur stage – ibtidāyī daur kī mufassil tārīkh*. Edited by Saiyid Masud Hasan Rizvi Adeeb, 1957. Lucknow: Kitab Nagar.

———. 1851. *Inder-Sabhā*, Urdu. Edited by Saiyid Masud Hasan Rizvi Adeeb, 1968. Lucknow: Kitab Nagar.

Khān, Dargāh Qulī. 1982. *Muraqqa'-i Dehlī (1739)*. Persian. Edited by Nūrul Hasan Ansārī. New Delhi: Shubah-i Urdu, University of Delhi.

Khān, Mardān 'Alī. 1863. *Ghunchā-i Rāg*. Urdu. Lucknow: Nawal Kishore Press.

Khān, Muhammad Mirzā, ibn- i Fakhr al-Dīn Muhammad. 1950. *Tuhfat al-Hind (1675)*. Persian. Edited by Nuru'l Hasan Ansārī (Vol. 1). Tehran: Intishārāt-i Buniyād-i Farhang-i Irān.

Khān, Saiyid Inshā' Allah. 1974. *Kahānī Rānī Ketakī aur Rāja Udaibhān kī* (c. 1800). Urdu. Edited by Dr. Abdul Sattar Dalvi. Mumbai: Mahatma Gandhi Memorial Research Centre.

Shāh, Wājid 'Alī. 1914. *Mahal-khāna-i Shāhī*, Urdu. Translated from Persian by Mirza fida'Alī Khanjar Lucknawī. Lucknow: Munshi Ram Kishan Printers.

———. 1965. *Parī-Khāna*. Urdu translated from Persian by Tahsīn Sarwarī. Rampur: Kitabkar Publications.

———. 1880. *Saut al-Mubārak*. Persian. Matia Burj. Kolkata: Matba-e Sultani.
———. n.d. *Musamma ba Banī*. Urdu. Matia Burj. Kolkata: Matba-e Sultani.
Surūr, Rajab 'Alī Beg. 1957. *Fasāna-i 'Ibrat*. Urdu. Lucknow: Kitab Nagar.
Unnāmī, Muhammad Karam Imām Khān. 1925. *Ma'ādin al-Mūsīqī (1856)*. Urdu. Lucknow: Hindustani Press.
Willard, Captain N. Augustus. 1965. *A Treatise on the Music of Hindoostan Comprising a Detail on the Ancient Theory and Modern Practice*, 1834, reproduced in *Hindu Music from Various Authors*, compiled by Sourindro Mohun Tagore (1875), Part I, Repr. Varanasi: Chowkhamba Sanskrit Series Office.

Secondary sources

Bor, Joep 2010. 'Early Indian Bowed Instruments and the Origin of the Bow'. In Joep Bor, Francoise Nalini Delvoye, Jane Harvey, Emmie te Nijenhuis (eds.), *Hindustani Music: Thirteenth to Twentieth Centuries*. New Delhi: Codarts and Manohar.
Crooke, William. 1896. *The Tribes and Castes of the North-Western Provinces and Oudh* (4 Volumes). Kolkata: Office of the Superintendent of Government Printing.
Dibāibī, Kanwal. 1983. 'Urdu kī taraqqī mein 'awāmī drama (swāng ya nautankī) kā hissa'. *Shā'ir*, Urdu, (5). Mumbai: Universal Litho Press.
Fakhr-ul Kalām, Muhammad. 1924. *Hindustānī Mūsīqī*. Urdu. Lucknow: Hindustani Press.
Jones, Rosie L. 1992. *A Very Ingenious Man, Claude Martin in Early Colonial India*. New Delhi: Oxford University Press.
Kalyanpurkar, M. S. 1959. 'Nritta'. In Mulk Raj Anand (ed.), *Marg*, XI (4). Mumbai: Marg Publications, September.
Manuel, Peter. 1989. *Thumri in Historical and Stylistic Perspective*. New Delhi: Motilal Banarasi Dass.
O' Malley, Lewis Sidney Steward. 1941. *Modern India and the West: A Study of the Interaction of Their Civilizations*. Oxford: Oxford University Press.
Shahinda (Begum Fyzee Rahamin). 1914. *Indian Music*. London: William Marchant & Co.
Sharar, 'Abdu-l Halīm. 1965. *Guzishta Lucknow: Mashriqī Tamaddun kā Ākhiri Namūna (1913–20)*. Urdu, Edited by Shamīm Anwar, Lucknow, translated and edited in English by E. S. Harcourt and Fakhir Hussain under the title *Lucknow: The Last Phase of an Oriental Culture*. London: Paul Elek, 1975.
Trivedi, Madhu. 2000. 'Hindustani Music and Dance: An Examination of Some Texts in the Indo-Persian Tradition'. In Muzaffar Alam, Françoise Nalini Delvoye and Marc Gaborieau (eds.), *The Making of Indo-Persian Culture: Indian and French Studies*. New Delhi: Codarts and Manohar.
———. 2010a. *The Making of the Awadh Culture*. New Delhi: Primus Books.
———. 2010b. 'Music Patronage in the Indo-Persian Context: A Historical Overview' (13th-19th Centuries)'. In Joep Bor, Francois Nalini Delvoye, Jane Harvey, and Emmie te Nijenhuis (eds.), *Hindustani Music: Thirteenth to Twentieth Centuries*. New Delhi: Codarts and Manohar.
———. 2012. *The Emergence of Hindustani Tradition, Music Dance and Drama in North India, 13th to 19th Centuries*. Gurgaon: Three Essays Collective.

13

INDIAN TRADE TEXTILES

Transition in patronage, transformation in style

Gauri Parimoo Krishnan

Introduction

> The growth in long distance world trade in the 18th century was in Indian textiles, Chinese tea and ceramics, West Indian sugar and American tobacco and cotton. Southeast Asia has again become a crossroads rather than a major beneficiary of world trade.
>
> (Reid 2015: 196)

The Dutch East India Company (Vereenigde Oost-Indische Compagnie) or the VOC monopolised the spice trade in Asia for whole of the 17th century. Several factors, including a shift of power balance in Europe, trading and financial management policies of the company and competition from the English East India Company led to their final decline and demise in 1799. Asian rulers overthrew the Dutch and Spanish monopoly and under the British increased the production of pepper and coffee and re-entered the market, this time as individuals and not as states. The 17th and 18th centuries were marked by trading in luxury goods, which benefited not only the European economies but also the Southeast Asian ones. Many Indian trading family networks took to maritime trade in which Gujarati[1] Muslim (Khoja, Bohra and Memon), Hindu (Bhatia and Lowana), Malabari Mopillah and Chulia Muslim traders resumed trading in Coromandel, Gujarat and Bengal textiles with Southeast Asian ports, even though most Southeast Asian states had begun producing their own textiles.

Indian textile production and international trade along the Indian Ocean between the 18th and 19th centuries had faced many upheavals with irretrievable consequences in most cases because of the economic disturbances they brought about in the handmade textile industry and livelihood of

textile manufacturers. This is a rather well-documented history[2]; however, what is not much known or studied by other than trade textile historians and unknown to textile enthusiasts widely is why and which type of Indian trade textiles were popular abroad, how they were traded and what significance they held for those communities that collected them. Many of these trade textiles would not even make it to the domestic markets and were produced at times with stylistic constancy for centuries, while adapting to the requirements of the clients and needs of different markets for which they were commissioned. The ideas of monotonous replication and temporary 'amnesia' or 'constancy' and 'change' are continuously negotiated when one encounters major museum collections of Indian trade textiles all over the world. These trade textiles were variedly known as *sarasa*, *chintz*, *maa'*, *chinde* and so on in European records and Southeast Asian languages, when they began to be identified and exchanged as heirloom textiles against spices, sandalwood and resins in remote areas of Island Southeast Asia. This chapter focuses on the material culture of certain Indian Ocean communities while remaining art historical in focus when analysing motifs and their evolution. For textile historians studying connected histories of textile manufacture and consumption so far, there has been a greater interest in the consumption side than the production side. For me, I have been fascinated with current production centres, techniques and stylistic changes that have come about today and how we could reconstruct what was happening in the 17th and 18th centuries. Using textile artefacts, paintings, murals, wood carvings and stone and bronze sculptures as parallel evidence in the absence of written records, I have attempted to examine and reconstruct the practice and trade of textiles within India and Southeast Asia. More research is required in the area of the interconnectedness of Indian Ocean communities, and this chapter is an attempt in that direction. It also underscores the idea of transformation in style brought about by the transition in patronage as suggested in the title. This chapter brings to attention the find-spot of textiles vis-à-vis the production centre of a group of textiles in the 18th century and what transnational trade tells us about mapping India's textile trade with Indonesia in special reference to Gujarat and the Coromandel Coasts.

The objective is to draw attention to how, through mobility and circulation of textiles via merchant as well as community groups of a certain class and kinship, certain transformations have come in the stylistic and artistic forms. The chapter also focuses on how, depending on the demand, the source communities in Indonesia who bought and preserved these textiles for generations changed their format and productions for export. In the source communities, either the motif continued for generations or transformed completely, inspired by local artistic innovation. In both situations, what is unfathomable is the creative process of textile production, which again has to be studied based on current practice.

Motif- and format-based textile analysis

This chapter surveys seven textiles from a large collection of over 300 pieces I selected for acquisition from Roger Hollander for the permanent collection of the Asian Civilisations Museum as its senior curator in 2009, along with co-curator David Henkel. It examines certain types of textile formats, patterns and motifs and their functions in the countries or communities where they were collected. Needless to mention, some of the textiles we examine here, such as the *patola* of Patan, were richly coveted by the Gujarati community that produced them. In the case of other textiles, such as the hangings with the dancing women motif, the Ramayana battle scene motif or the *daun bolu* leaf/rain/tree motif, which were found largely in Sulawesi, Moluccas, Flores and so on in Indonesia were so unique and made for a specialist clientele that they were rarely seen in circulation in the domestic market. It is certainly difficult to ascertain if they were used and disappeared from the domestic market or the foreign market was so strictly monitored that the special orders never entered the local markets. Sometimes, several centres imitated and mimicked popular patterns to meet the voracious demand from foreign markets. By the 18th century, much of the foreign demand fell, and the craftsmen languished, which resulted in many patterns being lost or forgotten from the production centres in India when in Southeast Asia they were carried on in cheap imitation or adapted into the local textile tradition. Such is the story of Indian trade textiles, which does not get mainstream attention and hence needs to be told, especially in the context of the 18th to 19th century, widely known as the period of decline and total dislocation.

The Indian epics, the Mahabharata and the Ramayana, had been well entrenched in the cultural ethos of Indonesia since the 9th century stone reliefs on Prambanan temples came to light with no similar examples of that period found in India yet. Here, I discuss a textile representing the Rama-Ravana battle scene produced in the Andhra region, which has not been found in India yet, whereas many examples from around the 18th to 19th century were found in Indonesia instead. Several such textiles depicting the same scene with little variation were collected in Sulawesi and have come to light, suggesting demand for the ceremonial hangings during rituals. The textile possibly had no narrative or storytelling purpose but functioned as an heirloom cloth in ceremonies which the Kalamkari craftsmen from the Andhra region produced. This textile for the spice trade supported the port centres such as Masulipatnam, a famous Golkonda kingdom port that was also operated by the Dutch, British and French East India trading companies. This example showcases how cotton growing, weaving, plant-based dying and decorating developed in the hinterland of the Coromandel Coast, supplying a specific requirement of painted textiles for the Indonesian trade, which most likely did not enter the domestic market and did not find local patronage. This is perhaps clearer because the Kalamkari textiles from

Sri Kalahasti in Andhra Pradesh, where figurative Kalamkari flourished for centuries, provided for the temples for ritual decoration though comparable examples today are of completely different iconography, composition, colour palette and scale.[3]

Figurative textiles from the Coromandel Coast find a market in Indonesia

I have selected this piece (see Figure 13.1) based on its uniqueness and its absence from the local Kalamkari textile genre as well as the regularity with which this episode from the Ramayana has been illustrated, which suggests that the veterans of the Toraja community who began using it in rituals had a purpose that has been lost currently. The traditional textiles have also been replaced by other cheaply and easily available proxy textiles of local make or machine make. It is the 'absence' or 'replacement' of these textiles

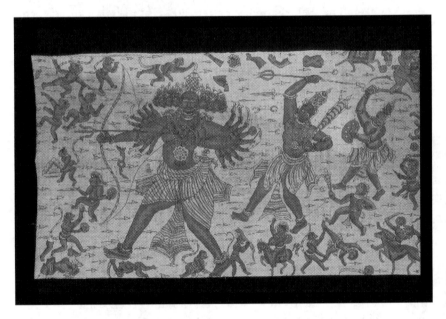

Figure 13.1 Ramayana battle scene, ceremonial hanging *maa'* depicting a Ramayana battle scene

Coromandel Coast for export to Indonesia
Late 18th century
Cotton, stencilled, mordant dyed and painted
95.5 x 517.8 cm
1999.2689
Ex-Roger Hollander Collection
Image Courtesy: Asian Civilisations Museum, Singapore.

today that makes their relevance in the past most meaningful for their socio-religious and economic significance as trade cum heirloom ritual cloth.

This example is a unique type of trade cloth from the Coromandel Coast which illustrates a narrative episode of the Yuddha Kanda from the Ramayana epic centring on the battle between Rama and Ravana. This type of heirloom ceremonial textile (*maa'*) appears in many museums and private collections and is widely accepted as being found in the Indonesian islands of Bali and Sulawesi (Bennet 2013). Especially well documented among the Toraja people of Makassar in Sulawesi are the well-preserved textiles as reverential heirloom ceremonial *maa'*. They are known to be used in funerary rituals, weddings and rebuilding celebrations and as precious status symbols which are well preserved despite the inclement tropical weather since they were kept ventilated and smoked, according to Roxana Waterson based on her extensive documentation (Waterson 2009). No known examples of this genre of Ramayana scene cloths have come to light from the Coromandel Coast yet, and so most scholars are not sure of the domestic function, yet the possibility of an original purpose for a local community cannot be ruled out as such.

There are no borders in this textile, and the battlefield occupies the whole space. The main protagonists striking the warrior pose fill the centre, dividing the two sides – the monkey and bear army led by Rama, Lakshmana and Hanuman on the left and the demon army led by Ravana and his commanders on the right. Rama has Vaishnava marks on his forehead and sports a *chakra* finial arrow, while Ravana has Shaivite markings and wields a *trishula* finial arrow. Above Rama's head, a winged *gandharva* is showering flowers of divine grace. The figures are drawn in identifiable details – the whole scene is action packed with many monkeys and ogres engaged in physical combat, arrows in different shapes flying from both sides and mutilated bodies strewn across the field. The figures are well drawn and filled with mordant that gives two shades of the red dye and small areas of indigo and yellow, creating a rounded volume and shading effect. In this textile, there is a horse and a camel, a new element introduced which is not found in earlier textiles (Barnes 2002: 60–1).

There are many examples of this genre of textile in numerous museums all over the world. However, in those in the Art Gallery of New South Wales, Sydney, Art Gallery of South Australia, Adelaide (Bennet 2013: 114–15) and the TAPI collection in Surat, the position of Rama and Ravana has been flipped from right to left. This shows that they were stencilled and possibly hurriedly produced, while lacking the refinement and intricacy of the earlier painted and mordant- and resist-dyed Golkonda *rumals* (Swallow and Guy 1990: 117), the Pulicat hangings of the 17th and 18th centuries (Bennet 2013)[4] or the Sri Lankan Ramayana of the 18th century (Irwin and Hall 1971: 4–5, plate 1–5). The Tapi collection piece (TAPI 01.183) is significant, as it has a handwritten VOC inscription[5] on the right upper corner,

suggesting that such pieces could have been commissioned by the Dutch from the Coromandel Coast to Batavia from where they were further transhipped to the inner islands of Indonesia (Barnes 2002: 60). While Indian ports produced many cloths for the Southeast Asian market based on their requirement in the 15 to 17th centuries, this genre of Rama-Ravana battle scene seems to have been produced entirely based on Indian iconography and narrative details in the 18th century, despite the good and evil characters having flipped over. This points to the fundamental difference in how they were interpreted – in India or Bali, they bore sacred narratives for storytelling scrolls or backdrops, while for the remote Toraja people, they represented auspiciousness, status, wealth and protection for generations. While they were highly prized and well preserved, they did not play any part in the transmission of mythological stories like they did in India. Maybe originally when they were first imported, their content was understood, but over generations, the meaning has been lost, though the reverence continued.

Today's painted Kalamkari textiles, revived soon after Independence in the 1950s by the visionary Kamaladevi Chattopadhyay,[6] are produced using natural and chemical dyes, following the format of traditional mural paintings in registers with narrative text and illustrations, for storytelling and invoking sacredness. The practice of donating sacred textiles based on the epics, especially the Ramayana, to Hindu temples has been discontinued in India and has lost its ritual significance. This unusual moment in the history of figurative natural-dyed textiles in the 18th century on the Coromandel Coast stands as a beacon of the artistic creativity of Andhra and Tamil art that made its way through maritime trading networks as far east as the eastern islands of Indonesia. It is not very widely known that the tradition of painted textiles since the 17th century from Golkonda, Bijapur, Palkollu, Petaboli and Masulipatnam, among other centres on the Andhra coast, are the precursors of the Kalamkari painted and block-printed natural-dyed textiles revived in mid-20th century.

Gujarat double ikat textiles for the Indonesian market

The weaving of double ikat silk in natural-dye colours, well-known through Sanskrit literature, is associated with Jalna in Maharashtra and appears in the textiles of Ajanta murals from the fifth to the seventh centuries in the Aurangabad district of Maharashtra (Crill 1998: 50–1). Examples of patola (singular: *patolu*) produced by the Salvi weavers of Anhilvad Patan in north Gujarat since the reign of the Solanki king Kumarapala, around the 12th century, were the most unimaginably beautiful textiles, be it for the domestic market or for export to Southeast Asia, with known examples dating back at least to the 18th century.[7] They could tear but not fade, such was their reputation. References to woven ikat designs can also be found on the religious and secular architecture of Gujarat in the UNESCO world

heritage site of Rani Vav stepwell located in Patan and the Jamae Mosque in Khambhat, while painted wall murals also hail from remote Kerala temples, mosques and palaces. All strata of society coveted these textiles – from royals, elite nobles and commoners to today's rich, whose fascination for these textiles has revived the weaving technique and given support to many languishing weaver families across Gujarat. Scholars of textile history from all over the world have acknowledged the complexity and virtuosity of the double ikat technique, which has survived in the major production centre of Patan for 700 years but during the peak of eastern trade may have been produced at other centres, such as Surat, Baroda, Cambay, Ahmedabad, and Broach. A definitive fieldwork-based, technical, historical and art historical study on double ikat conducted by Alfred Buhler and Eberhard Fischer appeared in 1979. Double ikat survives on a smaller scale at Bali in Indonesia in the village of Tenganan Pegringsingan, where narrow cotton (not silk) textiles in double ikat are still produced (Gittinger 1982: 153).

European travellers, such as Duarte Barbosa and Tome Pires, mention 'Cambay cloths' and patola from Gujarat; however, these generically refer to both multi-coloured, multi-patterned cotton and silk cloths. It is only from Tavernier's descriptions (Tavernier 1925) from the 1650s that 'we unquestioningly recognise the patola of today' (Gittinger 1982: 153; Buhler and Fischer 1979: 1, 235). Patola textile weaving of double ikat has a comprehensive history in India and Southeast Asia, which to this day, carries special significance in the way it has brought about transformation while being transmitted through intra-regional and trans-regional trade.

Fascinating but not commonly known research conducted in the 1980s by Balan Nambiar and Eberhard Fischer in Kerala has brought to light extensive information regarding the use of the patola, known as *virali pattu* (Malayalam) or *viravali chelai* (Tamil), a variegated cloth. This ethnographic and art historical research has brought to light the many uses of the textile – as tent panels, canopies, headscarves, waistbands, hip wrappers and wrapping cloths for deity images, a newborn or a dead body. It is widely believed the patola yarn had medicinal uses because of which it was preserved reverentially even if it was tattered and disintegrated. It had ritualistic purpose as well, since it was worn by oracle-men and attached to Theyyam masks' back panel and ritual canopies; it was also given as a gift to honour heroes and brides (Nambiar and Fischer 1987: 126). Many Tantric families and worshippers of the mother goddess Bhadrakali and Bhagavati used the *virali pattu* for ritual practice. Oracle-men in Kerala as well as Indonesia wear this type of cloth as a shoulder or waist cloth, known in Malayalam as *melmundu*, which is narrower than a dhoti or a sari in width. Indonesian patola patterned *selendang* (shoulder cloths) are also narrower in width. This practice has been replaced by tying a red cloth around the waist as recently shared verbally by K. K. Gopalakrishnan, who belongs to a family of Theyyam patrons. Today, among many other places of worship in Kerala,

the patola-inspired patterns can be seen on the Vadakkunnathan temple at Thrissur and old Jumma Masjid (Mosque) of Punnol near Thalasserry. The latter has a *minbar* (pulpit) with panels painted in *virali pattu* patterns.

It is possible to surmise that the Bohra traders of Gujarat, who were great patrons of the *vohra gaji bhat* (pattern) of the patola may have traded this type of textile with the Moplah traders of the Malabar Coast in exchange for spices, especially pepper. This is one possible way these textiles could have made their way into Kerala and onwards to Indonesia, transmitting culture, beliefs and trading goods while transforming the receiving cultures and their way of life. Another frequently encountered pattern of double diamond *rattan chowk bhat* (jewel and square pattern as identified by Rosemary Crill), which was never used traditionally in India but found its way into Kerala as can be noticed on the mural paintings in Kerala as well as Southeast Asia (Crill 1998: 50–1).

It is now well documented that patola textiles from Gujarat reached Java, Sumatra, Bali and other Indonesian islands (such as Timor, Sulawesi, Roti, Flores, Sumba, Banda and Moluccas) through Asian trade networks. They were used by the royal family to tailor trousers for the sultan and princes, as well as dancers. They were also used as shoulder cloths, hip wrappers, waistbands, flowing sashes and belts by performers as well as breast wrappers, canopies and backdrops for special rituals and ceremonial performances. Rosemary Crill has identified the pattern in the trellis (*tran phul bhat*, three flower trellis) as widely used in Indonesia for belts, breast covers and trousers (Crill 1998: 39–40). Many Ramayana characters in the Sendratari Ramayana modern dance ballet performance that I have seen at Yogyakarta incorporate patola-patterned sashes in their costume ensemble even today. Many historical black-and-white photos from the Kraton museum of Yogyakarta and Surakarta from 1900 to the 1920s reveal the sultans wearing the tailored pants from the Gujarat patola textiles as well as the dancers wearing the sashes and belts (Buhler and Fischer 1979: 245–53).

The trouser (Figure 13.2) and belts form a group that reveals how the patola textiles exported from Gujarat were fashioned as garments in Java. They are still in fashion, often used by dancers and bridal couples during weddings in Javanese culture.

I will now discuss another important patola weave in the large 'elephant pair' pattern, which was used quite widely as a backdrop in Indonesian courtly practice and collected across several centuries. A few of them from the 18th to the 19th century have come to light in the museum collections in the National Gallery of Australia, Canberra; Victoria and Albert Museum, London; Art Institute of Chicago, Chicago; and the Tapi Collection, Surat, to name a few. The fact that this iconography of the elephant pair is widely collected by the royal as well as tribal societies across Indonesia reflects the practice of collecting certain motifs of patola as auspicious, invoking the blessings of the ancestors.

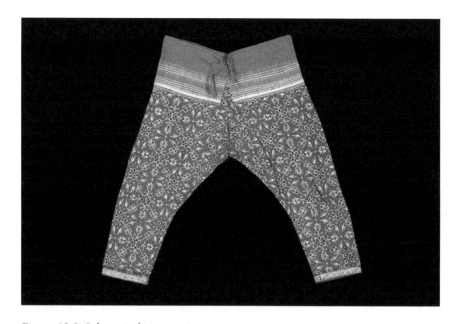

Figure 13.2 Seluar cinde (trouser)
Patola patterned trousers tailored in Java
Gujarat, 19th century
Cotton and silk, double ikat
58.4x103.5 cm
2009–01892
Ex-Roger Hollander Collection
Image Courtesy: Asian Civilisations Museum, Singapore.

These hangings (Figure 13.3) with two caparisoned elephants facing each other surrounded by humans, animals, birds and vegetal motifs are seen in pairs or two pairs with mirror images. Such textiles were once believed to be for export only. They are not designed like saris but as hangings with narrative images. While doing fieldwork in Gujarat in 2010, we came across a textile of the same motif reproduced by the Vinayak Salvi family of patola weavers from Patan based on a sample from the Tropenmuseum in Amsterdam. The Asian Civilisations Museum in Singapore also has a few older examples in its collection. Recent research by the present weavers has brought to light an important fact that such textiles had local relevance once upon a time but somehow lost it over time. The fact that this type of textile only survived outside of India in Indonesia should not be misconstrued as meaning it was 'for export' only.

What the motifs represented was not known to the Indonesians beyond the most obvious. They generally described elephant patterns as *patola*

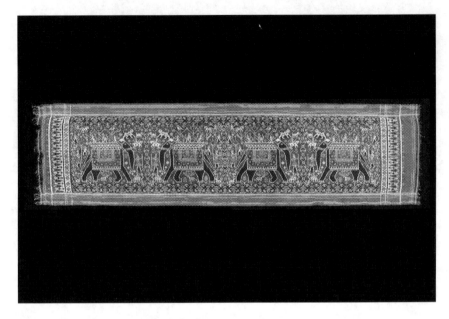

Figure 13.3 Large caparisoned elephant pattern hanging
Shrikar bhat (pattern)
Gujarat, late 18th to early 19th century, radiocarbon dated 1798–1811, acquired in Indonesia
Silk, double ikat
106.7 x 421.6 cm
2009–02046
Ex-Roger Hollander Collection
Image Courtesy: Asian Civilisations Museum, Singapore.

ketipa Gadja (based on Buhler and Fischer 1979: 37–8) and coveted them and preserved them with utmost respect as heirloom textiles. It is this sentiment that has preserved such textiles until today. From the Indian context, we can identify this motif as the representation of a historic event held during the Solanki era (940–1244 CE) of the public celebration of the writing of the Prakrit and Sanskrit grammar text *Siddhahaima Shabdanushasana* by the highly acclaimed Jain monk and scholar of Gujarat Hemachandra Acharya (1086–1173). The Vinayak Salvi family, who reproduced it, has named it "Shrikar bhat", based on the well-known historic event in which Solanki King Siddharaja Jayasimha's favourite elephant, Shrikar, carried the great book of grammar on his back and paraded through the capital city of Patan. This recent reinterpretation of the historic tale and other sources cited by Shilpa Shah (Shah 2008) refers to their domestic significance in Gujarat and the acclaim and function of these textiles during festivals such as Guru Purnima, Jnana Panchami and Paryushana Kalpasutra Varghoda

processions. They were used in celebrating Jain and Pushtimarga Vaishnava festivals by the Jain and Hindu communities living in Patan to honour and felicitate scholars, religious gurus, teachers and deities. This explains why the motif of elephant and horse riders occurs so frequently in Gujarati textiles from this period through the 18th and 19th centuries; these textiles were acquired in the remote Indonesian archipelago for similar reasons and conferred the same reverence as a textile denoting power, prestige, wealth, auspiciousness and healing powers.

Analysing the frequency with which many more large elephant-pair-pattern cloths have come to light, Rosemary Crill draws design inspiration parallels for this type of textile originating from Sumatra in the *palepai* ceremonial hanging with the abstract ship pattern in large format: 'If the *palepai* is turned upside-down, then the projecting stylized ends of the ship show a remarkable similarity in outline to the elephants' sloping back and front legs, as well as the trunk and tail' (Crill 1998: 53–7, pl.42). She opines that in the layout and design of this textile, there is a reverse borrowing from Indonesia to India, a hypothesis which is still unconvincing and needs further design analysis and contextual research.

Imitation patola and their role in secondary markets

The preceding examples amply support the popularity and prestige of double ikat silk woven patola in Gujarat, South India and Indonesia with ritualistic, religious and political establishments. Now I would like to discuss the 'imitation patola' textiles and their mass production using block print and silk-screen techniques on handwoven or mill-produced imported cotton textiles, which catered to the masses and the inner-island dwellers of Indonesia who too would have coveted these textiles to earn prestige and respectability. Joanna Barrkman (Barrkman 2009: 160), who has conducted research on the weaving technique and rituals associated with textiles in West Timor among the Biboki kingdom, notes that woven and block-printed imitation patola entered Timor through coastal ports for exchange with white sandalwood, beeswax and slaves. It is because of reverence for these foreign textiles that they entered the royal and clan treasuries in western, central and northern Timor. Many clan houses keep sacred heirloom textiles in respect for elders and ancestors. One such clan house, the Sonaf Lalim Neno Konpah ceremonial house, is open to the public and contains sacred patola cloths hanging from the rafters. One of the oldest patola patterns, identified by Buhler (Buhler and Fischer 1979: 158) as Motif Type 25 of double diamond and another older imitation patola textile with X motif can be seen repeated in imitation patola produced in Java, entered Bali, Borneo and eastern Indonesia since they were widely and easily available in Southeast Asia, according to John Guy (Guy 1998: 96). They were also used in war and headhunting rituals, marking

their favour amongst all strata of society, as well as for protection from evil spirits and for healing. Imitation patola were block printed and stamped with the VOC stamp in Batavia while the second-generation machine-made ones were available in the 19th century. Shamans and priests in Sulawesi and village elders in Nias wore patola sashes for magical power and prestige and during exorcisms. Machine-printed patola were also produced in the Netherlands, in Rotterdam and Helmond, for Indonesian markets until the 1950s (Guy 1998: 94–5).

This popular patola pattern of a flower basket motif, *chabadi bhat patola* (see Figure 13.4), was decreed by the Sultan of Surakarta, restricting its use for himself and his brothers, as curtains for use in their sedan chairs.[8] From photographic documentation, it is learnt that daughters of the Raja of Ternate in Roti, as well as unmarried women from Lewotala, eastern Flores, wore the flower-basket-patterned patola-influenced local textiles and *patola selendang* shoulder cloth in cotton. John Guy has noted that Gujarat patola continued to be sent to Indonesia up to the 1930s, and one way to identify

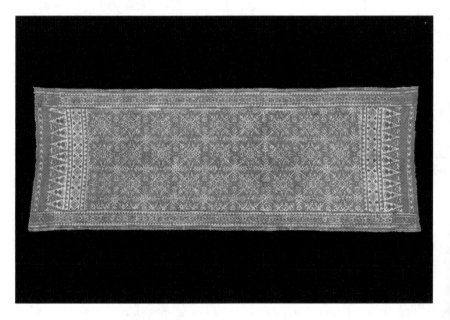

Figure 13.4 Block-printed flower basket pattern patola

Probably Gujarat or Coromandel, radiocarbon dated 1727–1813, acquired in Indonesia
Cotton block printed and painted, mordant dyed
95.3 x 271.8 cm
2009–02059
Ex-Roger Hollander Collection
Image Courtesy: Asian Civilisations Museum, Singapore.

them was the cotton borders that were the feature of export examples since the domestic market ones would be all silk (Guy 1998: 93).

The practice of producing block-printed patola as a cheap and quick imitation of the original silk double ikat woven is much older in India itself, and examples from both Gujarat and the Coromandel Coast can be found from the 17th to 18th centuries with at least one example found by Mattiebelle Gittinger from Sumba with a Dutch VOC stamp. She records that Buhler has suggested that this kind of imitation patolu may have been made in Ahmedabad. Similar imitations were found in North Sulawesi and Bali. Gittinger records, 'Cotton textiles with other patterns imitating patola have been found in Sumatra, Sulawesi, Bali, Lomblen and in Western New Guinea' (Gittinger 1982: 139, fig.124). This would be to meet the brisk trade and high demand for the textile in the Southeast Asian market as well as to produce an affordable and easily reproducible alternative.

Block printing as a technique of surface decoration has a long and uninterrupted history in Gujarat with textiles exported to West Asia as well as Southeast Asia. Ahmedabad and the nearby village of Pethapur are among the major production centres of wooden patterned block carving and printing and the washing and starching processing from the 17th to the early 20th centuries. From there, the textiles were shipped to Cambay, Surat or Bombay for transhipment to various ports, such as Malacca, Aceh and Banten among others.

The imitation patola are generally *selendang* shoulder cloths or *dodot* hip wrappers and not any longer or wider, like the sari length, as they were meant for use by the local community from local looms or imported European fabric. The surface decoration of patola patterns, whether in floral, bird, animal or geometric motifs, was adapted to suit the local design vocabulary from which they evolved stronger local flavour, yet the Gujarat ikat patola motifs were identifiable by the traditional colour palette of blue, green, yellow and predominantly red.

Buhler and Fischer, in their magnum opus *Patola Textiles of Gujarat*, have also discussed the block-printed and silk-screen-printed patola, as well as the use of natural dyes, during the Dutch period trade of textiles for spices. According to Buhler, after the Second World War, no Indian patola were imported into Indonesia; local block- and silk-screen-printed patola were produced in Central Java, especially at Jogjakarta, Surabaya and Pekalongan in North Java. 'Graafland informs that *kain patola* were produced in Manila in the 1890s or about the Dutch machine textiles which Nouhuys says were imitation of the block-printed (also imported) *kain Toronkong* (with patola patterns) of Central Celebes' (Cited in Buhler and Fischer 1979: 159). Several imitation patola, ranging from mordant printed and blue painted to machine printed and weft ikat woven, are categorised by Buhler and Fischer (1979: 70–80) as 'imitation', which is an interesting definition worthy of re-evaluation today.

Block-printed cotton textiles of Gujarat from Cairo to Makassar

Let us turn our attention to the painted or printed and dyed cotton textiles of Gujarat which were acquired in Sulawesi with the Toraja people and thus suggest that they were produced mainly for export.

This group of similar-dimension heirloom ceremonial cloths (*maa'*) approximately 80–100 cm in width and 450–600 cm in length (see Figure 13.5) are three intact, uncut piece goods with interlocking floral and geometric patterns. They occur with regular frequency in the Asian Civilisations Museum's collection. Because of their stylistic similarity and consistent format, I have identified them as so-called 'Cambay cloths'. Many of the Gujarati trade cloths were traded by sea from Cambay; some could have been produced at Cambay or its hinterland. Tome Pires mentions that 'Cambay cloths' appear from Mocha to Malacca. Even though the definition is generic, it is worth exploring the typology of painted or block-printed-, resist- and mordant-dyed cotton cloths that could be associated with the region of Gujarat (Pires 1944).[9]

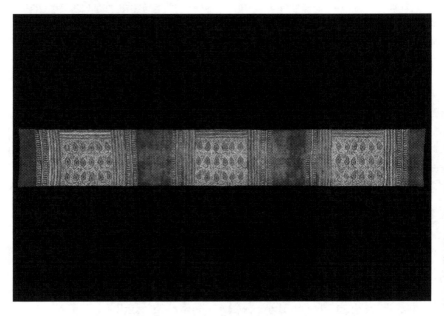

Figure 13.5 Piece good of three identical parts depicting *daun bolu* motif

Gujarat, late 17th to early 18th century, radiocarbon dated 1675–1700, acquired in Toraja
Cotton block printed, drawn and painted, resist and mordant dyed
88.9 x 673.1 cm
2009–01924
Ex-Roger Hollander Collection

Image Courtesy: Asian Civilisations Museum, Singapore.

Furthermore, the discovery of Fustat textile fragments at Al Fustat near Cairo in Egypt established the reach of Gujarati textiles in international trade with Red Sea ports. They have been identified by Pfister (Pfister 1938) based on Hindu and Muslim patterns and later by Irwin and Hall on the basis of technique – resist dye and block printed. These examples closely relate to the patterns of some of these textiles (Textile Museum, Washington, DC 6.303, 73.412 in Gittinger 1982: 44–5). Irwin and Hall have linked these patterns not only to the carved screens of Ahmedabad's predominant Muslim and Hindu architecture but also to Persian book cover designs and Italian silks, which were available in Gujarat in the 16th and 17th centuries (Irwin and Hall 1971: Vol I, 5). They identify most of the Fustat pieces from the 17th century or later, with few exceptions, as dating back to the 15th century. Some were used for book binding, modelled after the Italian silks that were well-known in India, while the block-printed or resist-dyed ones with indigo were certainly used as burial shrouds. Gittinger goes a step further to explain that 'the designs of this luxury commodity were translated into a cheaper medium.' However, since most of these textiles were collected in Indonesia and Sulawesi, we could assume that they also reached the remote islands of Indonesia through the Cambay-Malacca route and were further distributed by the Bugis and local Macassar traders. Ruth Barnes has identified that the popularity of this group of textiles, based on the betel leaf *daun bolu* or *sireh* motif, is inspired by older *maa'* cloths with a large teardrop-shaped tree with a trunk and single or pair leaf motif widely used by the Toraja community of Sulawesi. These would have been based on locally produced ceremonial cloths called *sarita* that may have been sent to India to initiate an Indian reproduction for the Toraja market (Barnes 2002: 22–3, pl. 4).

Roxana Waterson, who has conducted extensive research in the Toraja highlands of northern South Sulawesi, has closely studied the association of ritual poetry and ritual and cosmological beliefs with the Toraja textiles. She also agrees with Barnes in speculating that these may have been based on an earlier model sent to the agents or manufacturers in India, based on which particular patterns were created.[10] Since the 17th century, with the Dutch control of the textile trade, if pattern preferences were received from England, Holland and Thailand, why would the Toraja preference not be conveyed to the manufacturers in Gujarat? Whatever may have been the modus operandi of this trade, it is quite mind-boggling to fathom that for six hundred years, many different patterned Indian textiles in cotton and silk from Gujarat and the Coromandel Coast were used as prestige cloths or currency by which social status, power, rituals, healing and the afterlife could be controlled in a remote region of an Indonesian island.

The type of block-printed cotton textiles covering the entire field with an overall repeat pattern shown in Figure 13.6 were traded to Indonesia from the Gujarat Coast. The borders on the longer side are just a narrow band of

Figure 13.6 Hanging with grape leaf pattern
Gujarat, 18th century, acquired in Toraja
Cotton block printed, resist and mordant dyed
90.2 x 480.1 cm
2009–01946
Ex-Roger Hollander Collection
Image Courtesy: Asian Civilisations Museum, Singapore.

red and white, while the shorter sides have two or three *torana*, like narrow borders with a fringe-like pattern drawn with resist or block printing. This textile was acquired in Toraja and was possibly used as a *maa'* hanging during funeral ceremonies, as it has a strong blue, red and white colour combination. It was produced using mordant and resist dyeing in a technique that was widely practiced in Gujarat for centuries.

The design of the pattern in this textile (2009–01946) appears to illustrate a grape leaf which has either five or seven corners. There is an outer white leaf-shaped resist-printed area in which a smaller red leaf is stamped with mordant. There are several combinations of grape leaf, flowers and buds in these cloths, which are bright, cheerful and very aesthetically designed. Such motifs were possibly used for sari or the draperies of women in domestic markets of Gujarat; however, no visual references survive.

Since the textiles in this group are quite similar in technique, colour and interlocking patterns, they seem to suggest a general flavour of the Islamic aesthetics of West Asia with which the Cambay cloths could be associated.

The diamond or octagonal shaped medallions and cartouches with stars interlocked into grid-like patterns are sometimes interspersed with floral designs. All three panels have the same or different patterns, depending on the available time and the calibre of the workshop that produced them. The similarity with the Islamic architectural designs of Gujarat, especially the Ahmedabad, Champaner and Cambay Sultanate architecture, and that of West Asia are so striking that one cannot miss the battlement-shaped pattern in the borders. This similarity could be attributed to the trading connections along the west coast of India, especially the Gujarat ports, as well as the Islamic cultural exchange through traders and clerics.

Figurative 'Dancing Women' textiles of Gujarat for the Indonesian market

The next group of heirloom textiles that merit mention are figurative textiles which relate closely with the Jain manuscript painting style (there is no reference to Jain religious iconography as such) that were traded to eastern Indonesia and found in Toraja, Sulawesi. It is possible that these textiles were in circulation within Indonesia, and hence, it is difficult to surmise if they were made exclusively for the Toraja people of Sulawesi. However, based on the research conducted by anthropologists in Toraja, this group of textiles has a strong possibility of exclusivity since they have observed the presence of these textiles there before most of them were sold off to the art market. Documented by Nooy-Palm from the 1970s onwards, the use of Indian trade textiles in feasts and funeral rituals (which are individually worth ten to 20 buffaloes) is ubiquitous and central to every ceremony, either for draping on ritual objects or places, display or ceremonial use. Even touching them was restricted to a person, generally a woman, who would first give it a 'kiss', meaning 'breath upon', before using it reverentially in the *merok* feast, *mangrara baua* ritual or *maro* ritual, to name a few. The buffalo to be sacrificed in the funerary ritual is also draped with an Indian trade textile in the characteristic deep-blue colour and rain pattern (Varadarajan 2011: 472).

Here, about ten to 12 large figures were drawn in the characteristic style of Jain painting with the protruding second eye in the figuration and stylisation and other details resembling the *horror vaccue* effect generally associated with the manuscript painting in western India from the 12th century onwards, patronised by the Jain community. What sets these textiles apart is their scale, the theme of dance and music and the densely filled foliage interspersed with birds, animals and attendants. Some of the women strike dancing poses, play on a veena, gaze at a mirror, hold flower garlands and auspicious objects or feed a pet parrot, and they are bewitchingly beautiful and filled with grace. It creates an auspicious atmosphere for which they could have been used, but no domestic use of such textiles is known; hence,

they are currently still associated with export. I have identified these figures with traditional sculptures of *apsaras* and *yakshis* and found their antecedents in the traditional architecture of Gujarat, Jain and Hindu manuscript illustrated painting, *shringara* poetry and classical dance and aesthetics (Krishnan 2010, 2011). The finest example of this iconography is found in the Tapi collection (01.28) (Crill 2006: 106–7), the Victoria and Albert Museum, and the National Gallery of Australia, among others.

The image in Figure 13.7 illustrates rougher block-printed textiles of the 17th and 18th century that lack the fineness of the details seen on earlier hand-drawn and block-printed dancing women textiles. The faces are tattooed or painted, and the bodies are highly bejewelled. The entire textile was produced using one block; mass production began to replace the originality of the fully drawn textiles of earlier centuries. The popularity of the blue and red colours in contrasting arrangements certainly suggests the popularity of these dyes; however, the general decoration covering the entire field of the textile remains unchanged from earlier centuries.

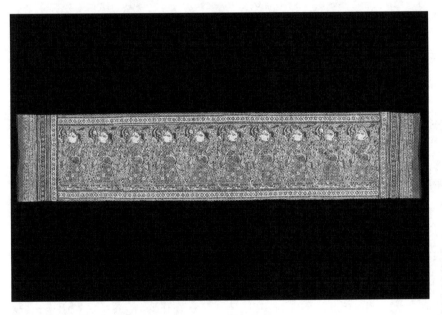

Figure 13.7 Hanging depicting women with veenas and parrots

Gujarat, 17th century, radiocarbon dated 1603–1612, acquired in Indonesia
Cotton block printed, resist and mordant dyed
104.1 x 505.5 cm
2009–02087
Ex-Roger Hollander Collection

Image Courtesy: Asian Civilisations Museum, Singapore.

The block print of ladies holding parrots and flowering stalks in their hands appears frequently, with minor variations, to this day. All are printed with blocks, but later examples have simpler forms, with large areas of colour and bold shapes. The shapes of the eye, breast and veena, which fit the shape of the hip in profile, are dyed with a different colour, which is visually pleasing. Alternating figures wear yellow dhotis, which contrast nicely with the blue dhotis. By the 17th century, the intricacy of detail is quite standardised, so is the iconography, which is limited to the veena and parrot, an indication of the standard demand from the Toraja region.

In understanding how a genre of textile generically called here as 'hanging depicting women with veenas and parrots' or 'Dancing Women' or 'Jain Ladies', originating from Gujarat was collected over 500 years ago and continues to play a significant part in the rituals of the Toraja community in northern South Sulawesi, the role of women in ritual practices identified by anthropologists has to be emphasised. Furthermore, my research into these figures, as interpreted with examples of nature spirits like *apsaras* and *yakshis*, from the paintings and sculptures of Gujarat, spanning the eighth to 15th centuries, is a new perspective employing visual interpretation in the absence of evidence from written records. Fertility and prosperity, protection and growth, sacredness and auspiciousness were important to the Toraja community, and the timeless, unfaded motifs and dyes on the cotton cloths may have given a sense of sacredness, which was almost divine and omnipresent. So even when the currency changed from cloths to precious metal, the importance of the auspicious women motif did not diminish.

In conclusion, it is fascinating to learn what ports and their hinterlands on the Coromandel and Gujarat Coasts in the 18th century were producing, either as a continuation of the previous centuries or as introduced new fabrics, which were a direct response to the demand from Southeast Asia based on samples and specifications, especially from Indonesia in this case. This short survey of seven examples from the collection of the Asian Civilisations Museum in Singapore provides a window into the prolific manufacture of hand-spun, natural-dye cotton produced with beautiful resist or mordant dyes and block or stencil printed or intricately hand drawn and double ikat woven silk textiles. Making copies in various techniques as 'imitation' reveals what transformations came about in the 18th century in the global 'textile for spice' trade and how the manufacturers responded to the changing circumstances. Even though more field-based and archival research is required to understand the production and consumption aspects of Indian trade textiles, this chapter helps to unravel how the transition in patronage and economic conditions brought about transformation in the style of textiles, while their emergence and disappearance both remain unfathomable and the craftsmen and producers in their place of origin continue remain unknown and uncelebrated.

Notes

1. Makarand Mehta, 2009, sheds light on merchant families from Gujarat in international trade and the organisation of custom duties extensively among other aspects of trade history in Gujarat from medievel times onwards.
2. K. N. Chaudhuri, 1978, provides a much needed insight into the English East Indian company's relations with Asian counterparts setting the stage for its complex power struggle and well as control of resources.
3. Shakuntala Ramani (2007: 1–3).
4. http://collections.vam.ac.uk/item/O88502/wall-hanging-hanging-unknown/ Last Accessed 12 March 2019.
5. These textiles, which were traded by the Dutch East India Company, were required to be stamped with the VOC monogram and letter B, most likely referring to Batavia (Jakarta) in Java, as per records studied by Laarhoven showing that between 1670 and 1740, approximately 600,000 textiles were exported from the Coromandel Coast to Southeast Asia. This explains the rushed, standardised and hurried manner of production. The Ramayana scene cloth has also until recently been kept in the royal collection of Los Palos in East Timor, indicating its wide reach and currency in global commodity trade in the 17th and 18th centuries (Bennet 2013: 114–15).
6. Kamaladevi Chattopadhyay (1903–1988), one of the few early women freedom fighters and social reformers, who is credited for envisioning almost all major Indian institutions supporting the arts and crafts of India, has been widely acknowledged for her work in supporting, reviving and making Kalamkari relevant today as India modernised and globalised.
7. The Asian Civilisations Museum in Singapore has conducted radio carbon dating of patola fibres in the Rafter Radiocarbon Laboratory in New Zealand and found the earliest examples in their collection date back to the 18th century. The laboratory tests were conducted using the accelerator mass spectrometry technique to measure the radiocarbon age of the textile fibers. The results are still unpublished. The author was involved in this study as the former senior curator overseeing this collection.
8. John Guy (1998: 88) has published a photograph of the prince of Surakarta and his family against the backdrop of a Gujarati patolu with a tiger and elephant pattern in the Mangkaunagaran Palace, Surakarta, circa 1924, which shows that textiles such as this were collected through the 17th and 18th centuries as heirloom textiles representing prestige and protection.
9. Tome Pires in 1512–1515 travelled to Malacca and documented the extent of the Asian trade that the Portuguese so desperately wanted to participate in.
10. Roxana Waterson has discussed this point in an unpublished paper for the Asian Civilisations Museum in Singapore for a forthcoming volume the author is editing.

References

Barnes, Ruth, Steven Cohen and Rosemary Crill. 2002. *Trade, Temple and Court: Indian Textiles from the Tapi Collection*. Mumbai: India Book House.

Barrkman, Joanna. 2009. 'Indian *Patola* and Trade Cloth Influence on the Textiles of the Atoin Meto People of West Timor'. *Archipel*, (77): 155–82, Paris.

Bennet, James. 2013. *Realms of Wonder: Jain, Hindu, and Islamic Art of India Including Nepal and Pakistan*. Adelaide: Art Gallery of South Australia.

Buhler, Alfred and Eberhard Fischer. 1979. *The Patola of Gujarat, Double Ikat in India* (Vol. I–II). Basel, Switzerland: Krebs.

Chaudhuri, K. N. 1978. *The Trading World of Asia and the English East India Company, 1660–1760*. Cambridge: Cambridge University Press.

Crill, Rosemary. 1998. *Indian Ikat Textiles*. Victoria and Albert Museum, Indian Art Series. London: V&A Publications.

——— (ed.). 2006. *Textiles from India, the Global Trade*. Kolkata: Seagull Publications.

Gittinger, Mattiebelle. 1982. *Master Dyers to the World*. Washington, DC: The Textile Museum.

Guy, John. 1998. *Woven Cargoes, Indian Textiles in the East*. London: Thames and Hudson.

Irwin, John and Margaret Hall. 1971. *Indian Painted and Printed Fabrics*. Ahmedabad: Calico Museum of Textiles.

Krishnan, Gauri Parimoo. 2010. 'For Ancestors and Gods: A Note on a Unique Textile from Gujarat for Southeast Asia in the Collection of the Asian Civilisations Museum, Singapore'. *Arts of Asia*, 40 (1): 82–4.

———. 2011. 'Gujarati in Spirit and Form, An Heirloom Trade Textile found in Sulawesi, Indonesia'. In Lotika Varadarajan (ed.), *Gujarat and the Sea*. Vadodara: Darshak Itihas Nidhi.

Mehta, Makrand. 2009. *History of International Trade and Custom Duties in Gujarat*. Vadodara: Darshak Itihas Nidhi.

Nambiar, Balan and Eberhard Fischer. 1987. *Patola/Virali pattu – from Gujarat to Kerala: New Information on Double Ikat Textiles in South India*. Asiatische Studien: Zeitschrift der Schweizerischen Asiengesellschaft = Études asiatiques: revue de la Société Suisse-Asie.

Nooy-Palm, Hetty. 1980. 'The Role of Sacred Cloths in the Mythology and Ritual of the Sa'dan Toraja of Sulawesi, Indonesia'. In Mattiebelle Gittinger (ed.), *Indonesian Textiles*. Washington, DC: Irene Emery Roundtable on Museum Textiles, Proceedings, The Textile Museum, 81–95.

Pfister, R. 1938. *Les Toiles Imprémées de Fostat et l'Hindoustan*. Paris: Les Editions d'Art et d'Historie.

Pires, Tomé. 1944. *The Summa Oriental of Tome Pires; an Account of the East from the Red Sea to Japan, Written in Malacca and India 1512–1515; and the Book of Francisco Rodriqgues, Rutter of a Voyage in the Red Sea*. Edited and translated by Armado Cortesao (2 Volumes). London: Hakluyt Society.

Ramani, Shakuntala. 2007. *Kalamkari and the Traditional Design Heritage of India*. New Delhi: Wisdom Tree.

Reid, Anthony. 2015. *A History of Southeast Asia, Critical Crossroads*. West Sussex: Wiley Blackwell.

Shah, Shilpa. 2008. 'Of Merchants, Monarchs and Monks: An 18th Century Patolu Re-Examined'. *Marg*, 60 (2): 44–51, Mumbai, December.

Swallow, Deborah and John Guy (eds.). 1990. *Arts of India: 1550–1900*. London: V&A Publications.

Tavernier, Jean Baptiste, Baron of Aubonne. 1925. *Travels in India*. Translated by V. Ball (Second Edition, Vol. I). London: Oxford University Press.

Varadarajan, Lotika. 2011. *Gujarat and the Sea*. Vadodara: Darshak Itihas Nidhi.

Waterson, Roxana. 2009. *Paths and Rivers: Sa'dan Toraja Society in Transformation*. Leiden KITLV.

INDEX

aesthetic 8, 12, 22, 35, 39–40, 42, 51–2, 54, 73, 161–3, 165–6, 221–2, 226, 234, 241, 270, 272; aestheticization 234, 235
Agra 13, 25, 144, 146, 174, 185, 185, 189, 233
agrarian 13, 134, 141, 142, 169, 171
Akbar 135, 157, 162, 167, 170, 171, 174, 180, 136, 237; Akbari 161; *Akbarnama* 170
Anglo-Scottish union 40
Angria 96, 99–110, 112
apodemic literature 8, 17, 21; *see also* Ars apodemica
Appiah, Kwame Anthony 114, 115, 130, 131
archaeology 242
aristocratic 10, 169, 171
Ars apodemica 21
Arya Samaj 88, 142, 144, 146, 147
Aurangzeb 1, 2, 11, 12, 95, 110, 164, 174, 219–22, 235, 236, 239
Awadh 1, 11, 12, 52, 169, 171, 187, 195, 234, 241–4, 247–8, 251–2, 254; Awadhi 82, 83; *see also* Oudh

Baedekar, Karl 33
Bahurūp, Bahurūpiya 242, 243
ban on music 11, 219, 220
Barthes, Roland 22; 'Blue Guide' 22
Bhagatbāz, Bhagatbāzī 242, 243
Bhānd 163, 242, 243; bhandetī 242, 243
biography 12, 13, 37, 64, 158, 169, 170, 171
Bombay, Bombay Presidency 12, 20, 29, 31, 53, 96, 98, 100–113, 146–7, 152, 234, 241, 253, 267

Bradshaw, George 31–4; Bradshaw Railway guide 29, 31–2; *Hand-Books to the Presidencies* 31; *The Overland Bradshaw* 31
Brahmin 51, 86, 134, 135, 140, 142; Brahminical 140
British: British Empire 3, 4, 14, 18, 30, 35, 38, 43, 45, 76, 78, 90, 182; British Guiana 80, 82, 85, 86, 91; British India 2, 18, 20, 25, 30, 35, 91, 130, 152, 171
Buchanan, Francis 18, 33, 44, 60
Buddhism 76, 116, 118, 119–20, 122, 124, 125, 131, 134
bureaucracy, bureaucrat 11, 60, 157, 159, 171

Calcutta 11, 19, 21, 25, 40, 45, 50, 53, 62, 81, 86, 139, 142, 144, 182, 234, 241, 244
Carey, William 19, 35
Caribbean 78, 84–5, 86, 88, 91
caricature, caricatura 194, 198, 205, 210, 213, 214
cartography, cartographic, cartographer 8, 18, 21, 29, 31, 37, 39, 40, 41, 43, 44, 51, 52
cartoons *see* political cartoons
caste 9, 18, 51, 61, 70, 81, 86–91, 136, 139, 140, 147, 150, 152, 159, 163, 178, 243, 254
Celtic 39, 42, 49, 50, 52
Chandni Chowk 165, 176, 182, 186
Chellaby, Ahmed 101, 104, 105, 108
Christian, Christianity 23, 30, 58, 60, 127–9, 132, 179, 182, 183, 187
civility 155, 160, 171

INDEX

colonial India 13, 30, 77, 79, 90, 112, 151, 166, 202, 205, 213, 254
colonialism 1, 6, 9, 35, 36, 37, 38, 46, 53, 66, 90, 180, 192, 203, 210, 238; multipolar colonialism 38
communal, communalism 88, 137–8, 146–7, 148, 151, 152, 177, 190, 234
Cook, Captain 42, 43, 46
Cook, Thomas 17, 28, 34, 35
coolie 71, 86, 87, 88, 90
Coromandel 255–60, 266, 267, 269, 273, 274
cosmopolitanism 9, 114–30
cow protection movement 133–51
Culloden 41, 43, 52
cultural separatism 43

dādra 245, 246–9, 251
Darjeeling 8, 56–76
Defoe, Daniel 41–2, 53
Delhi 10, 30, 45, 49, 135–6, 140, 146, 165, 173–90, 211, 222, 223–8, 243, 251
Desideri, Ippolito 115, 116–18, 123, 127–30, 132
dhrupad 228–33, 236, 238, 247
diaries, Consultation Books 96, 102, 110, 111, 175, 182, 183, 186, 187, 190, 237
Din-i-illahi 179
Doctrine of reconciliation 176
domesticity 10, 155
Dutch East India Company 236, 255, 274

East Africa 80
Emergency years 193–4, 211, 213
English East India Company 3, 96, 97, 110, 112, 120, 255
Enlightenment 6, 8, 19, 40, 49, 131
ethnography 8, 17, 18, 43, 52, 56, 57, 60, 64, 66, 68, 70–6, 261
exhibit, exhibition, exhibitionary 19, 28, 30, 33, 49, 63, 187, 243, 250

factory 96, 97
familial 156, 158, 162, 164, 170
feast 160, 162, 167, 169, 271
field sciences 43, 51
Fiji 80, 82, 84, 86–8, 90, 91
firanghi 187
firman 103, 107

Fort William College 21
Fraser, James Baillie 8, 37–53
freedom of expression 211
French East India Company 257
frigate 99
fundamentalism 173

gau mata 135, 147, 149, 151, 152
gender 35, 149, 155, 157, 163, 164, 171, 172
Ghadar party 88
Ghalib 10, 173–90; *Dastanbuy* 173–91
ghazal 120, 173, 179, 184, 190, 245, 246, 247, 249, 251, 253
Gilchrist, John Borthwick 20–1, 26, 34
girmitiyas 79, 90
globalisation 115, 130
Gokarunanidhi 144, 152
Golkonda 257, 259, 260
graphic satire 11, 192, 195, 205, 206, 212
Gujarat 5, 9, 12, 77, 81, 87, 95–6, 98, 101, 109–12, 136–7, 142, 159, 181, 255–7, 260–75
Gurkha War 44–5, 52

hill station 50, 56, 71, 74
hill tribes 8, 48, 56, 69, 70, 72
Himalayan anthropology 60
Himalayan Journals 63, 64, 65, 75
Himalayas 8, 40, 44, 45, 51, 57, 59–62, 64, 66, 72, 76, 131; sub Himalayas 61, 76
Hindu, Hinduism, Hindutva 3, 33, 90, 119, 131, 134–52, 159, 170, 171, 174, 177–81, 187, 238, 241–3, 254, 255, 260, 265, 269, 272, 274
Hodgson, Brian Houghton 60–4, 75, 76
Hooker, Joseph 54, 57, 59, 63–5, 75
Hujjat Allah al-Bālighah 180
humanist 173, 175, 179

indentured system 79–84, 89
Inder-sabhā 241, 248–53
Indian diaspora 9, 77, 79, 89, 90, 91
Indian Mutiny (1857) 30, 151, 152, 174–5, 184, 187, 188, 193, 195–9, 234, 239
Indian National Army 88
Indian Ocean 12, 85, 96, 97, 99, 111, 112, 255, 256

INDEX

Indian public sphere 11, 192, 202, 213, 214
Indian textile 255–75; block print 266–73; double ikat 260–5, 267, 275; heirloom 256, 257, 259, 264, 268, 271, 275; Kalamkari 257, 258, 260, 275; *maa'* 256, 258–9, 268–70; Patan 257, 260, 261, 263, 264; patola 257, 260–7, 274, 275; resist dye 269–70
Islam 116, 119, 12–13, 126, 130–2, 150, 155–6, 171, 178, 180, 181, 183, 270–1, 274

jagir 99, 101–3, 106–7, 110, 157; *tanka* 99, 102, 104, 105, 108–11
jalsa, jalsa wale, jalse wāliyan 244–5, 248–52
Jawab-i-Shikhwa 178
Johnson, Samuel 41, 42–3, 53
Jones, William 2, 18, 19, 35, 238, 244, 254

kala pani 85
kalawant 160, 162, 163, 165, 223, 228–30, 236
kangani 78, 80
Kanhoji Angria 110, 112
Kashmir 14, 116–32, 170
kathak 77, 242, 245–8, 251, 252
Khan, Teg Beg 98, 100–109
Khan-i Dauran 99, 101, 108
khayal 225, 228–34, 237, 238, 240, 247
khushnawis 189
Kuka agitation 140, 142

Ladakh 5, 9, 10, 114, 132
Lal Kunwar 223–4, 236
landscape 7, 10, 18, 40, 42–5, 48, 49, 50–4, 56, 71, 73, 77
lashkar 183, 251
Laxman, R.K. 193, 194, 209–14
Lepcha 58, 61, 65, 67, 69–70, 75
linguistic traditions 140
Linnaeus, Carolus 19; *Systema Naturae* 19
Lonely Planet 8, 17, 33, 34
Lowther, Henry 99–109

Madras 27, 29, 31, 40, 86, 100
madrasa 168, 182, 184
Mahabharata 175, 176, 257

manliness 155, 159–69, 171
map, mapping 6, 13, 17–22, 29–33, 39–44, 49, 54, 56, 60, 73–4, 135; mapmakers 51
Marathas 95, 99, 105, 109, 110, 111, 156, 163, 181
marginalized 60, 161, 167, 168, 169
Martin, James Ranald 27, 34; *The Influence of Tropical Climate* 27
Masulipatnam 257, 260
Mauritius 80, 82, 84, 88, 91, 211
medical guidebooks 26–8
mehfils 163, 222, 224–30, 237, 238
migration 7, 9, 60, 77–91, 114, 119, 125, 126, 233
Mill, James 18, 33, 35; *History of British India* 18
Mill, John Stuart 2, 3
missionary 19, 58, 60, 116, 127, 129, 130, 131, 183
modernity 2, 3, 10, 13, 49, 75, 115, 130, 155, 163, 174, 193, 205–6, 232, 234
monastic organization 116
Moorcroft, William 115, 120–1, 124, 130, 131
mordant 258, 259, 266–8, 270, 273
Mughal: capital 243; court 2, 99–100, 156, 165–7, 182, 225, 226, 228–30; culture 11, 145, 162, 183–91, 224; elite 137, 157–9, 162–5, 224; Empire 1, 9, 124, 136, 162, 169–72, 173–6, 180–1, 232; patronage 237; rule 2–3, 95–8, 101–4, 107–10, 122, 125–7, 135, 150, 222
Muhammad Shah 136, 224–5, 229, 231, 237, 239
mujra 243, 246, 249
Murray, John 29–31, 33, 34; *Handbook for India* 29–30, 34
'museological modality' 42
mushaira 166, 184
musicians 160, 162, 165–6, 169, 172, 219, 222–9, 233–8, 243, 245–7, 250
Muslims 122, 123, 125, 132, 136, 139, 142, 144, 147–50, 178, 187, 243
mutineers 85, 177, 187–8, 190
mythical past 174–6, 179, 184, 188

nautanki 253, 254
Niamat Khan 223, 225–33, 236, 238
normative 156, 163, 166–7

278

INDEX

objectivity: geographical objectivity 6; literary objectivity 157; scientific objectivity 56, 57
Orientalism 13, 19, 36, 76
Ossian 41
Oudh 11, 146, 192, 193, 194, 202–6, 209, 212–13, 254
Oudh Punch 192–4, 202–5, 209, 212, 213
overseas 9, 43, 82, 90, 91; journey 77, 78; plantation 86 ; settlement 85, 89; trade 9; travel 9, 78

Paar, Thomas 70, 71
Parī-Khāna 244, 248, 253
pariyon kā akhārā 250
pashmina 122, 125
patronage 252, 254–7, 273
photography 8, 56, 57, 62, 64, 66–8, 73, 75, 76
People of India, The 19, 70, 71
picturesque 22, 30, 33, 41–2, 45–56, 69, 70, 73
piracy, pirate 96–9, 101, 108, 111, 112
plantation 9, 39, 40, 56, 74, 78, 81–2, 84, 86–9
political cartoons 11, 192–214
politics of the street 202, 203
portrait, portraiture 68–70, 72, 74
Portuguese 1, 100, 109, 112, 274
press censorship 193
print culture 183, 187, 192, 194
privateers 97
proselytizing 187
Punch viii, 192–209, 212–15; Mr. Punch 194–5, 203–9, 214; *see also* Oudh Punch; vernacular Punches

Qawwal, qawwali 224, 227–33, 237–8, 247
Qutubuddin Aibak 177

racial composition 120
Rādhā Kanhaiyya kā qissa 245
rāgini ke jalse 244
rahas 242, 244–9; *jalsa-i rahas* 244, 245; *rahas ke jalse* 244
Ramayana viii, 257, 258, 259, 260, 262, 274
Rās-dhārī, Rahas-dhārī 242
Rās-līlā 241, 242, 245
rastkhiz-i bi-ja 181

remittances 80, 86, 91
Rennell, James 18, 44, 51
riots 139, 140, 142, 144, 146–8; Holi Riot 135–7, 151; Sikh riots 175
Roberts, Emma 24–5, 35; *The East India Voyager* 24, 35; *Sketches of Anglo-Indian Society* 25
Roy, General 40
Royal Asiatic Society 63, 170, 171

sabha 241, 251, 252
sacred: code 23, 140; cow 134, 135, 138, 151, 152; idols, objects 116, 221; spaces 141, 150, 156, 228; symbols 10, 139, 141, 147–52; textiles 260, 265, 275; texts 33, 134, 135, 148, 260
sāngiya 242–3
Saraswati, Dayanand 138, 142–5, 151, 152
satire 192–5, 197, 199, 203–6, 209–12, 214
Schofield, Katherine ix, 162, 163, 172, 219, 221, 228, 235, 237, 238
Scotland, Scots, Scottish 37–50, 54
Scott, James C. 9, 115, 132
Scott, Sir Walter 39, 50
Scottish Highlands 38–42, 48, 50
sexual economy 223, 225, 237
Shah Wali Allah 152
Shah Waliullah 183
Siddi 96, 98–109, 110
Sikkim 57–9, 64, 75
Singh, Rajman 62, 63
slavery, slaves 9, 13, 68, 76, 78–82, 84, 89, 90, 91, 110, 158–61, 167, 170, 265
spatial metaphoric 38
spectacle 19, 30, 35, 45, 69, 70, 76, 186
Sri Kalahasti 258
Stein, Gertrude 114, 132
Stocqueler, J. H. 25–6
studio 70–1
sublime 42, 49, 51, 52, 129
subversive laughter 194, 212
Sulawesi 257, 259, 262, 266–9, 271, 273, 275
Surat 96, 98–109, 111, 112, 113, 236, 267; governor 102
Suriname 80, 90
Swāng 242, 243, 253, 254

INDEX

'tactical modernity' 206
Taj Mahal 184
takhallus 183, 189
Taylor, John 41
tazkirahs 10, 155–62, 165–9, 171
Tenganan Pegringsingan 261
thumri 230, 245–9, 251, 253, 254
Tibet 9, 10, 53, 57, 59, 61, 70, 75, 76, 114–32
topography 18, 22, 43, 45, 46, 51
Toraja 257, 259, 260, 268, 269–73, 275
tourist 17, 28, 29, 31, 32, 41, 70, 71, 74
trader 77, 81, 87, 96, 132, 136, 255, 262, 269
travel: guidebooks 17, 21–33, 35, 42; literature 37, 42
traveller 6, 8, 9, 17, 20–5, 28–35, 38, 39, 41–2, 47, 50, 57, 71–3, 96, 119, 177, 261
Trebeck, George 115, 120, 124, 131
Trinidad and Tobago 80, 82, 88, 91

urban: city 173; life 175–7, 190; middle class 250; space 146, 174; theatre 11, 241, 248, 252
Urdu: drama 244, 254, 252; ghazals 184; language 19, 21, 120, 172, 182–3, 188; poets and poetry 10, 178, 183, 253, 254; weekly 11, 192

vade mecums 8, 20, 32, 33; *see also* apodemic literature
vakeel, broker 102, 104–6
vernacular language press 202
vernacular *Punches* 206
vidushaka 205, 213
violence 138, 145, 175, 184, 186–8, 199; communal 147
virali pattu 261–2, 275

Whadat-ul-wajud 179
Williamson, Captain Thomas 20–4; *The East India Vade Mecum* 20, 34, 35

Yudhistra 176

Printed in the United States
By Bookmasters